JAN 3 1 2007

The Lives and Loves of

# Daisy and Violet Hilton

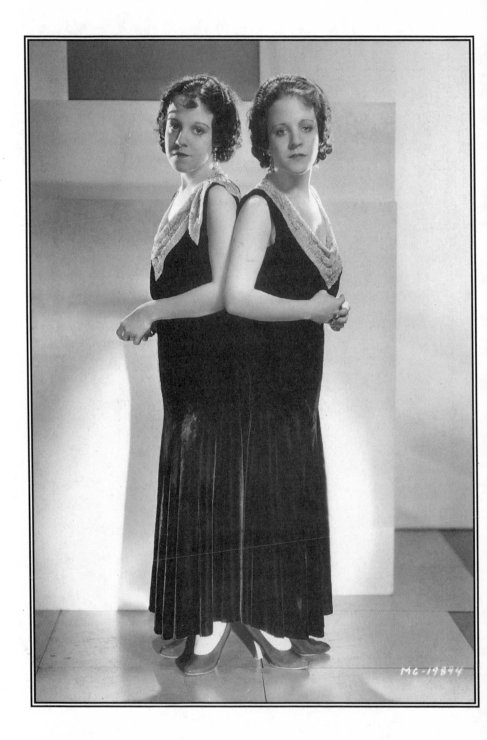

MG-19894

The Lives and Loves of

# DAISY AND VIOLET HILTON

*A True Story of Conjoined Twins*

DEAN JENSEN

TEN SPEED PRESS
Berkeley | Toronto

1🅴

Ten Speed Press
PO Box 7123
Berkeley, CA 94707
www.tenspeed.com

Distributed in Australia by Simon and Schuster Australia, in Canada by Ten Speed Press Canada, in New Zealand by Southern Publishers Group, in South Africa by Real Books, and in the United Kingdom and Europe by Publishers Group UK.

Cover design by Scott Idleman
Cover photo courtesy of the Circus World Museum, Wisconsin Historical Society, Baraboo, Wisconsin
Interior design by BookMatters

Frontispiece: MGM *publicity still of Violet (left) and Daisy (right) Hilton, 1932, shortly before the release of Tod Browning's film* Freaks. *On the reverse side of the photograph is the following studio caption:* "Daisy and Violet Hilton, pretty Siamese twins, have long been famous in side shows but make their motion picture debut in the Metro-Goldwyn-Mayer picture *Freaks*. They are accomplished musicians, each playing the saxophone very well and though they have been joined since birth they enjoy the best of health. Strangely enough, these twins have entirely different likes and dislikes." (Author's collection)

Library of Congress Cataloging-in-Publication Data on file with the publisher.

ISBN-13: 978-1-58008-758-2
ISBN-10: 1-58008-758-2

First printing, 2006
Printed in the United States of America
1  2  3  4  5  6  7  8  9  10 / 10  09  08  07  06

*For my wife, Rosemary, my daughters, Jennifer and Jessica,*
*and my son, Dane Marco, with love.*

# ACKNOWLEDGMENTS

Daisy and Violet Hilton existed for me only in the most faintly drawn outlines when I first thought about writing their story. For bringing the sisters vividly to life, I am indebted to many who, unless they requested otherwise, are iden-tified in the text and in the footnotes. While they are not renamed here, it should be understood that their contributions were enormous.

It was complicated to keep the twins in sight during their early years abroad. I am grateful to those who assumed the tedious job of tracking the sisters' move-ments. These able researchers include: in England, Paul Braithwaite, Joan Goddard, Mervyn B. Harding, Mr. and Mrs. R. D. Harvey, P. D. Rooth, Pete Stanifroth, Lady Teviott, and Ned Williams; in Australia, Wendy Baker, Peter A. D. Fogarty, Joe Hobson, Mark V. St. Leon and especially Sam Marshall and Sophie Townsend; in the Netherlands, Bert Degenaar.

Fred Dahlinger Jr., former director of the Robert L. Parkinson Library at the Circus World Museum in Baraboo, Wisconsin, and a longtime friend, would nearly qualify as the book's co-producer. Others who extended especially help-ful favors: Elfrieda Abbe, Carol W. Auspacher, Kitty Caparella, William Fitzhugh Fox, Joseph Haestier, Ken Harck, Ward Hall, Lynn Keziah, Johnny Meah, Carol Ness, Bill Russell, David J. Skal, Al C. Stencell, James Taylor, Bill Whiting, Dale Whitmore, and the late Gretchen Worden.

There are two new women in my life as result of this project. Susan Subtle took an early interest in the Hiltons' story, gently goaded me to keep writing, and hand-delivered the manuscript to Phil Wood, publisher of Ten Speed Press. My feelings of gratitude for Susan are without bounds, and this is also true for Veronica Randall, my editor at Ten Speed. She made innumerable improve-ments and, magically it almost seems to me, infused the book's narrative with the kind of texture and animation that now feels absolutely right.

Lastly, I thank my dear wife, Rosemary, who read the earliest drafts of the book. I noted every page where I saw her nodding off, and determined these parts of the story needed some attention. I thank her, too, for her ongoing sup-port and tolerance of my many absences as I searched, like some crazed groupie, for more on the remarkable story of Daisy and Violet Hilton.

# CONTENTS

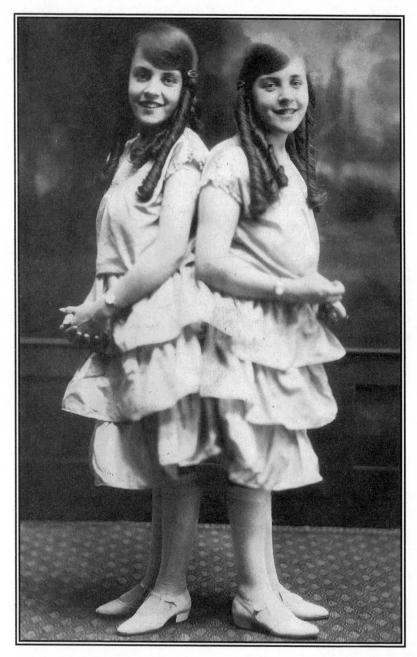

*Violet and Daisy, early 1920s. (Author's collection)*

# THE BRIGHTON UNITED TWINS

Kate was having a hard labor. The contractions were coming so close together that the pain from one never completely subsided before the next one started. It had been going on since before dawn on the morning of February 5, 1908. Fourteen hours later, the sun had set and the small second-floor room overlooking Riley Street was dimly illumined by lanterns.

Kate was twenty-one and unmarried. She was striking in appearance with softly waving cinnamon-colored hair, sad green eyes, and a complexion so pale her face almost appeared to be emitting light. She was tall and of slender frame, but she had become huge in pregnancy.

She clenched her teeth and fixed her eyes with each contraction, fearing her middle was going to tear open. Sometimes she screamed so loudly from the pain that the tenants in the adjoining row houses banged on the walls.

It was dank and cold, but because Katie complained of breathing trouble, the room's single window had been thrown open, letting in salty sea air and the stench of horse droppings and garbage from the street below.

Sitting on Kate's bed, holding her hand and talking soothingly, was her mother, Mary Ann Skinner, and although the chamber was scarcely large enough for the bed, it was occupied not just by Kate and her mother, but also, Mary Hilton, a midwife, and her daughter,

Edith Emily Hilton. Two of Kate's sisters, Maggie, fifteen, and Winnifred, nine, came and went as the evening wore on.

Maggie had known before anyone that this was going to be the day that Kate was going to deliver. It was 5 A.M. and still dark when she woke up in the bed she shared with Kate and discovered that the bed clothes were sopping. Soon after, Kate's contractions started. They were mild at first and widely spaced, but by midmorning they had become violent and kept coming without interruption.

Kate resided with her family in Brighton, England's most popular seaside resort. But the Skinners lived nowhere near the grand hotels, posh music halls, glittery arcades, and shooting galleries that were clustered along the famous boardwalk. Their row house was in the Bear Hill section of the city, which was not a part of town that tourists visited. Even the ocean breezes seemed to avoid Bear Hill. It was a slum, an almost impenetrable fortress of tightly clustered, badly drained, and appallingly over-crowded brick and mortar dwellings.

Mary Hilton was the best known midwife in Bear Hill. Over more than thirty years, she had presided at the births of hundreds of babies. She was in her fifty-fifth year. Some of the babies she was now delivering were the children or grandchildren of girls who, decades earlier, she had also brought into the world. But for all her experience at midwifery, as the hours passed in Kate's bedroom, Mary was becoming increasingly concerned.

In appearance, Mary Hilton was a woman without any sharp corners. She was plump with waist-length chestnut-colored hair that she wound, piled, and pinned into thick coils on top of her head. Kate knew her not just as a midwife, but also as an employer. Mary and her husband Henry, along with their daughter Edith Emily, operated a pub in Brighton, the Queen's Arms. It was a place known by the locals not so much for the quality of its food, but for the continual coming and going of barmaids with pregnant bellies, none of whom was paid.

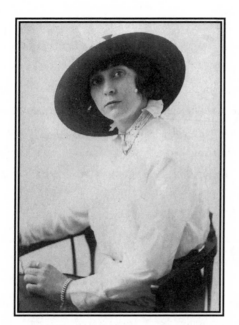

*The twins' mother, Kate Skinner.*
*(Author's collection)*

They worked at the Queen's Arms in exchange for Mary's promise that she would deliver their babies.

When unmarried young women in Kate's circumstances became pregnant, they rarely sought the services of doctors. Usually they gave birth in their own beds, often with a midwife in attendance. Kate's pregnancy had been complicated. She had complained of bleeding and unusual pain six months into her term. It's impossible to know what the nature of her problems were, but her concerns were serious enough that she was also placed under the care of a doctor. The medical attention Kate required took most of her skimpy earnings as a grocery store clerk. Because her pregnancy forced her to give up her job, she was unable to pay room and board and could do nothing to ease the family's financial strains.

Her father, Charles Laker Skinner, worked as a butcher's assistant. Besides Kate and Maggie, there was another child in the family, a younger brother, Charles Jr., and all were living in the narrow row house at 15 Riley Street.

Fourteen or fifteen hours had passed since Kate's labor had begun. Although Kate was widely dilated and her contractions were strong, Mary Hilton still didn't see any signs of movement by a baby. She told Mary Ann, Kate's mother, it was likely the infant would be stillborn. It was time to summon a doctor. She left the Skinner residence to find a public telephone.

The physician whom Kate had been seeing was James Augustus Rooth, a member of London's Royal College of Surgeons and a highly regarded doctor not just in Brighton, but the entire county of Sussex. Rooth lived in Hove, a community bordering Brighton to the west. He was home when Mary Hilton's call came in. The nurse reported that something was wrong, that although Kate had been in labor since the predawn hours, she still had not delivered. Soon he was seated in the rear of a horse-drawn hansom, rolling toward the Skinner residence.

Rooth wore a mustache that was so fastidiously maintained it appeared to have exactly as many hairs on the left side as on the right. He was tall and lean and seemed to be implanted with some leveling device that kept him absolutely perpendicular to the ground. When he entered a room, most people felt inclined to stand at attention. Rooth had been a medical officer during the Boer War in Africa, and had never lost his military bearing.[1]

It was Kate's father who received Rooth at the door. He told the physician that only minutes earlier, his daughter had finally delivered, and that although he himself hadn't been in the birthing chamber, he thought Kate may have delivered twins. Rooth could hear the squalling of two babies the moment he entered the house. What was

immediately more disconcerting to Rooth was Kate's hysterical shrieking. He bounded up the stairs to her bedroom.

Even the doctor was startled by the scene: Kate, lying atop bed-clothes that were soaked in blood, her legs drawn up to her chest, was maniacally throwing her body from side to side and still screaming. Mary Hilton and her daughter Edith Emily were struggling with Kate, trying to restrain her. Maggie Skinner had her hands tightly pressed to her ears, trying to muffle her sister's chilling cries.

Lying beside Kate, still sticky with blood and vernix, were two bawling girls. Rooth reached down for the infants and then drew them to eye level to make his appraisal. They were large for twins, probably weighing about six pounds each. The lower leg of one of the babies was slightly twisted, but each girl had all her fingers and toes and appeared to be well-formed, at least on first examination. And because of the twins' lusty crying, it was also apparent they had strong lungs. But the midwife had been right. There *was* something wrong with the infants, something terrible. Of the hundreds of births at which Rooth had been present, he had never seen babies like these. They were fused together. In the language of medical science, they were pygopagus babies, twins whose bodies were joined back-to-back by a bond of flesh and bone at their lower spines

The doctor tried to calm Kate. He attempted to place the babies in her arms but she only screamed more. Her face was turned away from her children. She was too terrified to take another look at them. Kate now believed she knew why her pregnancy had been such a dif-ficult one: The hideously fused babies were a sure sign that God had found her adultery to be deserving of the severest punishment. She wouldn't—she couldn't—bear to touch them. Even the medical world of the day used the term "monsters" to refer to human beings of such anomalous forms.

It was Mary Hilton who cleaned the twins of their afterbirth, wrapped them in swaddling clothes, and gently rubbed their backs and cooed to them softly.

Before leaving her, Dr. Rooth told Kate that while he knew of a few cases of conjoined twins, the odds were never good for their survival. He said that God had a way of sparing such creatures lives of wretchedness. While Kate's babies looked to be strong and robust, something was likely to change in their condition soon, the physician predicted. First one would die followed quickly by the other.

But what if the infants did survive? That is what Charles Laker Skinner wanted to know. He was barely able to put enough food on the table as it was. Now, in an instant, the number of mouths in the household jumped from seven to nine. He shouldn't have been surprised that Kate delivered twins, because they ran on the Skinner side of his family. His own mother had borne four sets of twins. He himself was a twin, as was Kate herself, although her sister Maggie had died at one year.[2]

After two or three days there was still no change in Kate's feelings toward her babies. She refused to hold them and screamed when her mother or Maggie brought them to her. Because Kate refused to suckle the twins, Dr. Rooth put them on a diet of diluted cow's milk.[3] Kate's mother and sister mostly carried out the bottle feedings with Mary Hilton and her daughter Edith Emily helping during their periodic visits to the Skinner house.

It angered Kate that day after day, the twins did not seem to be getting weaker, as Dr. Rooth had predicted, but stronger. When were they going to die? She had no desire to bond with them, but her mother insisted that Kate give the girls names. There was something almost poignant about the choices she made. She named one child Daisy, the other, Violet. Daisies and violets were among the first flowers to bloom in the window boxes of Brighton after the gray and

gloomy winters. They were also the flowers that Kate regularly sold at the green grocery. By conferring the names of these common but cheerful flowers on the babies, was she hoping that if they did survive, they might triumph over their illegitimacy, poverty, and deformity, and bloom into creatures of hardiness and gaiety? She may have been prescient in choosing the names, or so the passage of time would seem to have shown. As the twins grew older and their personalities began to develop, Daisy would show herself to be the sister with the warmer, sunnier disposition. Violet's temperament, on the other hand, tended to be cooler, darker, and more mysterious.

In the days immediately following the birth, Mary Hilton and her daughter Edith Emily Hilton were the only visitors to the Skinner household. Whether it was because of a desire to protect their daughter or their shame at what she had produced, the Skinners tried to keep their neighbors from knowing that Kate had brought forth Siamese twins. When the fish wives living around the Skinner row house hadn't seen anything of Kate for a week or so, however, they started asking questions. Soon it was known everywhere on Bear Hill that there were freak babies under the Skinners' roof.

Who had fathered the twins? In the streets and local pubs, people whispered that the babies had been the result of an incestuous relationship between Kate and her father or perhaps between Kate and Ernest Skinner, the fifty-eight-year-old unmarried uncle who worked as a carpenter and boarded with the family. Such suspicions were understandable in the British Isles at a time when intermarriages within the royal families had produced their share of physically and mentally challenged children. While the possibility that Daisy and Violet were born of an incestuous relationship cannot be ruled out absolutely, such an explanation for their anomaly is improbable. Nowhere in the medical literature is there a single documented case of conjoined twins who were born to biologically related parents. As

historically rare as conjoined twins are, they are not caused by hered-
itary factors. Such children can result only because a single fertilized
egg has divided imperfectly.

Daisy and Violet, years later, would make the claim that their
father had been a military officer, a "Captain Hilton." In the slim auto-
biography they produced, *The Intimate Lives and Loves of the Hilton Sisters,
World Famous Siamese Twins*, they summed up their father in just four sen-
tences: "He married our mother in Texas. She ran away from him after
we were born. We were unable even to learn our father's first name.
Our father . . . died in action during World War I."[4]

Like much else in the twins' memoir, the sketch of their father
appears to be entirely fabricated. As a lowly green grocer's assistant,
Kate Skinner never had the means to travel outside Sussex County,
much less a quarter of the way around the world to Texas. As for the
twins' assertion that their father's surname was Hilton, this was
clearly a concoction. The name Hilton came not from the man from
whose seed Daisy and Violet sprang, but rather from Mary Hilton,
the midwife who attended their birth.

The only known document providing a clue to the identity of the
twins' father is a handwritten note from 1921 by Mary Ann Skinner,
their grandmother. The note names a Frederick Andress as the father
of Daisy and Violet and is now in the hands of Jill Grove of East-
born, Sussex, England, a niece of Daisy and Violet, who has main-
tained a small collection of mementos relating to them, including pho-
tographs, newspaper clippings, genealogical charts, and some legal
documents.

According to the city's census records, only one Frederick Andress
resided in Brighton in the year of the twins' birth.[5] He was a hair-
dresser who maintained a salon at 5 Brighton Place. Frederick Andress
was thirty, nine years older than Kate, the son of Edward and Sarah
Andress. Edward Andress was a man of wealth and prominence in

Brighton. He was the publisher of a weekly newspaper, the *Brighton Times*, and also operated a printing company.[6]

The postulation that Kate became pregnant by a scion of one of Brighton's wealthiest and more powerful community leaders was given even more support by Jim Moore, a close and nearly life-long confidant of the twins. Moore seemed not to know or remember the name of their father, but the details he provided about their conception sounded perfectly credible. "Their mother [Kate] was a serving girl of some capacity in one of the great homes of Brighton. . . . The father was one of . . . the younger children of the family . . . [Kate] was in disgrace. [The father] wouldn't have anything to do with her after she became pregnant, so [Daisy and Violet] were born out of wedlock."[7]

While the birth certificates identified their mother as a "greengrocer's assistant," it is known that Kate had been employed by a Brighton family as a maidservant before taking work as a vegetable vender. It's reasonable to believe that Edward and Sarah Andress would have fired Kate had they learned she had become pregnant by their son. As one of Brighton's social pillars, Edward Andress surely would have gone to great lengths to prevent a scandal.

Whomever the father was, it is almost certain the twins' progenitor was already married when he impregnated Kate, or so it is believed by Joseph Haestier, a nephew of Daisy and Violet. Haestier's mother was Kate Skinner's younger sister Maggie who was present in the birthing chamber when the twins were born. "My mum had always been devoted to her sister Kate," said Haestier of Kent, England. "Maybe her devotion had something to do with the fact that Kate was six years older than her. It was probably a kind of hero worship or something. . . . I used to ask my mum why Kate never married the father of Daisy and Violet. She always answered that Kate couldn't marry the twins' father because he

already was married. As I understood it, Kate had a long-term affair with this man."[8]

Kate never married, but according to Haestier, she would have two more illegitimate children after the birth of the twins, both by the same man who fathered Daisy and Violet.[9]

Whether she was listening to a pub patron pouring out his woes or coaching a young unwed mother through her first labor, Mary Hilton could affect an empathetic, motherly manner. But Kate knew from the months she worked for Mary at the Queen's Arms that her outward appearance of benignity masked a woman with a cold and judgmental temperament. Even in the late stages of Kate's pregnancy, Mary insisted that Kate work long nights scrubbing kettles and waiting tables. When Kate protested, Mary told her she was free to go home, but if she did so, she would have to arrange to find another midwife.

Mary Hilton was no less reproving of Kate after the twins were born. Over and over, she told Kate that her monster babies were the result of loose morals.

As scolding as she could be to Kate, Mary doted on the newborns. She reported to the Skinner row house almost daily, usually accompanied by Edith Emily. Sometimes, in fact, she showed up two or three times a day to help feed and bathe the twins as Kate refused to suckle, bathe, or even take them in her arms.

The diet of diluted cow's milk that Dr. Rooth prescribed seemed to present no problem for the infants. Daisy and Violet weighed about twelve pounds at birth and, within just a few days, pushed the scale at thirteen pounds. But soon after coming into the world, the twins broke out with eczema. As Dr. Rooth would later write, the skin condition was a result of the fleshy and cartilaginous bond at the twins' backs. The sisters were so tightly joined at their buttocks, he

observed, that Mary Hilton was presented with "an extreme difficulty in keeping them both dry and clean."[10]

Kate spent her days and nights shut inside her bedroom. Each morning, she hoped her mother would appear at her bedside and tell her that the twins had taken a bad turn and had died or were dying. But all she ever heard from her mother was that the babies were showing healthy appetites, that they had slept through the night without fussing, and that they appeared to be growing ever more robust. Mary Ann Skinner was a gentle woman. She sometimes thought that maybe her daughter would begin having maternal feeling for the babies if she placed them in a crib and left them with Kate in the bedroom. At the same time, she worried that if Kate were left alone with the newborns, she might try to smother them.

There is no way of knowing whether Kate might have tried to kill her daughters, but she herself seemed to have lost the will to go on living. She refused to eat the food her mother brought to her bedside on a tray. Growing weaker each day, all Kate could think about was the bleakness that lay ahead if the twins were to survive. Because of the rope of flesh knotting Daisy and Violet together, they would never be able to appear in public without attracting attention. And Kate was sure that if she kept the children, she would never be able to go anywhere without being mocked and pointed at as an example of how God had punished the most sinful of his flock.

Even before she gave birth to her extraordinary daughters, Kate had wondered how, as a single mother, she was going to support even one child. Attitudes toward illegitimate children were anything but enlightened in England in the early twentieth century. Unlawfully begotten children of the poor were an affront to public morality. Under British law, in fact, such a child was regarded as *filius nullius*: a child with no name, no parents, no kin, and no right to inherit.

There were orphanages for foundlings and the children of the des-
titute, but Kate was not assured that any of them would take her off-
spring. Many kept their doors closed to illegitimate children in the
belief that such children inherited the moral weaknesses of their par-
ents and would contaminate the minds and morals of their lawfully
begotten wards. Another option for an unmarried mother was to send
her offspring to a so-called baby farm. Under such an arrangement, the
mother would pay a lump sum to the baby "farmer" for the child's
long-term maintenance. Only the most desperate mothers gave up
their children to baby farms. The newspapers regularly ran exposés of
baby farmers who practiced infanticide outright or let their charges
die of starvation and neglect. In 1896, for example, a Mrs. Dyer of
Reading was hanged after being found guilty of strangling the babies
that had been entrusted to her and throwing their bodies into the
Thames. She became the subject of a sardonic ballad, *Mrs. Dyer, the Baby
Farmer*, which had this refrain:

> *The old baby farmer 'as been executed,*
> *It's quite time she was put out of the way,*
> *She was a bad woman, it isn't disputed,*
> *Not a word in her favor can anyone say.*

Unaccountably to Kate, Mary Hilton's attitude toward her began
to change four or five days after the twins' birth. Mary no longer
reproached her for refusing to feed and care for the twins. Instead, she
seemed solicitous and unusually sympathetic. Her feelings toward the
twins, Mary told Kate, were special. She took great joy in bottle-
feeding and bathing the babies and in holding them in her arms until
they drifted off to sleep. Always before she left the Skinner home,
Mary visited with Kate in her bedroom. Sometimes for hours at a
time, she held Kate's hand and listened as the new mother talked

through her sobs about the fears she had for her daughters and herself. Kate was always soothed by Mary's visits.

As she had done almost daily since the twins were born, Mary Hilton called at the Skinner household when the twins were three weeks old. As sympathetic toward her as Mary had gradually become, Kate found the saloon matron and midwife to be even more tender on this occasion. After seating herself on the bed, Mary took Kate's hand and reassured the frightened young mother that there was no need to worry about what might become of her and the babies. Mary explained that after long discussions about the twins with her husband, Henry, and her daughter, Edith Emily, they were united in their desire to adopt Daisy and Violet. They were eager to give the girls a good and loving home.

Kate was silent for several seconds, at first not comprehending what she had heard. Then her lips began to quiver. In a moment, all the pain and terror welled up inside her and broke through. She threw her arms around Mary and, sobbing and shaking convulsively, held on tightly. Between gasps she blurted out her gratefulness. "Take my babies and care for them as a mother," she begged. "Tell them you are their aunt and never let them know who their real mother is."[11]

Adoptions were common enough in England in 1908, but they were usually carried out privately, with no filing of records. Britain had no laws governing the adoption of children, which meant that if a mother gave up her baby for one year and then wanted to reclaim it, the adoptive parents would have no legal right to the child.

For all her seeming guilelessness, Mary was cunning. Before telling Kate that she was prepared to adopt the twins, she had visited a lawyer to see if some legal instrument could be drawn up that would discourage, if not prevent, Kate from ever trying to get the twins back. The lawyer, J. G. Bramhall of Brighton, brilliantly devised

such a document. Under the terms of the agreement he drafted, if Kate
ever tried to regain custody of the children, she would be legally obli-
gated to pay Mary and Henry Hilton ten shillings a week for every
week the twins had been in their care. The document read as follows:

Memorandum of Agreement made this twenty-fifth day of February one-
thousand nine hundred and eight Between Kate Skinner of No 18 Riley
Road Brighton in the County of Sussex, a single woman of the one part, and
Mary Hilton of No 8 George Street Brighton, aforesaid the Wife of Henry
Hilton of the other parts

Whereas the said Kate Skinner on the Fifth day of February one thousand
nine hundred and eight gave birth to twin girls joined together at the hips
and named Daisy Hilton Skinner and Violet Hilton Skinner and the said
Mary Hilton attended her in her confinement and has since taken care of the
said children and it has been agreed between the parties hereto that she shall
hereafter have the custody and control of the said children on the terms here-
inafter expressed

Now it is hereby agreed as follows:

1. The said Mary Hilton hereby undertakes the sole care, custody and
control of the said children and agrees that she will hereafter at her own
expense make all necessary and proper provision for their clothing, mainte-
nance, support and education and will at all times hereafter keep the said
Kate Skinner indemnified from and against all expense and liability of every
kind in relation to the said children.

2. In consideration of the understanding and agreement in clause 1, the said
Kate Skinner hereby relinquishes all claim to the said children and irrevoca-
bly appoints the said Mary Hilton to be their guardian and the said Kate
Skinner agrees that she will not at any time hereafter seek in any way by legal
proceedings or otherwise to regain the care, custody or control of the said
children and also that she will not at any time hereafter molest or in any way
annoy the said Mary Hilton or make any claim whatever against her in respect
of the said children.

3. The said Kate Skinner agrees that if at any time hereafter she shall do
anything contrary to the provisions of this agreement she will pay to the said
Mary Hilton as liquidated damages and not by way of penalty, the sum of ten

shillings for every week which the said Mary Hilton shall have had the care, custody and control of the children.

As witness the hand of the said parties the day and year first above written.

The document was signed by Kate Skinner and Mary Hilton and bore the signatures of two witnesses, those of Kate's mother, Mary Ann Skinner, and F. Webb, an employee, most likely a secretary, of the law firm of J. G. Bramhall.

If, as some evidence suggests, it was Edward Andress's son, Frederick, who fathered the twins, then his father's newspaper, the *Brighton Times*, should have had the inside track on the story. In fact, it was another newspaper, the *Brighton Herald*, that broke the news. The *Herald's* account could hardly be viewed as a scoop. The twins were already six weeks old when the *Herald's* front page story appeared on March 22, 1908. To the relief of the Skinner family, the account did not refer to Kate by name but instead referred to the mother only as a "servant girl." The paper's report appeared under a two-tiered headline:

### BRIGHTON'S "SIAMESE TWINS"
#### *An Extraordinary Birth!*

An extraordinary freak of nature has just seen the light at Brighton. A servant girl has given birth to twins who are united at the hips by an indissoluble bond of flesh and bone. The twins are girls. The lower parts of their backbones are grown together so that just behind the hips, the two otherwise independent bodies are one. The union is all the more complete since, between them, the two children have but one set of certain vital organs. In other respects, the children are quite normal. In fact, they are a very healthy lusty young pair, and seemed possessed of uncommonly vigorous life. . . .

From Dr. James Rooth, who was kind enough to answer the questions of our representative, we learn that the two

children obviously possess entirely distinct individualities. One has been noticed to be crying while the other is asleep; one has had certain infantile troubles at a time when the other was unaffected. . . .

Whether they can be separated or not is a matter at present of grave doubt. Separation would almost certainly mean that one would have to be sacrificed. At present, both youngsters are full of life; and it cannot be said that one is more vigorous than the other.

We understood from the doctor that the case is one of an entirely exceptional kind, and is arousing intense interest in the medical profession. Before long the infants will be photographed under the X-rays so that doctors can see exactly how the union has been effected.

The children have been adopted by Mrs. Hilton, the motherly lady who helped bring them into the world; and one found her keenly excited and solicitous over the welfare of her extraordinary foster children. In all her wide experience, she has never known of such a thing; and she confesses that her emotions were very perturbed when she saw what had come into the world. But she never saw finer babies, and could not wish to have them doing better than they are now. . . .

In a sense, Daisy and Violet were adopted not just by Mary and Henry Hilton, but by all of Brighton. As word of the "extraordinary birth" spread, people began appearing at the Queen's Arms to drop off such items as hand-knit booties, quilts, and dolls. Brightonians were beginning to take pride in the notoriety their town was attracting as the birthplace of genuine Siamese twins. There was a tradition in Europe of celebrating human oddities, among them Chang and Eng, the original Siamese twins; General Tom Thumb, the twenty-eight-inch-tall midget; Millie-Christine, the Two-Headed Nightingale; and John Merrick, the Elephant Man. They were embraced by royalty and lionized by the press. Whenever such "celebrities" appeared anywhere

in public, they were swarmed by crowds who did not see themselves as being unusually rude or snoopy. They were simply uninhibited in their fascination.

Mary had arranged for the baptism of Daisy and Violet to take place on the evening of March 24, 1908. She was mindful of the harm that could come to the seven-week-old babies from overly enthusiastic curiosity seekers. She plotted the details of the christening with the secrecy of a military general planning a sneak attack.

Minutes before the ceremony, a horse-drawn cab rolled up in front of the Countess of Huntington Church, a large and imposing stone edifice on North Street, and disgorged Mary, Henry, and Edith Emily Hilton, Kate Skinner, and the twins. The party avoided the church's main entrance into which others were streaming for an evening service. Instead, with Edith carrying the twins cocooned in a blanket, the baptism celebrants walked briskly to the vestry at the rear of the church.[12]

Mary Hilton may have been fearful about the babies being mobbed in public, but she had no reservations about gaining more publicity for her new charges. She had alerted the *Brighton Herald* of the christening and a reporter was already on hand when the group entered the vestry.

Daisy and Violet were dressed in white christening gowns with silk ties at the cuffs. Mary fussed with the infants in the moments before the ceremony began, removing the white woolen shawls that covered their heads. The *Herald* correspondent was love-struck at the sight of them. He ravished them with this line: "They are, as far as is known, the most wonderful couple in the world."

The christening was presided over by the Reverend F. J. Gould, a visiting minister from the Lewes Road Congregational Church. Violet slept throughout the entire ceremony. Daisy was not so blasé. She gazed up at the minister, while sucking on a pacifier, with what the *Herald* called "a volley of smack, smack, smacks."[13] The reporter

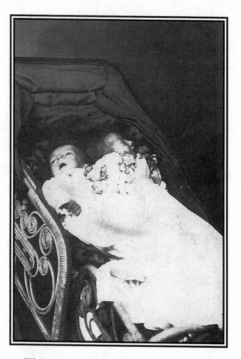

*The newborn sisters in their pram, 1908.*
*Already sensing an income opportunity, Mary*
*Hilton sold this two-penny postcard to visitors*
*at the Queen's Arms and later at the Evening*
*Star pub. (Author's collection)*

did not have any compunction about declaring which twin would be the hands-down victor in any beauty contest in which the two were the finalists. "Were they older," the writer observed, "one would hesitate to draw comparisons, but Daisy is undoubtedly the prettier of the two. She has a better forehead and her features are better moulded. She is indeed quite a charming little baby. Violet is not so well favoured. Still . . . she is quite a winsome and appealing little lady."[14] The *Herald* piece may have ranked with the fullest accounts of any baptism ever recorded. The story ran almost two full columns. The reporter even recorded the twins' passing of gas.

Following the baptism, Gould took Kate Skinner aside. In what the newspaper called "the kindliest words," the minister assured her that she was showing great love for the children by surrendering them to a family that would be able to take care of their special needs and provide them with a caring home.

Before leaving the clergyman, Mary reached into her purse and pulled out a deck of postcards that carried a photograph of Daisy and Violet in a buggy. The cards were printed with the a title, "Brighton's United Twins." She presented one of the postcards to the minister as a memento of what the *Herald* called "the most extraordinary christening he is ever likely to perform."

Gould was not alone in seeing Mrs. Hilton as a saint for adopting a pair of wretches that might otherwise have ended up in an institution. As word spread that the pub hostess and midwife had taken the children into her own home, there were those who believed that she was deserving of canonization. Soon, however, some of her neighbors and patrons began to suspect that maybe Mary had not adopted the twins entirely out of pureness of heart, but rather because she felt it might be good for business. Day and night, people queued at the Queen's Arms' door, waiting for a chance to see "Brighton's United Twins." It had also become apparent why Mary had invited a newspaper reporter to observe the christenings. She was hoping for some free advertising. The *Brighton Herald* obliged. It concluded one of its stories about Daisy and Violet with this plug:

> Brighton's United Twins are thriving abundantly, as persons interested may ascertain for themselves on giving Mrs. Hilton a call any day between eleven and seven at the Queen's Arms at 8 George Street. The twins are not really on public view, but Mrs. Hilton is prepared to let interested persons see them. And they can bring away a souvenir in the form of a photograph of them as they lie in their perambulator all in readiness for one of their periodic airings.[15]

*Two*

# A SURPRISING GIFT
# FOR SHOWMANSHIP

The grown-together babies swiftly became a cause célèbre not just in Brighton, but in all of England. Within days after the *Brighton Herald* reported on "Brighton's Siamese Twins—An Extraordinary Birth," the story was picked up by other regional newspapers, including the *Yorkshire Observer*, the *Leicester Daily Post*, and the *Leeds Mercury*. These accounts were retold by other papers, and, in turn, reprinted by still others.

The Queen's Arms came to be regarded as a national shrine of sorts, with Mrs. Mary Hilton its presiding saint-in-residence. Callers from every part of England flocked to the pub, a handsome two-story white stucco building with a bowed, mullioned window overlooking George Street. Many of the visitors were tourists already in the resort town for a holiday. But others, as though on a religious pilgrimage, came to Brighton expressly to see the freak sisters and the remarkable woman who had taken them into her care.

As long as the callers were willing to drop some coins into her tin, Mary was happy to interrupt her saloon work and lead them to the family living quarters where Daisy and Violet were always on view. Their naps were often disturbed as Mary lifted their gowns and pulled down their diapers to show the curious how the children were joined. It is impossible to know if these public barings caused psychological stress to the sisters during their infancy, of course. But by the time they

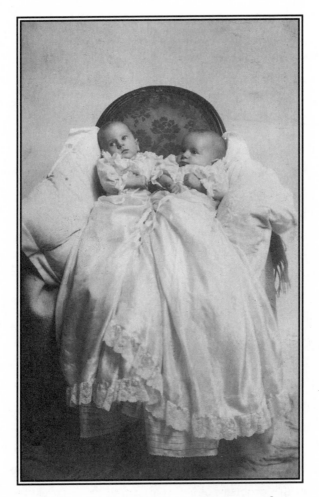

*Violet and Daisy in their christening gowns, 1908.*
*(Author's collection)*

reached the toddler stage, Daisy and Violet would reveal years later, they suffered shame each time their backsides were exposed to strangers:

Our earliest and only recollections are the penetrating smell of brown ale, cigars and pipes, and the movements of the visitors hands which were forever

lifting our baby clothes to see just how we were attached to each other. The customers could not be convinced that it was no fake, and they often lifted the baby clothes in order to find out whether or not there was some trick about our odd condition. This exhibition lasted for years and years. . . . It is little wonder that we can remember . . . so deeply is the memory of it impressed on our minds."[1]

Mary encouraged every visitor to take a souvenir, a two-penny picture postcard showing the United Brighton Twins in their pram. The coins that the curious plinked into Mary's tin added up to sizable sums by the end of each day, but that was just one reason for the rise in her fortunes. The Queen's Arms was now always swarming with new customers.

In addition to her newfound source of income, Mary Hilton was now widely regarded as a bona fide saint. In their Sunday sermons, Brighton's ministers referred to Mary as a heavenly helper, a selfless spirit of virtue, humility, and piety. The newspapers were equally adoring. They characterized her as an innocent who was on a crusade to wipe out human misery wherever she found it. Who else but a saint, after all, could be so sacrificing and great-hearted that she would take such untouchables into her home and life?

Mary was perfect at assuming the new role as a martyr. She reminded interviewers that even though she was not a young woman and had health problems of her own, including severe arthritis in her legs and hands, she wouldn't have been able to live with herself if, after bringing Daisy and Violet into the world, she had allowed them to be warehoused in an orphanage for the crippled, diseased, blind, deaf, and dumb. Besides, she said, the grown-together girls were such angelically beautiful babies, so pert and lively even at the instant of their births, that she couldn't help losing her heart to them. "I fell in love directly I saw them," she said.[2]

From all accounts, Mary was a poorly educated, simple woman. After becoming foster mother to the twins, she revealed a surprising gift for showmanship. Indeed, her natural instincts for show business seem to have revealed themselves the instant the twins emerged from the womb. While their terrified mother saw the babes as a curse from God, Mary seems to have immediately sized them up as cash cows. And certainly she recognized that there was no better place than Brighton for exploiting them.

From Easter to late October, Brighton was a kind of Babylon, a place of raffish gaiety overrun with tourists. Trains rolled into the seaside resort from London at the rate of one every ten minutes. Many tourists headed directly for the Palace of Pleasures on Palace Pier where they could take in a flea circus or feed coins into the hand-cranked peep shows that featured such offerings as "What the Butler Saw" and "A Night of Love." Others fanned out for the new motion picture houses, the racetrack, the theaters, the football stadium, and the Aquarium. Brighton also drew hordes of health-seekers who believed they could detoxify their bodies and regain the vigor of their youth by dipping into the salty waters lapping at the town's chalky cliffs. The beaches were always full. Young, pale females—shop girls, office clerks, and domestic workers—occupied most of the deck chairs that could be rented for a tuppence. They placed themselves on display for the young men who roved in pairs and threes and fours, shopping for love.

There was nothing original about Mary's idea of showcasing the Brighton United Twins in a saloon. Tattooed ladies, dog-faced boys, midgets, living skeletons, and other human oddities had been putting themselves on display at least since the mid-eighteenth century in England's public houses. These itinerants had found Brighton to be an especially fertile ground for enthusiastic and free-spending audiences. Indeed, it is likely that Chang and Eng Bunker, the eponymous

Siamese twins, made appearances in Brighton's taverns years earlier. The Thai-born Bunkers, who for a time were represented by P. T. Barnum, made two tours of the British Isles, one of them extending fifteen months in 1829 and 1830, and the other lasting six months in 1869.

Business so boomed at the Queen's Arms after Mary placed the twins on exhibit that by March of 1909, a month after Daisy and Violet's first birthday, the family relocated into an even larger tippling house, the Evening Star at 56 Surrey Street.[3]

Daisy's lower right leg was twisted slightly outward at birth, the apparent result of crowding inside the womb. Several times a day, over a period that would turn into years, Mary and Edith Emily took turns kneading the leg.[4] As gentle as they tried to be when manipulating the limb, the sessions always brought on great wailing from Daisy, and, thus, they were carried out when the pub was closed. After several years, Mary and Edith Emily were gradually able to reshape the limb to a correct alignment with the thighbone.

The fleshy, cartilaginous bond that kept the twins pinned back-to-back in their first months of infancy began to stretch as they became more active. By the time the sisters were eighteen months old, the short tether had become so elastic that Daisy and Violet could position themselves side-by-side. It was about then when they started to crawl. Their ability to move as one provided the Evening Star's patrons with a fresh spectacle, but the sight may have made all but the most jaded customers squirm in discomfort. Daisy and Violet provided this account of their earliest attempts at moving together:

> When we were turned loose on the floor to crawl, we seemed to move without too much effort because we propelled each other. There seemed to be only a short time before we gained speed and direction. Then something happened. We discovered to our dismay that we could not pass when the leg

of the bed or table was between us. . . . We cried and tried again and again
to pass the table leg and bed post. . . .[5]

Mary kept the twins clothed in the most beautiful of baby gowns
and always saw to it that they were scrubbed and scented with tal-
cum powder. And whenever she exhibited her charges, she presented
herself as a warm and doting foster mother. For all her public displays
at being affectionate, Mary was cold to Daisy and Violet, or so the
twins would claim years later. They insisted that Mary Hilton never
showed the slightest maternal tenderness toward them, but only val-
ued them as chattel. "She never petted or kissed us or even smiled,"
Violet once said. "She only talked."[6]

When the twins began forming their first words, Mary taught
them to address her not as Mama or Mum, but rather as "Auntie."
Among Daisy and Violet's earliest memories of their warder was a
short speech she recited daily, like a mantra: "I am not your mother.
Your mother was afraid when you were born, and gave you to me . . . .
You must always do just as I say."[7] By reminding the sisters over and
over that their biological mother had rejected them out of fear and
revulsion, Mary seemed intent on preventing Daisy and Violet from
developing any sense of self-worth. This was likely unconscious as
Mary was hardly sophisticated enough for such an intimate psycholog-
ical insight. But conscious or not, her cruelty did not end there. The
twins had this recollection of "Auntie" from those early years: "About
her waist was always a wide leather belt, fastened with a large metal
buckle. And it took only a little jerk to release the buckle. . . . When
we displeased her, she whipped our backs and shoulders with the
buckle end of that same wide belt."[8]

As much as Daisy and Violet feared their adoptive mother, there
were others who struck even greater terror in them. These were the
medical men from near and far who called regularly at the Hiltons'

pub to examine the children. "We were punched and pinched and probed until we were almost crazy—and we always screamed, scratched, and kicked," the twins recalled. "When the doctors and scientists left, Auntie would often whip us and call us ungrateful little brats."[9]

The doctors maintained that the twins belonged to science and that in the interests of medicine, Mary should consent to their wishes to surgically separate the pair. Although there had never been a successful operation in parting conjoined twins, the surgeons offering their services apparently had no concern about the grave consequences that almost certainly would have resulted. They were opportunists who looked upon the conjoined sisters as guinea pigs who, if they did happen to survive the surgery, would bring the doctors everlasting distinction in the medical annals.

The question of separating Daisy and Violet had in fact already been raised at a meeting of the Sussex Medico-Chirurgical Society. After examining X-rays of the twins' fused lower spines and "the internal arrangements of the viscera and blood vessels," it was unanimously concluded that an operation "would certainly result in the death of one child and probably of both."[10] Dr. Rooth, himself a member of the physicians' society, told his colleagues that he wholeheartedly agreed with their conclusion.

*Three*

# NOWHERE ELSE UNDER THE SUN

Mary Hilton loved the look of amazement that appeared on the faces of visitors to the Evening Star when she ushered them into the tavern's back room to see the United Brighton Twins. "Yes, ladies and gentlemen," she would say, "you're getting a first-hand look at a marvel that all future ages will contemplate. You're seeing an absolutely unique manifestation of God's handiwork that is to be found nowhere else under the sun."

After lifting the twins' gowns and revealing the thick rope of flesh that tied the pair together just above their backsides, she would explain that the connection was a conduit through which the blood circulated from one child to the other. By tickling and sometimes lightly pinching the ligament, she also demonstrated how the children simultaneously responded to sensation. Mary invited the curious to touch the fleshy connection if they wished. Few ever accepted the offer.

Because of the constant influx of new tourists to Brighton, there seemed to be no end to the twins' pulling power. Even after two years, people were still coming to the pub in droves and the money continued to roll in for the Hilton family. But Mary was no longer content with the status quo. At the time she adopted the sisters, she could not have imagined they would produce a steady income for her. But as the earnings began to accumulate, she started to think about

places outside Brighton where the crowds could be even greater and where, at the end of each day, her purses would be even bigger. She began thinking like a true impresario.

By the late spring of 1910, when Daisy and Violet had just turned two, Mary, along with Edith Emily, took the girls on the road. The twins' earliest engagements outside Brighton were in saloons, small circuses and carnivals, and street fairs. Because the appearances went unadvertised, no records survive of exactly where Daisy and Violet were exhibited. Typically, the babies were presented in "pit shows," deep holes that had been dug into the earth at the fairgrounds or pens fenced with waist-high canvas around which the ticket holders circulated.

The foursome traveled the provinces by hitching rides with the small tramp circuses, carnivals, and fairs that criss-crossed the countryside in horse-drawn wagons. Mary found plenty of opportunities to exhibit her monster girls. During the warm weather months there were pleasure fairs all over Great Britain that mostly featured such common fare as fire-eaters, sword-swallowers, and dancing bears. Siamese twins had always been viewed as the true royals in any sideshow, the rarest of all human oddities. Daisy and Violet were a major sensation wherever they traveled, especially since the British press had already made them known everywhere in the country.

By late October or early November of 1910, when the first snows began feathering the countryside, England's outdoor season ended, and the circus and carnival wagon trains returned to their winter quarters. Winters were brutal for sideshow freaks, especially if they had not been able to salt away their earnings from the summer season. There were few employment opportunities for them beyond the sideshow tents. Most holed up for the winter in cheap boarding houses and tried to hang on until April or May. The skin of an illustrated man could become so loose from weight loss over a winter that by the time

he was called back to work, his tattoos of Da Vinci's *The Last Supper* and *Mona Lisa* looked like scribblings on a crumpled napkin, and a professional fat lady could lose so much weight between November and May that she was no longer employable.

Thanks to a combination of generous press coverage and word-of-mouth advertising, Mary felt no need to return to Brighton when the outdoor fair season ended. There were permanent, year-round venues elsewhere in the United Kingdom that were eager to engage the girls. In Edinburgh, Scotland, the twins appeared for two weeks before turnaway crowds at Stewart's Waxworks, a large hall filled with life-size, life-like mannequins of such subjects as Henry VIII and his six wives, Mary, Queen of Scots, and Jack the Ripper.[1] The four next traveled to Glasgow where the twins were given star billing at Pickard's Waxworks.[2]

In an era before motion picture theaters began proliferating, the wax museums were among the most popular of England's amusement centers. London alone had at least a half-dozen waxworks at the turn of the century, and most of the provincial cities boasted at least one such establishment. At the scruffier museums, the wax figures often bore little resemblance to the notables they were supposed to represent. At Pickard's, however, visitors always marveled at how much the effigies resembled their subjects. But even at the better waxworks like Pickard's, there were limits to how many times a customer could be enticed to view the same kings, queens, serial killers, and baby butchers. To keep people coming back, the proprietors had to offer other allurements, including freaks, palmists, snake charmers, and strong men.

Daisy and Violet were the headliners at Pickard's when the museum was visited by the famous Harry Houdini, the American escapologist who had been appearing at the Glasgow Coliseum.[3] Houdini and the Hilton sisters could hardly have been separated by more distance in the caste system of popular entertainment. Houdini by this time was one

of the world's biggest stage attractions, an entertainer who packed in crowds wherever he appeared, whether in New York, London, St. Petersburg, Paris, or Berlin. Daisy and Violet, by contrast, were still identified with the lowliest of venues.

Perhaps no one in the world was more admiring of freaks than Harry Houdini. Whether a fellow human soul had been born with no legs or three, he believed that such distinctions deserved to be celebrated in the same way that the public might honor a gifted athlete, like a runner who blazed a mile in less than four minutes. His fondness for freaks dated back to the 1890s when, as a newly-fledged professional magician, he performed twenty or so shows a day in twelve-hour shifts in the dime museums. Not only did Houdini share the cramped stages of the "dimes" with all manner of human oddities, he developed lasting friendships with many of them. Houdini once recalled the complex seating arrangements that were involved when he and his fellow attractions at Huber's Dime Museum in New York entered an eatery. "I have often sat at the table with [Carl] Unthan, the Armless Wonder, who would pass me the sugar [with his feet], and Big Alice, the fat lady, who would obligingly sit at the edge of the table so as to give poor little Emma Shaller, the Ossified Girl, plenty of room."

Long after Houdini graduated from the dimes to such entertainment cathedrals as the Palace in New York, the Hippodrome in London, and the Wintergarten in Berlin, he continued to haunt the lowly venues that featured freaks. Dr. Morris Young, one of the world's most respected authorities on Houdini, offered this view on why the escapologist felt such empathy for them:

> He himself always felt like an outsider, somebody who didn't quite fit in society. His feelings of 'otherness' resulted from the way the world viewed him. Maybe the public didn't look at him as being a freak, but people did view him as somebody who was not quite of the world. He was, in the eyes of the public, a superman, somebody who could walk through brick walls or escape

from the most tightly secured prison cells. He was thought to be a mystical stranger in their midst. He himself worked hard at maintaining his persona of a mystic, a being with supernatural powers. He couldn't, even for a day, let down his guard and act as though he was just another man on the street. Had he done that, he would have lost his place in the popular imagination as the world's greatest mystifier.[4]

Extensive tours throughout the United States and Europe afforded Houdini many opportunities to seek out freaks and phenoms. In fact, he may have encountered more human oddities than any other person of his time. Even so, he was wonderstruck when he entered Pickard's Waxwork and saw Daisy and Violet Hilton. Not only were they the most amazing human oddities he had ever seen, but the blue-eyed, curly-haired moppets were also just about the most beautiful children he had seen anywhere, period. The girls appeared to be almost ethereal, otherworldly, like *putti* in a Raphael painting. Houdini's excitement at his discovery was heightened by his knowledge that in just days, he would be able to bring the twins to the attention of Ike Rose, an American talent scout who had not only launched the escapologist into the big-time, but also such entertainment eminences as W. C. Fields, Isadora Duncan, and Will Rogers.[5]

Several hundred Scots were waiting on the platform when the train carrying Ike Rose arrived at Glasgow's Central Station. It was not the famed talent scout that drew the crowd. The Glaswegians, most of them men and boys, were hoping to get a glimpse of the celebrities with whom Rose was traveling, the world-famous Siamese twins, Josefa and Rosa Blazek, and Rosa's eight-month-old son, Franzel.[6]

Excitement over the Blazek sisters had been building for weeks in Glasgow. There was hardly a wooden fence or an outhouse that was not emblazoned with colorful posters ballyhooing the sisters' scheduled appearances at the Coliseum. The lurid advertisements depicted the Blazek sisters in ballooning, see-through pantaloons. Their

sequined bras were so overfilled they seemed on the verge of bursting. When Rosa and Josefa stepped awkwardly off the train, they bore absolutely no resemblance to their poster idealizations as tall, willowy temptresses. They were, in fact, short, dumpy, and gnome-like.

Rosa and Josefa were joined back-to-back by a thick mass of flesh-covered cartilage and bone that started just above their shoulder blades and continued to their rumps. The grotesque hump, which was fully forty inches in circumference, kept their heads so distanced from one another that, as a reporter once oddly observed, it was only "by severely twisting their necks [that] they can kiss each other."[7] Sometime before the Blazek girls had entered adolescence, their lower extremities had taken extended vacations from growing. By the time they reached adulthood, their normal-sized trunks were mismatched to what seemed to be the legs of ten-year-old girls. Rosa and Josefa were charming in disposition, but besides being cursed with fat, stubby little legs and the huge mass of flesh between them, they had the faces of gargoyles.

The sisters had been the subject of crude and cruel jokes from the time they entered puberty. Signor Saltarino, a turn of the century circus authority, wryly commented, "Their future groom will have . . . two wives—and only one mother-in-law."[8] Some observed in print that one sister or the other would be a perfect mate for the man with a particularly ravenous carnal appetite since he could lawfully bed down with two women each night. In fact, physicians reported that the sisters had but one vagina and one rectum between them, although each had a uterus. The jokes about them became even more brutal after April 16, 1910, when Rosa, at age thirty-two, gave birth to a nine-pound boy, Franzel. Her new motherhood provoked barroom discussions about the complex acrobatics that must have taken place between the father and the sisters at the moment of conception. After becoming a mother, Rosa variously assumed the names of Mrs.

Vorschek or Mrs. Franz Dvorak. Her claims to having a husband were contradicted by official record. A baptismal certificate, recorded at the Apollinarus Catholic Church in Prague three days after Franzel's birth, listed her by her maiden name and stated that Franzel was illegitimate.

After Franzel's birth, Ike Rose immediately started billing the trio as a quintet: "A Mother, Sister, Son, Aunt and Nephew in the Strangest Family Group the World Has Ever Seen!" The pay he offered the Blazeks was generous for the time. He signed them for a reported "$10,000 yearly, plus all the postcards they could sell."[9]

Houdini met with Rose for dinner after the showman had spirited the Blazeks away from the train depot and seen them safely settled at a hotel. Rose could not remember another occasion when Harry had seemed any more excited. Houdini told his ex-manager that as great a draw as the Blazek sisters might be, he had discovered another pair of Siamese twins that had the potential to be a far bigger attraction. Their names were Daisy and Violet Hilton, they were just tots and, as luck would have it, they were presently appearing in Glasgow.

There was nothing about Rose's appearance that hinted at his wealth or eminence in the stage world. Altogether he had the appearance of an old prize fighter whose numbers had been much higher in the right column than in the left. His nose was mashed and, like his eyes, mouth, cheeks, and the other facial features, seemed to have been moved some centimeters from where it had originally been placed. He had thinning, tin-colored hair, was short and fat, and wore suits that looked cheaply made.

Not one to miss an opportunity to scout for a new freak attraction, especially one that came recommended by so highly regarded a judge as Houdini, Rose ventured out that same evening on the Trongate, a stretch notorious in Glasgow for its penny arcades, tattoo parlors, pawnshops, and vice houses. He found Pickard's Waxworks and

entered. In the words of one profiler, Rose was absolutely besotted at the sight of "two of the prettiest children he ever saw . . . , two-year-old Daisy and Violet Hilton, born in Brighton, England."[10] He felt the rush of excitement he had experienced years earlier when he first discovered Harry Houdini and Isadora Duncan.

Rose's talent for looking over armies of unknown dancers, singers, comedians, and magicians and plucking out the rare performers who had true star potential seemed unerring. One of his successes was with an Australian-born dancer Clarissa Campbell. He had spotted her for the first time in 1894, in a New York burlesque production of "The Night Owls."[11] Miss Campbell was a startling beauty with long legs, waist-length red hair, and green eyes that made men suddenly anxious to propagate their species. Except for the fact that, in Rose's word's, Clarissa was able to immediately seize every audience member's attention "by suddenly appearing . . . as though shot out of a cannon," at the time, she was just another hoofer of the high-kicking, ten-dollar-a-week variety. Rose was sure he could change that. He met with the dancer and her mother the next day and got them to sign a contract naming him as agent. A few months later, he got Clarissa to sign another agreement, a marriage contract. She was sixteen, he was thirty-two.

Rose rechoreographed her routine, discarding her cheerleader kicks and bounds and replacing them with the slow and seductive moves of Salome. He also threw out trunks of costumes, reducing her wardrobe to a few filmy veils that she could easily transport in a purse. Finally, he christened his bride with a new stage name, Saharet. Within a few years, she was playing London and Berlin and commanding $1,000 a week. She was also getting star billing in such New York musical comedies as *The Merry Widow* and *The Belle of New York*.

Over and over, Rose repeated this knack for plucking unknown performers from obscurity and transforming them into headliners. While visiting backstage at a theater in Vienna around 1903, Rose was

approached by the famous American clown Billy Burke, who told him that he had a seventeen-year-old daughter who was a talented singer, actress, and comedienne.[12] After auditioning the young woman, Rose concluded that she did indeed possess exceptional stage gifts, but that her name, Mary William Ethelbert Appleton Burke, would require some tinkering to have marquee pizzazz. He got the carrot-haired, freckle-faced ingenue her first major booking. The world soon came to know the young star as Billie Burke until 1914, when she became Mrs. Florenz Ziegfeld.

Rose was eager to represent Daisy and Violet from the moment he saw them. He sat down with Mary Hilton and told her the Brighton United Twins were far too remarkable to be appearing in lowly wax museums and traveling fairs. Because of his connections in the show world, he boasted, he could get bookings for them in important theaters everywhere on the Continent and in England. Mary may have been impressed, but to Rose's dismay, she refused his offer. She explained that because her husband, Henry, was no longer in the best of health, she couldn't continue touring with the twins and had to return to Brighton.

Before leaving Glasgow, Mary did accept Rose's invitation to take Daisy and Violet to see Rosa and Josefa perform at the Coliseum. The Blazek twins danced with something approaching the gracefulness of two yoked oxen. They also sang, played violins, and, according to a newspaper account, performed a "spirited duet on the xylophone." Mary must have been impressed with the Blazeks and was shrewd enough to recognize that if the Brighton United Twins were ever to amount to anything more than a sideshow attraction, it was important that they develop some stage talents. On returning to Brighton, she immediately engaged a German music teacher to start instructing three-year-old Daisy and Violet in various performing arts, including voice training, dancing, and a variety of musical instruments. Daisy

recalled years later that "Auntie" had ordered their music teacher not to make any allowances for either the sisters' youth or their handicap. "Teach the girls the hard way, professor," Mary instructed. "They're strong and tough, old for their years. Teach Violet to play the piano; Daisy, the violin."[13]

Ike Rose could not get the twins out of his mind. He carried photographs of the sisters and looked at them often. He even dreamt of the sisters. As human wonders, they represented the ultimate. He coveted them as he had no other discovery.

Early in 1912, a little more than a year after he had seen Daisy and Violet in Glasgow, Rose made a special trip to Brighton to call on Mary Hilton. After seeing the twins a second time, he was surer than ever that the two could be the greatest attraction he ever promoted. Under the daily tutelage of their music teacher, Daisy and Violet had learned to sing in harmony, dance, and play violin and piano.

Rose once again begged Mary for a chance to represent the sisters. This time she gave in to his importuning. Her change of heart may have been prompted as much by her husband as by Rose's assurances that, under his management, the names of Daisy and Violet Hilton would soon be blazing on the marquees of Europe's grandest theaters. Henry Hilton's health had continued to decline. The year 1911 was the last in which he and Mary were able to operate the Evening Star pub.[14]

Of all the people who figured in the twins' early childhood, Henry Hilton is the most shadowy. He received only a cameo role in the twins memoir. Daisy and Violet observed that Mary quarreled with Henry constantly, a situation that might have aggravated the illness that ultimately forced him to stop working. The twins also made the claim that Henry was Mary's fifth husband. The assertion may be accurate, but it has to be considered with at least some suspicion since many of the claims in their autobiography are demonstrably exaggerated or patently false.

## DAISY AND VIOLET

**The Pretty Grown-together Children**

The Modern Siamese Twins

If we have interested you, tell your friends to visit us.

*The twins at about three years old.*
*(Author's collection)*

Sometime in March or April of 1912, the Hilton clan—Mary, Henry, Edith Emily, Daisy, and Violet—sailed from Southampton to Berlin where they were to connect with Rose and begin preparing for a national tour of Germany's theaters. The entire family was jammed into a tiny cabin. As dyspeptic as Henry was, he presented a softer side to the twins than Mary. Daisy and Violet remembered Henry and Mary fighting throughout the trip because he thought her treatment of the twins was contemptible. "He thought we should go to religious

services. She argued that people would not pay to look at us if they could see us for nothing. Auntie won."[15]

Ike Rose began to make over the Brighton United Twins from the day they arrived in Berlin. Daisy and Violet Hilton, if they were to appeal to the theater set, could no longer be retailed as mere sideshow monstrosities. They would have to endear themselves to the public through talent, charm, refinement, beauty, and personality. As young as Daisy and Violet were, they already had these qualities. It was now Rose's job to burnish and magnify their attributes. He took over every detail, selecting their wardrobe and even making decisions about how they should wear their hair. And for long hours each day over many weeks, he rehearsed them in an empty theater, drilling them over and over on their stage movements, their performances on the piano and the violin, their singing, and dancing.

So completely did Rose choreograph the twins' stage turn that when the curtains parted on the night of their theatrical inaugural, the sisters skipped to the center of the stage and didn't show the slightest sign of jitters. Daisy and Violet were pinafored in white. Their heads bore great cumuli of chestnut curls in which were pinned white satin bows so large that it must have seemed to the spectators that the two could be kited aloft in a strong wind. The twins bowed ever so slightly to the audience and then, with a nod to the conductor in the orchestra pit, signaled him to get on with his job.

Daisy and Violet began by singing a duet. Their arms were interlaced and they swayed this way and that way, kicking up their slippered feet in a kind of modified can can. They seemed unfazed that they were being watched by more than a thousand people. They performed with the insouciance of children putting on a recital for the sole enjoyment of a beloved grandmother. The crowd cooed its adoration.

In time, each sister had her own moment in the spotlight. Daisy was first. She presented a violin solo and, although her performance

couldn't have drawn comparisons to the great soloists of the day, when she finished, she was paid with house-rattling applause.

She and Violet then moved out in front of the footlights. Daisy looked into the orchestra pit, and, with a toss of her head, signaled the conductor that he could leave. She then led the fourteen-piece orchestra on her own, waving a baton that was approximately half her height. The audience was deliriously approving.

Then it was Violet's turn. She and Daisy climbed onto a bench before a grand piano. When Violet discovered that she was too short to reach the keyboard, she whispered something to her sister and together the two descended to get a pillow. Once again the sisters positioned themselves on the bench, but the one cushion still had not elevated Violet high enough to touch the keys. Again the twins made a descent and added a second pillow. To building laughter in the house, the sisters went through the pillow-stacking exercise two or three times more. Finally, with Daisy turning the pages of the sheet music, Violet began her recital, playing "The Emperor's Waltz." The crowd cheered and applauded when she finished. The twins descended from their perch, curtsied, and then once again ascended the tower of pillows. This time Violet accelerated the tempo to the gleeful roaring of the audience, once again concluding with "The Emperor's Waltz."

The twins again climbed down from the bench. They bowed and, with practiced expressions of great weariness, once again scaled the pillows. Violet started playing something slow, dreamy, and soporific. When the audience appeared to have been lulled half to sleep, Violet's playing changed mid song. Once again she lapsed into "The Emperor's Waltz." Now the crowd went crazy. Everyone was applauding, cheering, stomping their feet, and whistling.

If Mary took any pride in the mass adoration with which her charges had been accorded at their stage debut, she was unwilling to

let them bask in the glory. "The theater thundered with applause our opening night," Daisy and Violet recounted, "and as we came off the stage, Auntie and Edith rushed us into the dressing room in the midst of the cheering. They refused to open the doors to the knocks from backstage folks."[16]

During their stay in Germany's capital, the twins were examined by a Dr. Bochenheimer and a Dr. Stier of Konigsberg, described as "brilliant surgeons." "The cartilage, muscles and bone could be separated," Bochenheimer whispered to Mary Hilton as he stared down at the twins in their hotel bed, moving his cold stethoscope over their chests. "It will be a worthwhile and interesting experiment to separate the nerves of the spinal column. . . . There has never been a set of Siamese twins operated on while they were living, and science is deeply interested in making the experiment."[17]

The sisters pretended to be asleep as the doctors' faces hovered closely above them. Daisy and Violet later recalled the same horrific vision. Each saw themselves strapped to an operating table. Each saw knives and saws. And, finally, each saw blood pouring out of their lower backs in great torrents. They were relieved when Auntie gave her reply to the doctors. "The girls belong to me," she said. "I'm going to keep them the way they are."[18]

Even if the doctors could have positively assured Mary that both sisters would survive a surgical division, it seems unlikely that she would have ever consented to such an operation. As long as Daisy and Violet remained fastened to one another, they could provide her with a generous income. Were they to be separated, they not only would lose all their stage value, but they could become liabilities.

The Brighton United Twins may have stopped the show at their stage debut, but they were not so enthusiastically received after they left Berlin. For all his brilliance at discovering unknown talents and promoting them to world-class standing, Ike Rose evidently was no

great student in geopolitics. He could not have picked a worse place and time to launch the twins' stage careers than Germany in 1912. The newspapers were filled with stories about the inevitability of a war between Germany and England. Most Germans hated anyone or any-thing British. Furthermore, anti-Semitism was growing in Germany. Ike Rose, born Isaac Rosenbaum, a Jew, now found himself persona non grata at theaters that earlier had rolled out red carpets for him.

So infrequent were the twins' theater bookings in Germany that, after a while, Rose resorted to presenting them in beerhouses, pit shows, and wax museums. Daisy and Violet remembered the tour this way: "We lived in dingy . . . boarding houses, traveling at night between exhibitions at bars, fairs, carnivals, and circuses.[19] Under the terms of his contract to manage the twins, Rose was to pay Mary Hilton $60 a week, plus travel expenses for everyone in the entourage. By the time the showman settled with Mary every seven days, then shelled out for the hotels, train fares, and meals for everybody, he found he "positively could not make a dollar."[20]

Rose's road expenses may have showed at least a modest decrease after May 5, 1912. The Hilton clan was reduced by one when Henry died in St. Jacob's Hospital in Leipzig.[21]

Not only did Rose find it harder and harder to find bookings for Daisy and Violet as the German tour continued, but he also discov-ered that audiences had been shrinking for his other premier attrac-tion, the Blazek sisters. Reasoning that four heads were better than two, he started offering theater owners two sets of Siamese twins in a single package. The move brought no great upturn in his fortunes. Still not ready to throw in the towel, he brought in a troupe of midgets and started advertising the Ike Rose Wonder Exhibition. He presented his shows in city squares, at fairs, and in the back lots of cir-cuses. When they weren't on a stage, Daisy and Violet, not yet five, were exhibited in a tent.

They remembered how punishing those days were:

"We appeared before the public not only during the regular performances . . . but for the entire day from early morning until late at night."[22]

While things were unraveling in Rose's professional life, they were also falling apart in his personal life. Saharet, a child of sixteen when he married her but now a woman of thirty-four, had started engaging in extramarital dalliances—all of them with Spanish dancers.[23] Rose started a divorce action against her.

After struggling for months to win bookings in the increasingly hostile climate of Germany, Rose decided to leave the country with both sets of Siamese twins. He was able to sign the Hiltons and the Blazeks for appearances in late October of 1912 at a big fair in Basel, Switzerland. He felt a salubrious change the instant he left Germany. The Swiss were actually welcoming. The newspapers were filled with stories that were admiring of Rose and his pairs of conjoined twins. The *National Zeitung*, for example, placed this spin on the news that the showman was favoring Basel with a visit:

> The upcoming fair prepares itself for a visit by Ike Rose, the world-famous impresario from the New World, who is bringing with him, Daisy and Violet Hilton. In every city they have been in, they have created excitement because they are the only Siamese twins living today who have the possibility of being separated. This has been confirmed by Dr. Bochenheimer of Berlin and Prof. Stier of Konigsberg. Rose is also the one . . . who is bringing to Basel the Blazeks. . . . Rosa and Josefa Blazek are twin sisters who were born in 1878. . . . The whole world has admired these twins. . . .[24]

No record exists of how the Hiltons and Blazeks were received at the Basel fair. Even if they attracted great throngs, Rose must have

been wondering where he and his troupe might go next. Uncertainty ended when a cable was delivered to him at the Basel fairgrounds from a faraway place: Australia.

Rose regarded the wire as a missive from heaven, especially considering the offer it advanced. It had been sent by J. D. Williams, an old friend. Williams was about to open Luna Park St. Kilda, a seaside amusement park just south of Melbourne. Would Rose be interested in presenting the Brighton United Twins in his new park? Williams was willing to pay $500 a week to engage the twins, plus the fares in getting all concerned to Australia.[25]

## *Four*

# A TOTAL ABSENCE OF SYNCHRONY

D aisy and Violet made their way down the long gangplank of the *Scharnhorst*. They had been on the German vessel for a month on a 13,000-mile voyage from Genoa, Italy. It was February 3, 1913, two days before their fifth birthday, and they had just arrived in Australia's Port Victoria. They were in high spirits when at long last they stepped on solid ground.

Their glee was quickly dispelled. Soon after disembarking, they were informed that once again they would have to submit to an ordeal they hated above all others. Because, in the words of a Melbourne newspaper, "their peculiar malformation was regarded as being of great scientific interest," arrangements had been made for them to undergo yet another medical examination.[1] What was worse, this time they were to be looked over not by one or two doctors, but by the entire membership of the Medical Society of Melbourne, an organization of more than fifty physicians.

The twins appeared before the society in Melbourne's Masonic Hall on the afternoon of February 7. It isn't known whether they were again "punched and pinched and probed" as they had been in the earlier scrutinies of their bodies by teratologists, fetologists, hermatologists, and other assorted medicos. But this time the examination seems not to have gone as badly as they had feared. A newspaper reporter was present at the event. To judge from his account, Daisy and Violet

seemed almost to have enjoyed themselves. He recorded the occasion this way:

> In appearance, the two sisters, who are robust and not slow at making friends with strangers, resemble children slightly deformed. They are possessed of all the faculties and limbs of normally healthy girls and are both able to run almost side by side. In fact, they displayed wonderful agility when climbing the steps onto the stage of the Masonic Hall last night, while their activity in reaching one end of the hall from the other surprised many who were invited to meet them.[2]

The examination presumably was arranged by someone in the Luna Park publicity department. Whoever set up the event had probably taken a cue from P. T. Barnum, who, five decades earlier, arranged for doctors to examine Chang and Eng wherever and whenever the brothers made an appearance. The Connecticut showman recognized the publicity value of having his Siamese twins looked over by physicians. It gave him a chance to crow that the brothers were subjects of ongoing scientific interest. And by having the brothers closely and repeatedly vetted by physicians, Barnum could also dispel any suspicions that the Siamese twins connection had been faked.

Luna Park St. Kilda was a delirium of Egyptian, Romanesque, Rococco, and Byzantine architectural styles, suggestive of the crazy assortment of faux palaces, houses of mirrors, music halls, and flea circuses on the waterfront back home in Brighton. One of the more popular Luna Park attractions was the Palais des Folies, a huge funhouse with distorting mirrors, various trip-wire surprises, and steeply dipping and curving slides that were slicked with cornmeal. There was also a tunnel of love called the River Caves of the World, that provided the romantically inclined with boat rides through dark, underground grottoes where, if the voyagers were not too engrossed in canoodling, they might glimpse a mermaid or Arlo, the Human Frog.

But the most conspicuous architectural feature of the park was its entryway, a concrete, moon-faced head sixty or seventy feet high. The massive visage had huge illuminated red eyes that rolled suggestively from side to side. When visitors entered through the moon man's leering, grinning mouth, they left behind a world of conformity, regimentation, and dullness and passed into a new realm, a wonderland where excitement, exoticism, and surprises were everywhere.[3]

Like Ike Rose, J. D. Williams, the park's creator, was an American. From the time he was a young man, Williams had shown an uncanny ability to pitch out single dollar bills in one direction and have them boomerang back as fives and tens. He started his show business career as the assistant manager of a Parkersburg, West Virginia, opera house. Around 1904, he saw his first motion picture, a crude single-reeler from the Vitascope studio of Thomas Alva Edison. Instantly recognizing the commercial potential, he made up his mind to be an exhibitor.[4]

Because motion picture theaters did not yet exist, Williams traveled the country with a black tent, charging people 25 cents to see a blurry, shadowy, jittery photoplay of President William McKinley's funeral. Williams was already a wealthy man when he was drawn to Australia in 1909, nine years after it had become a commonwealth. He bought a rundown music hall in Sydney and reestablished it as a movie palace, the Colonial. While the city's other cinema houses offered just two shows a day, the Colonial's movies ran nonstop from 11 A.M. to 11 P.M. Within two years, Williams converted three more Sydney music halls into cinemas and started construction on the Crystal Palace. The Crystal was to become the city's most sumptuous movie house. It included a 1,500-seat theater, a grandly elegant tea room, and a mini-mall where visitors could shop for a variety of American novelties or take a stool at the world's largest soda fountain.

Early in 1911, Williams leased the remains of a small seaside amusement park in St. Kilda that had opened, and closed, in 1906,

earning it the epithet of "Deadland." He brought over many of the same designers and contractors that created the Dreamland Amusement Park on Coney Island, New York, and had them transform it into Luna Park St. Kilda. With 18,000 lights glowing like the Milky Way, the park opened in December, 1912, on Friday the 13th. Despite the bad portents usually associated with the day, Luna Park drew free-spending crowds on opening night and continued to be favored with great success.[5]

J. D. Williams regarded his signing of the Brighton United Twins as a major coup. He mounted a massive publicity campaign to let everyone in Melbourne know the sisters were coming. Posters trumpeting the twins' arrival were plastered everywhere. For weeks before their appearance in Australia, the newspaper carried ads huzzahing the park's triumph in engaging the attraction. And there was no shrinking from hyperbole: "The World's Most Astounding Freak of Nature," and "The Most Talked About Subjects of the World's Medicos," and "Secured for Exhibition by the Management of Luna Park at Enormous Expense Because the Best Is None Too Good for Our Patrons!"[6]

The twins were to appear in what he prized as the most magnificent of all the structures in his park, a performing hall christened Pharaoh's Daughter. A ziggurated Egyptian temple, its exterior was decorated with gold leaf and lapis lazuli, and two massive stone sphinxes flanked its entrance. While Daisy and Violet had been given top billing, other headliners included Le Vant, the Great Australian Illusionist; Baby Ben, a twelve-year-old who, at 351 pounds, was promoted as the World's Fattest Boy; and Electro and Electra, a man and woman who made sparks arc between their bodies whenever they kissed.[7]

Daisy and Violet made their first appearances in the Pharaoh's Daughter on the night of February 14. By the next day, the park's

newspaper ads made the claim that the Brighton United Twins' first performances drew "vast crowds . . . immense multitudes." In fact, despite the great sums Williams had spent in securing and promoting the sisters, the pair's drawing power was well below his expectations. Few visitors walking the midway of Luna Park St. Kilda seemed to care much about the sisters, nor did the press. None of Melbourne's major papers, in fact, even bothered to send out reviewers to see the twins' show.

So euphoric had Williams been when he signed the twins that he was sure that long lines would snake past the concrete sphinxes every day until the park closed for winter. He hadn't accumulated his kingly riches by making many miscalculations in show business, but his importation of the twins had been a massive misreckoning. So anemic was the act's appeal to Australians that, after just one week, Williams decided to drop it. A principled businessman, he did honor all the guarantees he had made to Ike Rose. Rose himself conceded that Williams had lost at least $5000 on the Brighton United Twins.[8]

Rose was no less dismayed than Williams at Australia's indifferent reception of the sisters, but he was not yet ready to write off the whole country. According to *The Billboard*, he became chummy with "a great bunch of sportsmen and big businessmen."[9] Rose was told that while there was something that made Australians recoil at the sight of anyone with extreme or unusual physical deformities, somewhat paradoxically, they went absolutely gaga over midgets. Rose's advisors noted that Australia had been visited only the year before by a troupe of dwarfs from England. The British show called "Tiny Town" reportedly netted $150,000 from the tour.[10]

Rose had been aware that something of a midget mania was occurring elsewhere in the world. Leo Singer, a producer of musical comedies, had started developing Lilliputia, a half-sized community for midgets in Vienna, Austria. Elsewhere in Europe, and also in America,

prize fights between dwarfs were being promoted, and operas were being staged with casts comprised entirely of little people.

Rose immediately booked passage on the next ship leaving for Germany. He told Mary Hilton it was urgent that he put together a troupe of little people but assured her he would return to Australia as soon as possible. He left Mary, Edith Emily, and the twins in the care of an aide. Mary was furious. She was also terrified. Rose had shepherded the Brighton United Twins to a distant continent with assurances of lucrative and steady bookings. Now he was abandoning the act, leaving Mary and the girls high and dry in a strange place without a single future engagement.

Because the twins had been such a dismal drawing card at Luna Park, no theater owners were willing to give them a try. Eventually Mary did find an opportunity. In exchange for a percentage of her receipts, the owner of a small wagon circus agreed to let her ride along with Edith Emily and the twins into the outback. Tramping through Britain three years earlier, moving from country fair to country fair, Mary already knew something about the rigors of trouping with wagon circuses. She was to discover that the trials of trouping into Australia's interior were almost beyond the limits of her endurance.

While the outback was always searing in the summer, the heat was especially lethal in 1913. The caravan of horse-drawn wagons rolled through a landscape where, in Mark Twain's words, "only a few of the hardiest kinds of rocks survive." They saw cattle become broiled steaks on the hoof and vegetation turn to ashes.

The circus put on its performances in bush towns of 200 to 300 people, but the settlements were so distantly separated that the caravan often rolled through emptiness for a full day or more to get to them. Because the people of the outback were so starved for entertainment, normally the circuses and carnivals could count on doing good business in the scattered stations and townships. But nothing was

THE PRETTY GROWN-TOGETHER ENGLISH GIRLS,
If we have interested you kindly tell your friends to visit us.

*"The pretty grown-together English girls, five years old."*
*(Author's collection)*

normal in the summer of 1913. Because of an extended drought, cat-
tle and sheep ranchers suffered massive losses. Depleted herds and
flocks meant farmhands, drovers, shearers, and laborers were thrown
out of work and had little money to take their families to a circus or
carnival. When the circus that Daisy and Violet traveled with put up
its big top, the clowns, strongman, and trapeze artists played mostly
to empty seats.

When the aide Ike Rose had assigned to her finally quit, Mary
wondered how she was going to keep plodding forward. Mary was

flinty to the marrow, but even she knew the Australian outback was not a place for two women and two five-year-old girls to be traveling without the protection of a man. Miraculously, another rescuer appeared. Trailing after the circus from bush town to bush town was Myer Myers, a balloon salesman and candy peddler. He had taken notice of Edith Emily from the day the Hilton family linked up with the caravan. Edith, as Myer preferred to call her, was a woman who blended unnoticed into the shadows of others. She was tall and thin, meek, shy, and appeared to be eternally sad. Myer's recognition of her may have been impossible in a space less deserted than Australia's interior. But somewhere in the sun-seared outback, romance began to blossom between Edith and the balloon vender. She was twenty-nine; he was twenty.

Myer Myers, who had been christened Meyer Rothbaum, was the son of George and Teresa Rothbaum, Austrians who had migrated to Australia and settled in the Clifton Hills section of Melbourne.[11] George was a bootmaker by trade and a sadist by temperament. As a child, Myer was given whippings by his father for the slightest transgressions. He was thirteen or fourteen when a traveling circus raised its big top in Melbourne. When the caravan left town, he was in one of its wagons. He had been a vagabond ever since.

Even in the frying-pan heat of the summer of 1913, the attraction between Myer and Edith kept growing stronger. Finally, he approached Mary to ask for her daughter's hand in marriage. Mary was sixty-one and troubled with a badly infected leg from a snake bite suffered in the outback. "We need a man to travel with us," she replied, still pondering Myer's request for her daughter's hand. "Will you give up your balloon concession?"[12] Myer answered that he was willing to do anything to make Edith his wife.

Myer was five-foot-four, and, like the balloons he sold, he had the appearance of being pneumatically inflated. His face and hands had

been baked brown by the sun and his black hair was slicked back with grease. His black eyes were unforgettable: They were like those of a shark, never changing expression. It was impossible to tell by looking at him whether he was feeling rage, joy, disgust, or passion.

Although Myer was always fawning whenever he was around Mary, the twins detected an acridness in his temperament. Their dis-like of him was immediate.

It was a matter of pride with Myer that he had often taken canings as a boy. He boasted to Daisy and Violet that the beatings had made him strong and conditioned him to the hard life of trouping. "We took this to mean," the twins said in their memoir, "that he approved of Auntie's thrashing us with her belt buckle."[13] From the instant Myer became a member of the Hilton sisters' retinue, he assumed much of the responsibility for them inside and outside their tent. He didn't show them any more mercy than Mary did. When they were not on exhi-bition, they were expected to work on their reading, spelling, and arithmetic lessons with Edith or to rehearse their act, practicing on their violins, saxophones, and clarinets. They were never given time off just for child's play, nor were they allowed to associate with any other children, either in the traveling troupe or in the bush towns where their tent was raised. And as if to impress the twins that now he was their lord and master, Myer insisted that they never address him by any name other than "Sir."[14]

Accompanied by a tattooed lady, the operator of a marionette show, and twenty midgets, Ike Rose returned to Australia in November or December of 1913. By that time, Mary, Edith, and the twins had set-tled in a small Melbourne apartment. Even though Rose had aban-doned them eight or nine months earlier, he was infuriated to learn that Mary had turned over the management of Daisy and Violet to someone else, and a balloon salesman of all people. He reminded her that she had entered into a contract that gave him full authority for the presentation

of the twins. He threatened Mary with a lawsuit for breach of con-
tract. She was not impressed.

Rose did get a court injunction to prevent Mary and Myer Myers
from exhibiting Daisy and Violet anywhere in the State of Victoria,
including Melbourne. But after a single legal challenge, he gave up.
"Having a troupe of midgets on his hands, he had enough worries to
keep him occupied," it was observed by a writer for The Billboard.[15]

Rose's imported midgets were from the Carl Schaefer company in
Germany. The company included Mike and Ike ("They Look Alike")
Matina, twins from Hungary who would later become immensely pop-
ular in America and even have a brand of boxed candy named after them.
In addition to presenting the Schaefer midgets, Rose also promoted box-
ing matches between the more bellicose members of the troupe.

It was as though Ike Rose had been hexed from the time two
years earlier when he first presented the Brighton United Twins. By
his account, he lost $18,000 trying to promote the sisters in Europe
and Australia.[16] His fortunes continued on a downward spiral after
he brought the midget troupe to Australia. The diminutive singers,
dancers, acrobats, and boxers didn't even generate enough money to
pay for their beer and whiskey consumption, which, Rose com-
plained, "was oceanic." He was a broken man when he left Australia
for the final time in 1914 and returned to his home in Berlin. His des-
titution was not permanent, however. A few years later, the impre-
sario assembled another platoon of little people, Ike Rose's Royal
Midgets, and brought the troupe to America. The company became
a staple of the vaudeville houses and bigger carnivals in the 1920s
and 1930s.

After a courtship that lasted more than two-and-a-half years and
took place before the constant gaze of Mary Hilton, Myer Myers and
Edith were married in Sydney on Christmas Eve, 1915. Mary Hilton
and one Jimmie Ellis signed the marriage license as witnesses. The

newlyweds, along with Mary and the twins, took up residence at 42 George Street, Sydney.[17]

Now and then, the Brighton United Twins performed in theaters in smaller towns, but most of their appearances were limited to the horse-drawn wagon circuses that rolled through Australia and New Zealand during the summer months.

In January of 1916, Myer scored something of a coup. He won an engagement for Daisy and Violet at the grand opening of White City, a nine-and-a-half-acre amusement park in Sydney. The booking was the most impressive of the sisters' nearly four years of trouping Down Under. Myer, however, was less than ebullient at having landed the engagement. By this time, he had a new ambition for Daisy and Violet. He wanted to take them to America.

While the twins hardly made a ripple in the media all the time they were in Australia, they caused something of a stir when it became known that they were leaving the country. *Australian Variety* made them cover girls in its June 10, 1916 edition and ran this story:

> Leaving for America . . . are little Daisy and Violet Hilton, the wonderful Siamese twins, who have been exploited throughout Australasia by Ike Rose, the famous American entertainer [sic], and subsequently by Myer Myers, the well-known Australian showman.
>
> "It is Mr. Myers who will, in cooperation with his wife, take the children to America at the instigation of several prominent amusement people, and that they will be a wonderful source of interest, if properly handled, goes without saying. The children . . . are most intellectual youngsters, and are thorough musicians and vocalists. Although linked together by that inseparable bond, the children are two ordinary human mortals, possessing two totally distinct and different personalities. Of late, their seemingly burdensome disability has been somewhat minimised by the extra strength

of the youngsters and the equally strong link between them. This latter is now more elastic and enables these two little girls to walk almost side by side. The most remarkable phe-nomenon, and [one] which has baffled scientific authorities, is the total absence of synchrony, for, strange to relate, the pulses of the twins are totally distinct. They have their likes and dislikes, etc., in common with other children, and enjoy their young lives to the full. Mr. Myers, who is well known throughout Australasia, will exhibit the twins throughout America, and it is safe to predict that the youngsters will cre-ate an unusual interest in the States.

The Myers were anything but paupers as they prepared to sail for San Francisco. At a time when the average factory worker in America was working more than fifty hours a week and earning less than $800 a year, Myer and Edith declared they were leaving Australia with the equivalent of $1,500 in U.S. currency.

The 400-foot, 6,300-ton *Sonoma* operated by the Oceanic Steamship Company of San Francisco left the port of Sydney on June 21, 1915.[18] Captained by J. H. Trask, the *Sonoma* carried 221 passen-gers, 150 of them in first-class cabins, including the Myers. Myer Myers should have felt at home. There were enough show people aboard to constitute a quorum for a group that could have called itself "The Society of Showfolks Who've Had It Up to Here with Australia." In addition to the Hiltons and the Myers, the liner carried Max Steinberg, a carnival man; E. C. Jenkins, the operator of a med-icine show; Meagher, Morris and Musette, a song and dance trio; and Tom Fox, the owner of two large chimpanzees, Casey and Bizz.[19]

Captain Trask recorded in his log that the seas were calm through-out the voyage. The trip did have its share of drama, however. One passenger, John Tomarces, of Greece, died of tuberculosis and was buried at sea.[20]

After having been at sea for nearly three weeks, all the passengers were on deck at noon on July 10. Tears were streaming down the cheeks of some. Others were cheering. The *Sonoma* had nearly reached the shores of California and the city of San Francisco. Daisy and Violet, Myer and Edith, and Mary were feeling elated as a gigantic red, white, and blue flag appeared in the distance. But their elation did not last. America, the promised land of unlimited opportunity, had hardly come into view when serious doubts arose about whether the twins would ever be able to step ashore.

# BETWIXT THE TWO, THERE AIN'T SO MUCH AS A FARTHING'S WORTH OF SELF-PITY

Myer Myers opened the buttons on his wool coat, then the buttons of the vest corseting his big stomach. He loosened his necktie and tugged at the yellow-stained collar biting into his neck. He was still having trouble breathing. He worried that unless he could start taking more air into his lungs, he was going to pass out.

He was in a small, windowless interrogation room, seated on an upright wooden chair before a small metal table. Across the table, wearing a green uniform, knee-high boots of shiny brown leather, and a holstered pistol, was an inspector for the United States Immigration Service.

Hours earlier, the *Sonoma* had steamed into San Francisco Bay and docked at Angel Island. Federal officers boarded the ship and, after looking incredulously at the fused bodies of the eight-year-old twins, separated them from Myer, Edith, and Mary. Myer was still shaken from the scene. As Daisy and Violet cried hysterically, a uniformed officer pushed and pulled the pair down the gangplank and then led them to the island hospital where they were to be given a medical examination.[1]

Next, guards led the Myers and Mary Hilton down the gangplank and shepherded them into an administration building. They were given numbered cards to pin to their clothes and directed to take seats

on a bench inside a large hall. The hall was occupied by dozens of other detainees, almost all of them immigrants from China. Four or five hours passed, and then Myer, Edith, and Mary were finally ushered into the interrogation room.

The inspector had already received a written report of the physical examination conducted on Daisy and Violet. It was when Myer saw the twins' documents folders on the table as he settled onto the chair before him that he began having trouble breathing. Penned in large black letters on the folders were the words: Unfit for Entry.

The inspector removed the medical reports from the folders and began studying them. Listed under "unusual identifying physical characteristics," the examining physician had written "Grown together at sacrum with sibling."[2]

The inspector's eyes widened. With hundreds and sometimes thousands of immigrants passing through Angel Island every day, he must have believed he had already heard of every sick and sorry condition a person could possibly have. But . . . *grown together?* He had never before seen a medical report with such a description. He seemed momentarily bewildered. Then he opened a drawer and brought out a thick, black manual. He turned to the index and, with a bony finger, started scanning its pages. He stopped somewhere midway through. He pushed the manual across the table to Myer's side and spun it 180 degrees. He tapped a finger on the appropriate regulation.

"Can you read, sir?" he asked. "Here is what the code says. You can see with your own eyes: 'Federal law prohibits the entry into the U S of A of any alien who has a physical deformity affecting his ability to earn a living.'"[3]

The inspector lifted his gaze from the manual and, for the first time, made eye contact with the man across the table.

"This means, sir, that you never should have tried bringing them freak girls here. America is not a dumping ground for foreigners with

deformities that could make them liabilities to the government. My advice, sir, is that you and your family book passage for an immediate return to Australia. Entry into the United States is denied."[4]

The Myers, Mary, and the twins had been at sea 19 days and 22 hours. They had traveled 7,411 1/2 miles.[5] They were now just three-and-a-half miles from America's shore, and the family patriarch had just been told they could not advance any farther. Myer couldn't speak. He could scarcely breathe. Mary and Edith had been silent during the brief meeting, but now Mary asked for permission to speak.

She identified herself as the twins' foster mother and spoke in a deferential tone to the inspector. Unusual though it might seem, she explained, the girls' deformity was not an impediment to their ability to earn a living. On the contrary, the sisters' physiognomy had been a source of substantial earnings. Doctors and scientists throughout Europe and Australia had pronounced them human wonders. People from everywhere flocked to see them, and paid to do so. Surely this would also be true in America.

The inspector replied that he was sorry, but he had to go by the book and the book was clear on the subject. Because of their gross deformity, the children could not enter the country. "Them little girls is human freaks," he stated again.[6]

Mary respectfully acknowledged that the inspector was only following the law by denying the twins entry into the country. Then she asked him whether there might be a process by which the family could appeal his decision.

The inspector's face became red and his expression grew taut as he rose from his chair to signal that their meeting was over. He was irritated that anyone, let alone a woman and a foreigner, could even suggest that he might have erred in his decision. He sternly told Mary that there was but one official who had the power to overturn his

*The postcard reads "Daisy and Violet" although*
*Violet is on the left and Daisy is on right.*
*(Author's collection)*

ruling in the matter, and that was the quarantine officer for Angel Island. He warned her it could be weeks, even months, before they were granted a hearing, and even then, ultimately, the family would likely be wasting their time.

Because their papers were found to be in order, Mary, Myer, and Edith were free to board the ferry to the mainland. Under no circumstances, however, could Daisy and Violet leave Angel Island. They

had been declared "physically and biologically inferior" by the health inspector who examined them at the hospital, and they were placed in detention.[7]

Throughout the tense ordeal, Edith said not a word nor expressed any emotion. Totally dependent on her husband and her mother, she was painfully shy and self-conscious, and tried always to avoid attention by staying in the background. Edith was all but incapable of making any decision more complicated than choosing which of her two plain, ankle-length, cinder-colored dresses she should wear. Indeed, she seemed barely to have an existence except as a near invisible appurtenance to the twins.

Inwardly, Edith felt relief when the immigration inspector ruled that the twins were unfit to ever enter the United States and advised Myer that he and his family should go back to wherever they had come from. Myer and Mary had been so sure they were going to find fortune in America. Edith understood how crushed they must have been at the ruling. But she secretly hoped that now, finally, they would see that it was time to quit their endless travels and return to Brighton, where everyone could resume a more familiar and quiet life.

Edith was crestfallen when almost the moment Mary and Myer left the interrogation room, they told her they were not ready to abandon their dream. Mary had already conceived a plan: She and Myer were going to take the next ferry to the mainland, and Edith was to stay behind on the island with the twins.

Edith became undone. She begged them not to abandon her. She told them of her fear that the guards would put her and the twins on a ship bound for Shanghai and that she would never see her mother and husband again. Through her sobs, she kept crying "No, no, no" as Mary outlined her scheme.[8]

Mary and Myer tried reassuring Edith. They didn't expect to be on the mainland for more than a day or two, and by then, the wheels on

Mary's plan would already be turning, and in time, all five of them could legally enter California. Myer and Mary embraced Edith and begged her to be strong. Mary's plan may have been the longest of long shots, but it was perhaps the family's only chance.

All of the island's detainees were held inside a compound ringed with a high steel fence laced with barbed wire. At the center of the contain-ment compound was a watch tower with a searchlight that, after night-fall, continually panned the barracks and the fences. The men and boys were segregated in one area, the women and girls in another. The sep-aration necessarily resulted in the breakup of family units. Wives and daughters were cut off from any communication with husbands, fathers, and brothers; and even very young children could be torn away from a parent and warehoused with strangers in same-sex barracks.

Edith was terrified as she presented herself to the uniformed offi-cers at the gate of the compound. After checking her papers, the offi-cers summoned a matron who led her to the barracks where the twins were being held. Except for the guards strolling the stockade with leashed dogs, everyone Edith saw was Asian. Most of the detainees were by themselves, sitting on the ground with their backs against the whitewashed sheds. Edith had never seen faces etched so deeply with despair. Many of detainees had been held in the compound for months. A few had been there a year or more.

Opened in 1910, the Angel Island Immigration Station had been established primarily to dam the ever-increasing flood of Chinese laborers into the United States. The first Chinese workers started arriving during the Gold Rush of 1848, and by the time construction started on the transcontinental railroad in the 1860s, they were surg-ing into the U.S. at the rate of 30,000 a year. Because the Chinese were willing to work for low wages, political forces claimed they were stealing jobs from American (meaning Caucasian) workers. So in 1882, Congress passed the Chinese Exclusion Act, the first immigra-

tion law ever to bar citizenship solely on the basis of race. Until it was repealed in the 1940s, the law all but put an end to what anti-Chinese politicos called the "yellow peril." The law, however, did not altogether stop Asians from trying to gain American citizenship. The country was still open to Chinese immigrants whose fathers had become naturalized citizens before passage of the Exclusion Act.

There were 100 to 150 detainees, most of them Chinese, stockaded on Angel Island at the time Edith entered the complex. Most had sworn they had fathers in America who already were naturalized citizens. Because they lacked documentation to back their claims, they were held in quarantine until authorities could either locate these men or, as was far more common, determined through interrogations that no such fathers existed. Detainees who were caught making false claims about citizen fathers were marched in chains onto outbound Chinese vessels and thrown into lockup, giving rise to the expression "shanghaied." Some desperate men and women awaiting deportation managed to avoid returning to China by fashioning ropes from strips of mattress ticking and hanging themselves in the barracks' lavatories.

When Edith first saw Daisy and Violet, they were sitting motionless on the lowest mattress of a three-tiered bunk bed. Gathered before them, seated cross-legged on the floor, were several dozen women and young girls, all of them Chinese. Some were eating rice and vegetables from small bowls. Others were picking at the carcass of a roasted seagull they had caught after luring it with handfuls of rice. All were staring in wonder at Daisy and Violet.

By this time, Daisy and Violet had been left unattended for ten or twelve hours. Edith threaded her way through the knot of gawkers bunched before them. She placed her suitcase on an upper bunk, and tried to embrace the twins. Daisy and Violet stared ahead vacantly, showing no sign they even recognized their much older stepsister. It was apparent they were still suffering from the trauma of being torn

from their family by Immigration officers and then turned into a spectacle at the hospital where they were disrobed and placed on view not just for the examining doctor and nurses, but for any Angel Island employees who wanted to see them.

Some of the Chinese women came forward thrusting their rice bowls towards Daisy and Violet, trying to communicate to Edith that the girls needed to eat. Edith shooed the women away, sat on the mattress beside Daisy and Violet, placed an arm around their small shoulders, and drew them tightly to her side. "We have to be strong," she sobbed. "Everything will work out, but we have to be strong, brave."[9]

<center>❧ ❧ ❧ ❧</center>

On the sidewalk outside the offices of the *San Francisco Chronicle*. Mary had a handbag filled with scrapbooks in one hand, a hickory cane in the other. She turned and hobbled into the building.

From the day she had adopted the twins, Mary had shown a gift for charming newspaper men. She always struck them as being grandmotherly, a woman of innocence, and pure in heart and soul. What other kind of woman would take such wretched children into her life?

Mary was surprised when she entered the *Chronicle's* news department. The paper's city room was several times larger than any in which she had ever been. After announcing herself to a secretary at the front desk, she was directed to take a chair. In a moment, she was ushered into a glassed-in office occupied by an editor. She drew the scrapbooks from her bag and placed them on his desk. Mary began leafing through the pages, showing articles and news photos of all the places the twins had appeared. "They're so, *so* lovely, they are," she said appraisingly. "They're so, *so* talented. And, may I say, betwixt the two, despite their condition, there ain't so much as a farthing's worth of self-pity."[10]

Mary was chirpy but then turned somber. She withdrew a time-piece from a pocket and calculated out loud: "Twenty-four, twenty-five hours since I've even been able to hold them in my arms," she sniffled. "A day and a night. Eight-year-old girls all alone and thousands of miles from home, and held in detention on Angel Island as though they were common thieves. I don't even know if they're alive or dead."

The editor didn't need to hear any more. He gathered up Mary's scrapbooks and returned them to her handbag. He took her by the arm and led her out into the city room to the desk of a staff writer.

Mary did not so much tell the story of the twins' misadventures, as dictate it. She embellished some events and underplayed others. At no time did she mention she had traveled to America not just with the twins, but also with a married daughter and son-in-law. Such a detail, she seemed to sense, would only water down her account. The saga was so much better when its cast of characters was limited to an eccentric and big-hearted old lady and the two angelically beautiful but physically cursed sisters.

In her retelling of the tale, Mary stressed her selfless generosity. She skipped relating her reason for coming to America with the twins, which, more than any other place in the world, was where she believed a true fortune could be made.

"Here, look at the scrapbooks of all the places they have been," she instructed the reporter. "London . . . Berlin . . . Leipzig . . . Milan . . . Glasgow . . . Melbourne. And on and on and everywhere. Wherever we traveled, though, all my babies would ever say to me is 'Auntie, Auntie'—they always call me Auntie—'we must someday go to the greatest land on earth. We must go to America.' Every night they fall asleep in their bed looking at picture books of America. I saved for a year. I secretly planned. Then, two weeks ago we leave Melbourne and sail the ocean for America. Oh, how excited my babies are when, after being at sea for days and days and nights and nights, they see

America come into view. Imagine how devastated the dears were when they learned the door to America was closed to them, that they weren't welcome because of their God-given condition. Doesn't it break your heart?"

Most critically, near the end of her recitation Mary introduced a Dr. Adrian Drew into the story. Was he a villain or hero? Only time would tell. Drew was the chief quarantine officer on Angel Island. He alone had the power to make the final ruling on whether Daisy and Violet would ever set foot on American soil.

When Mary emerged from the *Chronicle* building, Myer was still waiting on the sidewalk. They started walking in search of a hotel for the night. The winds had shifted on San Francisco Bay, draping a gauze of fog over the structures near the waterfront. Mary Hilton and Myer Myers hardly noticed. They were in a fog of worry and concern over how things would play out.

The *San Francisco Chronicle* account appeared the next morning, running under the headline:

### TIE THAT BINDS THEM
### SEEMS NO BAR
### TO 'EARNING A LIVING'

The story could not have been more sympathetic to Mary Hilton if she had written it herself, which, of course, she all but did. It characterized her as a stooped and widowed old granny who was giving her last breaths to provide care and love to two pitiable girls who had been cast away by their own mother. The twins were portrayed as wretched creatures who had triumphed over the circumstance of their birth to become exceptional children who could serve as role models to less fortunate people everywhere.

In part, the *Chronicle* account read:

Daisy and Violet were born in Brighton, England, eight years ago, and have grown into healthy, rosy-faced girls. They are educated far beyond the average of their age, draw exceptionally well and are prodigies in music. Violet is an accomplished pianist and her sister plays several stringed instruments. They are on a trip around the world largely for their education.[11]

Just as Mary had hoped, the newspaper story prompted almost immediate action on Angel Island. Dr. Adrian Drew, the island's chief quarantine officer, was swamped with cases that required hearings to determine which of the island's detainees could be granted entry into the United States. Typically, a detainee waited weeks or months before he or she was given a hearing. Because the *Chronicle* had now turned the twins' case into a cause célèbre, Dr. Drew felt pressured to act with dispatch in the matter. He docketed the sisters' case for an immediate hearing.

Drew had a reputation for being tough. Almost all the appellants who appeared before him were ordered to board ships back to their homelands, rather than the ferry that could give them passage over the final three-and-a-half miles to California's golden shore. Since almost all the foreigners he barred from entering the U.S. were Chinese, he was generally able to carry out his job without attracting even the slightest attention from the press or public.

Drew may have worried that if he ordered the twins' banishment, he might be scorned as the evilest man in America. Surely he could imagine what the *Chronicle* and other papers across the country would do with the story. There would be front-page pictures of the tiny Hilton twins, woebegone and crying their eyes out, aboard a ship pulling away from Angel Island. He ordered the twins' immediate release from detention and authorized them to go ashore.[12]

Mary's claim to the newspaper that she traveled to America with the twins "largely for their education" was, of course, a fiction. When Mary, Myer, Edith Emily, Daisy, and Violet were finally able to travel ashore as a family, one of their first stops was the San Francisco office of *The Billboard*. Myer arranged for a large advertisement in the publication. The ad, which included a picture of Daisy and Violet seated back to back at the keyboards of two pianos and read:

### THE MODERN SIAMESE TWINS
*(Daisy and Violet)*

Just Completed a Tour of
Europe and Australasia
Playing to Big Business
Now booking high-class
Engagements for parks
And fairs or any good
Proposition
Address Myer Myers Care Billboard, San Francisco, Cal.[13]

Myer didn't wait long for a response. The ad caught the eye of W. H. Rice, the West Coast talent scout for Clarence A. Wortham, the owner of six large railroad carnivals that were touring the country. Rice met with Myer in San Francisco and opened negotiations for what Rice assured him would be "a dignified presentation of the girls in the show world."[14]

Within a week, Mary, the Myers, and Daisy and Violet were rolling northward through California on a train. They were on their way to Big Sky country—Anaconda, Montana.

# A SLIP OF MOTHER NATURE'S HAND

Daisy and Violet got their first glimpse of the Wortham World's Greatest Shows a half mile up the tracks from Anaconda. As their train was slowing to a stop, their hearts leaped. Could any carnival really be so sprawling?

The midway had sprouted in a field right alongside the Butte, Anaconda & Pacific Railroad tracks. It spread a wide band of jostling colors at the edge of the sullen company town that was otherwise unrelievedly gray.

A sparkling red ferris wheel, taller than the tallest church steeple in town, slowly churned against the sky. Striped tents were every-where, and, behind them, chomping on grass, were elephants, camels, and zebras. Luridly illustrated canvas banners were strung up behind all the ticket booths advertising such attractions as Tam Tam, the Last of His Race and Red Booger's Wild West Show.

Anaconda was a mining village. The settlement had started pushing up out of a piney wilderness three decades earlier with the discovery of a vein that would transform the area into the richest copper produc-ing region in the country. The town was laid out with row upon row of soot-powdered brick and frame houses. Smoke from the Anaconda Mining Company smelting factories hung in the air day and night.

Myer, Edith, and Mary could not have been more surprised nor more impressed when, along with Daisy and Violet, they alighted

from the train at the Anaconda depot to be greeted by the owner of the carnival himself, Clarence A. Wortham. His arms were brimming with kewpie dolls, teddy bears, and bags of taffy.

"Such pretty girls," Wortham appraised. "And I've heard about how talented you are as performers. I'm so pleased that you are going to be part of our shows. Now which of you is Daisy and which is Violet?"

"We liked Mr. Wortham immediately," Violet would say later. More than anyone else whom Daisy and Violet had met in the entertainment business, Wortham gave the sisters a sense that he viewed them as sensitive human beings, not as the mere chattel of the fat man and skinny lady accompanying them. There may have been another reason why they felt at ease with the showman. They only had to tilt their heads slightly upward to make direct eye contact with him. Wortham was a small man, barely an inch over five feet and just 125 pounds.

"Like Toulouse-Lautrec, Napoleon, and some of the other runts of history, Clarence Wortham became a towering figure in his field because he over-compensated for his diminutiveness," observed Joe McKennon, a carny himself who, in retirement, made himself generally handy around the Ringling Museum of Art in Sarasota, Florida. "Who knows what Clarence might have done with his life if he had grown another six or eight inches taller. He probably would have driven a milk truck."[1]

Wortham was accompanied by his chauffeur when he went to welcome Daisy and Violet, the Myers, and Mary Hilton. He directed the driver to strap the family's bags and trunks to his touring car. He then ferried the group to the railroad siding where the carnival's train was parked. Each of its twenty-five cars was painted red and emblazoned in gold with the title, Wortham's World's Greatest Shows. "Home sweet home," Wortham declared, as he showed the family the quarters they would occupy, a furnished stateroom that, rare for the

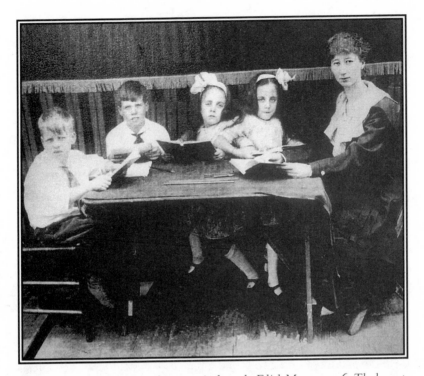

Violet and Daisy being tutored in a carnival tent by Edith Myers, 1916. The boys at left are Clarence Jr. and Max Wortham, sons of Clarence Wortham, the carnival impresario. (Courtesy of Carol Wortham Anspacher)

time, had both electricity and running water. Next, he squired them on a tour of his midway.

Myer Myers was amazed. Anaconda was a town of about 3,000 inhabitants, but the midway was so choked with humanity it seemed to him there could have been double that many revelers at the World's Greatest Shows. Long lines of people waited at every ticket booth, whether for Johnny Begano's Congress of Wonders, Red Booger's Wild West Show, the Whip, or George Farley's House of Filipino Midgets.[2] In an exercise that came almost as naturally to him as breathing, Myer started counting customers in the ticket lines and

multiplying these numbers by the 15-cent and 35-cent admission prices. He couldn't wait until his Siamese twins had an address on the midway.

To the people of remote communities like Anaconda who rarely traveled anywhere, a carnival was an exotic mix of the bizarre, the beautiful, and the grotesque. It wasn't surprising that preachers used their strongest invectives to fulminate against these portable Coney Islands. The carnivals encouraged carefree extravagance that could quickly undo the values of sobriety, seriousness, hard work, and frugality that the local ministers tried to instill in their flocks. Whatever the denunciations the small town people heard from the pulpits, few could resist the allure of the carnival, especially at night. The ferris wheel turned with a thousand lights, circumscribing a huge glowing circle that could be seen for miles in the darkness. The air not only carried the scents of frying meats, but also the sing-song rodomontade of pitchmen who stood outside the tents of monkey-girls, human pincushions, and nymphets from India and Egypt whose only costumes were their pet snakes. The night erased all the rough edges of the dreamland that was the traveling carnival. In the glow of gas lanterns, an overweight and over-the-hill dancer could look like a sylph.

Clarence Wortham was really without any serious competitors in the carnival industry. Known by competitors as the Little Giant, he insisted that each of his half-dozen carnivals offer only the biggest tent attractions and the latest, state-of-the-art thrill rides.

"If he had his designs on some new attraction or ride that other showmen wanted, he would outbid them all," said Joe McKennon. "He always won. He was willing to spend king's ransoms for midway attractions, whether for some new loop-to-loop ride, the fattest of the fat ladies, or a five-legged cow. P.T. Barnum was probably lucky that Clarence wasn't a contemporary. He would have given him a run for his money."[3]

The unchecked extravagance Wortham showed in collecting carnival attractions didn't carry over to his wardrobe. He apparently believed it was sinful for a man to ever own more than a single suit since he could never wear more than one at a time. He was known for donning the same tweed three-piece outfit day after day, week after week, without ever getting it cleaned. When it became evident, even to him, that a suit had begun showing too much wear, he'd reluctantly hand over $15 to an aide and send him into town to buy a new one. He disposed of his old suits by presenting them to employees. His castoffs usually ended up on the backs of sideshow midgets who, with help from some tailoring, looked quite dapper in them.

So great were the swarms that had massed before the Rice & Wortham Water Circus, its ticket booths were not even visible from the midway.

"It's been the same in every town we have played this season," Wortham said of the water circus's drawing power. "It's an attraction unlike any you'll find on any carnival traveling America today."

Hanging near the circus's entranceway, strung from a cable that was as high as a telephone line, was a hand-painted canvas that was at least as enormous as Gericault's *Raft of Medusa*, and almost as lurid in its imagery. The banner depicted three or four mermaids perched atop a rocky outcropping in the middle of an ocean. Each of the spirits of the sea was wearing what was recognizable as a come-hither expression, but each was otherwise naked from her golden hair to the end of her fishy tail. To the side of the pictorial banner, there was another canvas sign that read:

**DIRECT FROM NEW YORK CITY!**
*Neptune's Daughter*

Cost $50,000 to Produce!
Seeable Only At
Wortham's World's Greatest Shows

Wortham lifted the twins into his arms, and with the Myers and Mary tailing him, bore them through the crowd to the attraction's entranceway.

The audiences for the water circus viewed the spectacle from bleacher seating that encircled a canvas-lined tank that was eight feet deep and twenty-four feet in diameter. The show got underway when daredevil Joey Florey streaked down a long wooden chute on a bicycle, tore through a wall of fire, and, after flying forty feet through the air, landed in the water tank. The crowd was still roaring as Florey then ascended an eighty-foot pole, and, from a tiny perch, executed a swan dive into a pool below.[4]

As spectacular as the stuntman's feats were, most of the crowd had been drawn to the water circus to see "Neptune's Daughter," a musical production that, a few years earlier, had been presented to large and approving audiences in New York's Hippodrome. The play's storyline involved the mermaid daughter of King Neptune who is determined to avenge the death of her sister who had been caught in the fishing net of a mortal man. But on her way to plotting the fisherman's demise, Annette, the avenging mermaid, falls in love with him.

Besides its principals, the Wortham revue included a corps de ballet of a dozen young women. These splashers were hired less for their swimming abilities than for what they did for bathing suits. "Men and boys always outnumbered the female patrons at the shows by at least three to one," McKennon calculated.[5]

Wortham was always so far ahead of the curve with his carnival features that he was beyond the reach of all other showmen. In addition to the production of "Neptune's Daughter," he introduced another major money-maker in the 1916 edition of his World's Greatest Shows. The attraction was called "A Trip to Mars" and was a portable version of a feature that, in a far more primitive form, had

been a sensation at the 1901 Pan-American Exposition in Buffalo, New York.

The ticket holders for Wortham's "A Trip to Mars" entered a large, darkened tent and took their seats inside a rocket ship whose under-carriage was attached to a maze of steel bars. After all the patrons were belted in, there was a ground-shaking explosion, and, in the next instant, there would be a terrible shuddering of the spaceship as its nose would lift upward. Motion pictures were projected onto the tent's interior walls, and, by peering through the portholes of their rocket, the "passengers" got a strong impression they were leaving Planet Earth. After streaking through the Milky Way and then a celestial electric storm, the craft made a noisy and bumpy landing on Mars. Next, the audience saw a pocked, tomato-colored landscape inhabited by little green men, actually some dwarfs that had been borrowed from George Farley's House of Filipino Midgets. Finally, the spaceship again lifted off and returned everyone to earth.

Daisy and Violet were beside themselves with excitement after the ride, but Wortham told them he had one more surprise. He led the sisters and Myer, Edith, and Mary away from the bustling midway to a drab tent near the railroad tracks. Inside, working by the light of lanterns, a lone painter was leaning over a canvas as massive as the one they had seen for the "Neptune's Daughter" production.

The artist was nearly finished with the painting. Daisy and Violet were dumbstruck, as were Myer, Edith, and Mary. The canvas depicted, four or five times life size, two girls, standing closely side-by-side. They could have been eight or nine years old, and each was pretty enough to have stepped out of a Raphael painting. Both girls were covered with ermine-trimmed blue velvet robes. There were dia-mond-studded tiaras on their heads and gold slippers on their feet. Buckingham Palace was in the background. Above the mural, in let-tering readable from hundreds of feet, was the legend:

## DAISY AND VIOLET HILTON
## THE ROYAL ENGLISH UNITED TWINS

Wortham spoke cautiously. "I hope," he said, "that nobody minds that I tossed out that old name of 'Brighton United Twins.' It struck me as sounding a little too . . . well, parochial."

Roustabouts strung up the banner the next day and a tent was erected. The playhouse was smaller than most of the canvas pavilions lining the midway. It was also patched and faded. Wortham apologized for its size and condition but said it would have to do until a new top could be made and delivered.

There is no published account of how Daisy and Violet were received at their American premiere. The *Anaconda Standard* printed only one review of the carnival's appearance, and it ran a day or two before the twins arrived in the town.[6]

It can be supposed that the circumference of Myer's bankroll started thickening from the sisters' first day on the midway. After finishing the stand in Anaconda, the Wortham carnival played Butte, Great Falls, and Kalispell.[7] The cavalcade then moved over the rails to Spokane, Washington, for a week-long appearance at the Interstate Fair. The *Spokane Daily Chronicle* reported that in the fair's first day alone, the Royal English United Twins drew "thousands of visitors to their cozy tent." The newspaper went on to declare Daisy and Violet to be among "the most interesting and . . . most popular of all the . . . attractions." A rival paper, the *Spokane Press*, seemed positively smitten with Daisy and Violet. It pronounced them to be "excellent musicians" but seemed even more impressed that the sisters, at the tender age of eight, were already poised and scintillating as raconteurs. "The two children, who have only recently arrived in America from Australia, . . . are entertaining visitors with their bright . . . stories of travels in Europe and the Antipodes," the *Press* observed.

Wherever the Royal English United Twins' tent was raised, the

public's response was the same. From the time the midway opened in the morning until after midnight when the carnival extinguished its gas lanterns, droves of people kept streaming into their canvas hall.

At least part of the reason for the twins' enormous popular appeal could be credited to Jay Henry Edwards, or, as he preferred to be addressed, Professor Jay Henry Edwards. In the parlance of the sideshow, Professor Edwards was a "talker" or "lecturer," the authority figure who stood on a platform outside the tent and described the wonders inside. Edwards was a veteran sideshow spieler who had a reputation in the outdoor amusement business as the best in his profession. He seemed to have cultivated his manner from both an Oxford classics scholar and a snake oil salesman. Whatever the subject of his lectures, he dropped the names of Homer, Aristotle, and Plato as though he regularly sat down with them at the local Moose Lodge for rounds of poker. He wore derby hats, vests, checkered suits, and he always had a fresh boutonniere in his lapel.

Day and night, Edwards stood on a platform outside the tent of the Royal English United Twins, making outrageous claims. He took pride in his ability to invent. No two of his lectures were ever the same, but they always lured townsfolk off the midway like a candle flame to moths.

"Ladies and gentlemen, boys and girls," he would begin, "it is through the kind auspices of His Majesty, King Edward the Seventh of England, that Mr. Clarence A. Wortham's World's Greatest Shows is able to present the Royal English United Twins. I promise you, ladies and gentlemen, boys and girls, that when you step inside our comfortable amphitheater, you are going to see, live, the rarest, most inimitable attraction ever to be presented on a stage anywhere in America. You are going to see two genuine British princesses who have blood coursing through their veins that's bluer than the waters of the Aegean Sea. The princesses are descended in a direct line from Queen Victoria and Prince Albert. They're the most beautiful children

you'll ever see, but there is something about them that's very differ-
ent from you and me. Because of a slip of Mother Nature's hand while
they were in their royal mother's womb, their bodies grew together
the way tomatoes on the vine sometimes do."

Professor Edwards then pleaded with the crowd to treat the sis-
ters with the deference that should be accorded all creatures of noble
birth.

"The royal twins will sing for you, they'll dance for you, they'll play
all the instruments of a philharmonic orchestra," he would declaim.
"They'll talk to you. You can talk to them. You might find them to be
a little reserved, though. The carnival life is still new to them. Until
Wortham's World's Greatest Shows brought them to America, the
twins spent most of their time cosseted in their castle, reading Chaucer
and Descartes and playing chess with dukes and viscounts and other
assorted grandees. Miss this one-time opportunity to see the Royal
English United Twins, ladies and gentlemen, boys and girls, and you'll
regret your misjudgment all the rest of your days. The show is just 35
cents for the adults, a nickel and a thin dime for the little ones. Enter
our hall and stay as long as you like. You'll thank me on your way out."

From Spokane, the World's Greatest Shows traveled on to cities
in Oregon, Idaho, and California. According to a report in *The
Billboard*, Daisy and Violet "were making a hit all along the way," and
were drawing in more money to the carnival than any attraction but
the Rice & Wortham Water Circus.[8]

Money was gushing into the show daily, thanks to Daisy and
Violet, so that in the course of just a month or two, Myer Myers was
transformed into a parvenu. The sisters did not benefit in any direct
way from their growing wealth, however, nor did their lives change
much. The rules had been laid down earlier by Myer and Mary: They
were not to associate with other children, especially those from out-
side the carnival. Actually, they were forbidden by Myer and Mary

from being seen by the public anywhere outside their tent. The twins weren't allowed to do anything or go anywhere that might risk tarnishing their aura as the rarest of sideshow attractions and possibly discourage some townies from paying to see them.

From the time he was a child, Jim Moore was fascinated by the carnival and circus gypsies who set up their here-today gone-tomorrow canvas pavilions and rainbow-colored thrill rides in the weedy fields of San Antonio, Texas, where he grew up. He dreamed about wandering with these carnival folk who would appear in town one day, seemingly out of nowhere, and be gone the next. Because they were almost the same age, Moore was especially spellbound by Daisy and Violet. He hung around their tent day and night whenever the carnival brought them to town and he developed a close and, ultimately, an intimate relationship with them.

Moore recalled the pains that were taken by the twins' warders to prevent any townspeople from getting a free glimpse of them after the carnival closed for the night. "The Myers kept them isolated," he said. "They had a limousine pick them up right in the back of the tent that they were being shown in, and they were driven straight back . . . to where they were staying, and were never seen."[9]

Moore said that as a child, he always wondered when, if ever, Daisy and Violet had a chance to rest. He remembered another rule by which the sisters had to abide: If they were not on stage performing, they were either being drilled by Edith in dancing or singing two-part harmonies, or they were cracking school books and memorizing the names of U. S. presidents or the capital cities of the world. "When you went in (their tent), their books were right there," Moore said. "They were studying. The girls were quite well educated and they were talented. They had charming singing voices."[10]

It may have been Mary, more than Myer, who was insistent that the girls receive rigorous tutoring in reading, writing, geography,

and history. Freaks were common enough, she told them daily. She expected them to be something more. She said she expected them to be more intelligent, more talented and more socially skilled than any classroom full of *wunderkinder.* "I want you to be the smartest Siamese twins in the world," she commanded.[11]

By November 13, 1916, the World's Greatest Shows traveled to Phoenix for a six-day booking at the Arizona State Fair. In the three months that the family had been traveling with the carnival, Myer had seen dozens of towns and cities in six or eight different states. There was something about Phoenix, however, that seemed to have placed him under a spell. The town had sprung up in the desert as a supply point for cowboys and miners. Its population wasn't quite 15,000. Everywhere on Phoenix's streets there were cowhands in sweat-stained Stetsons and scuffed boots. The look of the town, along with the searing heat, probably reminded Myers of the frontier towns that had pushed up in Australia's bush country as watering holes for the sheep and cattle men.

Following its appearance at the Arizona State Fair, the Wortham carnival was scheduled to play a few more engagements before ending its 1916 season and rolling back to El Paso, Texas, its winter quarters. This time when the show train left for its next stand the Royal English Twins were not aboard. Myer, Edith, and Mary had decided to establish a home in Phoenix. The family took up residence near the downtown district in a house at 1220 East Jefferson Street.[12]

The Myers and Mary weren't quitting the life of carnival gypsies permanently. With the fast and easy riches they had started to enjoy in America with the grown-together twins, that would have been foolish. But Edith was pregnant with her first child. It was time for the family to suspend its peregrinations and settle in one place until the new baby arrived.

# STRANGELY WISE AND FILLED
# WITH UNVOICED THOUGHTS

The delivery took place in the family's rented house in Phoenix. Mary, of course, coached Edith through her labor. Of the hundreds of births at which she presided in her many decades as a midwife, this one was the most profoundly affecting. As she later recounted, "All them other babies were just practice. Today I got to assist in my own multiplication." She was made all the happier when Edith and Myer christened the infant Therese Mary, a name that would always remind the child of her maternal grandmother.

"That little baby, as near as I could tell, became the entire focus of Myer's dreams," Jim Moore observed. "Therese Mary was still sucking on her mother's teats, and Myer was saying he was going to buy her a pony and he was going to build her a playhouse and fill it with dolls. Of course he was counting on Daisy and Violet to provide all the things he wanted for his daughter. They were the geese that laid golden eggs for the family."[1]

As emotionally detached from Daisy and Violet as Myer and Mary always had been, they became even more distant after the arrival of Therese Mary. In fact, they never viewed the twins as actual family members. To them, Daisy and Violet were a business, a cottage industry on which they depended for their livelihood.

But even Jim Moore conceded that, through their own greed, Mary Hilton and Myer Myers probably provided Daisy and Violet with the

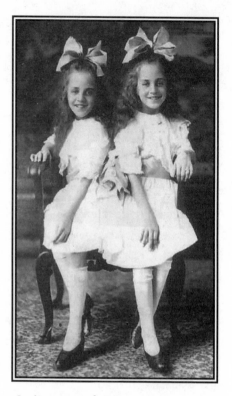

Studio portrait of Violet and Daisy at about
ten years old. (Author's collection)

best option available to them at the time. After all, the usual alterna-
tive for "freaks of nature" was life in an institution. Because the sisters
were always on the move to new places, their childhood was filled
with adventure. And because they were forced to interact with thou-
sands of strangers, they developed poise and social skills beyond their
years. And more importantly, they also received the kind of schooling
that was denied to all but the most privileged children.

"In effect, Daisy and Violet had a private tutor," Moore observed.
"Even after Edith gave birth to her own daughter, she continued to
school the twins in reading, writing, arithmetic, and geography. And

every day, before the twins' tent was opened to the crowds, she rehearsed them in new song and dance routines. Myer and Mary could be hateful in their treatment of the girls, but somehow Edith remained quite devoted to them."[2]

Even as late as the first half of the twentieth century, a large segment of the public viewed conjoined twins, microcephalics, and other teratogenic creatures as the offspring of irredeemably evil parents on whom God had visited his wrath. It was common practice for such unfortunate infants to be placed in church- or state-operated institutions because of their parents' shame at having produced them. Some were drowned like unwanted kittens by parents who felt too disgraced, too fearful, or too challenged to raise them. Few such cases of infanticide were detected by authorities since many of the births took place in homes rather than in hospitals.

Royal though they were in the carnival world, the Misses Hilton were not without rivals. Often appearing on the same midway was Percilla Bejano, known as the "Monkey Girl" because, from the time she was a small child, her face and body were covered with a thick growth of dark hair. As if her extreme hirsutism alone wasn't a distinction that would set her apart, young Percilla had another characteristic that made her a wonder to orthodontists, if not the wider public: She had double rows of teeth in both her upper and lower jaws.

Percilla took the position that if it hadn't been for Mary Hilton, Daisy and Violet might have been stuffed into a weighted gunny sack and dropped into the English channel or deposited at the padlocked door of an orphanage for insane, diseased, and severely crippled children.

"It was easy for do-gooders to condemn the carnivals for presenting human oddities like the Hilton twins and me," she said, "but you have to remember that a lot of the sideshow people had been cast out by their own families."[3] Born in Puerto Rico in 1912, Percilla herself was

given up by her parents at age three to Carl Laufer, an American sideshow impresario. Laufer and his wife could not have treated her more lovingly if she had been born to them, she said.

Jeanie Tomaini shared the Monkey Girl's view that the sideshows were just about the only haven where a freak might discover a measure of independence, happiness, camaraderie, and, sometimes, even romantic love. Jeanie was born in Bluffton, Indiana, in 1916. A lovely child by any standards, she was christened Bernice Evelyn Smith, but before her first birthday, thanks to the striking cloud of curly, light brown hair, her mother started calling her Jeanie after one of Stephen Foster's loveliest songs.

By this time, however, the Smiths' neighbors had given her the much crueler moniker of "Half-Girl." Jeanie's body ended at her hips. She had been born without lower extremities. Her mother and father, not surprisingly, were at first horrified at having brought such a creature into the world. But because of the curiosity her baby aroused in the farming community of Bluffton, Bernice's mother soon came to the realization that her child could help keep food on the table. This was a responsibility about which her husband, a drinker, had always been indifferent. Mr. Smith launched Bernice's show business career when Jeanie was just three, exhibiting her at local pumpkin fairs. Soon after, Jeanie Smith was touring with a major carnival, Dodson Brothers World's Fair, where she was billed as the World's Only Living Half-Girl. Jeanie never appeared on the same midways with Daisy and Violet, but she knew them well. She saw parallels between her life as a carnival stray and those of the twins.

"Would Daisy and Vi have been better off if, instead of appearing on the sideshow stages as youngsters, they had grown up behind the locked steel doors of some institution?" she asked. "That's not a life I would have wanted for myself. Even as young girls, the Hiltons were exceptionally well-educated, worldly and poised.

They did everything—sang, danced, played the piano, violin and reeds—and they were gorgeous to look at. I never saw them put on a performance when they didn't leave their audience absolutely spell-bound. I would say they were world-class entertainers, and they gained all their polish and charm because they traveled in the sideshows. They couldn't have gotten any more polish if they had been educated in the most exclusive boarding schools."[4]

As great a sensation as Daisy and Violet had been during their first round on the American carnival circuit, that experience turned out to be but a dress rehearsal for the frenzy they were to set off the following season. News of the grown-together sisters had already started spreading far and wide, broadcast mostly by people who knew a man who knew a man who had already seen the pair.

For the 1917 tour, Clarence Wortham had switched the Royal English United Twins from the midway of his World's Greatest Shows to that of the most lollapaloosan of his half-dozen carnivals, his flagship C. A. Wortham Shows.[5] The carnival's first appearance of the season was in San Antonio, Texas, where, for ten days and ten nights, its rides and tented attractions were set up on the downtown plaza for the War of the Flowers Fiesta, a festival held in the city each April to commemorate the state's independence from Mexico.

In all, twenty-six separate tent shows were featured in the carnival, and Wortham had reserved the choicest place on the midway for the Royal English United Twins. Their theater was situated directly across from San Antonio's most hallowed site, the Alamo. Eighty years earlier, Davy Crockett and a hundred freedom fighters had holed up for twelve days, trying to fend off the attacks of a Mexican army of thousands, before each of them was slaughtered.[6]

The crowds flocked to the twins: families of ten or twelve with just enough coins knotted in a handkerchief to buy tickets for everyone; dandies with pretty women on their arms, who arrived in new

Oldsmobiles and Essexes; men who worked in oil fields, and women who worked in shirt factories; and, of course, the men who owned the oil fields and shirt factories.

Myer Myers hadn't merely been cooing promises to his newborn daughter over the winter months. Ever an expansionist, he had drawn together the components for a second attraction to present on the midway, a show called Myer Myers' Congress of Human Wonders. The production advertised such attractions as the Half-Man, Half-Horse; Walter Cole, the Skeleton Dude; an eight-piece Darkies Band, and a feature he imported from his native Australia, the 772 Pound Queen Lil and Her Tribe of Whistling Aborigines.[7]

Myer was poorly educated, crude, and rude, but there could be no denying that he was a showman of audacity and farsightedness. Most sideshow managers were content to present their attractions inside dimly lit, mildewing tents with rickety stages and tattered curtains. Myer took the position that the manner in which an act was packaged was at least as important as the offering itself, especially since every carnival midway had dozens of features that were all noisily competing with each other.

Over the winter of 1916–17 he assembled a crew of carpenters, electricians, and scene painters to create a theater of his own design for the United Twins. The resulting playhouse, which was erected for the first time at the San Antonio fair, set a new standard on the midway. Its massive facade had taken the form of a medieval British castle, complete with towering turrets on either end. It appeared to have been constructed of rusticated stones, an illusion created by its trompe l'oeil paint job. There were squint holes everywhere in the walls, and near the castle's center there was a lancelet archway. The ticket buyers passing through the portal were received by ushers in Beefeater uniforms and escorted into a near cathedral-sized tent with cushioned seats and silk-shaded lamps overhead.

Rubin Gruberg, a critic of the fantastical architecture that rose in such places as Coney Island, provided this summary of the feeling that came over him upon entering the playhouse: "All is as spick and span as in any theater. In fact, so perfect has the illusion of a permanent and elegant opera house been created that at night the impression is that one is comfortably sitting in the orchestra seat of a metropolitan theater deluxe."[8]

As always, Professor Jay Henry Edwards held forth outside the Hilton girls' canvas hall. He stood on his elevated platform, a megaphone to his mouth, and, over and over, threw out his spiel like a lariat, roping strollers from the promenade. "Ladies and misters, girls and boys," he intoned solemnly. "Miss out on this one-time opportunity to see the world famous Royal English United Twins and, mark my word, you'll regret it until the day you begin your eternal sleep."

It was at the War of the Flowers Fiesta of 1917 that Jim Moore entered Daisy and Violet's tent for the first time. He was twelve years old, long-bodied, and skinny. For Moore, if not for Daisy and Violet, it was love at first sight. It was the beginning of an abiding relationship between the three that, many years later, would take a surprising turn.

"The twins were in beautiful, ruffled white dresses the first time I saw them," Moore recalled. "The girls seemed to be glowing, as if there were auras around them. They were bathed by light in a tent that was otherwise dark. I started shivering. The scene was a little like that in the movie *Song of Bernadette* where Bernadette comes upon a grotto in the French countryside and gets a vision of the Virgin Mary. Daisy and Violet didn't seem to be earthly creatures. Rather they appeared to have been sent here from someplace beyond. I knew my life was not going to be the same again."[9]

Moore had a natural empathy with the twins. Like them, he felt out of place in almost all social situations. He was a foot taller than

most boys his age and, with his long brown hair slicked back and parted in the center, he seemed to be trying hard to affect the appearance of a matinee idol. He was indifferent to river fishing, sandlot baseball, mumblety-peg, and the other activities with which other boys were preoccupied. Most summer days he hung out at a dance studio in downtown San Antonio. His father thought dancing was for sissies, and Jim never had money for private instruction. He absorbed what he could by watching. At home and alone in his room, he practiced with broom partners.

Moore was to be found in the twins' theater every day it was set up on the San Antonio plaza, not leaving until around midnight when the midway closed. Edith usually emceed the twins' performances. Moore endeared himself to her by running errands and holding four-month-old Therese Mary while Edith was on stage.

"It was almost impossible to have contact with the girls," Moore remembered. "They were under strict orders from Myer Myers not to talk to anyone unless he, Edith, or Mary was at their side. Sometimes, though, Edith would have to leave the tent for a short time, and then I could at least tell the girls how much I enjoyed their performances. I also showed them that I was mastering all the dance numbers they were doing on their stage. I really wanted them to like me."[10]

Moore had been on hand every minute of the time the C. A. Wortham Shows was on the San Antonio plaza. Now, ten days later, he was watching it dissolve. Working by torch light, roustabouts were striking the great tents, dismantling the rides, and reloading the carnival's cargo on the flat-beds of the twenty-seven-car train.

Moore stood in the darkness outside Daisy and Violet's Pullman car. He was aching. How he wished he could run off with the carnival.

The curtains inside the Pullman had been drawn for hours. It was four or five o'clock in the morning and presumably everyone inside was

fast asleep. After a long doleful wail from the steam locomotive, the front of the train began to move. There was a sequential clanking of the couplers as the train started rolling. Moore looked up one last time at the windows of the twins' car. Daisy and Violet had drawn back the curtains. They were gazing at him through the window. They looked like ghosts, unearthly, just as they did the first time he saw them in their tent. In the seconds just before their car disappeared in the darkness, the sisters did something that made Jim Moore's heart leap. They smiled and, simultaneously, blew him kisses.[11]

The Royal English United Twins were, by far, the most popular attraction on the C. A. Wortham Shows' midway. They were, in fact, the most popular attraction on any carnival midway anywhere. There wasn't a sideshow man in the country who wouldn't have entered into a pact with the devil to take possession of so powerful a draw. Often the crowds who flocked to the carnival headed straight for Daisy and Violet's playhouse, and after seeing the pair, left the lot without leaving a dime anyplace else. Not since P. T. Barnum was trotting out such attractions as Tom Thumb and Chang and Eng, probably the first conjoined twins to be publicly exhibited, had any human wonders caused as great a public stir as the Royal English United Twins.

As inimitable as Daisy and Violet were as carnival attractions, the sensation they created could be traced in large part to Myer Myers' adroit management. He had already revealed himself to be an impresario of daring when he erected the biggest and most opulent theater ever to be seen in any traveling carnival. He also showed himself to be a genius at promotion.

Of all the sideshow operators traveling with the C. A. Wortham Shows, Myer alone was given approval to load his touring car on the train. This allowed him great personal mobility whenever the carnival rolled into a new town.

Joe McKennon, the carnival expert, described Myer like this: "One of his publicity maneuvers was to take Daisy and Violet to see the mayor of a city, or, if the carnival happened to be in a state capitol, the governor. Because reporters and photographers always buzzed like flies around these officials, the twins' visits frequently resulted in front-page stories and pictures."[12]

And maybe more than any other carnival man of the time, McKennon observed, Myer recognized the value of radio, a medium that was just becoming established in 1917. "He would pinpoint all the radio stations that were within fifty or seventy-five miles of where the carnival was playing. He would then squire the twins to all of those stations. During their radio appearances, the girls would talk, sing, and play their violins and saxophones. It was brilliant marketing. Often with horse and buggies, farm families traveled great distances to see the twins. Those radio appearances accounted for much of the traffic that streamed into their tent."[13]

Daisy and Violet were completely at ease in their radio interviews and invariably charmed their hosts. They were probably no more preoccupied with their mortality than other nine-year-olds, but over and over their interviewers asked how they would feel if one of them should become gravely ill and die. Violet once answered the question this way: "We were lucky enough to come into the world together, and when the time comes, we'll feel blessed to go out the same way."

Through the publicity Myer kept engineering for them over the airwaves and in newspapers, Daisy and Violet became widely known in households across America. But there remained only one place where the public could see them, their performing hall on the midway. Myer absolutely guarded against appearances by the twins in such public places as department stores, restaurants, and movie theaters, or for that matter, even inside the tents of the other midway attractions. Like almost all of the edicts he issued for the twins, his logic was

motivated by greed. "Why would anyone buy a ticket to see you if they can see you for free at a hotdog stand?" he would ask.

Myer quickly ascended to the position of prince of the midway. He relished everything about his elevated stature. He savored the looks of envy that appeared on the faces of other show operators when they walked by the United Twins' theater and saw the swarms of customers waiting for a chance to go inside. In their face-to-face encounters, these presenters of five-legged cows and alligator wrestlers regarded him with deference, but Myer knew they were green with jealousy. Scouts from Barnum & Bailey's Greatest Show On Earth, as well as other circuses and carnivals, regularly called on Myer, trying to persuade him to show his United Twins with their operations.[14] After listening to their offers, he promptly sent the emissaries on their way.

The dimes, quarters, and dollar bills that were pushed through the ticket windows for the United Twins' accumulated to such a staggering sum by the end of the 1917 season that Myer felt like Croesus. He wondered how he was possibly going to be able to spend so much money. He certainly tried.

After having established a residence in Phoenix the previous year, Myer moved with his blended family to San Antonio, the winter quarters for several large railroad carnivals, among them two or three owned by Clarence Wortham and the Dodson Brothers World's Fair. Myer made such a display of profligacy that San Antonio's other citizens of wealth, most of them cattle barons and oilmen, started to wonder if the short, fat newcomer was one of the principal beneficiaries of Andrew Carnegie's will. Myer's first major purchase was a small ranch on the city's outskirts into which he moved the family. Next he acquired three or four houses in San Antonio as investment properties. He also bought a vacation home on Medina Lake, forty miles from the city. In Poteet, he bought an interest in what was

described as "one of the finest horticultural farms in Southwest Texas."[15] Still he had money left. He invested tens of thousands of dollars in bank and railroad securities. He assembled a domestic staff of maids, handymen, and a chauffeur.

Daisy and Violet were held in near solitary confinement even during the months when the carnival was off the road and the family was at its San Antonio ranch. Camille Sweeney, daughter of Emmett Sweeney, a prominent local attorney and businessman, may have been the only youngster from San Antonio ever allowed at the ranch, and, as it turned out, she had special entrée. She was goddaughter to Daisy and Violet.

Camille Sweeney, who years later would marry Frank Rosengren, a screenwriter and playwright, had this girlhood recollection: "No neighborhood children were allowed to visit Daisy and Vi, nor were they allowed to leave their home to play with other kids. They never had a chance to interact with any peers. They were prisoners. There were times when I joined my mother and Aunt Dorothy in visiting the Myers' home. These occasions may have been the only ones when Daisy and Violet had a chance to socialize with anyone from outside the gates of their home."[16]

Camille Rosengren said she was never clear about how it was that her father and mother came to know the Myers but speculated that the introduction was probably made through Dorothy Lodovico, an aunt who was a dancer in vaudeville and later a chorine in the Busby Berkeley movies. "Except for the people who entered their tent, Daisy and Vi had no chance to relate with anybody from the outside world," Rosengren said. "As a result, they formed a strong attachment to Aunt Dorothy and my mother. They were such sweet girls. When my mother became pregnant with me, the girls became very solicitous of her. They asked if they could be godmothers to me. Of course, Mother said yes."[17]

After presenting the Royal English United Twins for two seasons with Clarence Wortham's empire, in 1918 Myer decided to switch to the midway of another mammoth carnival, the Johnny J. Jones Exposition of Amusements. Not only did he bring along his Congress of Human Wonders but a brand new third unit, Myer Myers' Fat Folks' Chatauqua. It struck some carnival employees as odd that Myer would assemble a show that was wholly made up of grossly obese men, women, and children when his own circumferential measurement seem to exceed that of his verticality.

The switch to Johnny J. Jones' carnival probably did not signify a rift with Wortham but rather a sound business decision by Myer. Wortham's carnivals mostly traveled the western part of the United States. Jones' colossus—advertised as an exemplar of "Meritorious Attractions, Cleanliness and Square Dealing"—criss-crossed the Atlantic side of the country, along with Canada's eastern provinces. With the move to the Jones enterprise, Myers could gather new audiences for his attractions.

Percilla, the Monkey Girl, Bejano, six years old at the time, was one of the attractions on the Jones midway. "The Johnny J. Jones show was one of the biggest carnivals of that time or any time," she said. "Forty railcars, I think. Maybe this is going to sound like bragging, but no carnival or circus ever had two attractions on its midway that were bigger than me and the Hilton Siamese twins. It was like having Fred Astaire and Gene Kelly or Margot Fonteyn and Cyd Charisse on the same stage. I mean, how do you get bigger and better than that?"[18]

It was natural enough for Percilla to invoke the name of famous dancers when explaining the excitement she and the Hilton sisters brought to the midway. Dancing, or something resembling it, was the performing art she valued above all others. In her adult years, when she and her husband, Emmitt, the Alligator Boy, Bejano were

traveling as the World's Strangest Married Couple, she entertained sideshow crowds with approximations of Salome's Dance of the Seven Veils. "Percilla learned to dance early," said Ward Hall, her one-time manager. "As a youngster, she used to sneak into the tents of the girlie shows. She marveled at the affect the dancers had on men."[19]

Percilla said that on Sunday mornings, before the Jones midway opened, there were times when Myer allowed Daisy and Violet to invite her over to play. "Mostly we entertained ourselves by having tea parties," Percilla recalled.[20] Surely Alice's teas with the Mad Hatter, March Hare, and the Dormouse could not have been any more curious than the picnics outside the Myers' Pullman car. Not only did the attendees around the table include Siamese twins and a bearded six-year-old girl, but also Percilla's pet monkey, Joanna.

Bejano said she thought it was unfair to judge Myer Myers harshly because he never let the twins out of his or Mary's or Edith's sight. "Carl Lauther, my manager, also kept constant watch over me and had the same rule. I'm sure the twins' manager was only trying to protect them. Probably he was worried that someone might try to kidnap them. There were a lot of crazy people on the outside, do-gooders who felt they had a religious mission to rescue the children of the sideshow."[21]

The summer of 1918 turned out to be one of the most challenging seasons of all for the outdoor entertainment industry. By then, the United States had joined with Great Britain and France in a war against Germany. Such great numbers of roustabouts were raided from carnivals and circuses by the military that the shows had trouble putting up and taking down their shows. And the demand for coal, steel, and other resources used in the manufacture of armaments meant the railroads became so overtaxed that they often denied passage to the carnivals.

By August, when the Johnny J. Jones Exposition was touring the South, the show was battling a new adversary. An epidemic of influenza was spreading across America, and thousands were perishing from the scourge each week. In a massive effort to slow the wildfire spread of the disease, health officials everywhere ordered the closing of public gathering places, including beaches, movie theaters, and state and county fairs.

By midsummer, according to *The Billboard*, 90 percent of the traveling shows had already limped back to their winter quarters and "the carnival business . . . is almost at a standstill." Although the cancellations of contracted dates caused the Exposition to bleed money in torrents, Jones tried to keep his show rolling. He finally had enough when one of the carnival's most profitable stands, the Georgia State Fair in Augusta, was expunged from the 1918 season. He directed the crew of his thirty-seven-car train to pilot the caravan to the show's home base in Birmingham, Alabama, and kept the whole agglomeration in mothballs until the pestilence had come to an end and "the Kaiser has abdicated and leaves for parts unknown."[22]

With a war raging and a deadly plague spreading, not just in the United States but in Europe as well, Myer Myers felt sure it would be a long time, if ever, before the carnivals rolled again. With a wife and child who were dependent on him for survival, along with a mother-in-law and Siamese twins, what was he going to do now?

It was not a question he had to ponder for long. By October, the Allied Forces began to win all of the major battles overseas, and on November 18, 1918, Kaiser Wilhelm II gave up his throne and fled to The Netherlands. The influenza epidemic eventually claimed more than six million lives, but in the United States, at least, it had run its course by late in the year.

Soon after the start of the new year, Johnny J. Jones stepped out of a chauffeur-driven sedan at his carnival's winter quarters in

Birmingham and issued a directive to his staff. They were to round up as many laborers as possible and start spit-shining the train and all the rides. The Exposition was going back out on the road in 1919.

The rigors of gypsy life—cold rains, muddy lots, searing heat, and dust storms—had finally taken their toll on Mary Hilton. She was now stooped over and could walk only by leaning on two canes. Mary had long ago ceded the decisions concerning the twins' exhibition to Edith and her son-in-law.

But Mary was a carny through and through. Such souls seem to have a kinship with migratory birds. When spring comes, they are stirred by some unappeasable instinct that impels them, sometimes even against their wills, to leave one place and, with others of their species, travel to another. Mary was aboard the shiny green train of the Johnny J. Jones Exposition when it pulled out of Birmingham.

Mary Hilton died in Atlanta Hospital at 3 A.M. on April 20, 1919. The cause of her death, according to the death certificate, was an acute infection of the kidneys, along with "complications of age." *The Billboard* put her years at "about eighty," an estimate that likely was based on her appearance. In fact, she was sixty-seven.

Daisy and Violet, in their memoir, said Mary's death marked "a turning point" for them. They were orphans now. They had convinced themselves that if they could somehow get away from Myer, they could find help and finally gain some measure of independence. "We had become strangely wise and filled with unvoiced thoughts," Violet said.[23]

It had angered Myer that Daisy and Violet hadn't shown the slightest signs of sadness over their foster mother's death. "Your hearts are made of flint," he berated. "How could you be so unfeeling? Auntie had never shown you anything but tenderness and love. Had it not been for her, you'd be rotting today in an asylum."

The wake for Mary Hilton was held at the Harry G. Poole Funeral

Chapel in Atlanta. Daisy and Violet provided a detailed, if melodramatic, account of the vigil. While Edith and Myer were at the rear of the viewing room, visiting with callers who stopped by to offer condolences, the twins walked up to the coffin. For the first time, they observed, they were able to move within Auntie's presence and not feel threatened.

"As we looked at her, our first corpse, and, you might say, our first friend, the cunning and shrewdness seemed out of her face," Daisy recalled. "I did . . . not care that she was dead."[24]

Daisy looked to her sister and saw changes coming over her. Violet's eyes were welling with tears and she was trembling.

"Why cry?" Daisy whispered. "We have hated her forever."

"I'm afraid without her. Now Sir will boss us."

"Let's run," Daisy said.

Violet was surprised by the challenge but felt emboldened by it. "We'll never have this chance again."

"Let's run!" Daisy repeated.[25]

The sisters turned from the coffin, and, with their heads bowed, began slowly walking toward the door. Daisy had moved only a few feet when she felt her sister lagging, as though Violet were carrying some great weight. She turned and saw Myer. He had dug his fat fingers into Violet's shoulder. His face was crimson.

"Don't touch me," Violet hissed, squirming and straining to break free.

Myer dragged and pushed the twins to a seating area. Not wanting to create an even greater scene in the chapel, he said nothing. Finally he shoved the sisters onto a single chair beside Edith and, still glaring, signaled to them to remain seated. The sisters feared for the punishment they were sure was coming. However, after the family left the funeral chapel and returned to their hotel room, Myer stewed in silence as if he were waiting for the twins to offer some explanation.

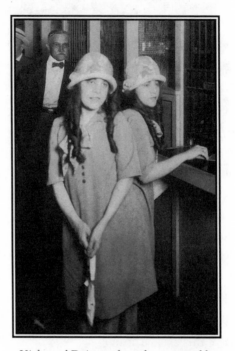

*Violet and Daisy at about eleven years old.*
*Although it has the look of a candid snapshot,*
*this photograph was probably an orchestrated*
*publicity stunt, as the sisters did not have*
*access to their own money.*
*(Author's collection)*

Violet was sobbing, still dreading the caning that she was certain was coming. Daisy was fearful of a whipping, too, but she wore an expression of smugness at having summoned the courage to take a stand against him. The wordless standoff between the twins and Myer was finally broken by Edith. She turned to her husband.

"Tell them." she said.

Myer dug into an attaché case and brought out a sheaf of typewritten pages that he waved before the twins' faces. Next, he turned to the final sheet of the document. The page bore the inked signature of Mary Hilton. After a tense pause, Myer finally spoke.

"You girls belong to us now," he shouted, in a voice edged with triumph. "You'll do just as we say. See here? Auntie left you to us. You and her jewelry and her furniture are now ours. Do you understand?"[26]

It is doubtful that any court in the land would have upheld a last will and testament that "willed" two minor children to another party or parties. But at eleven years old, Daisy and Violet could hardly be expected to know that Mary's will was without legal merit.

The twins' version of their failed escape attempt may be accurate in its broad details, but there are known errors of fact in their published account. To begin with, Daisy and Violet wrote that Mary died not in Atlanta, but in Birmingham, a matter contradicted by the death certificate. They also related that before going to their foster mother's wake, they stuffed their shoes with cash that had been given to them seven years earlier by a theater stagehand in St. Louis, Missouri. At the time of Mary's demise, the sisters had been in the United States only three years and had yet to perform in any American theater, whether in St. Louis or elsewhere. Different explanations might be offered as to why, in the recounting of Mary's wake and in numerous other recollections in the twins' autobiography, there are so many inconsistencies and what seem to be outright fabrications. Maybe Daisy and Violet had notoriously bad memories for details, especially those surrounding incidents early in their lives. It seems possible, too, that their idea of reality was shaped by the sideshow hawkers who took the position that truth existed only to be varnished, expanded, contracted, and reshuffled.

Whatever the factual errors in the twins' retelling of their escape attempt, this much is clear: The act was not without consequences for them. Because he feared they might again try to plot an escape, Myer took even greater precautions to keep them from ever leaving his sight. He insisted the twins start sleeping in the same room with Edith and him.[27] He also continued repeating, in slightly modified form, the invocation that Auntie had recited almost every day: "Your

own mother rejected you because you were so hideous and terrifying. You should kneel in prayer every night, thanking God that Edith and I care enough to save you from being thrown into an asylum for monster children." Myer, of course, never hinted during his deprecations of Daisy and Violet that he felt in any way beholden to them for the riches and fame he was enjoying in the carnival world.

Looking at things from a certain angle, it could be reasoned that Myer was deserving of every dime and quarter that was slapped down at the box offices for the Royal English United Twins. He had the vision to foresee opportunities in America that had never presented themselves in Europe or Australia. He fine-tuned every detail of their stage appearances and presented them in the classiest playhouse to be found on any carnival midway. And through his deft use of the media, especially radio, he installed the modern Siamese twins into the imaginations of people across America. Maybe it could be argued that Myer Myers, even more than the girls themselves, was responsible for turning them into the most sensational carnival attraction of the twentieth century. And did it even matter that Daisy and Violet saw none of the money they were minting twelve and fourteen hours a day? What use was money to them? They had no lives outside the sideshow. When they weren't on the stage, singing, dancing, and tootling their clarinets and saxophones, they were kept in isolation, sequestered in a small Pullman compartment with no contact with anyone but Sir, Edith, and Therese Mary.

More so than with the carnival's other members, a camaraderie existed among the freaks.

"We all considered ourselves members of the same family," explained Jeanie Tomaini, the Half-Girl. "Of course, that family consisted of such different types as fat ladies, human skeletons, dwarfs, giants, bearded ladies, sealboys, pinheads, and someone like me with only half a body. I'm not saying that things were always rosy among

us. I've seen fat ladies get into eye-scratching, hair-pulling fights over which one really weighed the most. I've also witnessed some nasty scraps between midget ladies who both had designs on the same man. All in all, though, all of us in the sideshow looked out for one another. When someone in our group got married or had a baby, we shared in their happiness. And when one of our number was down because of a death in the family, or maybe a breakup of a marriage, the rest of us extended helping hands. We depended on one another to survive. We couldn't expect help from the people outside our tents. The people from the so-called normal world considered us untouchables."[28]

Late at night, after the midway was closed, the freaks often gathered in the weedy fields behind the tents where they held torchlight picnics, celebrated birthdays, anniversaries, and baby showers, or simply socialized with one another. Daisy and Violet always received invitations to the gatherings but always had to turn them down. Myer forbade their participation in such outings, telling them the other sideshow attractions were God's throw-aways who were diseased and mentally deficient. "Edith and I don't want you corrupted by such elements," he said. His real worry was that if the other sideshow attractions got close to the twins, they might fill the girls' heads with ideas of independence. When the midway closed for the night, Myer immediately spirited Daisy and Violet, along with the money sacks filled that day, to the family's train compartment.

Myer Myers' callous treatment of the sisters didn't go unnoticed by the other human curiosities. Most regarded him with contempt. In their eyes, Myer was the most exploitative, most uncaring, and most venal man in the sideshow universe.

At one of those after-hours gatherings in the summer of 1924, somebody spoke up and said it was time all the freaks joined together and did something to show the Royal English United Twins that there were people who really cared about them. The proposal won

unanimous approval from everyone at the gathering, but no one seemed quite sure how to help the sisters.

In the weeks that followed, the freaks held other caucuses on the subject of Daisy and Violet. There were discussions of going on strike until Myer gave them assurances that he would begin treating Daisy and Violet more humanely, but ultimately everyone agreed that if too much pressure was placed on Myer, he would simply move the twins to another carnival. Since 1909, Myer had been rotating the twins between Johnny J. Jones and a number of Wortham carnivals. In the summer of 1924, he had them with Wortham. Clarence Wortham, the beloved head of Wortham's World's Best Shows, had died two years earlier. His widow had sold his carnivals, lock, stock, barrel, and snake pits, to two other showmen, Fred Beckmann and Barney Gerety. Because of the money Myer was making for them, not just with the United Twins, but also with his Congress of Human Wonders and Fat Folks Chatauqua, it wasn't likely Beckmann and Gerety would try making demands on him.

Despite the twins' move to a new carnival, the meetings continued. In time, the meetings were opened to all of the carnival's troupers, from the lemonade vendors and carousel operators to the hoochie-coochie dancers, and a plan finally emerged.

The carnies organized "Daisy and Violet Hilton Day," on July 2, 1924, in Hammond, Indiana. By midmorning, locals were already trying to enter the showgrounds. But on this day, a dozen or more carnival roughnecks were blocking the entranceway. One carny was carrying a megaphone. "Ladies and gentlemen, the World's Best Shows are closed to the public today. Come back tonight or come back tomorrow. The shows will still be here."

Myer Myers fumed when he arrived that morning and learned that the carnies were preventing paying guests from entering. Neither Myer nor any of the other managers made any move to upset the plot,

however. All 350 of the shows' tent performers and workers had been involved in planning this day. There would be an insurrection if management tried to spoil the party.

Daisy and Violet wept when they were told of the tribute their fellow travelers had planned for them. They were to be the carnival's only guests for the day. The entire midway was to be theirs alone.

Without any chaperones, Daisy and Violet took their very first rides on the ferris wheel, the Whip, and the Ocean Wave. They were treated to performances by the motorcycle daredevils in the motordome and the high divers in the water circus. Their eyes widened and their cheeks reddened when they entered the girlie show tent, and saw, for the first time, why there were always long lines of men and teenage boys waiting to get in. After a performance, a couple of hoochie-coochie girls led the blushing twins up the stairs to the stage platform and gave them some rudimentary instructions in their art.

Outside every tent and before ever thrill ride, there were big, hastily painted signs declaiming, "We Love You, Daisy and Violet!" and "Daisy and Violet Hilton . . . The Loveliest Girls On the Midway!" Some of the shows' most grizzled roustabouts became misty at the sight of the sisters really enjoying themselves for the first time in their sixteen years. All of the carnival's workers were congratulating one another, averring that from that day forward, life was going to be better for the Royal English United Twins.

But it was soon to become evident that "Daisy and Violet Hilton Day" was also a valedictory for the twins, their formal farewell to the tent show performers and workers who, at long last, they had gotten to know.

After touring the sisters on the carnival circuit for nine years, Myer Myers had decided that 1924 was to be their last on the midways. He had other plans.

*Eight*

# THE ACT CONTAINS NOTHING
# REPELLENT OR GRUESOME

With Daisy and Violet, Edith, and daughter Theresa Mary in tow, Myer Myers arrived in New York City in November of 1924. He was carrying scrapbooks packed with clippings about his Royal English United Twins; he was intent on conquering Broadway.

Myer's ego by now had become even more outsized. On the carnival showgrounds, he had grown accustomed to having subalterns carry his attaché case and open a path through the crowds so he could pass through. He was entitled to deferential treatment, he believed. He was prince of the midways. Through his adroit handling of the grown-together girls, he had turned Daisy and Violet into the carnival world's single biggest attraction. No longer content to be a mere sideshow impresario, he traveled to New York because he wanted to prove to everyone, and especially to himself, that he could turn Daisy and Violet into equally big stars in the theater world.

Myers may have achieved institutional status in the carnival world, but this didn't count for much with the agents who booked talent for the vaudeville houses. As soon as he announced he was representing Siamese twins, he would usually get a response that went something like this: "Mr. Thwaites is too busy to see anyone new today. He already has appointments with a roller-skating mezzo-soprano, the owner of a tap-dancing monkey, and a husband and

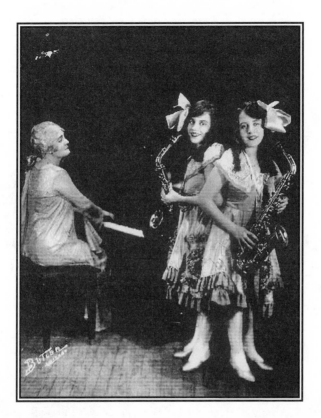

*Violet and Daisy on stage. Although the girls were around
seventeen when this photo was taken, their ruffled taffeta
dresses, huge hair bows, and long Mary Pickford-style
ringlets make then look younger. (Author's collection)*

wife bird-calling act. I suggest you try shopping your, um, girls out
on Coney Island."

Myer encountered so much resistance that after a while he started
telling bookers that, yes, while it was true the Hilton sisters had
bodies that were conjoined, this peculiarity was incidental to the
impression they created as performers. Daisy and Violet were superb
singers and dazzling dancers. While Myer might not go so far as to
call them musicians of concert caliber, they could plunk, bow, or pipe

out tunes on every instrument known to Paul Whiteman's orchestra. He all but begged the bookers for a chance to present the girls in an audition.

Despite Myer's most earnest urgings, the agents always had the same response: However much talent the sisters might have, they were freaks first and foremost. There was only one venue for such a pair—the sideshow. One booker said, "Here's my card. You get some sawbones to cut the girls apart and come back to see me. Then, if they're as talented as you say, I'll find them more work than they can handle."

Of course, many of the acts that were trotted out on the vaudeville stages were every bit as outlandish as the offerings presented in carnival tents. For example, one vaudeville house was headlining an Egyptian entertainer named Hadji Ali whose forte might be called selective regurgitation. As the opener to his act, the professional vomiter swallowed a combination of pennies, nickels, dimes, and quarters and then somehow brought up the coins according to the denominations called out by the audience. As surprising as this feat was, it was not as astonishing as the finale, when Hadji would guzzle a quart of water chased by a pint of kerosene. After regurgitating the kerosene onto a large wooden dollhouse, he then tossed a burning match onto the structure, turning it into a small inferno of leaping flames and black smoke. After watching the conflagration for a few seconds, Hadji brought up the water from his stomach and, in a high-pressure torrent, spewed it over the flames. Joe Fanton, an acrobat who often appeared on the same bills with the Great Regurgitator, was always left astounded by the audience's response. "Believe it or not," Fanton said, "people would applaud this, really applaud."[1]

As broad as vaudeville's definition of entertainment was, the house managers drew the line at freaks. They represented themselves as purveyors of wholesome family entertainment and took the position that

most theatergoers, especially children, would be terrified at the sight of human beings who, because of a misfiring by nature, entered the world as monsters. Many vaudeville managers also held the belief that if a pregnant woman saw an "armless wonder" or "lobster boy," she could, through some mystical form of embryonic imprinting, bring forth a child with a similar deformity. They quailed at the thought of being sued by women who came to their shows while pregnant and then later delivered freak babies.

Myer was becoming ever more disillusioned. After two weeks in New York, he still hadn't gotten an engagement for his Royal English United Twins. A few bookers told him they might be able to line up appearances for the girls in the Times Square dime museums, and almost all of them mentioned the Coney Island sideshow operators who would fight for the chance to present genuine Siamese twins. As vivacious and as talented as his girls might be, Myer was told over and over, they would spell disaster for any theater that tried to present them.

Finally, Myer got a break. On November 24, 1924, the *New York Evening Journal* ran a lengthy story on Daisy and Violet's "sightseeing" visit to the city. The reporter who wrote the piece could not have been more enamored of the sisters and characterized them as gifted stage talents and ingénues with "beauty of face, charm and wit." Accompanying the story was a photograph, and indeed, the Royal Twins did appear to be arrestingly, almost supernaturally, beautiful.

Myer was in his hotel room when a phone call came in from an agent for B. F. Keith, the owner of one of the country's biggest chains of vaudeville theaters. The agent had seen the *Evening Journal* article. He was willing to give the Hilton sisters an audition. Myer was elated. All he wanted was a single opportunity to present the twins. He was sure they would win over anyone who was willing to give them a chance.

The theater chosen for the audition was the famed Hippodrome. The entire red brick facade was so densely clustered with flashing, multicolored lights that the building appeared to be throwing off fire. The largest theater in the world at the time, the 5,200-seat Hippodrome stretched the entire block of Sixth Avenue between 43rd and 44th Streets.

By the time Edith had gotten Daisy and Violet into their costumes backstage, the sisters were shaking so violently they could barely stand. Edith hugged them, trying to assure them they would do fine. An accompanist started playing, but the sisters were completely immobilized with stage fright. Edith tried to push them from the wings. Before she knew it, she herself was out on stage. Embarrassed, she quickly retreated, leaving Daisy and Violet stranded on the immense expanse. Because the twins were accustomed to appearing only on small platforms, they had no command of the theater's monstrous boards. They froze at the very spot Edith had left them. They tried singing, but their voices scarcely carried even as far as the footlights, and when they tried playing their saxophone and clarinet, their horns squawked like geese cornered by a fox.

Sitting in on the audition along with the agent for the B. F. Keith circuit, was the Hippodrome's manager. Before Daisy and Violet even got halfway into their routine, he sprang from his seat and sprinted up an aisle. Daisy and Violet were left sobbing on the stage.[2]

Back at the hotel, Myer cursed the twins for botching their audition and disgracing him. He declared to Daisy and Violet, too, that he and Edith had grown tired of devoting so much of their lives to them. The time had come, he said, for them to do what they should have done long ago: commit them to an asylum for the crippled, blind, and mentally feeble and walk away.

Hours later, Myer was still fuming when the phone rang. He barked a "hello" into the receiver. It was Terry Turner, publicity

*Violet and Daisy, mid-1920s. (Author's collection)*

director for the Loew theater chain. He told Myers that he had heard about the twins' disastrous audition at the Hippodrome but said he would be interested in seeing the girls for himself. Myer had not met Terry Turner before, but as a showman who consumed the pages of *Variety* and *The Billboard* each week, he knew Turner's reputation.

Turner was the master of the field. It was commonly understood that when he agreed to promote an artist, it was a *fait accompli* that the performer was on a rapid, nonstop ride to superstardom. So widely esteemed was Turner as a promoter, that not only was he sought out by the up-and-coming stars of the day, but also by all manner of performing screwballs who hoped he could land them on the cover of *Life* magazine. Once he was visited by a bearded lady who offered him a healthy share of the proceeds if he could get her signed as national spokeswoman for the Gillette Razor Company.

Turner wasn't prepared for the effect Daisy and Violet would have on him when, accompanied by Myer, they entered his office for the first time. He could hardly believe what he seemed to be seeing: two girls, maybe lovelier to look at than any he had ever seen, who were fused together as one and so at ease with their oneness.

Daisy and Violet were sixteen at the time, but they still had the appearance of moppets. They were small for their years, a few inches short of five feet. They spoke in chirpy, British-accented voices and were so animated that their long bottle curls bounced like coiled springs. Because all their life experiences had been shared, one sister began relating a story and midway through, the other would pick up the narrative and take it to its finish. Right there in his office, the sisters reprised their act, performing on their horns and violin, singing and dancing. Turner was charmed from the start. The Royal English United Twins had all the qualities needed to be stars of the stage, he told Myer Myers, but their act would "need some classing up."

Turner went right to work on the project. He arranged for new voice and dancing coaches; he hired a pianist, Ray Traynor, to serve as the sisters' musical director, accompanist, and emcee; he even shopped the costume stores, drawing together a new wardrobe for the pair. After working two months with Daisy and Violet, rehearsing them daily, Turner was satisfied with every detail of their stage routine. He was ready to approach his boss.

Marcus Loew controlled a network of 350 vaudeville and movie houses that stretched from Maine to California to Egypt, France, and England. He also headed the complex system that produced and distributed all Cosmopolitan and Metro-Goldwyn-Mayer movies. Loew was one of the richest men in America. So sprawling was his estate on Glen Cove, Long Island, that some believed the property should be split away from New York and declared a separate state.

Turner enjoyed favored status with Loew. The mogul had often confided that much of the Loew chain's growth was attributable to Turner's brilliance as a publicist and talent scout. Turner felt sure he could convince his boss to send the Hilton twins on a national tour of the Loew vaudeville halls. But when he outlined the plan for a Hilton sisters tour, the mogul's reaction was swift—and not at all the one Turner had been expecting.

"Absolutely not!" Loew exploded. His face was twisted in revulsion. "Siamese twins? All Siamese twins are monstrosities."

Turner was quick with a rejoinder. He congratulated his employer "on being greater than the Deity."

The entertainment baron looked at him in puzzlement.

"Well," said Turner. "God made the Siamese twins, but you're too high-class to let the public see them."[3]

In the next moment, Loew may have taken mental inventory of all the successes Turner had scored for the theater chain's operations. In the same instant, he may also have taken account of his own blessings. Loew himself was the proud father of young twins who, thank God, were normal in all respects. He seemed to have been chastened by Turner's response.

Okay, okay, Loew finally sighed, he would show the Hilton sisters.

Terry Turner's promotional machine went into high gear from the day Marcus Loew gave him his uneasy assent. Turner wanted, first of all, to obliterate any identification that the sisters had with the tawdry world of the carnival. Their original honorific as the "Royal

English United Twins" was scrapped. Daisy and Violet Hilton were born again, this time as "The San Antonio Siamese Twins."

Arrangements were made for the sisters to make their debut at the State Theater in Newark, one of the larger Loew playhouses outside Manhattan. Turner was especially concerned with impressing his boss. It was important that the twins' first theatrical appearance attract not just a respectable audience, but a sold-out crowd. He faced a challenge. Daisy and Violet may have been widely familiar to the folks that strolled the carnival midways, but they were unknown to the patrons of the vaudeville houses. Turner had to engineer a publicity stunt that would bring the sisters instant, popular, and stunning attention.

A couple weeks before the sisters' scheduled, but still unannounced, theater debut, Turner accompanied Daisy and Violet, along with the Myers family, to New York's Pennsylvania Station.[4] Train tickets were bought for the group to travel to Newark. All had been well rehearsed on how to advance Turner's scheme. The instant the train entered the tunnel beneath the Hudson River, Daisy started screaming with the torment of a child having her teeth yanked out, one by one. So unnerving was the commotion to the other passengers that they asked the conductor to investigate. The trainman barged into the Myers' stateroom, expecting to discover a child being tortured on a rack. Instead he saw two grown-together sisters on a bed, one of them wildly flailing her arms and legs and shrieking. Myers told the conductor that the child was suffering severe stomach pains.

The conductor phoned ahead to the Newark terminal. He told the station manager that there were monsters aboard the train, Siamese twins, and that one of them appeared to be possessed by the devil. He said he was not sure whether the girl needed a doctor or an exorcist but requested that an ambulance be on hand when the train pulled into Newark. Daisy was still caterwauling when white-coated attendants carried the twins off the train on a stretcher.

Daisy was given a thorough going-over at Newark's City Hospital. The attending physician later announced to reporters that while the patient and her sister were by then resting quietly, he was unable to provide any explanation for what might have caused the attack the poor child suffered. The twins' entry into Newark cornered front page treatment in the local newspapers and was the lead item on the radio. Daisy's performance, especially, had been a star turn. No event in Newark had ever generated as much media coverage.

The vaudeville debut of the San Antonio Siamese Twins was set for 2 P.M. the afternoon of February 16, 1925, a Monday. Terry Turner was in self-congratulatory spirits well before show time. He had only had to step outside the State Theater for evidence that he had engineered another smashingly successful promotional campaign. So great were the throngs streaming to the playhouse that they were causing massive traffic jams all over the area. The Newark Police Department had to rush in reserve forces to control the crowds and unsnarl the tie-ups of streetcars and automobiles.[5] There were signs in the theater's ticket windows: Afternoon Show Sold Out!

In the moments before the twins' turn was to begin, Ray Traynor, their musical director and emcee, walked onto the stage. He told the audience they should feel privileged: They were about to see the most exciting debut presented on any American stage in years. "Both love movies, flowers, and bon-bons, just like any other girls."[6] He revealed, too, that the sisters had a combined weight of 190 pounds and, perhaps to prompt some patrons to wonder whether it might be possible to be intimate with Siamese twins, declared that Daisy and Violet were both "capable of motherhood."[7] Finally, before exiting the stage, Traynor said there was no need for anyone to feel sorry for the two. "The young ladies themselves do not have a trace of self-pity," he assured, "and even consider their condition to be a blessing because it has brought them close to so many wonderful people."

*Publicity photo promoting a beauty pageant in Palisades Park,
New Jersey, 1925. (Author's collection)*

When the curtain lifted, Daisy and Violet, dressed in white, were seated center stage on a divan. The theater rattled with applause. The twins stood up, smiled demurely, and curtsied. In the words of a *Newark Evening News* theater critic who was present, they showed "none of the nervousness usually attending a stage debut."

Accompanied by Traynor's piano, they began by singing "Tea for Two," the most popular tune of the day and the hit song of the Broadway show *No, No Nanette*, which had opened earlier in the season. Next they showed off some of their talents as musicians. Daisy played her gold-plated clarinet and then someone in the orchestra pit handed up a violin to Violet. She began bowing a *legato* line and then, without interruption in their duet, the twins gracefully moved across the stage and took places on the piano bench beside Traynor. Daisy placed her clarinet in a stand and, with a toss of her curls, signaled to Traynor that his services were no longer needed. The musical director rose and Daisy seamlessly picked up his piano accompaniment to Violet's violin.

After a time, Daisy and Violet were ready for the finale. Appearing from the wings on either side of the stage were two sixteen-year-old boys in black tuxedos. Each approached a twin, bowed, took her hand, and stepped forward. Instantly, the foursome were interlocked in a *pas de quatre* that glided over the stage with the lightness of air. A massive tide of adoration swelled from the audience, almost sweeping Daisy and Violet off their flying feet. Everyone in the house was standing, applauding, and cheering. Some spectators were crying tears of joy. Quite a few patrons dashed from the auditorium to the box office to buy tickets for the next show.

The Newark State Theater had barely stopped reverberating from the twins' repeated curtain calls when Myer Myers was sought out by the Loew representatives who had been present for the debut. Marcus Loew had initially engaged Daisy and Violet at $1,000 a week.

Fearful that another vaudeville circuit might try to pirate the act, the agents tore up the first contract and handed Myer a second one to sign, this one for $2,800 a week.[8]

The reviews were not merely glowing, they were phosphorescent. *Variety*, the bible of the show world and a publication that could make or break careers, assayed the occasion this way:

> The greatest . . . attraction and business-getter that has hit vaudeville in the past decade are these two sixteen-year-old twins from San Antonio, Texas, Violet and Daisy Hilton. It is one of those draws which happens once in a lifetime. It could be played in any vaudeville house in the country regardless of the clientele and will duplicate its pulling power anywhere in America. The girls are pretty brunettes, tastefully dressed. Their motivation is as natural and easy as two people strolling arm in arm. . . . The act contains nothing repellent or gruesome.[9]

So great was the demand for tickets after the twins' triumphant debut that the State scheduled four shows a day instead of the usual three. Only a few weeks earlier, Jack Dempsey, the recently retired world heavyweight boxing champion, appeared in the same theater and broke all attendance records. His reign did not last long. As the *New York Morning Telegraph* remarked, "Violet and Daisy Hilton . . . copped Jack's laurels with a wide margin to spare at Loew's State, Newark." The twins put on twenty-nine shows during their week at the theater, the same number in which Dempsey appeared. With tickets to the Hiltons' shows priced at 30 cents for daytime performances and 50 cents for the evening and weekend shows, the theater grossed $36,000, a dizzying $5,000 more than Dempsey earned for the playhouse.[10]

Following their Newark engagement, the twins made week-long appearances at Loew theaters in Boston, Cleveland, and Buffalo. The

success they had in Newark was repeated. New box office records were established at each of the venues.[11]

During the same week that Daisy and Violet were performing in Cleveland's Loew's Theater, Harry Houdini was appearing next door at the Palace. He took in the sisters' show at his first opportunity and was no less captivated than he had been fourteen years earlier when he had first seen them in Glasgow. He made it a point to visit the twins backstage every day of their engagement in Cleveland.

The meetings between Houdini and the Hilton sisters would continue over the years whenever they found themselves performing in the same towns. Daisy once talked about just how great their love and respect was for the escapologist. "If we could have our choice of fathers," she said, "we'd pick Harry Houdini."[12] The greatest gift the twins received from Houdini, they claimed, was a lesson on how they could separate themselves from one another spiritually and emotionally and, in a certain sense, overcome the constraint of their physical bond. This capacity to achieve what Daisy and Violet called a kind of "mental liberty" would often prove useful to them, especially in the years ahead when each was regularly involved in romantic relationships.

The Hilton sisters' debut on Broadway was scheduled for March 23, 1925. There couldn't have been many New Yorkers who weren't aware of the upcoming event. There was hardly an elevated train kiosk or subway wall anywhere that wasn't covered with posters advertising "San Antonio's Siamese Twins, Daisy and Violet Hilton, Born Joined Together." "Never in the history of the Loew vaudeville circuit has that organization spent as much money in exploiting an act as it is spending on the Siamese Twins," *The Billboard* observed. "The amount totals several thousands of dollars weekly."

For weeks before the debut, the dailies were filled with pictures of Daisy and Violet, showing them in rehearsals, bent over crossword

puzzles, or hugging their fur coats and holding down their cloche hats against the blustery winter wind. The *New York Daily Mirror* probably went farthest in promoting their upcoming theater appearance. It ran a coloring contest for children aged thirteen and younger. Each day the paper carried a black-and-white line drawing of the twins in striped pajamas. The sixty children who showed the greatest "originality and neatness" at coloring the picture were to receive Daisy and Violet Hilton dolls made by the Effanbee Doll Company. "These dolls are almost as interesting as the Twins themselves," the *Daily Mirror* declared. "They're joined together just like the Siamese Twins; they open and close their eyes; and they're too cute to describe."[13]

While kids were jamming New York's mailboxes with crayoned artworks, sets of boy twins were making early morning visits to the stage door of the Loew State Theater on Broadway at 45th Street where auditions were being held to select a pair of male twins, sixteen or older, to serve as dance partners for Daisy and Violet. Winning the spot were nineteen-year-old brothers from Woodhaven, Long Island, Charles and Darwin Praitschling.

Marcus Loew was amazed by the sensation the Hilton sisters inspired. Never before had he seen the papers go so bonkers over a vaudeville act. Loew felt he had some atoning to do for labeling Daisy and Violet "monstrosities" four months earlier and telling Turner he was mad to believe that performing Siamese twins could ever be welcomed on Broadway.

Although Daisy and Violet had turned seventeen a month and a half earlier on February 5, Loew decided to throw a birthday party for the sisters on March 23, the same day as their advertised New York debut. He reserved the Astor Hotel's banquet hall for the grand occasion.

Many of the most important people in New York's theater and motion picture worlds turned out for the party, as well as more than a

hundred newspaper writers. Each table had a centerpiece of daisies and violets. There were also two massive birthday cakes that were fused together, each with seventeen candles. As flash bulbs popped and newsreel cameras ground away under klieg lights, Daisy and Violet cut slices of cake for the guests and placed them in fancy pink boxes. With the sisters seated on the dais beside him, Marcus Loew welcomed the guests, then turned the microphone over to Myer Myers whom he identified as "the uncle of these beautiful children." Myer diplomatically referred to Loew and Turner as great visionaries, geniuses of the theater who had been able to foresee the public's embrace of the San Antonio Siamese Twins when no other showmen would have anything to do with them. Following the luncheon, two hundred partygoers marched to the Loew New York State Theater where the first several rows of the orchestra seats had been reserved for them.

In addition to the San Antonio Siamese Twins, there were nine other attractions on the State Theater's bill, although these features were really window dressing for the headlining sisters. But at least two of the secondary performers who took the stage that afternoon would, in time, ascend to the uppermost heights of the entertainment world: George Burns and Gracie Allen, then in their fourth year as a vaudeville comedy team.

Daisy and Violet were as enthusiastically received at their New York debut as they had been in Newark. They received a long standing ovation and were brought back onstage for five curtain calls, a number that may have been unprecedented in any New York vaudeville house. Their debut notices were unanimously bright. The appraisal that appeared in *The Billboard* was typical:

> Daisy and Violet Hilton . . . [are] the most appealing personalities we have seen in years. Both are as pretty as one could wish any girls to be. The youthful, refreshing appearances

they make would succeed in making them pleasing as a sister act were they not Siamese Twins."

What was it about the twins that left the public and the press so smitten? They were uncommonly comely, vivacious, and talented. But there was another explanation why they were able to hold their audiences in thrall: Daisy and Violet were cursed with a gross physical anomaly more horrific than most people could imagine. Yet the sisters had not only come to terms with their condition, they had fully triumphed over it. Who could come to the theater feeling sorry for himself and then, after seeing Daisy and Violet, not feel his burdens taking on a smallness?

Of all the reviewers present for the twins' New York debut, Sam M'Kee, drama critic for the *Morning Telegraph*, may have come closest to describing the happy/sad feeling the twins engendered in the hearts of their viewers. M'Kee wrote:

> In the lines assigned by Ray Traynor, their announcer and accompanist at the piano, every effort is made to disabuse the listener's mind of the idea that the twins are to be pitied. Before they are seen, Mr. Traynor tells the patrons to be prepared to meet two normal, happy girls. When the drop curtain ascends and they are disclosed seated sidewise rather than back to back, the observers instantly are won by their modesty and prettiness. They are smiling. They confess nervousness. Associated with them is none of the compelling curiosity aroused by freaks. Somehow, though, the feeling of sympathy for them is not dispelled. Instead they inspire an emotion of affection from which regret cannot be eliminated. The talk between them and Mr. Traynor is innocently amusing. They play saxophones, they play golden clarinets, and, with light appealing voices, they harmonize in imitation of the Duncan Sisters. Then twin boys are brought out to dance

with the Hilton Sisters. There can be no doubt that everyone
leaves wishing happiness to Daisy and Violet Hilton, and a long
life of contentment. Their regard for each other is evident.[14]

Daisy and Violet did not want sympathy from their audiences.
They even disdained it. As carefree and ebullient as they always
appeared, however, it may have been impossible, as the critic Sam
M'Kee observed, for their audiences to ever fully forget the tragedy
of the sisters' situation. Rose Fernandez, an acrobat who sometimes
appeared in the same vaudeville lineups with Daisy and Violet, talked
about the conflicting emotions that stirred within her whenever she
saw them on stage: "You laughed at their girlish patter. You
applauded them when they sang or played their saxophones and vio-
lins. You rose to your feet when they danced. But all the time that you
were witnessing their triumphs on stage, you had tearing eyes and a
lump in your throat. They were so radiant and beautiful, so cheery, so
lovely as human beings in every way. But yet they had such a heavy
cross to bear."[15]

Sometime during the twins' opening day at the Loew's State, an
enterprising *New York American* reporter sneaked backstage and got a
surprising one-on-two interview. Daisy and Violet provided the
writer with the astonishing news that both of them had already
received offers of marriage.

"Yes," said Daisy. "We're both engaged, but we won't get married
for three years at least. . . . We're just seventeen, seventeen
today. . . ." The *American* rushed its scoop into print under the head-
line "Linked Twins Going to Wed, But Not Now."

By this time, Daisy and Violet had become practiced in the art of
flirting. Because they were almost divinely pretty, stagehands, flower
delivery boys, and other men had begun to look at them longingly. But
their claim that each was betrothed was clearly an invention. Not

only did Myer and Edith still watch the girls' every waking move, they continued to insist the pair sleep in the same room with their guardians. It seems doubtful that either sister had yet tasted an amorous kiss let alone engaged in talk about marriage.

Myer and Edith had been aware for some time that Daisy and Violet were having romantic, if not sexual, yearnings. But because of what Edith called "the complications of the situation," she said that she and her husband felt justified in doing what they could to put a stop to those feelings.

"If one of the girls should fall in love and decide that her misfortune made it impracticable for her to marry . . . ," Edith said, "then the girl's life would become embittered and ruined. And if, on the other hand, Daisy should give her hand to some worthy young man, a complication would arise that would be extremely embarrassing to sister Violet." Edith observed, too, that if both twins should decide to marry, "it might be extremely trying for the husbands" since the men would have to come to daily agreements on when it was time to go to bed with their wives and at whose domicile.[16]

The pace that Daisy and Violet maintained during their New York run was grueling. The first of their four daily shows began at 10:15 A.M. It was after midnight when the crowd from their last show finally exited the theater. Each day, the house shoe-horned in 15,000 patrons, 3,000 of whom had to stand. Even so, an entire class of people was denied the opportunity to see the twins perform. These were the thousands of other Broadway vaudevillians, musicians, actors, and dancers, working at the same time Daisy and Violet were performing. After receiving "hundreds of requests" from these players, Marcus Loew and the twins agreed to stage a special performance just for them.[17] The show was scheduled to begin at 11:30 P.M., after the other entertainers had closed their own shows.

Among the luminaries turning out for the late, late show were

Vivian and Rosetta Duncan, the popular sisters after whom the Hiltons styled some of their musical routines. The Duncans were appearing in *Topsy and Eva*, a musical of their own creation that was the hottest ticket on Broadway.

Still in their twenties, the girls had the untouched freshness of schoolgirls. Following the Hilton's special performance for New York entertainers, the Duncans, along with a great throng of other well-wishers, jammed into the twins' dressing room. Vivian and Rosetta graciously told Daisy and Violet they felt flattered by the twins' imitation of them. Then and there, a close and enduring friendship developed between the sister acts.

Within a week after their first meeting, the Hiltons were house guests at the Duncans' home in White Plains, New York. Each day Vivian and Rosetta faced Daisy and Violet in croquet, and each day the twins were victorious. When it was time to leave, Daisy and Violet embraced their hostesses and explained that it was because they adored the Duncans so much that they paid homage to Vivian and Rosetta in their act. "Well," said Rosetta, "let's enter into an agreement right now for the next time you visit. You give us croquet lessons, and Vivian and I will give you vocal lessons."[18]

Their names were in lights over Broadway; adulation poured from the theater crowds; friendship came easily with the rich, the powerful, and the famous. Daisy and Violet had never dreamed it was possible to be so happy.

*Nine*

# NOT A TRIFLING SUM

Daisy and Violet came into public prominence midway through a decade of national whoopee, a ten-year-long New Year's Eve party when revelers unsnapped and unzipped the last of their inhibitions. They were embraced by a generation that took sport in goldfish swallowing, pogo sticks, flagpole sitting, and petting parties, and hero worshipped such limited talents as Rudolph Valentino and Rudy Vallee. With their bodies pushed together like empty bookends so that when they moved they appeared simultaneously to be coming and going, they were the perfect poster children for a nation that, in the aftermath of the Great War, seemed unsure of where it was heading.

Almost from the moment Daisy and Violet first appeared on Broadway, everyone, it seemed, wanted to know them. Edith Myers assumed the role of their social secretary. She spent hours a day sifting through the invitations that poured in. For every request she accepted, she rejected twenty others.

Jackie Coogan, Robert Montgomery, and Constance Tallmadge were among the many actors who arranged to have publicity photographs taken with the sisters, believing that an appearance of friendship with Daisy and Violet would broaden their popularity.

Many evenings, after finishing their last show, Daisy and Violet, always chaperoned, made the rounds of the penthouse parties that

*The twins posed with a fleet of brand new cars before the start of a parade on a cold winter day. (Author's collection)*

were thrown for stage luminaries and the most fashionable Manhattanites. Even the most established hostess felt divinely favored when Daisy and Violet crossed over her threshold. It was a guarantee her soirée would receive notice in the gossip columns.

The twins cultivated numerous friendships with fellow vaudevillians, among them one of special closeness with Marion Barr and Miriam Davis. Audiences adored Barr and Davis as long as they were singing and dancing on stage, but it was rare for them to be invited to the after-show house parties. Indeed, the two were even banned from most of the restaurants where show people gathered. Marion Barr and Miriam Davis were African Americans. The Hiltons and

Barr and Davis got together regularly for private dinners in their hotel rooms. They also went together to the movie houses, although the pairs were usually ushered to separate seating sections. It really wasn't surprising that Daisy and Violet became close to Barr and Davis. They, too, had known the deep hurt of having much of society closed off to them.

Because their fellow stage performers were so accepting of Daisy and Violet, meeting with them at parties and after-show dinners, the sisters seemed to forget that, as conjoined twins, they left a lasting impression in the minds of all who saw them. During his earliest days as a vaudevillian, Jack Benny regularly appeared on the same bills with the Hiltons. After a year or so on the Loew circuit, Benny switched to another booking agency and began traveling a new vaudeville chain. Several years went by when, unbeknownst to the comedian, he happened to be appearing in the same city where the Hiltons were playing. Benny was not only surprised, but thrilled, when, between shows, he answered a knock on his dressing-room door and saw the twins standing before him. "Violet . . . ! Daisy . . . !" he cried out. "It's so good to see you again." He embraced one sister, then the other, then both together. Next, Benny stepped back and took a long look at his callers. It was at this point, the comic recalled, that Violet turned to her sister and, in all seriousness, observed, "See, Daisy, I told you he'd still remember us."[1]

Myer Myers' fortune grew faster than ever once Daisy and Violet became darlings of the vaudeville stage, but now it wasn't only their box office receipts that were providing the tailwinds for his upward mobility. The sisters had also started generating money through endorsements. In an age when many middle-class families had pianos in their parlors, the twins were courted by the major publishers of sheet music, Irving Berlin among them. Pictures of the fresh-faced, coil-tressed twins adorned the sheet music covers of such newly

minted tunes as "Someday," "Tea for Two," and "When the Red Red Robin (Comes Bob-Bob-Bobbin' Along)."

Numerous other businesses entered into contracts with Myer to have his San Antonio Siamese Twins boost their products. A New York Chevrolet dealer ran a series of newspaper ads showing the sisters posed inside his cars. Daisy, in fact, had started driving by this time. Violet necessarily was always relegated to the role of passenger because if she slipped behind the steering wheel, her sister would have to ride the running board.

Of all the larks in which the twins became involved during their first year in vaudeville, the craziest was their entry into a New Jersey beauty pageant. The two were sponsored for the competition by the Palisades Amusement Park. For weeks before the contest, Daisy and Violet made numerous pre-pageant appearances, posing in bathing suits for newsreel cameramen and newspaper photographers. But when the day for the judging arrived, the sisters were no-shows. They claimed they had a contractual obligation in Atlanta, Georgia, that prevented them from strutting the Atlantic City boardwalk. The contest officials were probably relieved. From the day they received the twins' application, the contest judges argued whether the Hilton sisters were one entrant or two.

Wherever Daisy and Violet performed, money washed into those theaters like shells from a storm-tossed sea onto the shore. In their first months on the Loew circuit, they generated more revenue than any other vaudeville attraction of the time. This was no small distinction, as America's vaudeville houses were providing employment for thousands of entertainers, including such superstars as Eva Tanguay, Eddie Cantor, Sophie Tucker, and the Ritz Brothers.

Nobody was more gleeful over the Hilton sisters mania than Marcus Loew. He was already one of the richest men in America, so the tens of thousands of dollars that Daisy and Violet brought into his box

offices each week were not going to bring about a significant elevation in his station. But still, he gloated at having them under contract. He knew this rankled Edward F. Albee, operator of the 400-theater Keith-Albee chain and Loew's fiercest rival in the vaudeville wars.

A pompous man who liked to think of himself as the king of Broadway, Albee hated being bested. What was most galling to him about Loew's signing of the Hiltons was that the Keith-Albee operation had been given the first chance to win the attraction but passed on the opportunity. Albee fired the talent scout who sat for the twins' audition at the Hippodrome and then stormed out on them, but this was small consolation. Each week the show papers buzzed with stories of the Hiltons' successes, and invariably the accounts taunted Albee and his management for having been too myopic to recognize the potential of the attraction.

Never in the history of vaudeville had newcomers settled more swiftly into a place of royalty than the San Antonio Siamese Twins. Loew issued orders to his playhouse managers that the Hilton sisters were to be treated as prima donnas. They were to be given the best dressing rooms, and these rooms were to be stocked daily with the most expensive toiletries and fresh flowers. And to Daisy and Violet's great joy, Loew presented them with a gift that was intended to show that he was more than casually grateful for the attention they had drawn to his theater empire. He gave them a Pekinese puppy whom the sisters named Boy. Boy went everywhere with the girls.

Wherever the twins were sent on the circuit of Loew vaudeville houses, they continued to post new box office records. They were held over for second weeks in Chicago, Philadelphia, and San Francisco, and for second and third weeks in Los Angeles. In Milwaukee, Daisy and Violet were the cause of a near riot. They had been booked for a week at the Miller Theater, with four shows a day. Because the Miller could only seat 1,500, there were not nearly

enough tickets for all the Milwaukeeans who had their hearts set on seeing the new vaudeville sensations. Some fans were so angry when the Miller posted a SOLD OUT sign on its box office that they threatened to burn down the theater. Ultimately a decision was made to transfer the twins' show to the Wisconsin Theater, a house with more than twice the seating of the Miller. Daisy and Violet filled every seat in the new house four times a day, every day, for the entire week.[2]

The relationship between Marcus Loew and the Hilton sisters appeared to be so salubrious to both sides that most vaudeville observers were predicting it would go on forever. After the twins had been touring the Loew circuit for nine or ten months, however, Myer Myers presented the entertainment mogul with jolting news. He had just entered into an agreement to have the William Morris Agency represent Daisy and Violet, cutting out both Loew and Terry Turner when their contract ran out in January, 1926. The Morris agency had already booked Daisy and Violet to make a tour of the vaudeville theaters operated by the competing Orpheum chain. Under the new contract, the twins were not only to enjoy a $1,000 jump in their $2,800-a-week salary, but each was also to have her own maid.[3]

As anguished as Marcus Loew was over Myer's breach of loyalty, he wasn't going to have to give up any caviar breakfasts because of his loss of the thousands of dollars the twins were adding to his coffers each week. But the sisters' shift to the Orpheum circuit was definitely going to necessitate some trimming in Terry Turner's personal standard of living. Daisy and Violet's act had always been billed as "A Terry Turner Production," and as the man who molded every detail of their stage presentation, Turner had been getting a percentage of the box office receipts. But with the sisters' move to the Orpheum circuit, the flow of cash would be turned off. Turner went into a rage, reminding Myer, probably rightly, that had it not been for him, Daisy and

Violet would still be lowly sideshow exhibits rather than the highest paid, most adored performers in vaudeville. Turner vowed he would get even.

The twins' switch to the Orpheum circuit also brought about changes in their backup troupe. Ray Traynor, their musical director, piano accompanist, and emcee, was replaced by Irwin Dash, an aspiring song writer. And brought in as Daisy and Violet's new dance partners were a pair of tall and gangling entertainers who called themselves "The Dancemedians." One of the dancers was George Byrne, the other Leslie Townes Hope, or, as he was to rename himself a few years later, Bob Hope. Hope had this recollection:

> At first it was a funny sensation to dance with a Siamese twin. They danced back to back. But they were wonderful girls, and it got to be very enjoyable in an unusual sort of way.[4]

Great precision, split-second timing, and a sixth sense were required of all the partners who attempted to become one with the twins in the flashy *pas de quatre* finales that always brought the crowds to their feet. Hope and Byrne spent endless hours practicing the rousing show closer with Daisy and Violet. Violet once revealed that when she and her sister were sure that no one was looking in on their practice sessions, they got Hope to teach them the Black Bottom, a dance that was considered far too risqué for their stage appearances.[5] To most eyes, the Black Bottom resembled less a dance than vertical copulation. The dancer's feet scarcely moved while their hips gyrated in slow motion. A dance that originated with southern blacks, the Black Bottom derived its name from the oozing mud at the bottom of the Suwannee River. The dance allowed for a lot of free invention. With maybe a thousand variations, its participants tried to create an impression that they were slipping and sliding, shivering and quivering while negotiating a gooey river bed.

Besides taking the stage in the twins' finale, Hope and Byrne also

Photo of Dancemedians, George Byrne and Bob Hope, or as he
was still known in the mid-1920s when this picture was
taken, Leslie Townes Hope. Hope and Byrne toured with the
Hiltons in their early years in vaudeville and were among the
sisters' early dance partners. (Author's collection)

appeared as a separate act on the theater bills, usually commanding the
second, or "deuce spot," in the lineups of eight or ten acts. Hope
described the Dancemedians' turn this way:

We wore the high hats and spats and carried canes. . . . Then we changed
into firemen outfits. . . . George had a hatchet and I had a length of hose with

a water bulb in it. We danced real fast to 'If You Knew Susie,' a rapid ta-da-da-da-da tempo, while the drummer rang a fire bell. At the end of this rou-tine, we squirted water from the concealed bulb at the brass section of the orchestra in the pit. It not only made an attractive finish but it had the added advantage of drowning a few musicians.[6]

The apprenticeship that Hope and Byrne served with the Hiltons was important in their careers. Because the twins attracted crowds, the Dancemedians were put to the test before large audiences. Now and then, the pair were singled out by reviewers, and almost always the notices were good. Typical of the encomiums was an appraisal made by a Pennsylvania newspaper writer in January, 1927, when the two were appearing with the twins at the Rajah Theater:

> Hope and Byrne have untamed feet. They just behave as if they have no control whatsoever, but, of course, their control is perfect. The boys are versatile dancers with humor crowded into every step.

Because Hope and Byrne were part of the Hilton sisters act, they were paid directly by Myer Myers. They earned $225 a week, not a trifling sum when compared with the pay of other secondary vaude-ville performers. But Hope and his partner complained that after they shelled out for their hotels, train fares, meals, and agents' fees, they never had any money left. Emboldened by their favorable mentions in the press, the Dancemedians approached Myer after a year and told him they believed they were deserving of more money. They quit when Myer balked at hiking their pay.

Daisy and Violet were at the height of their earning power in 1926 and 1927, taking in $4,000 a week, about three times the wage an average American worker took home in a year. Even so, the twins barely seemed able to keep the dollars coming in fast enough to keep up with Myer's profligate spending. In the ten years since he had left

Australia to come to America, Myer had not only acquired a lot of valuable properties in and around San Antonio, including the ranch, several downtown rental residences, the weekend retreat on Lake Medina, and the horticultural farm in Poteet, but now he was also snapping up real estate in upper New York state.

By now Myer was obsessed with an ambition to become one of the true social pillars in San Antonio society. He wanted a home and estate that, through its size and grandeur, would betoken not just great wealth, but refinement. When he acquired the ranch on San Antonio's outskirts in 1917, the property was occupied by a perfectly comfortable and habitable, if unpretentious, frame dwelling. But it would no longer do. It was time to raze the ranch house to make room for a mansion.

For years, whenever they traveled to a new town, Myer and Edith made a point of exploring the leafy neighborhoods of the rich and well born. They were searching for the one manor somewhere in the country that met all their ideals of perfection, a domicile of beauty, taste, and grandness that could be recreated on their ranch property. Their scouting ended when, while in Springfield, Illinois, where the twins were performing, they saw the home that Frank Lloyd Wright designed for Susan Lawrence Dana, a wealthy heiress.[7] With 12,000 square feet on three levels and thirty-five rooms, the brick and stone Dana residence was the largest of Wright's Prairie School homes. With some downsizing and the addition of some flourishes of their own, Myer and Edith agreed, it would serve perfectly as their model.

The new home that Myer and Edith had envisaged was to be a tasteful blending of Japanese influence and German modernism. While there already were examples of the new architectural style in the Northeast, the Myers residence, as was noted by the *San Antonio Express*, was likely the "first of its type" anywhere in Texas.[8] The Myers family, of course, became immediately popular with local

craftsmen. Their transformation of the ranch provided employment for dozens of skilled workers and artisans, including masons, carpenters, plumbers, cabinet makers, landscapers, metal smiths, and stained-glass designers.

In published accounts that appeared years after it was completed in 1927, the Myers' house was often incorrectly identified as a Frank Lloyd Wright creation, and tour guides showing off San Antonio's landmarks often referred to the residential masterpiece as a Wright project, explaining that the architect's cataloguers had somehow missed recording it as part of his oeuvre. The house, in fact, was designed by Harvey P. Smith, a native of San Antonio. Smith was a talented architect in his own right and would later become a major force in the drive to restore San Antonio's mission buildings, including the Alamo. At the time he was approached to design the Myers' home, however, he was still largely untested and was eager for commissions. He acceded to the Myers' request that in developing the plans, he quote liberally from Wright's architectural vocabulary.

Soon after its completion, the Myers' showplace received a two-page layout in the Sunday edition of the *San Antonio Express*. Among the spread's many photographs were two with Daisy and Violet, one of them showing the pair outside the tea house, the other depicting them before the manse's imposing arched portico. The *Express* account reported that the home had been paid for entirely from the twins' stage earnings, and that they had freely given it to Edith as a birthday gift for having "mothered and raised them from the day of their coming into the world."[9] If it was true that Daisy and Violet had presented the home to Edith as an outright gift with no strings attached, then surely the bequest must rank with the most notable presents made since Caesar took delivery of an oriental rug and found Cleopatra wrapped inside.

The newspaper put the cost of the Myers' home at a $100,000. In

addition, the *Express* said, the home's furnishings, including a large collection of antique Japanese porcelains, vases, folding screens, hand-painted scrolls, and Shinto and Buddhist altar items that Myer had amassed, had been given a "conservative estimate of $35,000 to $40,000 or more." In current dollars, that would place the dream home's construction bill at about $5 million and its collection of Asian antiquities at about $2 million.

# BY WILES AND CONCEITS

Since becoming celebrated as belles of Broadway, Daisy and Violet were enjoying their life as troupers more than ever before. They gloried in sharing bills with such stars as Eddie Cantor, Sophie Tucker, Jack Benny, and Fanny Brice. Their joy was apparent whenever they were on the stage. It was the one place where they could give and receive love. Increasingly, however, Daisy and Violet chafed at the control Myer exercised over them. Because of their far flung travels and associations with other entertainers, they were becoming ever more worldly.

But Myer continued to treat the sisters as though they were his chattel. He refused to relax any of his restrictions. Over even Edith's objections, he maintained the rule that when the family was staying at a hotel, Daisy and Violet were to occupy the same bedroom he shared with his wife. The sisters were nineteen.

Daisy and Violet weren't unaware of the money they were producing. The trade papers such as *Variety* and *The Billboard* reported regularly that the San Antonio Siamese Twins were the highest paid attractions in vaudeville. But Myer turned a deaf ear to the sisters' requests for even some small part of their earnings. He told them they already were enjoying a grander life than any freaks had a right to expect. He was seeing to it they had the finest clothes and a place to sleep in one of the most gracious homes in all of Texas.

He also turned down their requests for the freedom to do some things on their own, like shopping or, when the family was home in San Antonio, going into town to visit a restaurant or take in a movie. He reminded them over and over that if the public were able to see them in the everyday world, they would lose their mystique as stars of the stage.

Myer felt so confidently in control that he almost dared Daisy and Violet to try breaking his rules. He told them that if ever he had a mind to, he could see to it that they were deported to England and locked up in an asylum forever. Myer, in fact, had gained full legal control over the twins in 1927, soon after their nineteenth birthday. He had petitioned a San Antonio court to declare that because the sisters were hampered by an extreme physical disability, he was to serve as their legal guardian. Not only did Myer gain custody of the twins through the ruling, but he was given full authority to hire them out for stage appearances and collect all the income they generated.[1] Daisy and Violet felt thoroughly beaten down when they learned of the court's ruling. They concluded that their situation was hopeless and that they would remain forever indentured to Myer. In 1927, however, while the twins were out on tour, Myer finally so angered his wards that they decided to take a stand.

It happened without so much as a brush of the hands between Don Galvan and Daisy or, as far as anyone knew, even an exchange of words. Galvan had become smitten with her, and she with him. Born of Mexican parents, he had black wavy hair, brown eyes, and dark skin. When he was smiling, which was just about all the time he was awake, he looked like he had sixty teeth. He was movie-star handsome and he was a singer and guitarist. Whenever he was on stage, Daisy found an excuse to drag Violet into the wings with her. Daisy was sure she was the subject of every romantic ballad Galvan sang, an assumption he encouraged during his performances

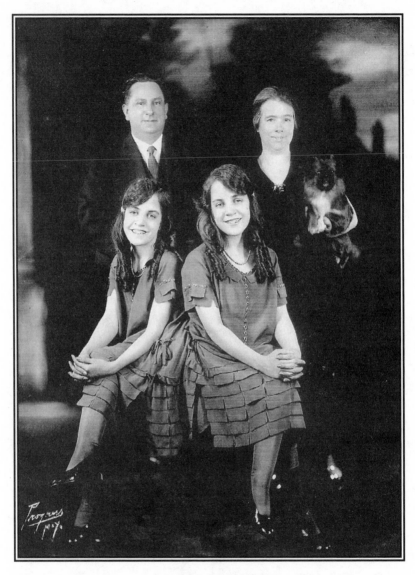

Violet and Daisy with Myer Myers and Edith Myers, mid-1920s.
Boy, their first Pekingese, is in Edith's arms. (Author's collection)

by regularly looking to the left or right of the stage to make sure she was there.

Galvan was twenty-four or twenty-five, five or six years older than Daisy, and he was one of several entertainers who appeared on the same vaudeville bill with the San Antonio Siamese Twins during the 1927–28 touring season. He sang with the plaintiveness of one who had had his heart broken by earlier romances. It was clear that Daisy was experiencing the stirrings of love for the first time. Certainly Violet saw the changes that came over her sister, as did others in the traveling troupe. One moment she could be giddy or dreamy and the next, snappish or gloomy.

Myer was aware that Galvan was captivated by Daisy and cautioned him against ever attempting to make an advance on her.

For several weeks, Galvan did try to suppress any outward signs that he was attracted to Daisy. He averted his eyes whenever he passed her entering or leaving the theater. When he was onstage, he no longer searched for Daisy in the shadows beyond the curtain, signaling her that his trillings were meant for her. Daisy was so heartsick over what she thought was his sudden change of feelings toward her that she cried herself to sleep each night.

What she didn't know was that Galvan, too, was aching. Finally he decided he had to somehow let her know that he still cared deeply for her. He placed a vase of yellow roses outside the twins' dressing-room. Myer was first to spot the floral offering. When he looked at the card and read Galvan's note of endearment to Daisy, he erupted. He kicked the vase, smashing it into shards and sending the flowers everywhere.[2]

The twins flew into a rage when they learned what Myer had done. When he entered their dressing room, they leaped onto his back, pounding and scratching at him.

"You still keep us caged up like animals at a circus," Daisy

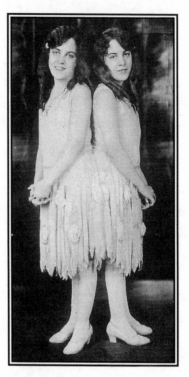

*Publicity photo, mid-1920s.*
*(Author's collection)*

screamed. "But tonight is different. . . . Don't you strike either of us or we'll yell like wildcats. And get us separate rooms. We're grown ladies and you should be ashamed to force us to share your and Edith's room."[3]

The assault ended only when Edith intervened. She pulled the twins off Myer's back. His neck and back were raked with scratches. His shirt was in tatters. But, probably most troubling to him, was his sudden realization that he was going to have to give up some of his control over the twins. Sheepishly he told Daisy and Violet that, yes, they were probably old enough now to sleep in their own room. Feeling vanquished for maybe the first time ever, he also agreed to the

demand that he start paying Daisy and Violet a share of the money their act was producing. He said he would immediately see to it that a trust fund was established at a bank in their names and promised to start making weekly deposits of $500 into the fund.[4]

Whatever other concessions Myer said he was willing to make in the wake of the attack, the truth was he had reached a point in life where he was ready to slow down. A wanderer since he was a boy, what he wanted most now was to relax at the ranch and watch his roses, his bankroll, and his daughter, Therese Mary, grow. He decided to assemble a management team to take over many of the business affairs of the San Antonio Siamese Twins. He would still be able to collect a large percentage of their earnings.

A short time later Daisy and Violet had just settled into their seat and they could hardly believe the sight just outside their train window. With Edith and eleven-year-old Therese Mary at his side, Myer was standing on the platform of the San Antonio station. He was finally letting them travel on their own.

Daisy and Violet kept waving and blowing kisses, but they were anxious for the train to start moving. They worried that if it didn't leave the station soon, Myer might have a change of heart and drag them off the train. Finally, they felt a lurch, and the train began rolling.

Daisy and Violet were brimming with more anticipation than ever as they started on their journey East to begin the 1928–29 vaudeville season. Myer had decided to stay home in San Antonio and enjoy the life of a rancher. For the first time ever, the sisters were traveling without their guardians. They would now have the freedom to do what they wanted to do, go where they wanted to go, and, most important, see who they wanted to see. They were only a few miles outside the city when they brought out their mirrors and began coloring their faces with lipstick, eyeshadow, and rouge.

From the beginning of their bloom into adolescence, the sisters had taken notice of boys and young men who appeared to be looking them over not as physical curiosities, but as potential conquests. With a blush or a shy turning away of their eyes, Violet and especially Daisy tried to signal to these admirers that their attentions had been duly noted and were appreciated. With their guardians always hovering close by, none of these occasions had ever been allowed to advance beyond the most nascent stage of flirtation. Without around-the-clock bodyguards at their sides, perhaps things would be different. The twins were open to anything.

Traveling on the same train was Bill Oliver, a pitchman for wrestling matches, circuses, and carnivals whom Myer had hired as the twins' advanceman. Oliver was slight of frame, short, and had thinning, hay-colored hair. He wore two-toned shoes and reeked of drugstore cologne, but he had a certain raffish appeal. The train had hardly traveled as far as San Antonio's outer limit when Oliver positioned himself across the aisle from the twins and started working his charm. After years of seducing roadhouse waitresses, he had honed his powers of persuasion to a high art. His words oozed like taffy from a confectioner's machine. Still new to the experience of being wooed, Daisy and Violet were easily intrigued. By the time the train reached the East, both were lovestruck. Bill Oliver was about forty, twice the twins' age. He also had a wife in Kansas City, Missouri. But Oliver didn't regard this as an impediment to cultivating additional relationships, especially when he was traveling.

At the time Myer hired Oliver, he spelled out what would be expected of his employee: Oliver would always be sent well ahead of the twins on the vaudeville circuit, arranging for their hotel accommodations and lining up publicity and advertising in the papers. Oliver more or less carried out all these assignments, but apparently he believed his job permitted him the freedom to continue his

advances on Daisy and Violet. Rather than being 50 miles up the train tracks in, say, Poughkeepsie when the San Antonio Siamese Twins were playing in Yonkers, most nights he could be found in the same hotel room in which the stars were staying. Needless to say, 1,500 or 2,000 miles away in San Antonio, Myer had no knowledge of these bunking arrangements.

The naïve, completely inexperienced twins were willing, at least at first, to receive their amorous nocturnal caller in a spirit of sharing. But it didn't last. As each grew more infatuated with Oliver, they became so jealous of one another that sometimes they didn't exchange words for days. As for Oliver, he relished having the two compete for his attention. His wife Mildred would later provide this perspective: "They both loved him. They showered him with lavish gifts — jewelry, a Reo motor car, and clothes. William had so many clothes they filled up all the closet space."[5]

Mildred was a waitress who reported daily to her job at a Kansas City diner while her husband was on the road. She learned of the *ménage à trois* when, on one of Oliver's rare and quick visits home, she went through his bags. Inside, she found a thick sheaf of perfume-scented letters in which, Mildred said, both sisters "were pouring out their love." When she confronted her husband with the incriminating evidence, Mrs. Oliver said, "he expressed no remorse." Instead he told Mildred that he was no longer attracted to her because he now "cared for the twins, and they for him."[6]

As strained as the relationship between Daisy and Violet sometimes became over Oliver's attention, there were periods when they declared a truce so they could present a united front in eliminating their competition. They believed that Margaret Moore, a young pianist whom Myer had hired as the sisters' road accompanist, was one of Oliver's conquests. There were nights when Oliver knocked on Miss Moore's hotel room door before moving on to the Hiltons' room.

On most of his visits to Margaret's room, he carried flowers, boxes of chocolate, and other small gifts that had been purchased with the allowance the twins gave him. Daisy and Violet raged whenever they learned that Oliver made a stopover in Miss Moore's room before coming home to theirs. They would pelt him with fusillades of jeweled cuff links, boxed argyle sweaters, satin pajamas, and other expensive articles they had presented to him as gifts, until he declared his contrition.

The twins' dust-ups with their shared suitor were almost always followed by lovemaking and then drinks and dinner at the best club in town. Oliver always appeared properly chastened after these upsets and vowed he would never again stray. His pledges, however, usually ran no longer than one-dollar watches. He continued to arrange assignations with the cigarette girls, secretaries, and waitresses he met in the course of making his rounds as an advance man. Daisy and Violet couldn't remove all the targets of Oliver's roving eye but were able to dispatch the piano accompanist. They wired Myer in San Antonio, telling him that Miss Moore was bumbling and altogether graceless as a pianist and that for artistic reasons, they could not go on working with her. Myer accepted the complaint at face value. He fired Miss Moore and sent in a replacement, a male pianist.

At the start of the 1928 vaudeville season Daisy and Violet discovered that everything in the business had changed. Two years earlier, the first talking pictures started being screened to large audiences. In their earliest incarnation, the new movies were crude affairs, blaring out dialogue and music to the audiences for a few minutes and then falling silent for the next half hour. But because of their novelty—and because people in even the smallest towns could now not only see, but hear such big stars as Al Jolson—the talkies became an immediate sensation. Hundreds of vaudeville theaters around the country

immediately became wired for sound. They began drastically cutting their offerings of live entertainment or did away with it altogether. Thousands of jugglers, dog trainers, ventriloquists, and buck-and-wing dancers were banished to oblivion. After decades of being the most popular form of entertainment in America, vaudeville was dying.

Because they possessed household names, Daisy and Violet were not among the vaudevillians who were immediately finished off, but even their engagements began to decline. For the first time in years, they were sometimes unemployed for stretches of as long as two or three weeks. And because fewer theaters were still presenting live entertainment, the twins were now only able to command $400 or $500 a week compared with the $4,000 a week they had been earning only the season before. Myer Myers, still back at the ranch in San Antonio, was panicking at the sharp drop in the twins' earnings.

As devastating an impact as the talkies were having on the twins' employability, the new motion pictures weren't the only reason for the drastic fall-off in the Hiltons' bookings and pay. Three years earlier when Myer had fired Terry Turner, the producer, promoter, and publicist had vowed that he would find a way to settle the score. Now, Turner had put a plan in place to carry out his threat.

Turner brought a new attraction to vaudeville that, at least in its concept, was a near perfect cloning of the Hilton sisters act. He had found another set of Siamese twins, Margaret and Mary Gibb of Holyoke, Massachusetts. The sisters, who had been exhibits in the Wonderland Circus Sideshow on Coney Island, were homely and had none of the Misses Hiltons' talent or charm. But Turner didn't view these deficiencies as serious drawbacks. He turned the pair over to Ray Traynor, Daisy and Violet's onetime musical director, and instructed him to start grooming them for the stage.

Traynor was more than challenged by the assignment. The Gibb sisters were eager pupils, but according to their tutor, they lacked the

capacity to master any human activity much more complicated than respiration. Traynor had this memory: "Mary and Margaret were no more trainable than jellyfish. I'd arrange a song in the key of G and one of them would sing it in B-flat and the other in D-minor. They weren't any better as dancers. They had enough trouble walking together, let alone doing something like a simple fox trot. They stepped all over each other."[7] A teacher of infinite patience, Traynor did not give up on them.

The Gibb sisters were fifteen in 1927 when they made their theater debut. In its broadest features, their show was a mimeographed copy of the Hiltons' act, complete with singing duets, piano recitals, and a closing that brought Mary and Margaret together in a dance with two young men. So pitifully lacking in entertainment value were the Gibbs sisters' stage appearances, the critics were hard pressed to write anything that would not make them appear to be bashing the unfortunate children. *Variety*, probably the most diplomatic of the newspapers present for the sisters' debut, summed up their act in tautological terms:

> Their [piano] playing and dancing pass as well as anyone could want, especially when not much is expected.[8]

Such notices contrasted sharply with the raves Daisy and Violet drew at their debut when most critics hailed them as the most sparkling act to appear on Broadway in at least a decade.

Myer Myers was infuriated by Turner's introduction of a second Siamese twins act to the stage world. But Turner was not quite through. A year or so after he launched the Gibb girls, he presented yet another set of conjoined twins, Simplicio and Lucio Godino, twenty-one-year-old brothers from the Philippines. The brothers were

startling to behold: One twin was six inches shorter than the other and the brothers were tightly pinned together back to back. Because of the disparity in their heights, the taller brother was forced to do all the walking, bending forward at his waist and carrying his twin on his back. Jim Moore described the spectacle this way: "The one that was walking [was] bent over just a little bit. . . . The [other] one . . . lying up on his back [looked] like a giant spider with arms waving and feet going. It was very grotesque."[9]

As astounding a sight as the Godino Siamese twins were, their act drew crowds everywhere. Yet, the people flocking into the theaters seemed less curious about Lucio and Simplicio than about the two women appearing with them, their Filipina wives Natividad and Victoria. The women were sisters, with undulant figures and long black hair. They were not unattractive, nor were they inhibited. At each performance, Natividad and Victoria gigglingly revealed what happened when the lights went out at night and Lucio, Simplicio, Natividad, and Victoria were under the sheets together, with arms and legs everywhere. So great was the box office appeal of the Godinos that Turner was able to book them into New York's Palace. Myer became apoplectic when he learned of Turner's coup. Even during the Hilton sisters' first two years in vaudeville, when they were at the height of their popularity, they had never gotten an engagement at the Palace.

Although the Godinos were a great sensation with the public, their show failed to receive endorsement from the professional critics. The reviewer for *The Billboard* fairly fumed at the breaches of taste in the brothers' act, stating that the most offensive part of the show came when Lucio and Simplico's "swarthy brides" joined their husbands and talked about their sex lives. The reviewer snapped:

> Something went wrong in the brains division of the RKO
> office . . . when they booked the Godinos into the Palace.
> To be brutally frank, they are as much out of place as a bur-
> lesque show in the chambers of the United States Supreme
> Court.[10]

But if there were bluenoses who stayed home because of the pub-
lished claims of the show's smuttiness, they were far outnumbered by
people who were lured to the performances precisely because the
brothers and their wives were so candid in describing the mechanics
of their couplings and quadruplings. To help insure that the houses
were packed wherever his Godino brothers appeared, Turner also pre-
sented screenings of the triple-X film, *The Miracle of Birth*.

Before being hired as the chief publicist for Marcus Loew's theater
and movie empire, Turner had been a city editor at the *Baltimore News*.
Because of the cozy relationships he retained with his cronies in the
world of journalism, great rivers of printer's ink flowed everywhere
he presented his Siamese twins. In Newark, New Jersey, for example,
the daily *Star* completely gave over its front page to the Gibb sisters,
including three photographs and three stories, one of them with an
eight-column-wide headline announcing their arrival in the city.
Observed *The Billboard*:

> Last Saturday's *Newark Star* was hogged by Turner for the
> Gibb Girls in a manner never previously noted for any stage
> attraction in any paper.[11]

However great the dissimilarities were between the glossy shows
of the San Antonio Siamese Twins and the coarse spectacles of the
Godinos and the Gibbs, the Hiltons were being steamrolled by the
juggernauts that Turner had assembled. Myer was helpless to do any-
thing about it. Terry Turner was one of the best-connected men in
show business. While he was placing his Siamese twins inside the

show temples of bigger cities like Chicago, Boston, and St. Louis, Daisy and Violet, when they were working at all, were now most often relegated to the small opera houses of towns like Waukegan, Illinois, and Fort Mason, Iowa.

The gaps in Daisy and Violet's bookings had become so extended by the 1929–30 show season that the two spent most of their time at home in San Antonio, leaving only occasionally to cover the few engagements that Ben Benson, their new contracting agent, was able to scare up.

Myer had become more sullen than ever. What happened to the standing-room-only crowds, the fabulous pay, the adoring press? Could the party be over already? In a big way, Myer himself was responsible for the unraveling of his fortunes. Out of greed, he hadn't been able to bear giving Terry Turner a percentage of the Hiltons' box office receipts and had dismissed him. If he hadn't dumped the promoter, Turner never would have assembled the Gibb and Godino Siamese twins acts that robbed the Hiltons of their uniqueness as a stage attraction. But Myers couldn't admit to his mistake. Instead, he held Daisy and Violet accountable for the decline in their bookability. He fought with them constantly. Great expenses were involved in maintaining the ranch, he told them. There was a domestic staff to pay: maids, butlers, a chauffeur, a handyman. How did they expect him to maintain the family's standard of living when they brought in so little money?

Late in the summer of 1930, Myer phoned Ben Benson to find out what bookings had been secured for the twins for the season ahead. The report from the contracting agent wasn't good. He hadn't yet lined up any engagements, and because the country was now in the midst of the Great Depression, theater managers were predicting that the coming season would be the grimmest ever.[12]

Myer couldn't imagine how things could become any more dire.

Then, on a November day, a process server knocked at his door and handed him a subpoena. With Edith looking over his shoulder, Myer's hands started shaking as he read the document. He tore out of the house screaming.

Edith ran after her husband, hysterical herself, pleading with him to calm down before confronting the twins. Myer found Daisy and Violet in the greenhouse. He was more agitated than they had ever seen him.

"You tramps!" he shouted. "You sluts! You cheap whores! You've ruined us! You've ruined everything!"

The subpoena was still in his shaking hand. The papers named Daisy and Violet as co-respondents in a lawsuit. They were being ordered to appear in the district court of Kansas City, Missouri, on February 15, 1931, to answer a complaint that, "by wiles and deceits," they had conspired together to alienate the affections of a married man, William L. Oliver. The lawsuit naming the twins had been filed by Mildred Oliver, the advanceman's wife of fourteen years. She was demanding a quarter of a million dollars in damages.[13]

*Eleven*

# A FOUR-SIDED LOVE TRIANGLE

The newspapers had a field day with the revelation that world-famous Siamese twins were being sued for luring a married man into their love nest. Not since Fatty Arbuckle was accused in the rape and murder of actress Virginia Rappe had they been able to run with a story that had as many juicy ingredients as the lawsuit against Daisy and Violet Hilton. Because the sisters were at its center, the scandal had celebrity. And because a threesome necessarily had to be involved whenever one or the other sister was engaged in lovemaking, the story had kinky sex. And because it wasn't just another tart, but Siamese twins that had the role of the "other woman" in the affair, the story had the twist of a Moliére farce.

The *Kansas City Times* referred to the case as a "four-sided love triangle." The *American Weekly*, then the country's most widely read periodical, breathlessly headlined its story as "A Serio-Comic Situation of Courtship and Jealousy, Unmatched In the History of the Courts." The *Weekly* account, which ran on for yards, not only included pictures of Daisy, Violet, Bill Oliver, and Mildred, but also a photograph of the sprawling Frank Lloyd Wright-inspired mansion that had been built with the twins' earnings.

Wherever two or more men gathered—in saloons, in barbershops, on the assembly lines—they passed around newspapers and magazines with pictures of Daisy and Violet posing in bathing suits or

*This palatial residence was built on the outskirts of San Antonio by Myer and Edith Myers using the twins' considerable earnings. The Frank Lloyd Wright-inspired home was featured in the San Antonio Light on January 13, 1931. (Courtesy of The Institute of Texan Cultures, The San Antonio Light Collection)*

voguishly decked out in cloche hats and raccoon skin coats. Always the men put the same questions to one another: Would you? Could you? Why not?

Oliver took his place in the popular imagination as something of a folk hero. As a man of forty who could service two twenty-year-old girls simultaneously, it was assumed he must have a libido that was always firing on twelve cylinders. What was even more impressive, some believed, was that Oliver was able to make love to one sister while at the same time keeping peace with the nonparticipating sibling at his elbow. One columnist observed:

> [Because of] Mr. Oliver's clear gifts for diplomacy, he seems
> qualified for some high and sensitive government position,
> perhaps secretary of state.

But if Oliver really had any secrets for keeping potentially warring rivals in harmony, he wasn't going on the record with them. By the time the lawsuit against the twins became public, he not only cleared his belongings from the house he shared with his wife, but he had also skipped out on Daisy and Violet. He moved in with yet another woman, his mother, in Decatur, Illinois. Mother Oliver shooed away the reporters who came to her porch and intercepted all the phone calls from newspapermen. She would only tell the callers that because Mildred had libeled her son's good name, he had suffered a nervous breakdown and was unable to talk to anybody.

Daisy and Violet felt betrayed by Oliver. After the three-way affair had become tabloid fodder, he abruptly ended all contact with the two, refusing to take any phone calls from them or respond to the notes they mailed to his mother's house. What had happened to the declarations he made during their hotel room trysts when he assured them that his love for them was so great he did not care how the world would view their romance? What had happened to his assurances that the three would always be together?

Especially heartbreaking to Daisy and Violet was that just before the lawsuit set off a national buzz, they had taken the first steps in a plot Oliver concocted that he promised would enable the three to slip away from Myer and Mildred. Oliver told them if they could travel far enough away, perhaps to a redoubt somewhere in the South Pacific, they would be forever beyond the reach of their controlling, life-sucking parasites. Carrying out such a plan would not be inexpensive, he warned, and while he wished the situation was otherwise, he himself lacked any getaway funds.

Goaded by Oliver, Daisy and Violet approached Myer and told him they wanted to make a substantial withdrawal from their trust fund. They didn't, of course, reveal that they needed the money to run away with their lover. Instead they told him they wanted to buy matching diamond bracelets for themselves, and also a diamond necklace for Edith. They had already done some window shopping, they said, and calculated they would need about $7,000 to make the purchases.

"We don't want anything cheap," Daisy told Myer. "We want something really nice."[1]

Under the plan, once the twins took possession of the diamond bracelets, they would promptly pawn them and, with the cash they received, travel with Bill Oliver to some distant place. Undoubtedly because Daisy and Violet told Myer they wanted to buy Edith a diamond necklace at the same time they acquired bracelets for themselves, he agreed to the trust fund withdrawal. The twins, however, weren't prepared for the way in which Myer would alter their plan. Instead of allowing Daisy and Violet to pick out the jewelry, he himself did the shopping. He returned to the ranch with two bracelets and a necklace, bragging that he had made a great deal. He claimed the jewelry had cost a total of $6,600—$4,700 for the bracelets, and $1,900 for Edith's diamond pendant. It would later be reported by the Hausendeck Jewelry Store that the three items had not cost $6,600 as Myer had claimed, but $4,125.[2] He had pocketed $2,475 for himself. The twins never got to execute their escape plan. Before they even had a chance to pawn their bracelets for travel funds, Mildred Oliver filed her suit against them and their lover fled to Decatur to hide in his mother's house.

℘    ⊚    ♂    ℚ

Harry Hertzberg was tall and skinny, and even though he spent much of his time in the Texas sun, his complexion never lost its pasty

color. The gloominess of Hertzberg's outward aspect contrasted sharply with his passions. He had two of them: carnivals and circuses.

Said writer Peyton Green: "He would welcome the train in the railway yards, fête the performers, hang around until the last tent was struck, and then stand by the siding until the last cage car pulled out at three o'clock in the morning."[3] Hertzberg's madness for circuses extended to his material interests. During the early part of the century, he spent half a million dollars collecting big top relics.[4] Eventually he amassed a collection of more than 20,000 items.

So it wasn't surprising that he had viewed the transplantation of the Hilton sisters to San Antonio as the most noteworthy event in local history since the bloody fight for freedom at the Alamo. He simply adored them. After befriending the pair, he took every opportunity to look in on them during their rehearsals in the downtown studios of Mrs. Fred Jones and Bee and Mimi Pomme, the twins' voice and dance coaches, respectively.

Hertzberg, one of the wealthiest men in San Antonio, was also an attorney and a member of the Texas bar, although he never practiced law for more than a year or two. Hertzberg did, however, freely offer legal advice to Daisy and Violet, and his counsel gave them their first bit of hope that they might some day be able to gain their freedom from Myer Myers. Hertzberg told the twins that if they believed Myer was exercising unreasonable control over their lives, they could petition the courts for emancipation. He also assured them that even though Myer had status as their legal guardian, there were no provisions under the law by which he could ever have them deported or institutionalized.

Myer had been in a state of near catatonia from the day the twins received the subpoena to appear in court. While he himself was not named as a party in Mildred Oliver's quarter-million-dollar alienation of affections suit, he worried about what might happen to him

if she prevailed in the case. He worried that he might be ordered by the Kansas City courts to surrender everything in his name, including the ranch and all his other properties, since all his assets had largely been acquired with the twins' earnings. It was critical that Daisy and Violet mount the strongest defense possible against Mildred Oliver, he concluded. He began asking friends for their recommendations of the ablest defense lawyer in San Antonio. One name came up again and again: Martin J. Arnold.

Indeed, so vaunted was the lawyer's reputation as a courtroom scrapper that his clients often ordered victory champagne the moment they got his agreement to represent them. One regular observer of San Antonio's legal arena characterized Martin Arnold's courtroom style in terms that sounded faintly like a description taken from *Great Fights of the Century*.

> There wasn't a lawyer anywhere in Texas who didn't tremble at the mere thought of going one-on-one with Martin. He always played with the opposing lawyer the way a tomcat plays with a mouse. He would, in a manner of speaking, bat his opponent from paw to paw. Then he'd twirl his rival around and around so the other lawyer couldn't tell up from down or west from east. Martin always exercised the Marquis' of Queensbury Rules of fairness, though. When his opponent was reeling, he'd release him and let him regain second wind. He even took sport in letting his guard down for a time to let his foe try to make a run at him. Finally, though, he'd pounce on his opponent and mercifully finish him off. He was brilliant to watch.

Myers' friends cautioned him from the start that he might have trouble retaining Arnold's services. The attorney was in his sixties and he rarely accepted any legal work anymore. Some years earlier, Arnold had started trading stocks and bonds and found the investment field far more lucrative than the law. But there was one thing about the Hilton sisters' case that appealed to Arnold. He was a man who

enjoyed basking in the limelight. Because the press had already blown the case into a cause célèbre, the trial was sure to bring even more attention to the lawyer representing the twins. Myer phoned him. Arnold was noncommittal in their initial conversation, but he did invite Myer to come to his office with the twins so they could talk further.

Myer Myers may have been surprised when, on December 15, 1930, he and Daisy and Violet entered Martin J. Arnold's wood-paneled office for the first time. There was nothing about the appearance of the man behind the desk that supported his reputation as a one-man reign of terror. Arnold had softly waving silver hair and gentle blue eyes that were magnified to the size of plums by his thick, rimless glasses. He was courtly and spoke in a slow drawl.

Myer threw down the copy of the subpoena on the lawyer's desk.

"Read her complaint," he said in a tone that, from the beginning, struck Arnold as being too commanding.

As Arnold read through the subpoena, page by page, Myer began to rant. "You have to fight this! You have to fight this!"[5]

Arnold repeatedly instructed Myer to try to calm down. Myer did quiet down for a minute or two, but when the attorney turned to the twins to question them about the nature of their relationship with Bill Oliver, Myer erupted again and answered for them.

Myer referred to Mildred Oliver's lawsuit against the twins as an attempt at a "shakedown." "Never for a minute was there ever any hanky-panky going on between my girls and Bill Oliver. That woman [Mildred Oliver] is nothing but a hash-house waitress. She never had two dimes to rub together. But somebody must have told her she could get rich by going after us. She's playing an extortion game, pure and simple."[6]

The twins tried to make themselves disappear in the single chair

they shared. Arnold's exasperation grew every time he posed a question to Daisy and Violet only to have Myer interrupt with an answer. Finally, Arnold rose from his chair. He firmly told Myer that he needed to hear the twins' side of the story if he was to handle their defense.

"Leave us alone. Close the door as you go into the other room. I want to ask the girls about this without you being present."

"You can't send me out," Myer protested. "I'm their guardian."

Arnold raised his voice for the first time. "They're over twenty-one, aren't they? They don't need a guardian. Now, will you leave us?"[7]

Myer's expression turned sheepish, and he left the room. Daisy and Violet were momentarily stunned. It was the first time they had seen anyone put Myer in his place.

Arnold's tone became avuncular. He already had some knowledge of the exploitation the twins had endured as Myer Myers' wards. He was a friend of Harry Hertzberg in whom Daisy and Violet had confided bits and pieces of their history.

Arnold tried putting the sisters at ease by telling them they really had little to fear from Mildred Oliver. She had filed the lawsuit in Missouri rather than a jurisdiction inside Texas, and he said it was unlikely that they would ever have to stand trial. If Daisy and Violet felt any relief on hearing the assessment, there was nothing about their expressions that changed. They still appeared to be terrified.

"You are two frightened girls," Arnold observed. "Isn't there something else wrong? Do you want to tell me?"[8]

His manner was one of friendly persuasion and because they had just seen him stand up to Myer, Daisy and Violet apparently believed they could put their trust in him. Starting at the beginning, they recounted how, just weeks after their births, they were given up by their own mother, and how, as tots, they were put on exhibit in taverns, wax museums, and carnival pit shows. They spoke so softly that Arnold

had to strain to hear them. Their story unfolded with one twin talk-ing for a time and then the other picking up the narrative. Their tale sounded Dickensian. Arnold was so mesmerized that he remained absolutely silent. For ten or fifteen minutes, the only sound in the room other than the sisters' utterances was the ticking of a grandfather clock. Then, startlingly, a single sob, ragged and muffled, issued from a corner the room. The twins abruptly stopped. Once again they appeared terrified. Martin Arnold was clearly chagrined. He swiveled his chair in the direction of a folding screen in the office.

"You can come out now, Miss Stotzer," he said.[9]

Stepping from behind the screen was Martin Arnold's embarrassed secretary, Louise Stotzer. A pretty woman with brown hair, she was holding a stenographer's notebook. She had become so absorbed in the twins' story that she had started sobbing.

"It was a strange experience for us to see someone crying over our predicament . . . ," Daisy would observe later. "We have never known self-pity."[10]

At Arnold's direction, the secretary settled into a chair beside the twins and Daisy and Violet resumed their story. The lawyer was astonished to hear that in the twenty-two years since they had first been placed on exhibition, the twins had earned hundreds of thou-sands, perhaps even a million dollars.

"What became of all the money you've earned? What about the beautiful home you have on Vance-Jackson road?"[11]

Though the ranch and the imposing new home sitting on it had been acquired with money they had earned, the property was in Myer and Edith's names. They told Arnold that while Myer had promised a few years ago to start giving them at least a small share of their earnings, he had made only one or two payments and then stopped altogether.

The meeting with Arnold and his secretary had lasted for forty-five

minutes. Myer had been outside in the anteroom the entire time, nervously pacing the floor. Before finally concluding his conference with Daisy and Violet, Arnold gave the girls very specific instructions. When they stepped out of his office and saw Myer again, they were to act as normal as possible and not reveal any of the details of their meeting. Arnold further instructed them to phone his office the instant they were dropped off at the studio of their voice coach for their weekly lesson. He said he would take care of all other details.

"I'll help you," he promised. "From now on you're my clients. You don't have to go home with this man."[12]

Like straws in a tumbling, racing river, for the next hour or so, Daisy and Violet were uncertain of the direction they were heading. But just as they had been instructed, they phoned Arnold as soon as they arrived at the studio of Mrs. Fred Jones, their voice coach. The attorney directed them to retrace their steps to the building's entrance and wait just inside the door. Daisy and Violet kissed their teacher goodbye and took their places at the building's front door. A cab appeared. Lucille Stotzer, the secretary, threw open a rear door of the vehicle and signaled for them to enter. Within minutes, Daisy and Violet found themselves cosseted inside a suite at the St. Anthony hotel, San Antonio's finest. There were flowers in the room, a radio, candies, magazines, and newspapers.

"Girls," Lucille told them, "you're Mr. Arnold's guests. Order anything you like. Telephone your friends. See if you can't enjoy yourselves."[13]

For a long time, Daisy and Violet could not believe that in the course of a single afternoon, their lives could have become so absolutely changed.

"It was like a dream . . . ," Violet said, remembering what it felt like for her and Daisy to make decisions on their own. "For the first time we could order something on a menu which we wanted. We had

dresses sent up, and ordered no two alike, and all the silly hats we wanted. We could dress and act our age, and no longer be made up as children with bows in our hair. We got permanents and pinned up our hair. I . . . always wanted to drink a cocktail. Daisy . . . always wanted to smoke a cigarette. We did."[14]

Martin Arnold, accompanied by Lucille, regularly visited Daisy and Violet at the St. Anthony in the days that followed. He had already begun to prepare the lawsuit against Myer and Edith. He would seek to have their guardianship rights terminated and ask the court to award the sisters a substantial financial settlement.

Daisy and Violet were deliriously happy. They paged through *Variety* and *The Billboard*, looking up their fellow performers. Among the first to get a phone call from them was Don Galvan, the Mexican troubadour. Even though Myer Myers had succeeded in preventing Daisy and Galvan from having any private moments together, Daisy said, "I always thought that Don told me with his songs and brown eyes that he loved me."[15]

Galvan expressed delight but no great surprise upon from hearing Daisy.

"I always hoped you would break away from him," he said. "I knew you'd call if you had the chance."[16]

Also getting a call from the sisters was Blue Steele, a prominent band leader whose orchestra had often been in the pit when the twins were playing the vaudeville theaters. Steele was at least twenty-five years the twins' senior. He was also married. Still, Violet believed the conductor had always been romantically fixated on her, and to some degree, maybe he was. Indeed, Steele never seemed to be shy about revealing his tender feelings toward Violet. There were times, in fact, when tens of thousands of people across America were listening in while he communicated his fondness for her.

Blue Steele and His Victor Recording Orchestra were regulars on

Saturday night radio broadcasts. The orchestra's signature song was a ballad written by Steele called "Darling." As the trombones lowly soughed the opening bars of the tune, Steele would pick up the microphone that piped his voice throughout the land. "Ladies and gentlemen," he would often declare, "I would like to dedicate this number to a real darling, Miss Violet Hilton. Vi, darling, wherever you are, whatever you're doing, this is for you."

There was a rap at the door of the twins' suite at the St. Anthony. The instant they opened the door, Violet felt the weight of her sister tugging her downward. Daisy's knees had started to buckle. Standing in the corridor was Don Galvan. Daisy was so surprised she couldn't even utter a greeting.

"He was even better looking than I remembered," she would later recall. "His dark eyes glistened and his teeth flashed white against his Spanish complexion."[17]

Galvan, too, had trouble saying anything. He had never before been so close to Daisy, at least not without Myer or Edith being on hand. Now he felt shy and awkward, especially with Violet standing by. Daisy, suspended in a state of expectancy, was trembling. After a moment, Galvan kissed her, but on the forehead rather than on the lips. The peck, if anything, only heightened Daisy's tension.

"It was disappointing," she complained later. "Don was 'Old World' and did not believe a man should kiss his . . . love otherwise before they were married."[18] Galvan told Daisy that he wanted to be near her throughout the trial. He said he had told his booking agent to suspend any further engagements until it was over.

Galvan called regularly at the twins' room at the St. Anthony Hotel in the days ahead. In preparation for the visits, Daisy put on her finest dresses, daubed herself with perfume, and had wine sent up to their room. The caballero could have completely had his way with her, but he always left Daisy frustrated. The only physical contact

between the two were the forehead pecks that he bestowed at the moment of their greetings and farewells. Even Violet was left disappointed by Galvan's decorousness.

"Gee, Daisy, I'm tired of waiting for Don to kiss you," she said after each of Galvan's departures.[19]

The Hilton sisters might have been San Antonio's most famous residents, but it was rare when any locals got to see the pair. When they weren't out on tour, they had been kept confined behind the brick walls of the family compound. Most San Antonians knew the twins only through the stories about them in the city newspapers. Invariably the local papers proudly referred to the Hilton sisters as "San Antonio's own." They always portrayed the sisters as being rich beyond imagination, glamorous, sublimely happy, and absolutely adoring of their guardians. The first suggestion that all had not been well at the Myers' ranch greeted San Antonians on the front page of the morning *Express* on January, 13, 1931:

FAMED SIAMESE TWINS
KEPT IN BONDAGE,
ACCOUNTING SUIT SAYS

It had become official. The day before, acting on the twins' behalf, Martin J. Arnold filed the lawsuit. In their court papers Daisy and Violet stated that virtually all the assets listed in the names of Myer and Edith Myers—the ranch and other real estate, the stocks and bonds, the savings accounts—had been acquired with the Hiltons' earnings. They petitioned the court to establish the value of the assets and award them an equitable share of the holdings. They also asked the court to nullify a contract that committed the twins to keep working for Myer Myers at least until March 31, 1937. The contract had no validity as a legal instrument, the twins contended in their court papers, because when they signed the papers on April 1, 1927, they

were still minors and had no real understanding of the document's terms or binding clauses.

Within days after news of the twins' lawsuit exploded in the San Antonio newspapers, other papers across the country started running accounts of the Hiltons' lives, some of them suggesting that not since the Dark Ages had two children been more cruelly exploited and mistreated. The papers painted Myer as one of the most fiendish souls the world had ever known, a man so greedy and morally base he enslaved children who, because of their extreme physical deformity, already had been doomed to lives that were tragic beyond imagining.

In hopes of implementing some damage control, Myer and Edith welcomed reporters into their home so they could present what they claimed was the true side of the story. They represented themselves to be the real victims in the case, insisting they had taken in the orphaned sisters not out of greed, but because they could not have loved Daisy and Violet more if the two had been their own issue.

Edith, in one tearful interview with the *San Antonio Light*, said she could offer no explanation why Daisy and Violet would have betrayed the two people who cared most about them. Over and over, she emphasized that she had cared for the sisters almost from the instant of their births when their own mother rejected them out of fear and revulsion.

"They don't seem to be making any allowances for the time I have spent with them, constantly caring for them, and attending to their wants," she sniffled. "I have spent the best part of my life in their interests, and now they ignore me. Why, they didn't even send me a Christmas card."[20]

Myer, too, expressed bewilderment at why Daisy and Violet had turned on him.

"The girls must have the idea that they can make 'whoopee' like other young people," he said, "but they can't do it. They would

appear obnoxious and out of place. My wife and I have tried for four-teen years to take the girls to all places possible, constantly taking them to theaters, dances, and other places, but they can't fit in with that kind of life and should realize it."[21]

The Myers' declarations to the press of their piousness and selfless-ness did not seem to have won them much sympathy in San Antonio. Whether they were shopping for groceries or stopping at the post office, they were scorned by most locals. If Myer had anything at all about which to be thankful, it was that frontier justice no longer pre-vailed in Texas. There were San Antonians who believed he was so reprehensible that he should be run through a gauntlet and then strung up by his neck from the highest pole in the Alamo plaza.

*Twelve*

# FREEDOM WAS THE MOST IMPORTANT

It was still dark on the morning of Friday, January 16, 1931, when the crowds began massing by the hundreds on the square outside San Antonio's Bexar County Courthouse. It was the day the trial of Myer and Edith Myers was to begin. Pandemonium broke out when, at 8 A.M., the doors to the red stone building were opened. Curiosity seekers, most of them women, rushed through the corridors to the courtroom of Judge W. W. McCrory. A few spectators were nearly trampled in the stampede.

Within minutes, every seat in the courtroom was filled. The bailiffs permitted 700 spectators to squeeze in—by far the biggest crowd ever for a San Antonio trial. A like number of people had to be turned away because there wasn't room for them. Having the best seats in the house, on the aisle and in the front row just behind the rail, were McCrory's wife, Ethel, and his five-year-old grandson, Travis. Also filling the prime front rows were dozens of courthouse employees, most of them stenographers and clerks who had abandoned their jobs. A reporter for the *San Antonio Light* counted fifty attorneys among the spectators. Like everyone else, they were anxious to see the Siamese twins, but an equally powerful drawing card was Martin J. Arnold. It had been a long time since the brilliant attorney had been seen in any courtroom.

The entrance of Daisy and Violet Hilton could hardly have been

more dramatic. They entered the courtroom from the rear, ringed by five or six deputy sheriffs. They were wearing silver fox coats with outrageously large collars. Their eyelids were kohled and their cheeks were heavily rouged. They had recently had themselves shorn of their waist length, schoolgirl curls. Their brunette hair was now short and bobbed in the style of flappers.

A few spectators poked their hands through the cordon of body-guards just to touch the two. Daisy and Violet seemed unfazed by the stir their entry caused. They smiled brightly and waved to the spec-tators calling out their names. After they made their way beyond the rail, the deputies helped them remove their furs. The hubbub in the seating section quieted as the crowd got its first good look at the sis-ters. Daisy and Violet were wearing ankle-length, dark blue silk dresses that were joined together at their waists to conceal the fleshy tie between them. It was not just the close fusing of their bodies that made them such a sight to behold. They were so child-like, so achingly pretty and so tiny, standing barely five feet tall even in their high-heeled shoes.

Judge W. W. McCrory was tall and gaunt and had lank gray hair that fell down the right side of his head. His eyes were sunken into deep, dark sockets, and his face was so chalky and so tightly stretched that, from just a few feet away, his head appeared to be a naked skull.

McCrory had hardly settled into his place behind the bench when Martin J. Arnold charged forward. He immediately directed the judge's attention to the defense table where the Myers' two attorneys, T. J. Saunders and Will Barber were seated. Myer and Edith Myers were nowhere to be seen.

"The arrogance of this man and his wife," Arnold bellowed, his voice crackling with indignation. "The effrontery. A good part of San Antonio is here with us this morning, but the defendants themselves

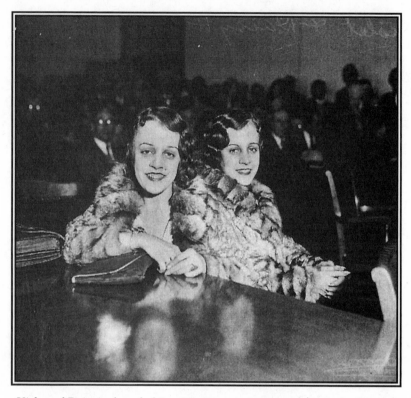

*Violet and Daisy in the packed San Antonio courtroom, 1931. (Author's collection)*

didn't show up for their own trial! They've tried to turn these pro-
ceedings into a sham."[1]

Arnold demanded that Myer and Edith be cited for contempt for
their failure to appear in court and asked the judge to immediately
issue a bench warrant for their arrest. He also moved that the two
defense attorneys be held in contempt because of their failure to ensure
their defendants were present for the proceedings. Long practicing
attorneys in San Antonio, T. J. Saunders and Will Barber knew
McCrory didn't have a reputation for being lenient with anyone who
tried to subvert the legal process. Even they appeared to be discon-

certed by their clients' absence from the courtroom. Still, they felt that they had to make some effort at damage control. They conferred with one another in whispers.

Finally, Saunders addressed McCrory. "We're here to represent them," he said of the missing defendants.

Arnold pirouetted a quarter turn so he was facing the defense attorneys. He placed his hands on his slightly rounded waist and scoffed. He insisted the trial could not proceed without having the defendants in the courtroom and accused the defense lawyers of concealing the whereabouts of Myer and Edith Myers in the hope they would not have to testify.

"I intend to use Myers as the first witness," Arnold declared. "I also demand that Mrs. Myers be present as I intend to use her as a witness."[2]

As Arnold carried on, Saunders rose from his chair and once again tried to persuade the judge that there was no need for the Myers to be present.

"We're here to represent them," he repeated.

Arnold looked to Saunders and sneered.

"Do you mean to say that the defendants are trying to dodge these proceedings?"[3]

"They're not trying to dodge anything!"

Arnold countered with a surprise blow.

"Since Mr. Thomas J. Saunders claims there is no need for the Myers to be here, your honor, and since Mr. Saunders would have the court believe that he knows fully how the defendants would testify if they were here, then, your honor, I would like to put Mr. Saunders on the witness stand."[4]

Saunders suddenly looked ill. He tried to interpose an objection, but McCrory was clearly irritated that Saunders and Barber had not been able to ensure the presence of the defendants in the courtroom.

McCrory granted Arnold's motion for an opportunity to examine Saunders on the witness stand.

Cheers and applause rang from the spectators' section as Saunders left his place behind the defense table and climbed the steps to the stand. The crowd's sympathies were clearly on the side of the twins. There was a twinkling in Arnold's eyes.

"Have you seen Myers this morning?" he asked his witness.

Saunders was visibly humiliated, but he muttered a reply. "Yes, I saw him. About an hour ago."

"Here?"

"Here in San Antonio."

"Did you see him in your office?"

"Yes."

"Where did he go after he left?"

"I do not know."

"Where is he now?"

"I do not know."[5]

Saunders kept cutting imploring looks at his colleague to do something to get him off the witness stand. Barber sensed his partner's discomfort, but he seemed at a loss for what to do. Finally, Barber asked the judge for a recess to see if the two sides could enter some kind of truce. The lawyers met in McCrory's chambers.

Saunders did not return to the witness stand when the hearing resumed in the courtroom fifteen minutes later. Instead he stood before McCrory and made two announcements. He said the defense was joining with Arnold in asking that the hearing be adjourned for a couple of days. Saunders also assured the judge that Myer and Edith Myers would be present if the proceedings could be delayed.

When he referred now to Martin J. Arnold, Saunders' tone, at least for the moment, had turned decidedly more deferential. He had been humbled when Arnold placed him on the stand. He certainly didn't

want to cross his adversary in a way that might return him to such a humiliating predicament.

"We will furnish counsel for the plaintiffs with any document in our possession if he will furnish us with a list of those desired," Saunders volunteered solicitously.[6]

McCrory agreed to adjourn the hearing for two days, until the following Monday.

The opening day proceedings lasted just forty-five minutes. Like boxing fans who had paid good money to see a championship fight only to see a knockout in the first round, the crowd seemed resentful that the drama was over so soon. Ignoring the bailiffs who ordered them to stay back, they rushed past the rail to more closely ogle the twins. The first person to shake Daisy and Violet's hands and wish them luck was the judge's wife, Ethel, and right behind her was W. W. McCrory himself.

Daisy and Violet chatted amiably with the fans swirling around them as they autographed copies of the *San Antonio Light* and *San Antonio Express* that carried their pictures on the front page. They were swarmed by press photographers and newsreel cameramen. When some of their well-wishers blocked the view of the photographers, the twins, always intent on selling themselves to the largest public possible, politely directed their fans to move to the side. Over and over, they were asked how it felt to be in the spotlight of a courtroom.

"It's different from a stage," Daisy answered. "You don't have the footlights and all. But we like it. It's fun finding out how many friends you have in the world."[7]

Just before the trial started, the twins had moved from their suite in the St. Anthony Hotel to an apartment on Burr Road. There they received hundreds of letters and telegrams from people across the country who had read the newspaper accounts of their lives and wanted to wish them success in their battle with the Myers. Among

the letters were several from old acquaintances in the carnival and vaudeville worlds who offered to appear as witnesses to support the twins' charges that they had been kept in bondage. The most unexpected wire of all came from someone of whom the twins had only the dimmest memories, Ike Rose. The showman was in Waterloo, Iowa, where he was presenting his latest stage venture, "Ike Rose and His Twenty-Five Royal Midgets."

Rose had not forgotten that nearly two decades earlier, while the twins were touring Australia under an exclusive contract with him, Myer had "kidnapped" the girls. In wires to their attorney as well as to the twins, Rose said he would travel to San Antonio to "tell the true story of the girls."[8] He claimed in his communication that he had suffered incalculable losses because Myer pirated the twins from him and said that when Daisy and Violet finished the suit against their warders, he, too, was going to bring Myer to trial and demand half a million dollars in damages.

When he heard that Rose was threatening to start a second action against Myer Myers, Thomas J. Saunders said neither he nor his clients had the slightest fear. Indeed, Saunders seemed almost to dare the twins' one-time manager to start a lawsuit. He said Rose had the chance to promote the twins to stardom and, because he was an "inferior showman," botched the opportunity. He further observed that the Hilton sisters had become nationally famous only because of Myers' brilliance as a talent presenter and promoter.

"My clients say that Ike Rose . . . is only a notoriety seeker," Saunders told the press, "and if he manifests any interest in the twins, it will be for a selfish purpose, hoping to gain employment from them. My clients vehemently deny all statements made in his telegram. . . . My clients are well-acquainted with him and his past activities. We do not believe for a moment that Ike will appear on the scene during the trial and take the stand and subject himself to cross-examination."[9]

It isn't known whether Rose ever consulted a lawyer about filing a lawsuit. And for all Rose's bluster about getting even with the Myer, he never made his promised appearance in San Antonio.

Because accounts of the opening day of the trial so dominated the newspapers and radio broadcasts in San Antonio, the public interest in the case swelled over the weekend. By the time the sun rose on the morning of January 19, 1931, there were thousands of people in the courthouse square. Many mothers had small children in tow, hoping they could give their kids a look at real Siamese twins, and the city's schools reported high rates of absenteeism.

Judge McCrory's courtroom was absolutely jammed a minute after the bailiff unlocked its door. A few women found their way into an anteroom and, by standing on a table they had pushed before a locked door, peered into the courtroom through a transom window. Many of the San Antonians who didn't make it into the courtroom became testy when uniformed deputies ordered them to clear out of the corridors and leave the building.

As Saunders and Barber had guaranteed the preceding Friday, Myer and Edith Myers were in the courtroom that day. There were hisses from the onlookers when Martin Arnold called Myer to the witness stand. McCrory banged his gavel. He warned that he would eject any spectators who could not keep their opinions to themselves while in his courtroom.

"This is not a show," he lectured sternly.[10]

Myer's anger at having been made to stand trial was only intensified by the crowd's hostility toward him. After settling his portly frame into the witness chair, he glared at Daisy and Violet for a moment and then turned his head away in disgust.

Attorney Martin Arnold's objective became apparent from the start of his examination. He set out to show how the Myers had become wealthy by cheating the twins. He began his inquiry by asking Myer

about a receipt signed by Daisy and Violet in 1927 that indicated they had received $36,142 from their warder.

"Isn't it a fact that they signed this receipt, but never received the money?" Arnold asked, waving a slip of paper in the air with a well-manicured hand.

"I don't know. They were paid through my bookkeeper in New York."

"Don't you know where the $36,000 went?"

"I don't know."

"What bank do you do business with?"

"I don't know."[11]

The audience guffawed at the preposterousness of this claim. Arnold continued to probe, and the witness continued to profess ignorance of any bank or banks in which he had funds, stating that all his financial affairs were handled by Herman Klein, whom he identified as a New York bookkeeper and the husband of a cousin.

Arnold returned to the subject of the $36,142 receipt. He spaced his words and even the syllables of his words apart, like a sharpshooter carefully squeezing off rounds to confine all the bullets to the bull's-eye.

"I—am—ask—ing—a—gain: Did—the—girls—get—that—mon—ey?"

Myer was silent for fully thirty seconds. Finally, he admitted that they had not.

"Where is that money, Mr. Myers!?" Arnold asked, his voice rising.

Myer's face seemed to flatten momentarily as though squashed by the force of Arnold's words. "All my money was deposited in the Trade Bank of New York or the City-Central Bank of San Antonio."

"You mean to tell this court that you took this money belonging to your wards and just used it?"

"All that was handled by Herman Klein. . . ."

Arnold next asked Myer how much the Hilton Sisters act was

paid in 1925, the twins' first year on the vaudeville circuit. Myer referred to a piece of paper on which he himself had written some fig-ures: "Seventy-nine thousand, three-hundred and eighty dollars and eighty cents."

Arnold delivered a surprise. He produced a copy of the performers' contract the twins had with Marcus Loew's corporation. It showed that Daisy and Violet, in fact, were guaranteed $114,000 under their initial agreement with the Loew chain.

Myer shifted in his seat. His face became redder.

"Well tell us what became of the $36,000 that was left?" Arnold insisted.

"I cannot answer that question," Myer mumbled. "I do not know."

"Do you claim to be a businessman?"

"In a way. All these matters were handled by my bookkeeper."[12]

Next Arnold produced a contract that showed the twins earned $3,850 a week in 1926, while touring vaudeville houses. The attor-ney asked Myer how much money the twins saw.

"It all went into one lump, into the family treasury."

"So it was just a family affair?" Arnold clarified.

Myer spat out his reply. "Yes, and a happy family, too, until you stepped in and corrupted it."

Arnold exploded. His attention turned from the witness to the judge.

"If this man makes another remark like that, I am going to ask the court to protect me, or I will protect myself."[13]

Thomas J. Saunders tried to ease some of the tension. He instructed his client to only answer the questions and to refrain from making any personal attacks on the plaintiffs' attorney. Judge McCrory, too, cen-sured Myer. He said he would not countenance any further outbursts from the witness.

Arnold insisted on having the final word.

"I do not wish to turn this into a personal matter," he warned, "but I will do so if I have to."[14]

He then began a searching examination of the defendants' assets. Myer placed the value of the ranch property and new home on Vance Jackson Road at $150,000. He said a 300-acre farm he owned in Atacosa County, Texas, was worth $28,000, and claimed that a few small houses he owned in the city of San Antonio were not worth more than $1,000 or $1,500 a piece.

Myer estimated the total value of his investments in stocks and bonds at somewhere between $35,000 and $40,000.

"All this property was bought with money earned by these little girls since you became their manager, was it not?" Arnold asked.

"It was bought with *my* money!" Myer retorted.[15]

Arnold asked why Daisy and Violet never saw anything of the money they earned. Myer made the ridiculous claim that, over the years, he had spent more than $100,000 on private tutors for Daisy and Violet, thus, he had never been in a position to make large cash outlays to the sisters. When Arnold pressed him to recite the names of the tutors, Myer came up with only one, Ray Traynor, who served as the twins' emcee and accompanist during the first year they were touring vaudeville.

On further pushing from Arnold, Myer said he paid Traynor $100 a week. Myer's face grew redder when he realized he had been caught in a lie: At a salary of $100 a week, Traynor would have had to have been on his payroll for nineteen years to earn as much as $100,000. But Myer tried to convince the judge that he employed Traynor only because he wanted the twins to have the best musical schooling available. "We did not need him in the act, but took him with us simply to give the girls music lessons," he testified.[16]

In an effort to further justify why he withheld their money, Myer claimed the twins were incapable of handling financial matters. At

this point, a smile crept over Arnold's face. He made reference to a court proceeding that Myer started four years earlier when the twins were nineteen. As a result of the legal action, Myer and Edith were granted full guardianship of the sisters, including complete control of their earnings.

Arnold looked Myer squarely in his eyes. "You filed that application, did you not?"

"Yes."

"Why did you do that?"

"Well, there were several reasons. I was advised that it would be necessary so they could sign their own contracts."

Arnold's bushy white eyebrows rose into great arches and his frown lines deepened. His expression became one of incredulity.

"So knowing these little girls were incapable of handling their financial affairs, you went into court and had the protection the law gives them set aside so they could sign a contract with you?"

"Well, there were other reasons. I do not mean to say these girls are crazy. They are far more intelligent than most girls their age, but they don't understand business. Every time I would mention business matters to them, they would fly into a rage and tell me they did not want to know anything about it, that they did not care for money."[17]

Arnold produced only a few of the many performing contracts the twins had signed in the previous half dozen years or so, but even these documents provided evidence that Daisy and Violet had earned more than $500,000 during that period. Arnold seemed determined to learn whether the defendant had anything resembling a conscience. He asked Myer whether he did not feel a twinge of shame for not seeing to it the twins received even some small portion of the money.

"They always told me they did not need money, that they wanted for nothing and knew of nothing on which to spend it. There was no use in giving it to them just to let them throw it around."

"So, you just took it yourself."

"Well, I was not going to throw it in the gutter."

"So you considered it your money? It did not occur to you to save it for the use of your wards?"

"I considered it my money."[18]

Throughout Myer's testimony, spectators hissed and snorted at the witness's repeated claims that Daisy and Violet so disdained money that they would refuse it even when it was offered to them. The twins themselves delighted in these public shows of scorn. Whenever they heard tittering in the gallery, they spun in their chair toward the spectators and giggled like schoolgirls. Most of the outbursts in the gallery now went unremarked by Judge McCrory, and he had stopped banging his gavel. He seemed to have concluded the witness's answers so stretched credulity that the audience's reactions were unavoidable.

Arnold turned to the subject of the new home on Vance-Jackson Drive in which Myer and Edith and their daughter were living. Myer insisted the home and all its furnishings, including its collection of Chinese antiquities and Oriental rugs, had been purchased entirely with his own money. In an attempt to trip up the witness, Arnold referred to a two-page story on the grand residence that appeared in 1927 in a Sunday edition of the *San Antonio Light*. The spread was headlined: "This Is the Birthday House San Antonio's Siamese Twins Gave Aunt Who Mothered Them." Arnold asked if it were true, as the *Light* reported, that the twins had made a gift of the house and all its furnishings to Edith Myers. Myers drew himself up in his chair with an air of pride and smugness.

"That was just a big publicity splash I cooked up. You know, showmanship."[19]

The crowd groaned in disgust.

After a long exploration of all the real estate in Texas and New York held in the names of Myer and his wife, Arnold questioned the

witness about his conduct toward the twins. He asked if there had been occasions when he directed profanity toward his wards. Myer conceded there may have been times when he raised his voice at the twins and "may have used a few mild curse words" but said he could remember only one instance when he directed strong language at Daisy and Violet. He recalled blowing up while the three of them were traveling by car and the twins were engaging in "a lot of back-seat driving." Myer said that Daisy and Violet were mocking his manner of driving and he finally erupted when he glanced into the rearview mirror, and one or the other of the sisters said, "I wonder what that son of a bitch is looking at?"

"Did you ever strike them or threaten to strike them?" Martin Arnold asked.

"Never in my life!" Myers shouted. "I never raised my hand against them!"[20]

Myer's denials drew smirks from a middle-aged woman sitting directly behind the table where Daisy and Violet were seated. She leaned forward and whispered something to the twins. They smiled and shook their heads in agreement.

Myer occupied the stand for five or six hours before Arnold concluded his examination. Next he called Mrs. Erma Wyams to testify, the woman seated behind the twins. She said she had worked for the Myers as a housekeeper and she clearly remembered a time when Myer had loudly cursed the girls as they sat across from him at the dinner table. On that occasion, she said, Myer rose from his chair and began slapping Daisy and Violet. Mrs. Wyams said her husband, the Myers' yard man, made a move to interfere in the confrontation, but she stopped him.

Martin Arnold had scheduled the twins to appear on the witness stand on the third day of the trial. The hearing was not set to resume until 9:30, but by 8:02, two minutes after the courtroom was opened,

all the seating and standing room was taken. As the deputy sheriffs were trying to push the courtroom doors shut, the crowd in the corridor tried to make a desperate push through the entranceway. There was a crashing of glass. One woman was pushed part way through the outer door. She was cut and bleeding and had to be rushed to a hospital for treatment.

Cheering and applause rang out when Arnold called the twins to the witness stand. McCrory pounded his gavel to restore order. "Spectators must respect the decorum of the courts or they will be removed," he warned.[21]

After being sworn in, the twins settled into the witness chair. Because of their smallness, their feet dangled a foot above the floor. F. C. Raeber, the court clerk, had a solution that drew laughter from everyone, including the judge. He stacked several fat, criminal court dockets beneath their feet.

Because Violet was to the left of her sister and, thus, nearest to the judge, Arnold designated that she answer the questions. He began by placing into evidence a copy of the 1927 court document that named Myer Myers as the twins' legal guardian and gave him control over their careers and their earnings. Arnold instructed the sisters to study the handwriting on the dotted line and asked them whether these were their signatures. Violet verified the signatures were theirs, but testified that neither she nor her sister knew the contents of this document nor any of the others they signed on Myer's orders. She said that whenever Myer presented them with contracts or other papers to sign, he always kept the contents of the forms covered with a book or a blank sheet of paper. If they asked him to explain the papers he wanted them to sign, he exploded. "When we hesitated, he would rave and ask us if we thought he was a thief and if we didn't trust him. We were always afraid, so we always signed them."[22]

Violet sometimes had trouble separating her own experiences from

those of her sister while testifying, and frequently used the pronoun "we" when answering questions. On occasions when she hesitated before replying to a question, Daisy tried prompting her with whispered answers. Once, when Violet was reciting the names of private tutors they had had over the years, she paused and turned to Daisy. "Can you think of any more, dear?"

Arnold spoke. "Please confine your testimony to what you yourself remember, Miss Violet."

Violet smiled. "I will do my best."

Arnold produced the receipt signed by the twins that indicated Myers paid them $36,142.67.

"Is that your signature?"

"Yes, sir," Violet answered

"Did you ever get one dollar of that money?"

"No, sir."

"Did you ever make Mr. Myers any presents of money?"

"No, sir."

"Did he ever tell you he was putting the money away for you or offer any explanation of what was done with the earnings of you and your sister?

"No, sir."[23]

Violet revealed that Myer treated her and Daisy as prisoners, and that while she and sister had often talked of fleeing, they were too afraid.

"He told us we were born in England and had no rights in this country," she said. "He said that if we ever left him, he would send officers after us and have us placed in an insane asylum so what would have been the use?"[24]

Violet also testified that Myer was so single-minded about advancing his fortune, he even refused to let her and Daisy attend church because he couldn't bear the idea of people seeing the pair without

paying for the privilege. "We were taught to do our praying at home," she said.

Arnold concluded his examination of Violet by asking whether she or Daisy ever cursed their guardian.

"I never swore at him but once when he had used every foul word he could think of to call me, I called him a beast. That was the worst I ever called him."[25]

Under cross-examination by Saunders, Violet testified that, unlike Myers, Edith usually treated her and her sister kindly, and looked after them as though they were her own daughters.

"Has Mrs. Myers always been good to you?" Saunders asked.

"Most of the time," she replied

"Has she been like a mother to you?"

"Yes, possibly so."

"You loved Mrs. Myers, did you not?" Saunders asked.

"Yes, we did."

"You love her now, don't you?"

"No."

"When did you cease to love her?"

"In about 1929, when we found out that we were not being treated right."[26]

Saunders opened his defense of the Myers by calling Edith to the stand. She looked old beyond her forty-seven years. Her hair had become the color of cigar ashes. Rheumatoid arthritis had twisted her hands into grotesque claws. She wore a shapeless dress.

Edith wept openly much of the time she was on the stand. At least at first, she came across as a sympathetic witness, one who seemed conflicted over her own ideas of what was right for the twins and what her husband thought was best. She testified she had tried to act as a mother to the girls.

"I have always loved them and always will love them," she said in a tremulous voice.

Scores of women in the audience daubed their eyes with handker-chiefs as Edith related that the twins' mother had been so repulsed and frightened of the babies she had brought into the world, she refused to nurse them or even hold them. Edith recited the history of her own involvement with Daisy and Violet, from the time they were placed in her arms as week-old babes, noting their weakness and Daisy's deformed leg.

"The doctors told us they could not possibly live, and that even if they did live, they could never walk. My mother and I massaged the deformed limb daily and it gradually straightened when she was about seven years old. The girls learned to walk when they were about three years old."[27]

Daisy bit her lip and her face became flushed as Edith recalled the long and daily sessions of massaging the crippled leg. Both twins seemed pained that Edith had been included as a defendant in the trial. They stared downward at their hands.

Edith said that because Daisy and Violet had entered the world with such a severe deformity, she and her mother believed it was important for the twins to be especially well educated and, as a result, great care was exercised in choosing their tutors.

"We gave them the best teachers we could find," she sobbed. "I wanted them to be smartest freaks that ever lived."[28]

Edith testified that the sisters had always been affectionate toward her, but that they had begun to change about two years earlier.

"The girls came to me in 1929 and demanded to know who their mother and father were. I asked them if they really wished to know, and they replied that they did. Although I was asked by their mother many years ago never to tell them of their birth, I finally told them the story. When the girls learned that Kate Skinner was a single mother, they said such bitter things about her I can't repeat them in the court-room. They told me they had always been under the impression their

father was an army officer. Where they got this idea, I do not know. At last I told them how we came to have custody of them, and their entire attitude changed towards Mr. Myers and me. At times they would be affectionate towards me and at other times bitter. They grew very unkind towards my husband and cursed and abused him on every occasion."[29]

Edith denied she and her husband tried to hold the twins as their prisoners. She also rejected the twins' claim that her husband sometimes threatened to have them deported or committed to an insane asylum. She presented such moving testimony about her role in mothering the twins that even the judge's wife was sniffling.

Martin Arnold was asked by McCrory if he wished to cross-examine Edith. The lawyer knew the judge might regard him with disfavor if he showed too much harshness while questioning her. At the same time, he wanted to impress upon McCrory that the witness might not be quite as saintly as she portrayed herself to be. Arnold asked Edith if she had always been willing to give the twins what they wanted. She replied that she had.

"Are you willing to give them that $36,000 for which they signed a receipt and did not get?"

He scraped a nerve. "I have nothing to do with the money," she replied, her voice rising.

Arnold bored deeper. "Since the girls have been in your care, they have earned about $500,000, have they not? How much of that do you want to take?"

Edith lost all of her self-possession. Her face became twisted in an ugly way.

She screamed, "How much do *you* expect to take!?"[30]

Arnold maintained his sangfroid. He continued to address Edith in a calm manner. He told her he believed her claim that she felt love and pity for the twins from the instant they were born, but he wondered

if, from the beginning, she also might have had some mercenary inter-
est in the pair. He asked if it wasn't true that she and her mother and
stepfather, Mary and Henry Hilton, put the twins on exhibit almost
from the day they took the babes from their mother and carried them
into their "beer hotel" in Brighton, England.

Edith finally admitted that, well, yes, she and her mother and step-
father had taken in the twins because they saw them as an attraction
that could help drum up business at the Queen's Arm pub. She also con-
ceded that as an inducement to get people to buy drinks and meals at
their establishment, the patrons were presented with the opportunity
to enter the parlor in back of the bar to see the Brighton United Twins.

Except for Edith Emily Myers, no other witnesses were brought
forward by Saunders and his co-counsel, Will Barber, to contradict
the testimony by Violet and others that the twins had been enslaved
and cruelly exploited by their guardians. Judge McCrory directed the
attorneys from both sides to present their final arguments.

Martin Arnold concluded his summation to the court by reading
from a slip of paper he said had been handed to him by someone in the
gallery. The paper bore a single terse statement "A farmer feeds and
provides harness for his mules." Clearly he wanted to leave the judge
with the final impression that even though Myer had accumulated
kingly wealth by enslaving and working Daisy and Violet Hilton, he
showed less respect and kindness toward them than the farmer pro-
vides for the dumb animals that work his land.

Saunders bristled at Arnold's use of the aphorism. "Which one of
your press agents gave you that?" he retorted.[31]

When he was given his turn to present his closing arguments,
Saunders portrayed Myer Myers as a martyr who had dedicated much
of his life to Daisy and Violet Hilton only to be betrayed by them. He
also used the occasion to fire salvos at the people in San Antonio
who seemed so anxious to see the defendant pilloried and stoned.

"I knew my client was at a disadvantage when he took the stand due to the mob rule of the audience," he said. "It was mob rule that crucified Christ and sent Bunyan to prison. Though scoffed at by the rabble, Mr. Myers sat there and told truth after truth. I knew he'd make a bad impression. If there is any condemnation coming from the bench at the end of this hearing, it should denounce Mr. and Mrs. Myers for giving these girls too many luxuries."[32]

Saunders said it might be easy to condemn the Myers solely on the basis of the testimony adduced in the courtroom, but he asked McCrory to try to imagine what the Hilton sisters' lives would have been like if they had not become the wards of the couple. The Myers looked after their schooling, brought them to America, and, through Myer's genius at promotion, turned them into world-class entertainers.

Judge McCrory didn't waste any time presenting his findings. Upon the conclusion of Saunders' final arguments, he spelled out his orders:

He enjoined the Myers from interfering "in any fashion" in the twins' future affairs. He also decreed that the Myers and their attorneys were to return to the court with detailed records of all the twins' earnings in the past half-dozen years. He also ordered the Myers to produce records for all the real and personal property and all the stocks and bonds listed in their names.

McCrory appointed Joe Freeman as a receiver for the twins. Freeman was one of the country's leading cotton exporters.[33] He was also a cattle rancher, the owner of a large Chevrolet dealership, and had seats on both the New York Stock Exchange and the New Orleans Cotton Exchange. He was one of San Antonio's wealthiest and most respected citizens. Freeman was to be entrusted with looking out for the twins' future interests, including reviewing any future performing contracts that might be offered to them.

While granting the twins everything they had asked for in their petition, McCrory conceded Saunders' point that Myer Myers was indeed a promotional mahatma who had rescued a pair of the most pitiable souls from the heap of human wreckage and turned them into national celebrities. The judge, in fact, likened Myer's promotional abilities to those of another professional exploiter who had elevated a complete unknown into a superstar.

"Jack Dempsey was nothing but a ham-and-egger until Jack Kearns took hold of him and developed him into a national champion," he declared. "The Hilton twins would not be where they are today had Myers not managed their affairs and proved himself a good promoter."[34]

Ultimately, after reviewing the records of all the Myers' property and investments, McCrory ordered Myer and Edith to turn over $100,000 to the twins, about $80,000 of which was in cash and securities, and another $20,000 of which was in personal effects, including their costuming.

The twins were jubilant over the settlement.

Said Violet: ". . . Our freedom was the most important, and that part of the court decision which gave the freedom rang loudest in our hearts. We did not care that the palatial home and grounds were given to Edith and Sir; other properties, too. Perhaps they earned them."[35]

A few nights after McCrory handed down his decision, Arnold and his wife threw a victory party at their lovely English Tudor house on Argyle Street. The event attracted a good slice of San Antonio's social register. There were judges, politicians, and assorted millionaires in cattle, oil, cotton, and stocks.[36]

Daisy and Violet were the guests of honor, of course, but attracting almost as much attention at the party was another national celebrity, the bandleader Blue Steele. Was there something going on

between Steele and Violet? Was it merely coincidental that he signed his orchestra to an extended engagement at the St. Anthony in downtown San Antonio soon after Violet phoned him in Memphis to report that she and her sister were luxuriously encamped at the hotel?

It was an era when bandleaders excited as much public worship as motion picture idols did. If Blue Steele was merely seeking a paramour, why a Siamese twin? As a major recording artist on the Victor label and a regular radio performer, he was one of the most widely known baton wavers in America. He was more than comfortably well off. And while he would not have presented a serious challenge to either Rudolph Valentino or Douglas Fairbanks in a beauty contest, he was ruggedly handsome. Even the musicians trouping with Steele were mystified that their boss would cultivate an extramarital relationship with a woman as visible as a Siamese twin. Perhaps his fascination with Violet was less libidinous than it was teratological.

Whatever the attraction was between Blue and Violet, the party at Martin Arnold's home probably didn't provide the two with many opportunities to take much pleasure, carnal or otherwise, in one another's company. Both were encumbered with crowds of well-wishers throughout the night.

Don Galvan, Daisy's ardent admirer, had remained in San Antonio throughout the trial, and he, too, was at the victory party. He spent much of the evening strumming his guitar and serenading the guests. With his dark good looks and plaintive ballads, he did melt hearts, but Daisy's was not among them. Because there was never a time when the twins were not being entertained by other admirers, the shy Galvan couldn't get near her.

As rare as Galvan's glimpses of his heartthrob were that night, he was troubled by what he saw. During all the years he had gazed at Daisy from the wings of vaudeville stages, he had been mesmerized by

her little-girl, almost angelic, demureness. Now she seemed changed. He was in pain at the sight of the child-woman who, all night long, held a cigarette in one hand and a drink in the other and coquettishly batted her long, mascara-blackened eyelashes at every young man who looked her way.

Daisy and Violet remembered the night of their liberation party this way: "We drank wine and smoked. Two young men begged us to dance. The 'don'ts' of our childhood were all 'dos' now, and we reveled in it. It seemed as though we had been transported to another world. We looked forward to a future promising real happiness."[37]

## Thirteen

# THEY WERE JUST AVERAGE GIRLS

The euphoria Daisy and Violet felt at being released from so many years of bondage was not swiftly dispelled. In the days, weeks, and then months that followed the trial, they showed a capacity for celebrating that bordered on the hedonistic, if not self-destructive. They seemed relentless in their attempts to make up for all their years of social deprivation.

Overnight, the twins had become San Antonio's darlings. Their names appeared on the guest lists of almost every celebration held in town, from childrens' birthday parties to the elegant soirées of the wealthy, with strolling mariachi bands and platoons of waiters balancing trays of piña coladas and hors d'oeuvres. To the extent it was possible, Daisy and Violet made appearances everywhere they were invited.

Like the working classes almost everywhere in the country, San Antonio's toiling ranks had been ground down by the Great Depression. Signs of the skid in the economy were everywhere to be seen in San Antonio. Many of the downtown shops sat abandoned, their doorways littered with whiskey bottles and discarded newspapers folded to the Help Wanted sections that most days were blank. Men gathered on every street corner at daybreak, hoping a rancher would appear in a truck and haul away a few lucky souls to day jobs.

The trial had offered some distraction from the wearying monotony

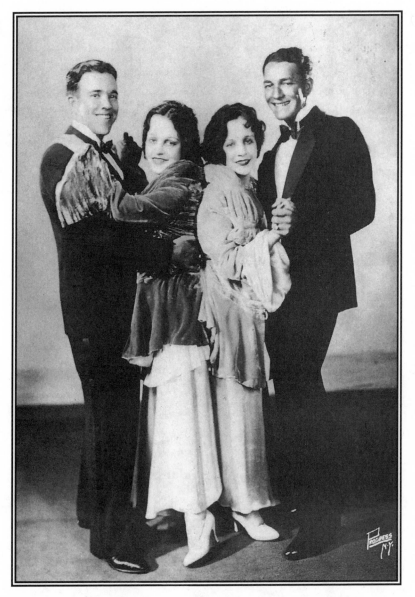

*Violet and Daisy Hilton with Gober Hodges (left) and Danny Mack (right), 1931.
(Courtesy of the Hertzberg Circus Collection, Witte Museum, San Antonio, Texas)*

of sacrifice and scrimping that most of San Antonio's working-class families were experiencing. And because the trial's outcome was a happy one for Daisy and Violet, it may also have provided a ray of hope to people who, after three years of hard times, didn't have a lot of confidence that things would get better. The contest in the court-room had been widely viewed as a morality play where the meek were pitted against the mighty. Almost everybody shared in the twins' exultation when good finally triumphed over evil.

On those rare evenings when the Hilton sisters were not being fêted somewhere, they were likely to be found in nightclubs or at the movies. Often they were accompanied by male escorts, many of them with good looks, good positions, and good blood lines.

It was a matter of amazement to some that the twins' deformity—so extreme and so visible—did not seem to prevent the sisters from attracting beaus.

Lucille Stotzer, Martin Arnold's secretary, had an explanation for the allure Daisy and Violet held. Most strangers, men and women alike, felt awkward and tongue-tied when they were first intro-duced to the sisters. But because Daisy and Violet were so at ease with their condition, and also because they were so practiced at charming new acquaintances, most people were won over by their vivaciousness, intelligence, and worldliness and quickly came to view the twins' connection as just another physical trait, like blue eyes or red hair.

"You were not conscious of it after you were with them," Lucille said of the twins' connectedness. "They were just average girls, gig-gling and talking to themselves. They were very congenial between themselves."[1]

Miss Stotzer remained close to Daisy and Violet after the trial and even shared an apartment with them for a time. She was often pres-ent when one twin or the other had a gentleman caller and was always

left wonderstruck by the sisters' amazing ability to put space between themselves when one or the other of them was being wooed.

"Daisy would have a date, for example, and Violet would sit there and read a book. She never knew what was going on. They had trained themselves that way."[2]

The twins' ability to dissociate themselves from one another extended even to the times when one or the other was involved in steamy love-making, according to Jim Moore. He recalled a time when both sisters were dating musicians in the Dale Stevens Orchestra.

"We were just sitting there chatting, just dishing, you know. And I don't who it was, but somebody asked Vi, 'Well, what do you do when Johnny comes by to see Daisy?' And Vi says, 'Why, I just turn over and read a book and eat an apple.'"[3]

If Daisy and Violet were outfitted with the internal apparatuses to tune one another out, not many of their male admirers were similarly equipped. Even the smoothest boulevardier couldn't deny feeling some self-consciousness at trying to woo one sister when he knew her sibling was close enough at hand to grade him on his style. Inevitably, complications arose between the twins and their dates whenever things proceeded beyond the hand-holding stage. Daisy and Violet talked about that.

"It gave us grave moments and much wonderment when our suitors were embarrassed by the inevitable presence of a third person," they said. "However, few were discouraged in their ardor. Some schemed ways to talk to one of us over the telephone. The shyer men wrote and wired."[4]

Don Galvan stayed on in San Antonio after the trial. He remained troubled by the suddenness with which Daisy had changed from a demure young woman to a bona fide flapper, but he hoped her attraction to cigarette smoking, drinking, and staying out late were a result of her new independence and would soon pass. On one occasion, he

went to see Daisy at the twins' apartment and took a place beside her on the sofa. He immediately let her know that he was troubled by some of the manners she had acquired since breaking free. He took the cigarette she held in her hand and snubbed it out. He pushed aside her wine glass. For a long time he just gazed at her with dreamy eyes. Daisy felt her temperature rising. She flushed. He was so handsome.

When Galvan did finally speak, it was in a pleading tone. "Marry me, Daisy," he entreated. "Forget about show business. Come to Mexico and live with my family." Daisy thought at first that he was only toying with her emotions, but then she realized he was serious. Her heart jumped. She and Violet had just started to enjoy the companionship of men, but marriage? At first she was too stunned to say anything. Finally, she found words.

"Have you thought this out? Violet would be with us every minute."

"I have thought it out," Galvan replied. "I'm sure I can make allowances for Violet. You will be my wife for six months of the year. Then, for another six months, you may go wherever Violet wants to go. And if she should ever get married, then, naturally, you must spend six months with her and her husband."[5]

Galvan may have researched the arcane subject of conjoined twins and their mates as the arrangements he proposed were a modification of a conjugating program that had been crafted by Chang and Eng Bunker, the Siamese twins who took the sisters Adelaide and Sarah Yates as brides in 1843. The brothers established separate residences on their Wilkesboro, North Carolina farm, and adhered to a schedule in which they would bed down with one wife for three nights and then with the other for three nights. The arrangement resulted in their siring twenty-one children between them.

Daisy would later describe Galvan's marriage proposal as the "most gleeful moment" of her life. Because of the complications she foresaw, however, she felt impossibly conflicted. She couldn't imagine an

arrangement where she would be with her husband for six months and then separated from him for a like term. She was also thinking of Violet. Galvan wanted to move to Mexico to be reunited with his family. While Daisy couldn't imagine anything more beautiful than becoming Galvan's bride, she felt such a union would be unfair for Violet. In her words, Violet "still carried a torch for Blue Steele."[6] Because Steele was married, Violet had to content herself, at least for the time being, with an occasional phone call from the orchestra leader. Daisy concluded that even if Violet couldn't be with her true love, it would be unfair to expect her to become part of a strange household in a strange land.

Daisy was crying. She told Galvan that while she was sure she could never love another man as much as she loved him, a marriage between them just couldn't work.

"I know that I should not like a separation from the man I married," she sobbed. "And I would never want to be separated from my twin. I couldn't bear to be separated from either of you."[7]

Like Daisy, Violet dissolved into tears when her sister said her final goodbye to Galvan. He immediately left San Antonio for Charlotte, North Carolina, where he was booked to play the Orpheum Theater.

Because of the widespread news coverage the trial received, the San Antonio Siamese Twins were bigger names than ever. They were swamped with invitations to appear in theaters and nightclubs. They declined all the offers. This caused some consternation for Joe Freeman, their court-appointed receiver and business manager. He hadn't become one of the wealthiest men in Texas by turning away money that was offered to him. Daisy and Violet, however, were in no hurry to return to work. They had their twenty-third birthday two weeks after the trial. They had just won $100,000 in a court settlement—a tidy sum at a time when the income for an average family

was $1,600 a year. They had been in the public sphere all but the first two months of their lives. They believed they were deserving of some respite.

Daisy and Violet took joy in being on their own. They took pleasure in cooking and learning how to sew. They apparently even enjoyed housekeeping. In the words of one San Antonio newspaper, "Every day they sweep, scrub, and dust their little flat. It is as clean as a Dutch kitchen."[8]

The sisters were now settled with Boy, the pekingese Martin Loew had given them, in a small apartment on Burr Road. They appeared to be living lives that were sweetly tranquil, even ordinary.

But what no outsiders knew was that the sisters still felt like the two loneliest people on the planet. How could it be otherwise? Because of their uniqueness, they were always aware of being profoundly different from everyone else, whether they were in a group of four or a crowd of four thousand. But there was another reason they always felt so utterly alone: They had no connection to anyone anywhere whom they could identify as a relative. Not only had they been abandoned by their mother, but it was evident they had been disclaimed by everyone else in the world to whom they had a blood connection. They were twenty-three, and in all those years, they had never heard from a single relative, not a grandparent, aunt, uncle, cousin, or even a niece or nephew several times removed. They appeared to be without a family of any kind.

During and after the trial, Daisy and Violet were regularly visited by newspaper and magazine writers. They talked about how badly they wanted to love and be loved by members of the family they knew were somewhere out in the world. They talked of returning to their birthplace in England and locating relatives who may have been too embarrassed to publicly acknowledge any kinship with Siamese twins, but who, almost a quarter-century later, might be

willing to embrace the girls. Mostly they fantasized about their
mother.

Two years earlier, Daisy and Violet had learned the true story of
their mother: Her name was Kate Skinner; she was twenty-one, poor,
and unmarried when she gave birth to the twins. She was terrified of
them, believing they had been delivered to her by God as punishment.
Daisy and Violet finally understood why their mother felt she had to
give them up and they knew they could forgive her. Kate would now
be forty-four. They wanted now only to have some relationship with
her, some connection that, if nothing else, would give them a chance
to send her Mother's Day cards and let her know she was in their
thoughts. They also fantasized about a future that might include a
father, grandparents, aunts, uncles, maybe even brothers and sisters.
It wasn't important anymore that none of their kin had ever tried to
establish contact with them. They were willing to let bygones be
bygones.

During one newspaper interview, the twins revealed just how
much they were aching for family.

> "We would like to adopt a child to call our very own, and
> give the child the benefit of an education" said Violet. "We
> couldn't take the child with us on our vaudeville tour, but we
> could care for the child just the same in a school. . . . The
> child could be with us when we are resting in San Antonio
> between tours. Then we will build a little house here which
> we can call our very own. Nothing big and fancy, but just a
> little place that will be comfortable and cozy."[9]

Six months passed before Daisy and Violet returned to the stage
the week of July 4th at the Metropolitan Theater in Brooklyn, New
York. Sometime during the engagement, they were called upon by Ben
Piazza, a Hollywood casting agent.

Piazza probably was exhausted by the time he met with Daisy and

Violet. For nearly a month before his meeting with the twins, he had been breaking bread with bearded ladies, hermaphrodites, dwarves, giants, dog boys, armless and legless wonders, and women whose bodies, neck to toe, were inked with colorful tattoos.

The agent told Daisy and Violet he was hoping to persuade them to take part in what he promised would be a new and exciting adventure. He wanted them to travel to Hollywood and launch a career in the movies. He spelled out the proposal: Tod Browning, the director who had gained fame for horror pictures like *London After Midnight* and *Dracula*, was preparing to film a circus movie for Metro-Goldwyn-Mayer. Browning, a stickler for accuracy, wanted all the film's sideshow characters to be real human freaks, not mere creations of the makeup department.

Piazza likely met resistance from the sisters as Daisy and Violet never again wanted to be associated with the sordid sideshow world. They looked back on the years they were trotted out as a carnival attraction with shame and took umbrage at any suggestion their success in the theater world was in any way traceable to the peculiarity of their bodies. The public adored them not because they were freaks, but because they were talented performers, artistes with myriad stage gifts as singers, dancers, and musicians

But Piazza was well-practiced at pitching the allure of Hollywood. A fellow talent scout said of him: "Ben could make Hollywood sound like the last way station on the way to Heaven. If you gave him ten minutes with the Pope, he would have had the pontiff trading in his beanie for a ten-gallon hat so he could appear in a Western." Piazza, in fact, had brought scores of unknown talents to the screen, among them the likes of Rosalind Russell, Vivian Leigh, and Robert Taylor, all of whom would become superstars.

Daisy and Violet were present and accounted for on an MGM lot in Culver City, California, on a morning in mid-October 1931, when

shooting on the new Tod Browning film was scheduled to get underway. The sisters arrived on the lot in a shiny black chauffeur-driven limousine.

Probably never before had a larger gathering of human freaks been concentrated in a single place. Ben Piazza had made especially heavy raids on the Coney Island and Ringling Brothers, Barnum & Bailey Circus sideshows. He recruited several freaks who, at least in the big top world, had hall-of-fame status. Among his most prized signings, in addition to the Hilton sisters, were Lady Olga, the Bearded Lady, Prince Randian, born without arms and legs and advertised as the Human Caterpillar, and the startling Johnny Eck, the Half-Boy, whose body ended just below the bottom of his rib cage. Among Piazza's other finds were Josephine/Joseph, the Half-and-Half because she/he had both female and male body parts, and Frances O'Connor, a golden-haired girl from Sheridan, Wyoming, who, because she was beautiful but also armless, was advertised as the Living Venus de Milo. Additionally, Piazza had rounded up such standard sideshow attractions as a fat lady, a fire eater, a sword swallower, a giant, several dwarves, some midgets, and four or five "pinheads," lamb-gentle, but feeble-minded souls with heads that looked like they had been shaped by a pencil sharpener.

Curiously, even before the cameras started grinding, the fat lady, the midgets, and many of the other freaks started affecting the personas of genuine film stars, according to Eck.

"They all started wearing sunglasses and acting funny." he said. "In other words, they all went 'Hollywood.'"[10]

Lady Olga may have been the most obnoxious one of the whole bunch.

"She was grand and ritzy," said Leila Hyams, a legitimate actress who was cast for the film. "You almost expected her to peer at you through a lorgnette."[11]

Christened Jane Barnell at the time of her birth in Wilmington, North Carolina, Lady Olga had done a lot of living in her sixty years. She felt she was entitled to respect. She had gone to the altar four times. She had traveled with every circus of note, including Barnum & Bailey, Forepaugh-Sells, Hagenbeck-Wallace, and Ringling Brothers, and had been one of the biggest draws at Huber's Museum on West 42nd Street in New York. Once, outfitted in a rhinestone-spangled gown, she accompanied Cole Porter to a cocktail party that actor Monty Woolley threw at the Ritz-Carlton in New York. There was not full unanimity among the hundred or so party guests regarding who had the more impressive beard—Lady Olga with her steel gray, House-of-David whiskers or Monty Woolley with his snowy, neatly clipped, face brush—but most threw their vote to the lady.

The title Browning chose for his new film was simple, but charged: *Freaks.* The story centered on a beautiful but duplicitous trapeze artist who marries a dwarf in the sideshow not out of love, but because of her greed for the fortune he has just inherited. The big top princess treats her new miniature husband with contempt, and, along with her real love, a circus strongman, starts plotting the dwarf's death so she and her lover can take possession of his fortune. The most compelling sequence of the screenplay was to be a scene in which all the sideshow freaks, in a show of sympathy for the degraded husband, gang up on the circus beauty and her paramour, and, with some fancy knife work, remodel the pair into a duck woman and a soprano-voiced eunuch, respectively.

Working for such film giants as MGM and Paramount Pictures, as well as smaller studios, Browning had directed some sixty films before taking on *Freaks.* Because of his preoccupation with gruesome topics and his collaborations with screen ghouls like Lon Chaney and Bela Lugosi, he had gained such sobriquets as the "Edgar Allan Poe of film" and "master of the macabre." For all the hideousness of the vampires,

werewolves, and assorted supernatural creatures that populated Browning's earlier films, these monsters were all make-believe, concoctions of the makeup and property departments. There would be no pretend monsters in *Freaks*. Browning was seeking a new realism in cinema. This picture would be inhabited by real human anomalies.

Browning's inspiration for the movie was a dark short story by Clarence Aaron "Tod" Robbins called *Spurs*. The Robbins story, set against the backdrop of a European circus and featuring such well-drawn characters as Monsieur Hercule Hippo and Griffo, the Giraffe Boy, appeared originally in 1923, in *Munsey's Magazine*. Browning was so taken with the piece that he persuaded MGM to buy the film rights for $8,000.

As David J. Skal and Elias Savada reveal in their excellent biography, *Dark Carnival: The Secret World of Tod Browning*, almost everything in the original Robbins tale was to become lost in the translation to film. Irving S. Thalberg, head of production for MGM, assigned Willis Goldbeck and Elliott Clawson, veteran scenarists, to transform the magazine story into a screenplay. Somewhere along the way, the two were joined by four more writers, Leon Gordon, Edgar Allan Woolf, Al Boasburg, and Charles MacArthur.

Even with a half-dozen script writers on the project, the overhauling took five months. When the screenplay was finally finished, it was just about impossible to trace its lineage back to the Robbins short story: The title *Spurs* was discarded for *Freaks*; the drama's setting was moved from France to the United States; and completely expunged in the script were every one of the richly imagined freaks that Robbins introduced in his story. Most surprising of all, the six-man writing committee scrapped every twist and turn of the Robbins work and fabricated an entirely new drama.

Because of his enthusiasm for the film project, and also because of Browning's vaunted reputation as a director, Irving Thalberg decided

initially to pull out all the stops for *Freaks*. He went to the very top of MGM's A-list of stars. He selected the newly-signed Myrna Loy to play Cleopatra, the venal trapeze queen of the film. At the same time, he named Jean Harlow, the blonde bombshell, to handle the role of Venus, a good-girl counterpoint to Cleopatra. But it was not long before Thalberg rethought his casting plans. After reading the many successive drafts of the screenplay the writing team kept cranking out, he began having reservations about how the picture would be received by the public, the press and, especially, the Hays Office. He was not at all sure the world was ready for a movie that included a castration and at least hinted at sex between a divinely beautiful woman and a dwarf. Because of all its inflammatory ingredients, Thalberg worried Browning's film might well explode upon its release. If that were to happen, he didn't want Loy and Harlow, two of MGM's most bankable stars, to incinerate with the project.

To his credit, Thalberg turned a deaf ear to those who tried to persuade him to scrap the film project entirely. He did, however, decide to re-cast the female leads. The role of Cleopatra was turned over to Olga Baclanova, an actress in her sunset years, who was probably happy for the assignment. Leila Hyams, a beautiful, one-time fashion model who had mainly served as window dressing in her earlier film parts, was called in to replace Harlow.

The substitution of Baclanova in the role of Cleopatra was perfect type-casting. Baclanova was a former dancer with the Russian ballet. An exotic and zaftig woman with platinum hair, large blue eyes, and a big red gash for a mouth, she had often been cast as a man-eating seductress. Off-screen, Baclanova was as gentle as a turtle dove. When all the freaks gathered on the lot for the first time, Browning personally escorted the actress on a tour of the circus encampment that had been created, introducing her to the human oddities with whom she would be working.

*Still from Tod Browning's 1932 film,* Freaks. *The actor at left,*
*Roscoe Ates, played Daisy's husband in the film. (Author's collection)*

Baclanova had this remembrance:

First I meet the midget [Harry Earle, who would be her husband in the
movie] and he adores me because we speak German and he's from Germany.
Then he shows me a girl that's like an orangutan [probably Lady Olga, the
Bearded Lady]. Then a man who has a head but no legs, no arms, no nothing,
just a head and a body like an egg [Prince Randian, the Human Caterpillar].
Then he shows me a boy who walks on his hands because he was born with-
out feet [Half-Boy Johnny Eck]. He shows me little by little and I could not
look. I wanted to faint. I wanted to cry when I saw them. They have such
nice faces, but it is so terrible.[12]

In time, Baclanova not only became comfortable in the company of
the sideshow denizens, but developed tender feelings toward them,

and they for her. In fact, one of the casualties of her surpassing beauty was Harry Earle, the three-foot, three-inch midget cast as her husband. In a case of life imitating art, Earle became sick with unrequited love for his co-star.

Poor Johnny Eck, the Half-Boy, was left in even greater ruins by Baclanova. Whenever she was before the cameras, Eck was to be found nearby in the shadows, watching her. Baclanova had this memory of the bright, sensitive, and painfully shy man-child whom everybody pitied but no one could love:

> He was so handsome. He looked at me all of the time, and I was so afraid of him, you know. And after, they tell me he is crazy about me. And when I am in the circus ring, he put his head down . . . and look at me all the time. And I always see that beautiful face, black hair . . . It was like he hypnotized me . . . When we finished the picture, he came and gave me a present. And you know what? He did it himself. He make a circus ring and he make it from matches. . . . It was like the circus we had, all the chairs we had, all about like the circus we had, and he says, 'I make it in your honor.'[13]

Daisy and Violet seem not to have been recruited for the film because they were needed to carry the story forward, but because someone, probably Thalberg, believed they might give the picture additional box office pulling power. Through their triumphs in vaudeville, and through the sensational trial that was chronicled in papers across the country, they were reliable brand names.

The roles that Daisy and Violet were given in the film, like almost everything else in the screenplay, were tailored from whole cloth. There were no Siamese twins in the original story. If the roles handed to the sisters were incidental to the movie's plot, their inclusion gave the picture some sexual overtones that were surprising for the time. Daisy has a husband in the film, a clown called Rosco, played by Roscoe Ates. Violet, on the other hand, is single. As the story unfolds,

Violet accepts a marriage proposal from a darkly handsome suitor who ostensibly is the owner of the mythical Rollo Brothers Circus, although, inexplicably, the suitor's role is never made entirely clear in the picture.

Because of the period in which it was made, the sexual carryings-on in *Freaks* are mostly alluded to rather than explicit. But Browning boldly included one scene that quite explicitly suggested that whenever one Siamese twin was in the throes carnal ecstasy, her sister, in a kind of two-for-one effect, was also simultaneously enjoying the experience. The scene takes place in the twins' circus wagon when Violet is asked by the big top impresario if she will marry him. Because Violet is weighing the consequences of changing the threesome of herself, Daisy, and Daisy's clown husband into a foursome, she is a little slow in giving her reply.

"Please, please," the circus boss urges. "Don't you want to make me happy?"

Violet still appears to be conflicted. "Yes, but I don't know what to say," she murmurs.

"Just say 'yes.' Will you?"

"Yes."

The face of the young, hunky circus owner melts into an expression of bliss. "Oh, Violet," he sighs. He gathers his newly won prize into his arms and locks onto her lips in a kiss that is tender, passionate, and long. The camera shifts from the faces of the freshly-betrothed couple to Daisy. As the lovers beside her continue with their kiss, she, too, seems to be experiencing physiological changes. Her eyelids flutter. Her expression tightens and then, by turns, slackens. A wave of ecstasy seems to roll through her entire body and she gives out a soft cry of pleasure that is faintly orgasmic.

A thinly veiled reference to the mating practices of Daisy and Violet is also brought out in another scene. Rosco tells a fellow

trouper of the frustrations that can be involved when one has taken a Siamese twin for a wife. He confides there were often evenings when he wanted to become amorous with Daisy, but, because of Violet, his desires were thwarted. "That sister-in-law of mine wants to stay up half the night to read," he complains.

The twins' on-camera appearances in the sixty-four-minute film take up less than five minutes. The acting talent they showed in their film debut was serviceable. Willard Sheldon, a script clerk on the lot, remembered Daisy and Violet as "bright, intelligent girls who always followed Tod's direction carefully, and turned out professional work whenever the camera was aimed at them."[14]

Possibly because the film awakened memories of the grim days when they were placed on exhibit for strangers to gawk at, Daisy and Violet remained aloof from the other freaks. Sheldon said that during breaks in the shooting, the midgets, armless wonders, fat lady, and human skeleton spent their time in a mess tent, drinking coffee and playing checkers, but the Hilton sisters were never part of the crowd.

"They were lovely girls, but I never got the impression that they were enjoying themselves very much," he said. "They got along fine with the working crew and with the legitimate actors, but they wouldn't have anything to do with the other freaks. They stuck pretty much to themselves which I suppose sounds funny now. What else do Siamese twins do but stick to themselves?"[15]

Except for Daisy and Violet, all of the film's freaks took housing in the Castle Apartments in Culver City, which were conveniently situated next to the circus lot created just for the movie. Because they were adamant about keeping their distance from the other human oddities during nonfilming hours, Daisy and Violet leased an apartment well away from the lot.

Slathered in pink stucco and ornamented with stained glass windows and iron grillwork, the Spanish-style apartments provided far

*Still from Tod Browning's 1932 film,* Freaks. *Violet's love interest in the film, shown here, is not identified in the movie's credits. (Author's collection)*

more luxurious accommodations than the freaks were accustomed to enjoying. Few of the sideshow travelers, in fact, seemed familiar with such creature comforts as flush toilets and bathtubs. As a result, the Castle's long-term tenants started filing complaints against the freaks almost from the day they moved in. For one thing, the Castle's residents were finding it impossible to sleep because of the constant glugging and pounding of the water pipes in the building. Every night, all night long, the pinheads kept flushing their toilet for the sheer entertainment of seeing the water vanish and then magically reappear.

Some of the freaks were so physically or mentally incapacitated they had to be diapered. Many of the MGM workers, especially those engaged on projects other than *Freaks*, were repulsed by the sight of so many freaks in their workplace.

Of the two dozen or so human anomalies Browning had brought to

Hollywood, only Daisy and Violet and the midgets Harry and Daisy Earle were allowed inside the MGM commissary. Josephine/Joseph, Lady Olga, the pinheads, and all the other freaks dined in a special tented cookhouse that was staked out in a weedy lot near the set. Joined by other MGM employees from floor sweepers to executives, Harry Rapf, a producer, had mounted a successful campaign to keep the sideshow element out of the lunchroom so, in his words, "people could eat in the commissary without throwing up."[16] It isn't known why the commissary ban didn't apply to the Hiltons. Probably even Rapf would have had to concede the sisters occupied a high rung on the Hollywood social ladder.

Robert Montgomery, then filming *Private Lives* with co-star Norma Shearer, sent a personal invitation to the twins to see him on the set. Even more impressive, Marie Dressler, the grande dame of moviedom, invited the Hiltons to her vine-covered cottage for tea. Dressler may well have had a special empathy for Daisy and Violet. As a child, she believed she was so conspicuously homely that she herself thought she was a freak. As Dressler related in her autobiography, she resolved early in life "to compensate the world for my ugliness" by becoming an actress. "I'd not only make [people] laugh. I'd make them love me."[17] She succeeded. When Daisy and Violet entered her two-story hillside house, their eyes were immediately drawn to a mantel where they saw the statuette of Oscar that had been presented to her earlier that year for her title role as the keeper of a wretched waterfront hotel in MGM's *Min and Bill*.

But for all the cachet the Hiltons had inside certain Hollywood circles, there were still some movie workers who believed the twins, out of respect and decency, should have voluntarily kept themselves outside the circle of the beautiful people. Among those holding this view, apparently, was F. Scott Fitzgerald, who had been brought to Hollywood by MGM to work as a screenwriter. Dwight Taylor, a

fellow writer, remembered accompanying Fitzgerald into the commis-
sary the day after a soirée at the Malibu beach home of Irving Thalberg
and Norma Shearer. Fitzgerald had become falling-down drunk at the
party and was still badly hung-over when he entered the commissary.

"Scott and I had no sooner seated ourselves than the Hilton sis-
ters . . . entered and took a single chair at the same table," Taylor
recounted. "One of them picked up the menu and, without even look-
ing at the other, asked, 'What are you going to have?' Scott turned
pea-green and, putting his hand to his mouth, rushed for the great
outdoors."[18]

For all the shock the sight of the conjoined twins might have given
Fitzgerald's gastro-intestinal system, he himself had degenerated into
a unfortunate figure. He was in an alcoholic haze almost all the time.
About the only writing he was doing anymore was penning his sig-
nature on his bar bills. He was fired by MGM a week after the lunch-
room encounter with the twins.

While the Hilton sisters may not have been Fitzgerald's ideal of
dinner guests, not all of Hollywood's beautiful people shared the
writer's view. Willard Sheldon remembered that Daisy and Violet
were constantly pursued by newspaper and magazine reporters all of
the time they were in Hollywood. "Just about everyday you picked up
the paper, you saw their pictures—'The Hiltons sisters seen dancing
in this nightclub,' 'The Hilton sisters being toasted at a party by the
elite of the movie world,' that sort of thing."[19]

Among the writers who interviewed the twins during their Holly-
wood sojourn was Faith Service, a respected film journalist. She
seemed totally enamored of them. "Daisy and Violet are more than
pretty," she observed in *Motion Picture*. "They are beautiful. They are
exquisitely gowned and groomed. Their hair is beautifully waved and
hennaed." Service also described the twins as "clever, sophisticated,
well-read, and witty."[20]

Although it is not known how much the twins were paid for their work in *Freaks,* Johnny Eck maintained that he commanded $1,000 a week during the four-month production. If Eck's claim was accurate, it can be assumed that Daisy and Violet probably earned considerably more.

But however much the sisters were being paid for their work in Hollywood, it may not have been enough to keep up with their lavish spending at the time. As Service reported, Daisy and Violet maintained the lifestyles of top film stars. They had a "lovely" apartment. They had a full-time secretary/manager who looked after their business affairs as well as their social calendar. They had a "big sedan" as well as a chauffeur to ferry them everywhere. They also had a status symbol that all movie actors needed to be convinced they had truly arrived in lotusland: The twins had, in Daisy's words, their own "colored maid."[21]

In their interview with Service, the twins talked about how dramatically their lives had changed since the trial ended six months earlier when they won their emancipation.

> We're happier now than we have ever been," Daisy said. "We're entirely on our own. What money we make is ours. . . . We do what we please, go where we please, have what we please. . . . We like to dance and go out with boys and do what other girls do. We don't feel different—we feel healthy and happy and normal. Life is lots of fun.[22]

If Daisy and Violet had traveled to Hollywood in the belief that their roles in *Freaks* would lead to regular employment in the movies, their expectations may have vaporized the moment the film was given its earliest preview screenings. Merrill Pye, the film's art director, was present for the first of the previews in early January of 1932. He was left with this painful memory: "Halfway through the previews, a lot of people got up and ran out. They didn't walk out. They ran out."[23]

Another of the film's architects, production manager J. J. Cohn, said one woman claimed to have been so traumatized by seeing a preview of *Freaks* that she suffered a miscarriage and, as a result, tried to bring a wrongful death suit against MGM.

Browning was desolated by the test audiences' responses to his film. He and a team of production employees immediately went to work on re-editing, employing a kind of slash-and-burn technique. When they were finished, they had excised fully a third of the celluloid, reducing the film's running time from an hour and a half to just over sixty minutes. Hacked from the film were some of its grisliest scenes, including its depiction of the freaks jumping the circus queen Cleopatra during a violent midnight rainstorm and gleefully changing her from a creature of seraphic beauty into a "Duck Lady," a monstrosity of scrambled facial features who was incapable of emitting any sound other than mallard-like squawks. Also scissored were some of the film's more twisted sexual content, including a scene in which an amorous seal seems intent on ravishing the Turtle Girl.

After all the excisions were made, *Freaks* was released for presentation in the commercial houses in February 1932. Just as Irving Thalberg had feared during the early stages of its production, the movie set off a firestorm. A court barred the movie from being screened anywhere in Atlanta, Georgia, when the secretary of the city's Board of Review condemned the picture as "loathsome, obscene, grotesque, and bizarre." Several of Browning's earlier films had been well received in the United Kingdom, but the British were not welcoming this time. While Great Britain had no shortage of carnivals, circuses, and wax museums that still exhibited human freaks, the Commonwealth forbade the showing of the film anywhere in England, Scotland, or Wales, and kept the ban in place for four decades. Surprisingly, perhaps, *Freaks* wasn't banned in Boston. It was, however, savaged by the city's newspaper critics. The *Boston*

*Herald* said the movie's "sadistically cruel plot savors nearly of perversion." The *Boston Evening Transcript* suggested that it was time to strip Browning of his title as "magician of the macabre" and then posed the question, "Where is that artistry that used to be . . . part of [Browning's] trademark?"

Concerned that the negative fallout from *Freaks* might forever sully the name of MGM and doom its future projects, the studio finally caved in to the citizen's groups, critics, and politicians who castigated the film as the most glaring example of all that was excremental and pestilential about Hollywood. It pulled *Freaks* from circulation late in the summer of 1932.

Daisy and Violet were forever angry with themselves for agreeing to take part in the film. They weren't mere carnival tent freaks. They were, after all, artistes of the stage. Yet they had allowed themselves to be permanently associated in the minds of filmgoers with the most pitiable of the sideshow's misfits, including the imbecilic pinheads, Johnny Eck the Half-Boy, and Prince Randian, the armless and legless Human Caterpillar who, in his grotesque displays, shows the rubes how he could roll and light his cigarettes by using only using his lips. Like everyone connected with the project, from Thalberg and Browning on down, the sisters would have been grateful if, by the wave of a wand, the movie could have been made to go away forever.

Willard Sheldon summed up the prevailing attitude: "Everyone who worked on the film wanted to go into hiding. Nobody wanted to have his name associated with a picture that was widely denounced as just about the sickest, most disgusting piece of work ever to come out of Hollywood. It was like having a pedophile in your family. You didn't want anyone to know about it."[24]

After *Freaks*, Daisy and Violet returned to the East to resume working in the theaters. When stage entertainers appeared in movies, they almost always sought to capitalize on the achievement and even

demanded greater pay for their future bookings. But the last thing Daisy and Violet wanted was identification with a movie that was almost universally anathematized.

The publicity materials that were developed for their return to the stage talked about work they had done in Hollywood but made no specific references to *Freaks*.

*Fourteen*

# HOW TO MANAGE A BRIDE WHEN HER SISTER IS PRESENT ON ALL OCCASIONS

D aisy and Violet's understanding of financial matters may have been confused with the study of the atmosphere. They seemed to believe that money was only slightly less plentiful than the air they inhaled. Once they were on their own, in fact, they developed an attitude toward money that almost seemed contemptuous. They appeared to view it as a mere medium of exchange that was to be kept for the shortest interval possible before being turned into fur coats, honoraria for boyfriends, and salaries for chauffeurs, maids, secretaries, and other assorted attendants.

The sisters began maintaining two residences in the fall of 1932 and then almost never stayed at either one of them. One of their mail drops was the San Antonio apartment where they set up housekeeping after breaking free from the Myers. And soon after finishing the shooting for *Freaks*, they signed a lease for sumptuous quarters in a New York apartment building at 25 Central Park West that became a haven for other stage entertainers, actors, opera stars, and show producers.

It was in Chicago and its environs, however, not San Antonio or New York, where Daisy and Violet were most likely to be found late in 1932. The explanation for their gravitation to the Windy City was elemental enough. After tearfully turning down troubadour Don Galvan's marriage proposal a year and a half earlier and believing she would never meet another man whom she could adore as much, Daisy

was again in love. Her new interest was Jack Lewis. Popularly known as the "Boy Maestro," Lewis was a Chicagoan, and it was in his hometown that his orchestra had its biggest following.

Lewis and Daisy were introduced to one another in the New York offices of Ferd (Ferdinand) Simon, one of the country's most powerful talent agents, who had just signed a contract to represent the Hilton sisters in their business affairs. Lewis, who had been represented by Ferd Simon since the time he started touring with his own orchestra at seventeen, was walking out of the talent agency offices at the same time Daisy and Violet were entering. He had seen Daisy for only seconds in their initial encounter, but, as he would recall later, his attraction to her was "immediate and profound."[1]

Twenty or thirty minutes later, after Daisy and Violet had finished their business with Simon and exited the building, they saw Lewis leaning against a taxicab with its rear door open. He was short and slight and still looked boyish, but he was splendidly turned out with a fashionable fur-collared camel hair coat and a Stetson hat. Daisy noted a shyness in his expression.

Lewis touched the brim of his brown felt hat. "Hello again, Daisy and Violet. Because we're now sharing the same agent, I think it's time we get to know one another. I'd be honored if you'd join me for dinner."

A moment later, the three were whisked away by cab to a trendy supper club where Lewis was a regular. He slipped the maitre d' a couple of dollars and the three were shepherded to the choicest candlelit table and settled onto a luxurious red leather sofa. Lewis positioned himself directly across the table from the twins. Whenever Daisy started talking, he slid nearer to her side. Then, when Violet picked up the conversation, he would slide to the other end of the sofa to be nearer to her.

If Violet had thought she was auditioning for Lewis's affections,

she must have known after their second or third date that she had lost the part to her sister. The romance between Daisy and Lewis efflo-resced with the swiftness of a hothouse Easter lily. Within a month or two after their first meeting, they announced they were engaged to marry. As was always the case when something eventful happened in the lives of the twins, the announcement of Daisy's nuptial promise stirred great excitement in the press. The *New York American* ran nearly two yards of type on Lewis, dissecting all of the strategies the young bandsman employed to win Daisy's hand. Its explanation of the Boy Maestro's battle plan sounded only a little less complex than Ghengis Khan's sack of Peking. The *American* theorized:

> Probably the most delicate of all Jack's courtship problems was to make Violet like him just enough, but not too much. Violet likes him, thinks he is a nice boy who will make her sister happy and would 'feel terrible' if the engagement should be broken. Now he has a 'friend of court' always there to put in a good word for him in case of one of those lovers' quarrels.
>
> Where Mr. Lewis shows rare diplomacy is in not letting Violet's liking go too far. . . . It must be something of a feat to keep one twin in love, and the other liking, but not loving, him. If in his efforts to keep Violet's favor he should under-estimate his attraction and cause the sister to fall in love, the demon jealousy would enter and there would be nothing for Mr. Lewis to do but go.
>
> Thus far, he has managed to walk the tightrope without a slip, but what about the honeymoon and the later more pro-saic days of married life? In all the literature of the world, there is not a word of advice on how to manage a bride when her sister is present on all occasions.[2]

When they were out in public, Daisy and Violet almost always wore identical outfits. Each also colored her hair with henna, and,

almost curl for curl, each had her tresses cut and styled in the same coiffure. In the view of at least one newspaper writer, the twins were "as alike as two silver dollars." Observers wondered what it was about Daisy that made her more attractive to Lewis than her twin. The orchestra leader tried to clear up the mystery. "Both of the girls are swell," he said, "but Daisy is so smart and cute at the same time. She is the cleverest girl I've known, and I've known a good many in my travels around the country. She has beautiful, curly auburn hair and the bluest of eyes. Daisy laughs a good deal, and yet she is one of the most serious young ladies I've met. She refuses to let her abnormality become an affliction, and a deterrent to her progress in life. 'Jack,' she has said to me, 'regardless of the imperfection of my body, my mind is normal and I'm going to let it rule my imperfection. Never will I forget that it is the master of my body.'"[3]

As lovestruck with one another as Daisy and Lewis were, each admitted to feeling some self-consciousness about cooing sweet nothings when they knew an eavesdropper was always present. As a partial solution to the problem, Daisy had a phone booth moved into their Central Park apartment. She then had carpenters modify the booth in a way that allowed her to enter the cubicle and carry on long conversations with Jack while Violet sat outside its glass door, reading a magazine or filing her nails. While Daisy primarily used the phone booth so she could have privacy while pouring out her love for Jack, the enclosure also proved useful to her when she was having spats with her inamorato that she didn't want to air before Violet.

More than once, Daisy refused to admit Jack into the apartment after he had let a dinner grow cold because he had been out drinking with the boys in his band. On those occasions, Daisy would meet him at the door, fix him with an angry glare, and address him in a stern, no-nonsense tone. "Here's a nickel. Go to the drugstore on the corner and call me up. I wish to speak to you."[4]

Lewis's courtship of Daisy meant that Violet often had to stay home when she wanted to go out or go out when she might have preferred to stay at home. Lewis was not ungrateful for the adjustments Violet had to make. He told the press that his prospective sister-in-law was always a "good sport" about doing anything she could to help nurture the romance. She spent endless hours in the apartment, glued to the radio, crocheting and working crossword puzzles, while Jack held hands with Daisy and murmured words intended only for her ears. Violet was mostly bored with the lovey-dovey talk between Lewis and her sister. Whether the three were sharing a sofa in a hotel room or a seat on a train, she often fell asleep whenever the conversations changed from trialogues to dialogues. But it shouldn't be supposed that Violet was always a mere tag-along on Lewis and Daisy's dates. Violet, too, had admirers, some of them with serious intentions, and often the parties were foursomes.

From the day the press learned that Daisy and Jack were engaged, reporters began pressing them about the date for the wedding. The lovebirds replied that while their trip to the altar could not come soon enough, they were postponing the event until Violet, too, was ready to stroll down the aisle—and not as a mere bridesmaid. While Violet was regularly seen in the company of different men, she cared deeply for only one, the orchestra leader Blue Steele. While she could listen to him most Saturday nights on the radio, and even carry on long conversations with him over the telephone, it became increasingly evident to her that Steele had no intentions of leaving his wife for her.

Late in 1932, while the twins were in Chicago, they applied for, and were granted, American citizenship. The reporters and photographers, of course, swarmed the city's office of the U.S. Immigration Bureau to record the twins' signing of their naturalization papers. Daisy and Violet said it had become especially important for them to have American citizenship because they were planning a visit to

England for a reunion with their mother and wanted to be assured that they would be able to return to the United States.

As Daisy and Violet prepared for their voyage, they carried another expectation, one shared by scores of other American performers. They were hoping to discover new audiences abroad. As bad as the conditions in the United States had become for stage entertainers in the late 1920s after the introduction of talking pictures, they had grown even worse in the early 1930s with the economic collapse brought on by the Great Depression. Even such big-name entertainers as Duke Ellington, Ethel Barrymore, Cab Calloway, and Buster Keaton were having trouble finding regular bookings at home. They, along with hundreds of other American musicians, singers, comics, dancers, and actors sailed to Europe to look for new opportunities.

Probably more than Daisy, Violet was especially eager to make the trip abroad. By traveling across the sea, she hoped that maybe she could get Blue Steele out of her heart once and for all. She had long despaired over the hopelessness of her love for him. There were nights when she thought she might suffocate from her grief as she listened to Daisy and Jack making love beside her and then, when they were finished, panting and cooing. She knew that in their bliss, Daisy and Jack had been able to displace her, to will her out of existence. Over and over, she kept holding her breath for long stretches, trying not to make even the slightest sound that could end the couple's illusion that they were all alone. And in the dark, she wept in silence at her own loneliness.

The twins arrived in London in January 1933. It wasn't lost on them that they were in the richest theater city in the world. They sometimes crammed two shows a day into their schedule, taking in plays by Shakespeare, Moliére, George Bernard Shaw, and Noël Coward. They were also regular visitors to the variety houses, especially the Pavilion and the Palladium, which regularly featured American entertainers, many of them comics, dancers, and acrobats

with whom they had shared vaudeville bills in the United States. But the strongest pull on the twins came from the sports arenas that featured prize fights.

Violet, especially, was a rabid fight fan, and her knowledge of professional boxing was such that she could have easily held her own on the subject with any barber in the shadow of Madison Square Garden. Her interest in boxing developed well before she and Daisy traveled to England. It was an enthusiasm she had picked up from Blue Steele. In fact, Steele had once aspired to become a professional boxer. A broad-chested, blocky figure with arms and legs like the trunks of pine trees, he wiped out all competitors in his youth, and then, after joining the U.S. Navy and becoming a member of its boxing team, continued to finish off most of his challengers.

Steele's aspirations to become a professional boxer were quickly extinguished, however, when he was matched in an Armed Forces tournament with a young Marine named Gene Tunney. Steele retained but a single memory from the meeting with the world's future heavyweight champion. It was the moment when the referee asked the combatants to touch gloves and instructed, "Now, boys, when the bell rings, you come out swinging, and I want you to give the folks a nice clean fight."

Before Steele had a chance to even aim a jab at Tunney, he was on his back on the canvas, unconscious. Just before opening his eyes, Steele remembered, he heard a chorus of angels, their voices in decrescendo. He interpreted the heavenly choir as a sign that he should abandon his aspiration to become a professional fighter. He decided to become a musician instead, and thereafter mostly indulged his passion for boxing as a ringsider rather than insider.

But every now and then, even years later, Steele could become bellicose when he was sufficiently provoked. In Cincinnati, for example, while performing with his orchestra for the 1931 Stage and Screen

*Violet and Daisy on tour in Great Britain, 1933. The twins made numerous personal appearances, including this one at James Beattie's department store in Wolverhampton during their run at the Hippodrome. Founder James Beattie (far right) shakes hands with Daisy as his son, Arthur, looks on. Daughter Christine Beattie (far left) shakes hands with Violet while an unknown woman looks on. Hippodrome manager, Jack Daniels, stands behind and between the sisters. (Author's collection)*

Scribes' Ball, his hackles were raised when some dance floor buffoon started pitching pennies into the bass horn of one of his musicians. Steele identified the hooligan, leaped from the bandstand, and decked him. Don Dearness, president of the Stage and Screen Scribes, had this memory of what happened next: "[Blue] then mounted the stand, peeled off his coat and vest, rolled up his sleeves, displayed his muscular arms, and made a speech telling of his fistic powers and defying anyone to start something. Somebody did."[5]

Actually, not somebody, but some*bodies*. The troublemaker whom he had felled was still writhing and moaning on the dance floor. Friends of the downed man charged the bandleader. A free-for-all ensued. When the donnybrook was over, Steele had a badly moused eye, a severely bitten left shoulder, a wrenched right leg, and cuts and bruises to his head, face, and body.

Crowds of reporters and photographers surrounded Daisy and Violet almost everywhere they turned up in London, especially at the fights. Their visit to one of the city's most venerable boxing temples, the Ring on Blackfriars Road in the East End, was noticed by one newspaper this way:

> The Hilton Sisters created a sensation . . . when the specta-
> tors became more concerned about watching the girls than the
> fights.[6]

The twins' appearances in the fight arenas likely would have caused a distraction even if they had not been physically entwined. Except for the tarts who combed the seats, trying to drum up post-fight assigna-tions, unescorted women were a rare sight in the sporting houses. Whenever Daisy and Violet arrived, they had their faces powdered, rouged, and lipsticked, and they wore silver fox coats and high heels.

Welterweight Harry Mason was on the main card one night when Daisy and Violet appeared at the Ring. He was immediately capti-vated by the doll-like figures he saw jumping up and down in a single ringside seat, punching the air with fists, and cheering him on. Mason's bout was scheduled to go twenty rounds, but he had no intention of putting in a full work day. In the fifth, he hammered his opponent with three or four chops to one side of the head and then repeated the process on the other side, dispatching his challenger to the canvas. Later, Mason sent one of his cornermen back out into the arena to invite Daisy and Violet to his dressing room.

The sockets around Mason's eyes were marked with scars, his nose had the appearance of being pushed about a third of the way back into his head, and his left ear was cauliflower. He was chipped and worn, but, like the British Museum's battered Elgin Marbles, he was still an impressive specimen. His chest appeared to be almost double the circumference of his waist, and his legs and arms were rounded like oak logs. He had gentle brown eyes, wore his thick, chestnut hair slicked back with grease and, when he was outside the ring, was snappily turned out in suits and hats from the finest haberdashers on Savile Row.

There are no known accounts of exactly what transpired in that initial meeting between Harry Mason and the Hilton sisters, but clearly the encounter went well, especially between Harry and Violet. They had their first date the same night.

Harry and Violet could have flipped through a thousand file cards at a professional matchmaker's establishment and not found better suited companions than they were for each other. Violet was dazzled by the professional pugilist who was already a national hero. He was equally awed at having made the acquaintance of a woman who was not only a walking encyclopedia of world boxing, but also 50 percent of the world-famous Hilton Sisters. Mason was always starstruck in the presence of genuine show business luminaries as he himself was an aspiring entertainer. As a sideline to boxing, he made occasional appearances in the lowlier English variety halls, playing a fiddle and declaiming doggerel. One of his music hall recitations went as follows:

*I love to defeat an opponent, it's true*
*Though I don't like maltreating a man.*
*If I can outpoint him, that's all I'll do*
*I'll avoid a knock-out, if I can.*
*I'll defend my title in any clime,*

*But one thing is certainly true.*
*I suppose I'll get hit on the chin sometime*
*And then as a champ, I'll be through.*[7]

Mason had no shortage of trophies and medals for his triumphs in the square ring, but even he knew it was unlikely he would ever be knighted as a man of letters. After each of his recitations, he summed up his gifts as a belletrist honestly, if succinctly: "It's not exactly Keats, but it's my own composition."[8]

Mason had grown up in the Jewish ghetto in Leeds, a breeding ground for scores of youths who later distinguished themselves as professional boxers. He was twelve when he started receiving his first earnings as a fighter. His earliest bouts were bare-knuckle affairs at the local greyhound racetrack. Men gathered there everyday to place bets with one another on the outcome of the fights. Before each contest, the gamblers tossed a few bob onto the pitch. The antes were intended as the jackpot for the winning combatant.

Mason turned professional in 1920, when he was seventeen. By the time he was twenty, he held both the British and European lightweight crowns. Two years later, still undefeated as a light-weight, Mason beefed up from 135 pounds to 147 pounds, simultaneously developing what one boxing writer called "the stomach of an alderman." He was forced to start fighting as a welterweight. There were fighters who had punches that were more devastating than Mason's, but none were more elusive than he was. He became known as the "Jewish Box of Tricks," a sobriquet conferred on him by other boxers. Like the magicians Howard Blackstone and Harry Thurston, he seemed to be able make himself vanish into thin air when the need arose.

The fight writer and boxing historian Nate Fleischer ranked Mason with the world's all-time greatest light- and welterweights. The

*British welterweight champion Harry Mason proposed to Violet only a few minutes before the sisters left England's shores and returned to the United States where Daisy expected to be reunited with her fiancé Jack Lewis. (Author's collection)*

encomium was not to be lightly regarded since Fleischer's talent for assaying pugilistic excellence was unerring.

Mason held Britain's welterweight crown in 1925 and 1926, but then came defeat, and he had to surrender the title. By 1933 he was well along in his crusade to regain his country's welterweight championship title when Violet came into his life. Although not yet thirty, he already had more than 400 professional bouts to his credit, probably more than anyone else his age.

Because of her longing for the unobtainable Blue Steele, Violet was implacably melancholic when she arrived in England. But she began brightening immediately after meeting Mason. On their first date, the two mostly talked about boxing and show business. But soon their discussions turned to matters of the heart. "To my great relief—and Daisy's—I got a crush on Harry. . . ," Violet said. "Harry dimmed

my torch for Blue, although he did not quite put it out. One thing, he had no objection to my being a Siamese twin. In fact, he liked Daisy."[9]

On those occasions when Violet and the boxer were caressing and talking amorously, Daisy always found ways of mentally absenting herself from the proceedings. She thought it was important that the lovers have the same space in which to operate as she and the band-leader Jack Lewis had enjoyed. Most often when Harry and her sister were cuddling and cooing, Daisy drew out her fountain pen and her lilac-scented stationery and wrote long letters to Jack back in Chicago, sketching what she foresaw as the life they would have together, with a house in the country, a large flower garden, and lots of babies. "I used to go on dates with Violet and Harry," Daisy said, "and never hear a word they said."[10]

In reality, Violet and Harry weren't able to spend much time together as they always seemed to be moving in different directions. Soon after Violet and Harry started dating, the twins were signed by Moss Empire, Ltd., a huge British entertainment conglomerate. They started criss-crossing the United Kingdom, appearing wherever Moss Empire operated theaters. During the same period, Mason was off to wherever he could find fights. Before he got another opportunity to fight for the welterweight championship, he had to prove to the British Boxing Board of Control that he was a worthy contender. This threw him into a mode of almost constant motion, traveling to differ-ent boxing emporia each week to eliminate, one by one, the dozens of other welters who also hoped for a chance to earn a championship bout.

Among the first cities Daisy and Violet visited on their tour of Moss Empire theaters was the place of their birth. A huge crowd was on hand to greet them as they stepped off the train in Brighton station.

"They were a grand pair with a great air of cheerfulness and broad

American accents," remembered Albert Dunk, an attendant and call-boy at Brighton's Hippodrome where the Hiltons were slated to perform.[11]

On their walk to the taxi rank, the sisters kissed babies, gave out autographs, and thanked their welcomers for being so hospitable. They were moved to tears by the size and warmth of the crowd that had turned out for their homecoming. Twenty years had passed since, as five-year-olds, they had left Brighton in the custody of Mary Hilton.

Daisy and Violet hadn't been back in Brighton for more than a few hours, when they were stricken with grief so great their first impulse was to cancel all their remaining bookings in Britain and return to America immediately. Their primary reason for returning to England had been to reunite with their mother. For years they had rehearsed how the first meeting with her was likely to play out. They would approach their mother cautiously, perhaps arranging the first contact through a minister or someone close to her. They expected her to still feel at least a little ashamed and remorseful at having abandoned them. They would tell her they understood why she felt she had to give them up. They would reassure her that, if they had ever felt any bitterness toward her, the feelings had dissolved long ago. They loved her, had always loved her, always would love her. There would be crying on both sides. Finally they would embrace, Daisy and Violet feeling their mother's warmth for the first time, she feeling theirs.

After making inquiries, Daisy and Violet did locate their mother, but there would be no reunion. Their mother lay in a small hillside cemetery under a stone monument, simply incised: Kate Skinner, 23 August 1886–1 August 1912. She had died in the Steyning Union Infirmary of complications from childbirth after bringing forth her fourth illegitimate child, Ethel Kate Skinner. She and Frederick Albert Skinner, born in 1910, were thought to be the children of

Frederick Andress, the Brighton hairdresser who was popularly believed to have fathered the twins.

Kate Skinner had been dead for twenty years. For Daisy and Violet, who had kept her alive in their imaginations from the time of their earliest memory, it was as though she died on the very day they came back to Brighton. Their sorrow was deeper than any they had ever known. There would not be, there would never be, a chance to tell her the past was over and that they only felt love for her.

Their brother, Frederick Albert, would have been twenty-two at the time of Daisy and Violet's return to Brighton; their sister, Ethel Kate, would have been twenty-one. It can't be absolutely determined the twins had no contact with their siblings during their stay in Brighton, but it seems most improbable. The newspapers chronicled the sisters' most quotidian comings and goings but made no mentions of any siblings. Indeed, it seems unlikely Daisy and Violet had contact with any relatives, whether close or distant, while they were visiting the city of their birth. The twins, according to Albert Dunk, didn't stay with kin, but rather roomed "with one of the theatrical landladies in Middle Street."[12]

"The poor girls must have been heartbroken upon realizing that, after all those years, they were still regarded as untouchables by all of their blood relatives," said Joseph Haestier, whose mother, Margaret, was an aunt to Daisy and Violet. "When I was a boy, I was often present for family gatherings during which my mum and other relatives talked about the twins, but I don't remember anyone ever talking about a time when Daisy and Violet came back home to Brighton. I'm quite certain that no one from the family ever made any effort to see them during their stay in the city. To be honest, I suspect my family felt embarrassment at being related to girls whom others regarded as freaks. They didn't want their friends and neighbors to know that Siamese twins were in our family tree."[13]

As forsaken as Daisy and Violet felt after learning of their mother's death and then being shunned by their Brighton relatives, they were persuaded by the Hippodrome's management to honor their contract to perform in the city. They may have taken at least a small measure of joy from the reception they received from the broader community. As the *Brighton Herald* remarked:

> Brighton is taking its own Siamese twins very much to its heart. . . . They have toured the United States as 'The San Antonio Twins,' but their return to their native country rein-states them as 'Brighton's Own.' . . . The Hilton Sisters are bonnie girls and there is something very appealing about their quaint little bows and their friendly smiles. . . . The humour that distinguishes their performance is of the most delectable kind.[14]

Daisy and Violet presented four shows at the Brighton Hippodrome, and each was a sellout.

"I remember them at two grand pianos, playing back to back, and as talented saxophonists and clarinetists," said Albert Dunk, who saw all the performances. "They would sing, dance, and entertain us with their comic patter, too. They were a couple with plenty of talent. I doubt if we'll see another act like theirs in a thousand years."[15]

The show the Hilton sisters headlined had been packaged by Moss Empire Theaters under the name "Britain's Siamese Twins & Variety Company." The program included appearances by such entertainers as Donald Stuart, the World's Tallest Conjurer; Al Ray, a ventriloquist who exchanged repartee with three wisecracking dummies at once; Alma Victoria, a trick cyclist; and others. These acts were mere garnish-ments as it was the twins who were attracting the sell-out crowds.

The sisters' British shows were closely patterned after their presen-tations on America's vaudeville stages, but they introduced at least one

new wrinkle. In the opening portion of their act, they were inter-viewed by two young men who displayed press cards in their felt hats and posed as newspaper reporters. The format enabled Daisy and Violet to reveal what their lives were like as conjoined twins. In reply to a question posed by one of the mock journalists, Daisy said that the most difficult thing about being physically connected to Violet was adjusting to her sister's sleeping pattern.

"Unfortunately, I wake up very early in the morning, and, as Violet refuses to sacrifice her sleep, I lie in bed reading a detective story until she wakes up," she said.

Violet drew laughter when she told the "newsmen" that the most hateful thing about being a Siamese twin was that, over and over, the press subjected her to the same "stupid questions." Later, the same two men returned to the stage in dinner jackets and joined with the sisters in dazzling displays of the tango, fox trot, and charleston. The specta-cle of the foursome moving as one, gliding and whirling onstage, had the same effect on the British as it had on Americans. They surrendered their natural reserve and applauded, stomped their feet, and rose from their seats, cheering and shouting, summoning the twins and their partners over and over to return to the stage to take more bows.

When he saw them at Liverpool's 3,000-seat Shakespeare Theater, Frederick H. U. Bowman, a respected theater critic, was impressed:

> Their show was memorable not because, as performing Siamese twins, they were a "novelty," but rather because there was such a sheen to their comedy, singing, musician-ship, and dancing. . . . They are performers of real merit and deserve the tumultuous applause accorded them everywhere they appear.[16]

The love affair the British had with the twins was not overlooked by the business world. In Wolverhampton, for example, the city's

leading department store, Beatties, hired Daisy and Violet to put on a fashion show, modeling the emporium's new line of dresses, coats, and hats.[17]

At the same time that Daisy and Violet were charming audiences throughout the provinces, Harry Mason was methodically going about the business of pruning the long line of scrappers who, like him, were hoping for a chance to fight for the national welterweight crown. He had been single-minded about regaining the title from the time he lost it seven years earlier. But after he and Violet became romantically involved, his crusade seemed to take on an even greater urgency. As though Violet was sitting ringside for each of his contests, his fight appearances, more and more, became displays in showboating. He took glee in openly presenting his face to an opponent, and then, in the microsecond before a fist was due to meet up with his nose, parrying left or right rather like Manoleto dodging a raging bull. Without knowing his campaign had been pitched to a new level because he was now in love, *The Ring*, the most respected of boxing journals, recorded his progress this way:

> Harry Mason . . . has made a great comeback in the last few
> months. He defeated Johnny Summers, Leeds; Wal Dinsey,
> Willesden; Fred Webster, Kentish Town; and boxed to a
> draw with Danny Evans, the Welsh welterweight cham-
> pion. It looks a certainty that Mason will get another chance
> [at a title fight].[18]

Late in July 1933, after having toured the United Kingdom for eight months, the time had come for Daisy and Violet to return to America. It was a time of joy and anticipation for Daisy. She was finally going home again to her fiancée, Chicago bandleader Jack Lewis. Now they could start making the final plans for their wedding. The twins' leave-taking from England was not so joyous for

either Violet or Harry Mason, however. Both were weeping as they embraced at Southampton harbor near the foot of the gangplank that angled up to the deck of the Cunard Line's freshly refurbished luxury liner, the *Aquitania*. As much as Harry wanted to travel to America with Violet, the time was not yet right. He had made great gains in his drive to be restored as Britain's welterweight champion. To leave his homeland now would mean throwing all that away.

Reporters and photographers swarmed Daisy and Violet the instant they stepped off the *Aquitania* onto a New York dock on August 6. Violet, comfortably at home in such situations, immediately started orchestrating an impromptu press conference. With flash bulbs bursting all around the sisters, she held out her left hand, displaying an engagement ring with a large diamond. She then made the announcement that was to send the newsmen tripping over one another, searching for phones to call their city rooms.

While in Great Britain, Violet revealed, she had fallen in love with Harry Mason, the prominent British boxer. He had asked her to marry him and had slipped the ring onto her finger moments before she and Daisy left England's shore. She and Harry would marry before a year was out, Violet announced. Theirs would be a double wedding. At the very same moment when she and Harry were marching to the altar, Violet said, Daisy and the bandleader Jack Lewis would be following in lockstep. "I am quite sure we will be the happiest foursome in the world," she purred.[19]

Violet made another surprising revelation: Because both she and Daisy had promised their hands in marriage, they would go on tour only one more time and then would retire from the stage forever. Violet said that she and Daisy, along with their affianced Lewis and Mason, had crafted a plan for the future. The four would settle somewhere on a farm and start bringing children into the world. "We're tired of vaudeville and tired of exhibiting ourselves," she said. ". . . We have

found two men who are as devoted to us as we are to them. . . . We have made up our minds to stop exhibiting ourselves all over the world and to gather as much peace and happiness as we can."[20]

But as Violet chirped on, effusing about just how happy she and Daisy and Jack and Harry were all going to be, it was apparent that Daisy was troubled. She kept standing on tiptoe and craning her neck, trying to look over and beyond the felt hats of the reporters crowded before the sisters. She was sure that in very next moment she would see a taxicab stop near the clot of reporters, and Jack Lewis would throw open a door and come running to her, with a large offering of roses in his arms.

But Lewis never did appear, nor did he ever send an emissary to explain why he was unable to greet her. He was a thousand miles away, back home in Chicago. The bandleader's absence from the Hilton sisters' homecoming didn't go unnoticed by the reporters. Because the newspapers had made so much of Daisy and Lewis's engagement announcement a year earlier, the writers now asked her if the romance was over.

Flushed and on the verge of tears, Daisy tried covering for her lover. "Jack has been writing to me almost every day since we left America," she said, "and I'm going to Chicago as quickly as possible. We'll plan out the wedding when I get there. He's been so busy, he was unable to meet the boat."[21]

# TOO BAD ONLY ONE OF THEM WENT FOR BOYS

Jack Lewis wept when, in his Chicago apartment, he took Daisy in his arms for the first time in eight months. He seemed genuinely remorseful that he hadn't bothered to show up when she and Violet returned from their extended sojourn in England.

"I was a terrible cad," he conceded. "I couldn't blame you if you never wanted to see me again."

Jack begged for Daisy's forgiveness. He tried assuring her that he loved her as much as ever. In the days ahead, however, it became clear to her their relationship had changed while she was abroad. Jack was noncommittal whenever she brought up the subject of when they would marry, and even though he used to be thrilled to have Daisy and Violet tagging along after his orchestra in and around Chicago, he now discouraged the sisters from turning up at his engagements.

Daisy suspected Jack had started seeing other women when she was abroad. That may have been so, but the reason for the slackening in their relationship may have been more complex. Even after proposing to Daisy a year earlier, Jack's thoughts kept shifting to whether a marriage to a Siamese twin could ever work. From the start, he was troubled by the idea that if he took Daisy as his wife, he would be entering into a union with not just one mate, but two. Upon learning that Violet had fallen in love with the English boxer Harry Mason and that she too was planning a trip to the altar, Jack realized that

matters had become even more complicated. He was now going to have to get used to the idea that he would have not just two partners in his life, but three, one of them another male.

Soon there was another matter dividing Daisy and Jack. While making plans for what they told the press would be their farewell tour of American stages, Daisy and Violet, along with their agent, Ferd Simon, counted on engaging the Jack Lewis Orchestra as the show's backup band. Daisy felt sure Jack would be elated at the arrangement. It would mean the two would be together on the road. She was desolate when Jack gave her his response.

"Until I met you, Daisy, dear," he said. "The only thing I wanted in life was to be a big-name bandleader. Now that's really starting to happen. The Jack Lewis Orchestra is becoming ever more popular. It's only a matter of a little more time before we're considered a national act. As wonderful as it would be if we were able to travel everywhere together, dear, I worry that the orchestra would lose its popularity if it now became a backup unit for a road show."

Indeed, Lewis's following had been growing ever larger, and not just in the Chicago area, but also in outlying Midwestern towns like St. Louis, Kansas City, and Milwaukee. Lewis was still only twenty-two, but he had ambitions of becoming a bandleader with the renown of a Paul Whiteman, Guy Lombardo, or Blue Steele. He was hoping to get a contract with a major record company as well as regular radio broadcasts.

"Let's not make a mistake, Daisy," Jack said. "We're both young. We've got the rest of our lives to spend together. It's only going to be a little while longer before the Jack Lewis Orchestra is on top. Then I'll be able to provide you with everything in life that you deserve."

Hoping to placate the sisters, and especially Daisy, Jack said he knew someone who would be ideal to lead their road show band. Maurice Lambert, he assured the twins, was a talented conductor

and arranger. As luck would have it, Maurice was also looking for work.

Jack arranged a dinner at a Chicago supper club so Daisy and Violet could meet Lambert. The sisters had been willing from the start to accept Jack's high assessment of Lambert's abilities as a conductor and arranger, but on seeing the job applicant face to face, they learned immediately that he had other credentials to commend himself.

Maurice Lambert was tall and thin. He had dreamy brown eyes and wavy, cinnamon-colored hair. Positioned equidistantly between his patrician nose and his upper lip was a thin, zipper-like mustache.

Violet couldn't take her eyes off Maurice. While the four were in the restaurant, discussing plans for the Hilton Sisters road show, Violet was comparing Maurice's beautiful, unmarked face with her memory of her scruffed and dented pugilist fiancé in England. She tried hard to establish a connection to Maurice that first night, signaling with her eyes that she was interested in everything about him. She couldn't tell if her coquetry was registering. Maurice was shy in manner and seemed always to have a slightly entranced expression, as though his thoughts were never fully grounded in the present.

Later that night, after the dinner party had broken up and Daisy and Violet were back in their hotel room, they had a discussion about Maurice Lambert's suitability as the musical director for their road show. Daisy said she had to agree with Jack: Maurice seemed perfect for the job. Violet's opinion was only slightly different: Maurice seemed perfect, period.

In their next meeting with Maurice, the twins told him they wanted him as their orchestra leader, and asked him to immediately start auditioning players for the band. They wanted him to put together the best ensemble possible.

Lambert gathered an orchestra of fourteen members. If there was one musician who shone brighter than the others in the new ensemble,

it probably was Howard Gustafson, the piano player. Gustafson, who was from Burlington, Iowa, was just sixteen and making his debut as a professional musician. Later, he would change his name to Bart Howard, and after penning such tunes as "Fly Me To The Moon (In Other Words)" and a slew of others, he would gain a reputation as one of the country's most beloved song writers.

Daisy and Violet were feeling flush. They had earned $3,500 a week while making the circuit of Moss Empire theaters in the United Kingdom. Not since their second year in American vaudeville had they commanded such high pay. But the overseas tour had left them exhausted. They felt they needed some rest before returning to the road. They decided to spend part of the 1933–34 winter at their apartment in San Antonio. It was there that they renewed contact with their closest admirer, one whom they first had met thirteen years earlier.

Jim Moore was now twenty-eight years old. But he was no less worshipful of Daisy and Violet than he had been during their carnival years when, as a teenager, he could be found inside their tent anytime the Wortham or Johnny J. Jones shows had spread their tents in San Antonio. In his eyes, the sisters were more beautiful than any of the sainted children he saw illustrated in the books of Bible stories. He had never viewed them as freaks, as creatures whose bodies had been fused together because of some misfiring of nature. Rather he believed that God must have bonded them together for some divine purpose, just as He had endowed Methuselah with lungs that could keep him breathing for a millennium.

Moore was feeling some chagrin at his situation at the time Daisy and Violet rejuvenated their acquaintanceship with him. He was living in a rooming house and working as a part-time instructor at the Mimi Pomme's Dance Studio in downtown San Antonio where the sisters themselves had studied. The job was a comedown for him. Only a few years earlier, he had been touring the country performing

*Violet and Daisy pose on the boardwalk with their orchestra, mid-1930s.*
*Violet's fiancé, Maurice Lambert (all in white) stands next to her.*
*(Author's collection)*

in variety shows. But with the rapid and widespread conversion of vaudeville houses into emporia for the new talking films, Moore, like thousands of other stage entertainers, discovered that his talents were no longer much in demand.

He was thrilled when the twins outlined their plans for a new touring show and offered him work as both a dancer and emcee. They did not know it at the time they offered him the job, but Daisy and Violet were to receive unexpected returns from their hireling. Moore was to become their closest confidant and, in time, something even more, especially for Violet.

The new road troupe, called the Hilton Sisters and Their Orchestra, gave its premiere performance in June 1933 at Fay's Theater in Philadelphia. With full-page ads in the entertainment trade papers, the enterprise was billed as "America's Super Box Office Attraction." Besides the twins, who sang, danced, and played duets on a variety

of instruments, the show also included bravura displays in rhumba, tango, and the Charleston by Jim Moore and a partner, Anita Marie Ciska. In the pit, waving a baton before a newly minted orchestra, was Maurice Lambert.

The stage production was glossy, fast-paced, and lasted an hour and a half, according to Moore. As always, the show closed with Daisy and Violet's signature finale, the *pas de quatre* in which each twin took a male partner. "I danced with one twin and a boy out of the orchestra danced with the other one," Moore recalled. "To see four of us doing it all together was sort of spectacular."[1]

Following the Philadelphia engagement, the company appeared at the State Theater in Baltimore, Maryland, and then moved to Proctor's Theater in Newark, New Jersey. Big outlays on road expenses and weekly payroll for the large retinue meant the production was too expensive for all but the largest theaters. Fortunately, a new type of entertainment venue had started to evolve that made the revue more widely in demand. After the 1933 repeal of the Prohibition Act, there was a proliferation of nightclubs that not only offered their patrons dining and liquor, but also live entertainment and dancing.

"The formula we had was an especially good one for the swankier nightclubs," Moore recalled. "The stage shows were slickly packaged. Most nights, we'd put on two shows, one at about nine o'clock, the other at eleven. Then, after we finished the last stage show for the night, Maurice and his orchestra took over. They provided dance music for the patrons until the wee hours."[2]

All indications are that it was Violet, not Maurice, who made the first moves in launching the romance between the two of them. Not only was she irresistibly attracted to him because of his boyish good looks, she was also swept up by his gallantry. Maurice came from a wealthy Virginia family. He was a man of breeding and elegant manners. Charm oozed from him like juice from an overripe peach.

What happened to the promise Violet had made to Harry Mason a few months earlier when, just before shipping off from England's shores, she let him slip a diamond engagement ring on her finger? Violet's jettisoning of the boxer, while betraying a certain hardness of heart, may be explainable in psychodynamic terms. Because she and Daisy were rejected at birth by their own mother and raised by warders who regarded them only as chattel, the sisters came into womanhood with a craving for love that seemed almost pathological. Certainly Harry was no longer in a position to fulfill Violet's needs. He was 5,000 miles away. He was also obsessed with regaining a boxing crown before settling down in a marriage. Maurice, on the other hand, was now readily on hand to take Violet in his arms and tell her over and over that she meant the world to him.

Among those with whom the twins worked and socialized, there were at least some who believed that Violet's romantic and sexual urges could have been as easily appeased by another woman as by a man. There had always been murmurings that she might have had bisexual, if not homosexual, tendencies. Intimations of Violet's possible ambivalent, if not antipathetic, feelings about men had already been publicly remarked upon when the sisters were quite young. The *New York Herald*, for example, provided this assessment in a story about the girls when they were sixteen:

> Violet and Daisy are, with the exception of the joining of their bodies, two distinctly separate women. Violet, whose hair is dark, is inclined to be quiet, is quite moody, and has no use for the attentions of the opposite sex. On the other hand, Daisy, who is blonde, is vivacious, has, it is said, several admirers and is declared to be an outrageous flirt.[3]

Lew Dufour, a carnival operator and friend of the twins' one-time employers, Clarence A. Wortham and Johnny J. Jones, intimated that

he had close knowledge of the twins' sexual wiring. "Too bad only one of them went for boys," he commented, tantalizingly.[4] While Dufour side-stepped the question of which Hilton might have preferred same-sex partners, there can be no doubt he was referring to Violet. Daisy was never coy about revealing her interest in men. She had always been blatant in pursuing them.

Rose Fernandez, a dancer who shared stages with the twins during their vaudeville years, made this observation: "Both girls were the sweetest things you ever saw, but it's true that Vi didn't seem as feminine as Daisy. There was something a little gruffer about her mannerisms—the way she talked, the way she smoked a cigarette. Some performers said she enjoyed the company of women over men. If that was so, though, it might have been just about impossible for her to act on her desires. Would even one woman in a million even think about entering into a lesbian relationship with a Siamese twin? I never knew of any lesbian relationships Vi might have had, but I do know she and Daisy double-dated all the time and that they both had male escorts. Violet may have had a stronger preference for women, but because both girls had been starved for one-on-one relationships for so long, I suspect she might have been willing to accept love in whatever form it presented itself, whether from another woman or a man."[5]

Another perspective on Violet's sexual wiring was provided by writer and playwright John Bramhall of San Antonio. Bramhall became something of an expert on the Hiltons in the course of doing research for *Daisy and Violet,* a play that was first produced at the Harbor Playhouse in Corpus Christi, Texas. Bramhall spent considerable time interviewing Jim Moore, the twins' closest confidant. Moore never discussed any same-sex assignations that either of the twins might have had, Bramhall said, but he did talk about their libidinous urges.

"Moore said that Violet and Daisy were both nymphomaniacs,

that they just couldn't get enough sex," Bramhall recalled. "He told me that both sisters had a great number of boyfriends, both serious and casual, and that Daisy and Violet might see two or three lovers at different times during the same night."[6]

Bramhall said Moore flatly denied he had ever slept with the twins, although the dancer reported that he had often "scrubbed the girls' backs when they were in the bathtub."

Whatever Violet's preferred sexual orientation, both sisters said that what each wanted most in life was to pair off with a loving mate. Speaking for her twin as well as herself, Daisy summed up their shared aspiration this way: "One thing we agree on is, every girl has a right to romance and love, and she can't be happy without them."[7]

Daisy and Violet created no small stir when, in the company of Maurice Lambert, they entered New York's Municipal Building on the morning of July 5, 1934. Their high heels clickety-clacked as they strode purposely over the terrazzo floor. They were attired in ankle-length, black velvet dresses. Lambert, who towered over the pair by at least a foot, looked like he could have been on his way to a fashion shoot for *Vanity Fair*. He was wearing a light beige flannel suit and brown and white spectator shoes. Because of the heat of the day, his brown wavy hair was damp and slightly tousled.

Within moments of the trio's appearance in the building, the switchboard operators seemed to have alerted every office in the forty-story structure. Filing clerks, typists, and stenographers left their posts to stand in doorways and ogle the threesome. Accustomed to attracting attention almost everywhere they appeared, Daisy and Violet maintained an air of cheerful unconcern. Maurice's expression was one of bemusement, but he may have been a little self-conscious. The office girls looking him over remarked to one another about just how gorgeous he was. Soon the three were leading a small procession

of curiosity seekers, including some reporters who had suspended a pressroom poker game to investigate the commotion.

Still tailed by the entourage, Daisy, Violet, and Maurice ascended a staircase. On the second floor, they walked halfway down the corridor and then entered a doorway above which was a large sign: Marriage License Bureau. Gushing into the office behind them was their entourage of municipal workers.

The three moved to the counter, Violet and Maurice hand in hand. Violet began filling out a form, frequently looking up at Maurice and asking him about such matters as his date of birth, mother's maiden name, and blood type. A clerk left her desk and came to the counter. When she got a closer look at the sisters and saw they were physically conjoined, she was momentarily too stunned to talk. Her face became flushed. Finally, she asked the license applicants to excuse her for a moment.

The clerk slipped inside the glass cubicle of the marriage bureau's chief clerk, Julius Brossen. She and her boss were out of earshot, but it was evident to everyone crowding the office that the clerk was agitated. After a few minutes, Brossen emerged from his office and made his way to the counter. He smiled wanly and introduced himself as the chief of the marriage license bureau. "Ah . . . ," was the only sound he was able to emit before clearing his throat. "But . . ." he tried continuing, and then cleared his throat again. "Well, what I mean to say. . . ."[8] Finally he apologized to Violet and Maurice, picked up their completed application form, and asked them to excuse him for a moment. He returned to his glass-walled office. In seconds he was talking into a phone.

Within minutes, Michael J. Cruise, the New York city clerk, and his top deputy, Philip Hines, turned up at the bureau office. Before entering Brossen's office, they had to part a crowd that was now spilling outside into the corridor. The marriage bureau chief, the city

clerk, and the deputy city clerk conferred for several minutes and then, as a trio, left to pay a call on the New York Corporation Counsel office elsewhere in the Municipal Building. Meanwhile, the reporters interviewed Maurice, Violet, and Daisy.

"We want to get married as soon as soon as we can," Lambert said. "We love each other very much."[9] He explained that when he first met the Misses Hilton, he was attracted to both of them, but that his friendship with the sisters initially was "purely platonic" and slightly complicated by his difficulty in telling the auburn-haired sisters apart. "Then, after a time, Violet and I realized that we were in love with each other," he said. "But I like Daisy, too. I couldn't want a nicer sister-in-law. We are all very congenial. And when I talk to Violet, Daisy may be reading or dozing or talking to her own friends."[10]

A newsman remembered that when the twins returned from Europe only six months earlier, Violet announced that she had just become engaged to the English boxer, Harry Mason. What had happened to that romance? he wanted to know. At that moment Daisy made an announcement that left even the reporters momentarily speechless.

"I'm going to be married to Harry," Daisy declared. She raised her left hand into the air for all to see. Glistening from her finger was a diamond engagement ring. It was the same ring that Mason had given Violet at Southampton harbor moments before the twins boarded the *Aquitania*.

Daisy explained that Violet had broken off her engagement to the fighter a couple of months earlier, and, coincidentally, she had ended her betrothal to band leader Jack Lewis at the same time. This gave her the freedom to step in for Violet and take over the romance with Harry Mason just where her sister had left it off. "He's coming over in six months," Daisy said of the English pugilist. Daisy didn't say whether Harry had yet been informed that he now had a new fiancée.

A half hour passed. Finally, Julius Brossen returned. He located

Violet and Maurice in the crowd. He handed them the form they had filled out. "I'm sorry," he said. Scrawled in pen on the paper were the words, "Application is denied on the ground that the bride is a Siamese twin." The writing bore the signature of Russell Tarbox, an assistant corporation counsel.

Immediately, several newspapermen made a beeline to the office of William C. Chanler, the acting head corporation counsel. While Chanler conceded that there was nothing in the city's code that would prevent a Siamese twin from marrying, he noted that the city clerk had broad discretionary powers in the granting of licenses. Chanler said that he supported the decision to deny the permit. "The very idea is quite immoral and indecent . . . ," he declared. "The city will not be a party to such an affair."[11]

Violet and Lambert were feeling frustrated when, moments later, they exited the New York Municipal Building, but they were not altogether vanquished. Within minutes, Violet, Maurice, and Daisy were speeding in a cab through the Hudson River tunnel. Their destination was Newark, New Jersey.

The Newark city clerk, Harry Reichenstein, had been tipped off by his New York counterpart that the three were heading his way. He was standing behind the counter, his arms folded before him, when Violet, Maurice, and Daisy entered his domain. "No," Reichenstein announced firmly. "I can't give you a license. What grounds? The same grounds as in New York. Moral grounds."[12]

Violet was sobbing openly when the three exited the Newark courthouse. Maurice tried reassuring her that their love would find a way, that in the end, everything would work out fine. But Violet no longer seemed so sure the story would have a happy end. The rouge on her cheeks bore thin tracks from her tears.

"This is terrible," she said, addressing the reporters on the courthouse steps. "How do they expect a girl to be moral?"[13]

If she was trying to imply that she and Maurice had intended to remain chaste until after they became legally married, she was likely being disingenuous. The band leader, after all, had already moved into the twins' apartment at 25 Central Park West.

Hours later, Daisy and Violet opened their apartment to Lady Terrington, a celebrated columnist for the *New York Daily Mirror*. The golden light of late afternoon was pouring into the spacious living room, ricocheting blindingly off a grand piano at its center. Boy II, a new Pekingese Daisy and Violet had gotten recently, was running all over the apartment, alternately chasing imaginary cats and then jumping onto Lady Terrington's lap.

Violet was in tears throughout the interview. "Why shouldn't I marry" she asked. "I'm a normal human with a woman's feelings and a woman's desire of fulfillment. I am in love with my fiancé, and the natural culmination is marriage."[14]

Lady Terrington made the observation that, as one half of a physically inseparable human set, and as a constantly traveling entertainer, Violet was living a life that was already more complicated than almost anyone could imagine. The writer asked Violet if she had really thought about how much more of a struggle her life would become if she and Maurice were to become parents. "I want children," Violet replied. "A boy and a girl. I love children, but I do not approve of having them until we can settle down. One cannot look after children right on the road."[15]

Accounts of the misadventures Violet and Maurice experienced in New York and Newark were carried in virtually every daily newspaper, in magazines like *Time*, on the radio, and even in the moviehouse newsreels. Within days, the star-crossed lovers started getting telegrams from municipal clerks all around the country who assured the pair they could obtain licenses at their courthouses. Many of the wires came from small towns in North Carolina,

*The twins with Maurice Lambert, mid-1930s.*
*(Author's collection)*

Maryland, Arkansas, Indiana, and Kansas. The clerk in Marion, Arkansas, told Maurice and Violet that if they chose his town for their Gretna Green, he could guarantee that the entire community would join in the celebration.[16]

Because it was the closest town from which they received an invitation, Violet and Maurice accepted an offer to obtain their license in Elkton, Maryland. Because their earlier efforts had set off feeding frenzies with the press and other media, they decided to keep their plan to themselves. To the extent that it was possible for the twins to travel anywhere without attracting attention, Violet and Daisy, along with Maurice, boarded a train in New York and slipped away

to the town just inside Maryland's border. After they filled out their application and paid a license fee, the Elkton city clerk congratulated the pair, kissed Violet, and shook Maurice's hand. After the requisite five-day waiting period, he assured them he would mail their marriage permit.

Violet and Maurice were overjoyed. However, they had hardly returned to the Manhattan apartment when there was more bad news. The Maryland state attorney learned that the Elkton clerk had accepted the couple's application for a license. He wired the clerk immediately, prohibiting him from issuing the license.

Like lovers in a Shakespearean drama, they felt helpless rage toward those who declared that a marriage between a conjoined twin and a normal man would not only be a misalliance, but an affront to society. Who were such people to decide what was right and wrong in the moral universe?

The love between Violet and Maurice didn't lose its intensity, but it did begin to change. It no longer had the lightness that characterizes the relationships of couples who have just committed themselves to one another. Their love started to feel dark, even grave. It felt ponderously heavy, a burden each was meant to carry. And because so many officials had characterized their efforts to marry as being outside the law, indecent, and even immoral, their love began to feel soiled.

To the press, Violet and Maurice declared they had every right to become Mr. and Mrs. and that they would not give up their fight. Between themselves, it was another matter. First one would sink into despondency, and then the other, in spite of their efforts to rally their spirits and offer each other assurances that everything would eventually work out.

Violet was accustomed to the invasions the press and public tried to make on her privacy. She couldn't remember a time when reporters

weren't trying to pry into highly personal matters concerning her life. And, of course, she was used to people gawking at her whenever she appeared in public. But Maurice, who was bashful by nature, found it agonizing to deal with all the attention and especially the smutty jokes that came with being engaged to a Siamese twin. Behind his back, even members of his orchestra jested about what his nights in the bedroom with Violet and Daisy must be like.

Lambert's uneasiness at being thrust into the spotlight was evident in a Fox Movietone newsreel that was produced at the time. Probably filmed in the twins' apartment, the three are shown sitting on a set-tee. Though Maurice kept gazing at his fiancée with a moonstruck expression, he apparently was too camera shy to vent his outrage at being denied the chance to marry the woman at his side. He didn't utter a single word during the film. Violet, however, looked unflinch-ingly into the camera lens. In a voice that sounded like she was on the verge of tears, she tried to present their case before America: "I am Violet Hilton and this is the bandleader for our show, Maurice Lambert. We tried very hard to procure a marriage license both in the states of New York and New Jersey, but were refused in both places. I feel very unhappy about it because I love Maurice very, very dearly and he loves me. I don't see any reason in the world why we should be denied the pleasure of being happy."[17]

Violet and Maurice still held a sheaf of telegrams from municipal clerks in small towns offering them licenses to wed. But they feared that if they accepted another invitation, their application, like that which they had filled out in Elkton, Maryland, would only be inval-idated at the state level. Finally, they consulted with an attorney, Irving Levy. A New Yorker who had represented the twins in contrac-tual matters in the past, Levy moved immediately to bring the case before the state supreme court of New York. He petitioned the high court to prepare a writ of mandamus against the city of New York,

ordering its officials to show cause why the couple should be barred from obtaining a marriage license.

Levy outlined the couple's case before Chief Justice Kenneth O'Brien on July 13, 1934. He argued that Violet and Maurice met every requirement of the law to be husband and wife. He reasoned that by denying the couple a marriage permit simply because the bride happened to be a conjoined twin, New York's licensing author-ities had acted in a way that was completely arbitrary.

Levy went on to argue that New York was the last place in the country where any official should be expressing concern about a hus-band and wife sharing their marital bed with the wife's sister. In Manhattan, especially, he observed, "two or three couples often dwell in the same one-room tenement." The attorney also dealt with a claim that the marriage bureau would be violating the law by granting a license to Violet and Maurice because, perforce, the freedoms of a third party, Daisy, could be abridged by the contract. Levy intro-duced an affidavit from Daisy in which she declared that she "unequivocally and irrevocably approves . . . the marriage of her sis-ter, and that she gives the consent fully aware of the consequences and relations which may ensue as a matter of normal married life between Violet and Maurice L. Lambert."[18]

After hearing Levy's arguments for why Violet and Maurice were entitled by law to wed, Justice O'Brien ordered the opposing side to respond. Representing the city of New York in the matter was Russell Tarbox, the assistant corporation counsel who earlier had written "Denied" on the couple's license application.

Tarbox began his pleading by stating that the marriage bureau denied Violet and Maurice a permit to wed because its officials could not be sure whether, under the law, the bride would be considered one person or two.

Levy tried exploding the counsel's argument by introducing evidence

showing that Violet and Daisy had always been two persons in other legal matters. He noted, for example, that the sisters were issued separate passports, filed their income tax forms separately, and entered into all their contracts as individuals. He also presented the high court with affidavits from medical experts and scientists, including comparative anatomists and geneticists, who declared that conjoined twins were separate entities. One of the affidavits came from Dr. D. H. L. Shapiro of the American Museum of Natural History in New York, who provided this testimony: "In my opinion, Siamese twins are two persons. The strongest basis for this conclusion rests on the fact that they reason and think differently."[19]

Attorney Levy then presented evidence that there already were precedents for the granting of marriage licenses to Siamese twins. He cited the case of Chang and Eng Bunker who, in 1843, married daughters of a North Carolina minister and together fathered more than twenty children. He also referred to the cases of Lucio and Simplico Godino who, in 1929, married sisters in the Philippines, a United States possession. "Because of an accident of birth, because of an accident of fate, . . . Violet was born a Siamese twin," Levy stated. "This should not preclude her from entering into the bonds of holy matrimony, which is the desire of every young woman. . . . To deny her rights is imposing an unnatural and immoral burden upon her . . . and it will prevent her from leading a full life, from indulging in those normal, intimate acts of married life, and possibly from bearing children. The ruling of the city clerk's office that Miss Hilton could not wed because she is a Siamese twin is arbitrary. She is mentally, morally, and emotionally fit to wed."[20]

Tarbox directed Philip A. Hines, New York's deputy city clerk, to take the witness stand. Under direct examination, Hines maintained that the law granted city officials broad discretionary powers in determining which couples were fit to obtain marriage permits.

Granting a license to a Siamese twin, he declared, would be contrary to public policy because it would mean the city was sanctioning a situation in which a third person would be present during the most intimate moments of a couple's married life. Hines declared also that the license bureau had refused a permit to Violet and Maurice because some city officials suspected the couple was not really marrying out of love, but rather because they wanted merely to attract publicity for their road show.

Levy sprung up from his chair as though he were on a jack-in-the-box spring, and then he blew up.

"I deny that," he shouted. "This is a true love match."[21]

He accused Hines of outrageous effrontery for impugning the motives of a couple who only wanted to spend their lives together. He also took exception to a claim made by the deputy city clerk that the public at large would be offended at the idea of a Siamese twin marrying.

"This cannot offend public decency in an era that permits interracial marriage, birth control, and nudist camps," Levy declaimed in what seemed to be a personal editorial about all he believed was decadent in society.[22]

Levy had been thorough and forceful in arguing the case for Violet and Maurice. It came as a surprise, when just a day after the hearing, the state supreme court of New York ruled that the city clerk's office had acted within the law by rejecting the couple's marriage license application. O'Brien, the presiding justice, provided no explanation for the finding other than to say his fellow jurists unanimously concurred in the decision.

Both inside and outside legal circles, there was widespread belief that the supreme court's decision was not based on any points of law, but rather on an agreement that had been hammered out by an "old boy" network involving city officials and New York's highest justices.

The *American Weekly* weighed in with an editorial calculated to per-
suade the country that justice had been grievously miscarried. It
pointed out that Violet and Lambert had both made successes of their
lives, had never been in trouble with the law, and that Violet, espe-
cially, had been a heavy contributor to the government through income
and real estate taxes.

> Any pair of male and female half-wits not actually in an insti-
> tution, any vicious man and woman, any tramp and disrep-
> utable woman, any two masculine and feminine jailbirds are
> welcome to be wedded so long as they give the license clerk
> the right answers, though statistics show they are almost
> certain to give the country a litter of criminals, idiots, or
> unemployables to be cared for in prisons, asylums or the bot-
> tomless pit of public charity.
>
> The children of Mr. Lambert and Miss Hilton should be
> fit mentally and physically to earn at least an average living,
> unless they happened to produce 'Siamese twins' in which
> case their fortune is assured. Suppose their mother should
> die early which would also drag Daisy to death in a few
> hours, and the father also happened to be killed by disease
> or accident. The orphans would inherit a large sum of
> money, preventing any danger of their becoming a public
> charge.[23]

The *American Weekly* went on to address the issue of adultery that
it said could be an ever-present temptation for a man whose wife is a
conjoined twin.

> In 'Siamese' cases, the wife is present at all times to protect
> her rights. . . . About the only conceivable way by which a
> husband could make love to the other undisturbed would be
> to knock the wife cold by hitting her on the head, a proceed-
> ing which could be done successfully only about once.[24]

Violet and Maurice, of course, were crushed. But they didn't quit their struggle to become husband and wife—at least not immediately. For the next year or so, wherever the Hilton sisters and the orchestra traveled, Violet and Maurice tried to slip off quietly to the local marriage bureau. Always they were rebuffed. And, because the clerks were quick to call the press in on the story, Lambert was always portrayed as a pathetic half-wit who, for all his physical beauty, had a loose screw that made it impossible for him to find happiness in a normal one-on-one relationship. In every town, reporters quizzed him about what it was like to love and be loved by two women simultaneously.

The love that Violet and Maurice felt for one another, once brimming over with promise, sweetness, and excited expectation, mutated into something that felt smutty, lascivious, and even un-American as, over and over, the two were beaten down by the press and the judicial system.

Because of his exhaustively publicized attempts at trying to marry a Siamese twin, Maurice had not only become a national laughing stock, he had also become fixed in the public's mind as a freak himself, a man of almost god-like beauty who was damned with a libido of the most curious wiring. As a result, Lambert was becoming almost pathologically shy. Whenever he stepped out to lead the Hilton Sisters Orchestra, he was aware that everyone in the house, including the musicians, viewed him as some kind of sexual misfit. What made everything worse was that there was no longer any place to hide. Because he and the twins had been photographed by the newspapers so many times in so many courthouses, he couldn't appear anywhere in public without setting off murmurs.

Finally, Maurice was unable to bear the strain and humiliation another day. One morning, while the twins' revue was out on the road, Violet and Daisy woke up in their hotel room to find he was

gone. Violet immediately got on the telephone, calling his relatives, musician friends, and agents to see if anyone knew his whereabouts. It seemed Maurice had vanished from the face of the earth.

In fact, Maurice boarded a ship bound for Europe. What happened to him there, or whether he ever returned to America, no one in the twins' circle ever seemed to know for sure. One thing is certain: Maurice never fulfilled his ambition to become a famous bandleader. Bureaucracy shredded that dream while it ground down his hopes of walking to the altar with the woman he truly seemed to adore. The gentle, bashful, charming, handsome Virginian should perhaps be remembered as a man who was turned away more times and in more places than any other prospective groom who ever sought to obtain a license to marry. Before finally giving up his effort to take Violet as his bride, he had unsuccessfully applied for a license to wed in twenty-one different states.

# SHE WON'T BOTHER US ANY MORE THAN A KITTY SLEEPING ON THE OTHER PILLOW

n the spring of 1936, Daisy learned she was pregnant. The discovery left her terrified about what might lie ahead. Violet, of course, felt desperate, too. What were they going to do? What would become of the child and what would become of them? They were twenty-eight and beginning to think they were washed up as entertainers. What would they do to earn a living if they could no longer work on the stage?

One thing was certain: The father of the child was not Harry Mason, whom Daisy had publicly named as *her* new fiancé after Violet had fallen for Maurice Lambert and then crossed Harry off her list. Harry was still back in England. He hadn't seen the twins since the day two-and-a-half years earlier when Daisy and Violet left England to return to America, leaving Harry behind to continue his quest to regain the British welterweight crown.

Indeed, even if an ocean hadn't lain between Harry and the twins, there were questions: Had he ever truly been smitten with Daisy after losing Violet? Some of his acquaintances suggested that even if Harry had agreed to go to the altar with Daisy, it was only because the resulting union would necessarily allow him to be with Violet, his true love.

Whatever feelings Mason had for Daisy before she caught him on a rebound from Violet, it was Daisy, not Harry, who ultimately broke

off their engagement. Daisy said she became disenchanted with the boxer because of what she called his outsized ego. "Harry is too conceited," she complained. "He's eaten up with himself. I can't stand that."[1]

Mason may have been unlucky in love with not just one, but both Hilton sisters, but clearly the fates were in his corner in the square ring. After an eight-year crusade during which he faced off with hundreds of contenders, he finally recaptured the British welterweight crown in November 1934, snatching it from Len Tiger Smith in a decision that came after fourteen rounds.

If Harry could be eliminated as the father of Daisy's lovechild, then who was it? Except for Daisy and Violet, and presumably the father, the only other person who knew for sure was Jim Moore, the twins' closest friend and confidant. A principled man who was not given to revealing secrets with which he had been entrusted, Moore would only identify the father as a musician with the Dale Stevens Orchestra.

The twins had hastily engaged the Stevens orchestra to deal with the crisis brought on by bandleader Maurice Lambert's abrupt departure and the subsequent rapid disintegration of the ensemble he assembled. The Stevens orchestra, which was organized in Mansfield, Ohio, was, according to Moore's characterization, "a semi-name band, a very, very fine band."[2]

"Both the girls had boyfriends in the [Stevens] band," Moore said, "and I will change the names. I'll call Daisy's boyfriend Johnny and I'll call the other one Stan. . . . Those were the two boys in the band that came to see Daisy and Vi. And Daisy somewhere along the line got pregnant. . . ."[3]

Whoever the father of Daisy's baby was, he was probably already a married man, or so it might be inferred not just from Moore's somewhat evasive discussion of the subject, but also from some remarks

Daisy herself made. She never publicly acknowledged she was carrying a child, but she did declare to reporters that she was in love with someone in the Dale Stevens Orchestra and hinted that there was an impediment blocking their way to the altar.

"Maybe there is someone in our band I do like . . . a lot, but there is no question of marriage for, anyway, a very long time," she said.[4]

In a syndicated newspaper column, circulated by the International News Services, she also talked about having a secret lover, but stopped well short of revealing that they had made a baby together:

> It may seem funny, but just like millions of other girls, I guess, I once had a crush on Rudy Vallee. So far as I know, he never was anything more than a friend to Violet and me. But I used to get just as much of a thrill listening to his singing, and talking to him, as any schoolgirl would.
>
> The boy that I care for now has those same qualities. But he's almost as little known as Rudy is famous. He's a musician, too, incidentally. You might say that while we're 'interested' in each other — there's nothing definitely settled yet. But there will never be anyone else for me, I know. . . .
>
> Perhaps you think he should try to be with me, even though it would mean slowing up his own career. But neither he nor I like this 'reflected' glory idea. No, he's going to go ahead and make a name for himself. And he knows I'm cheering for him all the time.[5]

The twins were being managed by the Consolidated Radio Artists of New York and Chicago at the time Daisy became pregnant. Stanford and Ben Zucker, brothers who operated the agency, were discomposed by the news. The Hilton Sisters and Their Orchestra had been one of their more profitable attractions. The Zuckers were sure that if the press and public found out Daisy was carrying an illegitimate child, the sisters' appeal as entertainers would be finished. Ben set out

to meet with the twins on the road. Jim Moore couldn't remember where the encounter took place, but he said the meeting between Zucker and the girls was anything but civil. Zucker raged at Daisy for allowing herself to become pregnant, Moore said. He also lashed out at Violet for not having done something to prevent it. Because of their carelessness, because of their reckless hedonism, they had placed their careers at risk, Zucker stormed. He told Daisy she had to act immediately to have the child aborted.

The dreams Daisy and Violet had of one day entering into marriages and living quiet lives of domesticity and motherhood now seemed to have slipped away from them forever. Where were there two decent men anywhere who would be willing to settle down with Siamese twins and an illegitimate child? The sisters' sense of self-worth was at an all-time low.

Zucker was not having an easy time persuading Daisy to seek an abortion. The sisters still carried the pathological fear of doctors left over from childhood when surgeons poked and prodded them with cold steel instruments, pleading with Mary Hilton for permission to slice the flesh and cartilage that yoked the girls' bodies together.

Zucker's method for dealing with the twins' resistance was one of sustained attack. He kept reminding them of just how desperate their circumstances had become. What would they do if they lost their ability to earn a living as entertainers? he asked repeatedly. Where did they expect to earn a living if not on the stage? Sure, maybe they still had some funds from the court awarded $100,000, but where would they be in another two or three years when the money ran out? They would most likely be institutionalized in a sanitarium for the morbidly crippled and destitute. "Is that what you want?" Zucker asked. "Is that how you want to spend the rest of your years?"

Daisy and Violet were aware that thousands of women died every year from infection or blood loss due to back alley abortions performed

by quacks working with kitchen utensils and coat hangers. They were also aware that medically supervised abortions were illegal except in instances when they were deemed necessary to save the life of a mother. The twins whimpered throughout Zucker's tirade, Moore recalled.

Finally, Zucker wore away the last shreds of their resistance. Daisy and Violet agreed to see a physician about having the child aborted, but only under two conditions: Because of their trust in Jim Moore and his dancing partner, Anita Marie Ciska, they insisted the pair accompany them to the doctor. They also insisted that if Daisy's pregnancy was to be terminated, the procedure was to be carried out in a hospital. "They wanted," Moore explained, "to have it done right, you know . . . to have an abortion and have it done clinically, and in a sanitary place. It could have been [performed] in the doctor's office, but they wanted no problems."[6]

Zucker told the twins that when they saw the doctor, it was important for them to emphasize that they shared some internal organs and, thus, both their lives would be at risk if the pregnancy continued to term.

Moore and Ciska not only accompanied Daisy and Violet to the doctor's office, they were right behind the sisters when the physician called them into his examining room. Moore provided this account: "So the doctor says, well, let him examine them, and so forth. Well, they were very adverse to that, but he got out his calipers and he started measuring a little bit on Daisy. And he says, 'No, this young lady is perfectly capable of having normal childbirth.' And he wouldn't do this abortion."[7]

"It was the only time that the girls ever consented to go see a doctor in all the time I knew them," Moore said.[8]

The twins were almost hysterical when they left the physician's office. It isn't known whether the twins felt sadness or relief at the

doctor's refusal to end Daisy's pregnancy. Their perturbation was probably only partly due to their terror of doctors. They may also have been guilt-ridden for even considering casting off Daisy's baby as they had been discarded by a mother who felt they would be just too burdensome for her. But for the decision of the physician, they had been prepared to throw away a life. They decided then and there they would go no farther in seeking to have the pregnancy terminated.

Although Ben Zucker continued to harangue the pair about how they could be jeopardizing their careers by permitting a child to enter their lives, now the sisters were firm in their resolve.

Daisy and Violet, along with their orchestra and road company, were appearing at a Detroit nightclub six weeks later, when they got a surprise visit from their past: promoter, press agent, and flimflam man extraordinaire, Terry Turner. Accompanying him was their booker Stanford Zucker, Ben's brother. By now, Daisy's baby tummy was already beginning to show, but surprisingly, neither Turner nor Zucker expressed concern about her impending motherhood. Instead, Stanford excitedly told Daisy and Violet he had just booked their show for an open-ended engagement at the Texas Centennial Exposition, a year-long celebration in Dallas that already had attracted millions of visitors.

Then Terry Turner started talking. His ice-blue eyes glazed over. His expression became one of pure rapture. The twins had often seen the same changes come over him during their first years in vaudeville when he was their promoter and publicist. Turner told Daisy and Violet he had dreamed up a publicity scheme that could prove to be one of the most successful show business promotions of all time: while the twins were making their appearance at the Texas Centennial Exposition, he wanted one of them—he didn't care which—to get married. The wedding, he said, would be performed in Dallas's newly erected Cotton Bowl. He was convinced there would not be a

newspaper anywhere in the world that would not play the story on its front page.

Like leaves or candy wrappers being nudged along a sidewalk by eddying breezes, people were always moved from their original positions when they were hit by Terry Turner's gusts of words. Now Daisy and Violet were being swept along, too. Turner reminded them that eleven years earlier, thanks to his careful molding of their stage presentations and his promotional efforts, he had turned them into one of the hottest, highest-paid attractions ever to appear in vaudeville. He promised that if they again entrusted him with making the decisions about how best to promote their careers, he would have them quickly re-elevated to superstar status.

Certainly Daisy and Violet must have been excited by his projections of the new riches they could soon expect. The weekly payroll and traveling expenses for he Hilton Sisters and Their Orchestra had been hemorrhaging money almost from start. The twins had been able to prevent the road show's demise only because they kept transfusing it with funds drawn from their savings.

Turner had the twins' full attention as he continued to reveal the plan, especially when he assured them they could expect to become, once again, one of the most sought-after attractions in all of show business. Who knows, he went on, the Cotton Bowl wedding might even lead to starring roles in major motion pictures, maybe even their own weekly radio show.

As pleasurably adrift on Turner's word zephyrs as they now found themselves, imagining what it would be like to be richer and more popular than ever, Daisy and Violet retained some skepticism. Even if one of the sisters did offer herself up as the bride for a staged wedding, they didn't see how Turner could make the marriage legal. Violet reminded Turner of all the brick walls she and Maurice Lambert had encountered when they tried to marry.

"Maurice . . . tried to get a marriage license to marry me in twenty-one states, and he couldn't," she said.[9] Her eyes were tearing, and she started sniffling. She apologized to Turner and Zucker. She said she still hadn't gotten over her heartache from all the rejection they had experienced.

Turner reached for a hand from each sister. "That's right," he concurred. "But if I can get a license, will you go through with the ceremony?"[10]

Violet then asked the big question: Who would the bridegroom be? Turner shifted in his chair. Frown lines appeared on his brow. He replied that a groom hadn't yet been selected, but he assured the sisters he would find a mate whom both would find attractive and compatible.

It all sounded outrageous. Was Turner merely pulling their legs? The twins only half believed he was serious about the plan he outlined. Still, Violet decided to humor him.

"I'll be the goat, if you can manage," she volunteered.[11]

A grin broke on Turner's face. Violet had given him the answer he wanted to hear. He threw his arms around both sisters. He kissed them over and over. He and Daisy and Violet were going to get along beautifully, just the way they had when he first introduced them to Broadway, only this time Myer Myers wasn't going to be around to call the shots and suck up all the money.

Turner left Detroit on a Dallas-bound train the next day. He was already on retainer with Lew Dufour and Joe Rogers, carnival men who were operating thirty-eight attractions on the midway of the Texas Centennial Exposition, including one called the "Streets of Paris," a recreation of belle époque Montmartre with nude dancers in every cabaret.

The Hilton Sisters and Their Orchestra continued their rounds of nightclubs and theaters in the Midwest and East. Weeks passed.

Daisy and Violet heard nothing more from Turner or the Zucker brothers about the planned Cotton Bowl wedding. Speculating that Texas, like all the other states, had told Turner it couldn't issue a marriage license to a Siamese twin, Violet and Daisy concluded he and the Zuckers must have abandoned the whole idea. In July, the Hilton sisters entourage made the long trip to Texas for the engagement at the Centennial Exposition.

Upon arriving at the Dallas train terminal, the troupe divided into small groups to travel by taxis to the state fairgrounds. The twins shared a cab with Jim Moore and his dance partner, Anita Marie Ciska. The four hadn't been in the cab more than a few minutes when they began to see billboards plastered all over town that left them astonished. Blown up four or five times larger than life, were pictures of Daisy and Violet. The billboards invited one and all to turn up at the Texas State Fairgrounds on the evening of Saturday, July 18, 1936, to attend the wedding of Violet Hilton of the "World Famous Siamese Twins."

As stunned as Violet and Daisy were at seeing their bodies inflated to such gargantuan size, they weren't nearly as shocked as Jim Moore was. He recalled the horror he experienced when he got his first look at one of the roadside wedding invitations. "I look up on the billboard," he said, "one of those sixty foot billboards, and it said, 'James Moore and Violet Hilton.' . . . First I knew of it!"[12]

Moore loved Violet and, for that matter, Daisy, too. But not *that* way. His own sexual predilections meant marriage was not a prospect the thirty-year-old dancer had ever considered in his life. In an instant he learned that he was not only due to take a wife, but it was going to happen in a stadium in front of thousands of spectators. He was left so traumatized that before he even got to the fairgrounds he slipped into what appeared to be a cataleptic state.

Jim Moore with his bride, Violet, and maid of honor, Daisy. The Reverend Henry A. May officiated at the ceremony, July 18, 1936, at the Dallas Cotton Bowl before a paying crowd. Daisy was four to five months pregnant by an undisclosed member of the Dale Stevens Orchestra. An annulment followed so swiftly on the heels of the wedding that the Dallas press wondered (in print) if it had all been a publicity stunt.
(Author's collection)

Terry Turner was ready and waiting for the convoy when it entered through the gates of the exposition grounds. He was fully expecting Jim Moore to be distraught at the discovery he had been selected to be Violet's bridegroom. Turner approached the tall, cigarette-thin hoofer carefully, half expecting Moore to punch him in the nose.

Turner told Moore he had every reason to feel upset. He tried to explain that plans for the public wedding had advanced more rapidly than he was able to control. As the event began to take on a life of its own, Turner just couldn't find a mate who was truly worthy of so lovely a bride as Violet. It occurred to him then, Turner said, that Violet could never hope for a more caring, gentlemanly, understanding husband than Jim Moore.

Moore remembered that his first urge was to choke the life out of Terry Turner. But as he continued to listen to the promoter's tale of woe, Moore said, he, oddly, began to feel some sympathy for him.

"It was too late," Moore said. "Turner told me there had been a lot of money spent on publicity. Of course, it's publicity. If I were smart, I'd capitalize on it. . . . But I was embarrassed."[13]

Moore said he felt impossibly conflicted. He knew that Turner was playing him for a chump. At the same time, he bought into Turner's claim that the Cotton Bowl wedding, because of the national attention it was sure to generate, would help the Hiltons retrieve the stardom and mass-adulation they had once enjoyed. Moore also gave some credence to Turner's claim that, as the bridegroom of a famous Siamese twin, he, too, would instantly become a national celebrity, and surely this would help him realize his ambition to become a star of stage and screen in his own right. Moore was finally won over. If Violet was willing to go through with the wedding, he told Turner, well, then, he supposed he could go though with it, too.

For Moore, he would reveal later, the hardest thing about agreeing to marry Violet was breaking the news to his parents in San

Antonio. Throughout his adult life, he said, his father had been pressing him to find a good woman, marry, and trade his sissy job as a dancer for real man's work. The senior Mr. Moore was less than approving when Jim told him that he was finally going to marry, and, by the way, the bride and new daughter-in-law happens to be a Siamese twin. "My daddy disowned me," Jim declared ruefully. "He just told Mama, you see, 'Don't even write to the boy.'"[14]

Because of the publicity blitz Turner had mounted for the Cotton Bowl nuptials, the wedding was already a main conversation topic in Dallas by the time the twins and Jim Moore had arrived in the city. Half the states in the union had denied them marriage licenses when Violet and Maurice Lambert tried to form a legal union, but Turner had somehow been able to persuade Texas officials to grant a permit. Most of the city's ministers were condemning the proposed union, declaring from their pulpits that such a marriage would make a mockery of the holy sanctity of matrimony and legalize bigamy. After a long search, Terry Turner found a minister willing to preside over the ceremony, the Reverend Henry A. May. Because Turner couldn't produce Violet's father, the honor of giving away the bride fell to Lew Dufour, one half of the carnival team producing the Cotton Bowl wedding. Picked by Turner as the best man was Joe Rodgers, a Broadway actor. Daisy, of course, was the natural choice for maid of honor.

Tickets for the wedding were set at 25 cents. This was a steal, Turner seemed to believe, since the modest admission price would not only provide the guests with a chance to witness the most unusual wedding ceremony of all time, but it would also admit them to a post-ceremony dance with music by the Dale Stevens Orchestra. For all the publicity the wedding had generated in the newspapers and on the radio, it had become clear by the day of the event that Turner may have seriously misgauged the public's interest. The advance ticket sales had been slow and even in the final hours before the wedding

was scheduled to take place, there were no lines forming at the Cotton Bowl box offices. Turner was tortured. How could he have blown what he had been sure was going to be his greatest promotional stunt ever?

The truth was, the Great Wedding was being eclipsed by another Texas Centennial Exposition attraction, Streets of Paris. This feature consisted of ten separate cabarets, each of them with obviously concocted Gallic names like Madame Pou Pou's, Charmaine's, La Poufee, Ti Tee's and, of course, the Folies Bergere. On each stage were dancers wearing nothing more than cologne. Public exhibitions of nudity were banned in Dallas, but the Texas State Fairground existed as an island unto itself with its own set of rules governing public conduct. Apparently the fairground police were willing to overlook any breaches of the moral code that fell short of murder, pillaging, rape, and treason.

Fair-goers buying tickets at the Cotton Bowl box offices never amounted to anything more than a trickle, while tens of thousands of people were already massed in the fair's ersatz French quarter. The crushing failue of the Great Wedding was, ironically, the result of Turner's own doing. He had directed the publicity campaign not just for the Violet Hilton–Jim Moore nuptials, but also for the "Streets of Paris."

It was now just a couple of hours before the scheduled 8:30 P.M. Great Wedding, and there was no longer any question the event was going to be a colossal flop. Terry Turner was clearly troubled as he paced the stands of the Cotton Bowl with a glass in one hand and a bottle of scotch in the other. Then he was hit with another crisis. He was approached by Joe Rodgers, the actor who had agreed to serve as best man. Rodgers had a black eye and his nose was a red smudge. He reeked of alcohol and his tuxedo was in tatters. "I can't go through with it." Rodgers declared. "I just got in a fight with a bartender. I guess you'll have to give away the bride yourself."[15]

The Dale Stevens Orchestra was already on the bandstand, tuning up. Turner wondered what else could go wrong? He spotted a Cotton Bowl janitor, leaning on a broom. He approached the young man and slipped him a few bills. "Rent a dress suit and be back here in thirty minutes," Turner commanded. "You're going to be in the wedding party."[16]

Violet would later remember that the wedding drew 100,000 people. In fact, the Cotton Bowl, when filled to its brim, had a maximum capacity of 72,000, and most newspapers reported that barely 10 percent of the seats were occupied for the occasion. The stage had been erected on the fifty-yard line. A collective murmuring spread through the stadium when the sisters appeared, with Violet on the arm of Lew Dufour, a tall, skinny, dour-faced man with sallow skin. Slowly, gracefully, at a halting pace to the orchestra's essaying of Mendelssohn's "Wedding March," the three walked over a long white runner leading to the stage.

Violet was in a white wedding gown of pure silk. Her face was veiled. Daisy wore a silky, ankle-length midnight blue dress blooming with white tea roses. She was now four or five months pregnant. Her waist had definitely thickened, but because she was so small and doll-like, her impending motherhood could not have been evident to anyone in the stadium seats. Jim Moore was already on the stage. He was outfitted in a black tuxedo with swallow tails and standing beside his best man, the janitor whose acquaintance he had made only minutes earlier. Moore was ghostly white and sweating. In the words of a reporter who was a witness to the ceremony, he looked "as unhappy as a dog being washed."[17]

Then, as his words were piped out to every corner of the stadium, the Reverend Henry A. May began speaking: "My dear friends, we have gathered here this evening to witness a miracle of love. Mr. James Moore and Miss Violet Hilton have chosen to become husband

and wife, and, friends, let us pray to God for his continued bless-ings upon the groom and the bride. Let us rejoice with Mr. James and Miss Violet in sharing their great joy on this occasion, and let us pray that these children of God know only happiness in their journey together until at last, in old age, they come to the kingdom of heaven. . . ."

The preacher's benediction went on for several minutes. After accepting the vows of Jim and Violet, he pronounced them husband and wife. The minister told Jim he could kiss the bride. Gentle laugh-ter rippled through the crowd at the spectacle of the six-foot-two, stick-figure groom bending down to smooch his four-foot-ten bride. If Moore was still feeling resentment at have been used by Turner, he was enough of a showman to give the audience his best performance. The people in the stands rose to their feet, cheering and applauding the couple. At least for a few seconds, Violet may have forgotten that every detail of the wedding had been stage-managed. She recalled the post-kiss moment this way: "I looked over the crowd and pulled the wedding veil over my face to hide my excited tears."[18]

Daisy, however, never forgot for even an instant that everything about the occasion was the work of a master puppeteer. She looked at Terry Turner, but then quickly turned away because she was afraid she might start laughing uncontrollably. She was, she said, "con-vulsed with mirth."[19]

At the invitation of the Reverend May, the spectators left their seats in the stadium and poured onto the field to congratulate the new Mr. and Mrs. James Moore. Police assisted in keeping the well-wish-ers in a line. Much of the Cotton Bowl crowd remained on hand to dance to the music of the Dale Stevens Orchestra.

Naturally, reporters swarmed like locusts around the newlyweds. They were eager to learn what arrangements had been made for Daisy when the moment came later that night for Moore and Violet to slip

into bed. Daisy tried to assure the writers that when the lights went off, her brother-in-law and sister would forget she was even on the planet. "When Jimmy kisses me good night, which we think will be quite proper considering that Vi can never wonder what we are up to, it will be goodbye until it's time to get up, unless the hotel catches fire, or for some other reason they need my spiritual as well as physical presence."[20]

When Daisy was pressed by the reporters to explain just how she thought she could make herself vanish between the sheets of the newlyweds' bed, she repeated the twins' oft-used claim that years earlier, each had learned from Harry Houdini how, under certain circumstances, to make one another vanish from consciousness. Violet kept nodding in agreement while Daisy kept assuring the incredulous reporters that when it was lights-out in the bedroom of the honeymooners, the happenstance of her being on the scene would in no way cool the ardor of the couple.

"That's the real truth, although I know most people won't believe it," Violet told the newsmen. "She won't bother us anymore than a nice kitty sleeping on the other pillow."[21]

Finally, with great difficulty, the sisters and Moore were able to extract themselves from the press. They hailed a cab and tried to leave the fairgrounds without attracting unusual notice. But that was hardly possible. Several photographers and reporters also piled into taxis and pursued Jim, Violet, and Daisy right to the door of their hotel room. Many of the newsmen, in fact, parked for the night in the corridor outside the trio's suite. Relentless and shameless, periodically journalists even pressed their ears and eyes to the keyhole of the honeymooners' room.

So great were the demands by the newspaper people for ever-deeper incursions on the newlyweds' privacy that Terry Turner was pressed into the role of ombudsman. When a cameramen asked him for

permission to photograph the newlyweds and Daisy in bed, he denied the request, concluding that such a family portrait might border on the fulsome.

Turner did, however, allow the photographers into the newlyweds' room the morning after their first night together. Violet and Daisy were in their robes and Jim was still in his silk pajamas, wrapped in a smoking jacket. All three of them were wearing beatific, somewhat woozy, faraway expressions, as though each had glimpsed heaven's gate the night before.

It is a mystery what Moore did to occupy himself during his first full night with the bride and the bridesmaid, but no one who knew him believed that he consummated the marriage, let alone for a second helping with his sister-in-law.

"Jim Moore was gay as a rag," said Camille Rosengren, goddaughter of the twins.[22] Her declaration was echoed by everyone else who knew him well. Whether on the night of his honeymoon, or any other night, the nearest Moore ever came to having a sexual experience with the twins, he would concede years later, was scrubbing their backs while they were in the bathtub.

"I never slept with them," he stated in the sniffiest of tones.[23]

Because the Great Wedding had flopped so thoroughly at the box office, Terry Turner was utterly chagrined. Although he had been right about one thing: The Violet Hilton–Jim Moore nuptials had cornered column inches in just about every newspaper in the country. And as a completely unexpected perquisite, Daisy was hired by the International News Service to produce a series of syndicated articles on what it was like to be such a close observer of another woman's honeymoon. In the first article, written the morning after she and Violet spent their first full night with Moore, she chatted effusively about how beautiful life had become:

## 3 NOT CROWD
## FOR SIAMESE

*Violet Hilton, Siamese twin, and James Moore, trombone player, were on
their honeymoon yesterday in Dallas, Texas, with Daisy, the maid of honor,
Violet's twin along, of course, but according to Daisy, "They hardly know I'm
around." Five-thousand people, at 25 cents a head, saw the ceremony
Saturday night, in the Cotton Bowl at the Texas Centennial Exposition.*

**BY DAISY HILTON**
(As told to International News Service)

DALLAS, TEX.—Well the kids are awfully happy. It's a true love
match, all right. Jimmy is a swell kid and they're both so
crazy about each other. . . .

We don't know yet what we're going to do, but for a few
days, anyway, we're going to honeymoon, off to ourselves,
and probably after the week is over, Jimmy and Violet will
know [where we're going next].

I'm not going to bother them about that for a little while,
however. Both of them are dyed-in-the-wool troupers and
they'll be aching to get back to work shortly.

I'll be getting married myself some of these days."

Terry Turner's promises to Violet and Daisy that the Cotton Bowl
wedding would restore them to superstardom proved to be overly
optimistic. Because of the national publicity the event generated, the
sisters did receive some offers for bookings, but the invitations fell
well short of the avalanche that Turner had predicted. The most
lucrative of the new offers came from New Orleans, Louisiana. The
Chez Paree nightclub offered Daisy and Violet a contract for a solid
two months of engagements. The Chez Paree, of course, also expected
Jim Moore to be part of the stage show because its patrons would
want to see the husband of a Siamese twin.

The nightclub had its own house band and was not willing to pick up the tab for the fourteen-piece Dale Stevens Orchestra. Daisy and Violet wrote the last of their payroll checks for the ensemble and, with tears on both sides, bade farewell to all of the musicians, among them the father of the baby Daisy was carrying.

Letters, cards, and telegrams of good wishes from every part of the Western world flooded into the trio's hotel room in New Orleans. Well-wishers believed that despite the challenges, love would conquer all. Long accounts on the newlyweds appeared in the Sunday newspapers, providing readers with reports on how famously well the three were still getting along one, two, three, and four weeks after the nuptials. But a week short of Violet and Jim Moore's two-month anniversary, the press and the public learned that it had been suckered, that the trio was not enjoying the state of harmonious, blissful, nonstop sensual gratification that had been supposed. The three, in fact, were not living together at all. It was revealed that upon their arrival in New Orleans for the Chez Paree engagement, the twins registered at one hotel, and Moore, using an assumed name, checked into another.

The press and public's first knowledge they had been conned came on September 9, 1936, when Violet and Moore jointly filed a petition in a New Orleans district court, asking that the marriage be annulled. In their plea, the two contended they had been coerced into the marriage because of a cruel hoax foisted on them and the American public by Terry Turner, their publicist, and Stanford Zucker, their booking agent.

"Your petitioners had no desire to be married and in going through the form of the marriage ceremony, it was without any intention of their entering into a contract of marriage or of assuming any of the responsibilities of their marriage status," they declared in their court papers. "Your petitioners . . . did not give their free consent to a legal

and binding marriage."[24] They stated further in their plea that after "all the plans [for the marriage] had been made and some publicity given . . . the said booking agent . . . informed [them] of the plans and arrangements, and insisted that it was necessary that [they] comply with the plan as arranged."

In oral testimony presented a month later before a New Orleans judge, William H. Byrnes, Jr., Moore said he and Violet felt they had no other choice but to participate in the sham because, upon the arrival of the Hilton Sisters' revue in Dallas, Zucker told them if they didn't comply, he would tear up their performance contract with the Texas Centennial Exposition. This would have left the sixteen entertainers and musicians from the Hilton troupe stranded with no funds to return to their homes, Moore said.

All the time Moore and Violet were appealing to have their marriage dissolved by the court, they remained close friends. Their quarrel was not between themselves but with Terry Turner and the brothers Stanford and Ben Zucker. Indeed, Moore and the twins remained so close as friends they continued to go out socially together.

One of the more memorable of their outings involved that other set of widely-known performing Siamese twins, Lucio and Simplicio Godino. The Filipino brothers stopped in at the Chez Paree one night and, after a long visit with Daisy, Violet, and Jim Moore in a dressing room, made plans to join the three for a late dinner. Moore remembered the attention the brothers drew when they entered the restaurant and then advanced to the table where Moore and Daisy and Violet were already seated.

"When they started to sit down," Moore said of Lucio and Simplicio, "they sat down on one chair . . . but they would sort of get straddled, and then they would go up and down and up and down and up and down. . . ."[25] Moore said the Godinos created such a strange scene just trying to take a seat in the restaurant, that Daisy and Violet

were mortified with embarrassment and wanted to slip beneath the table. The sisters were still fuming about the incident the next day, he said, and for all the humiliation Daisy and Violet themselves had suffered over the years as conjoined twins, they seemed unable to empathize with the predicament of the Godino brothers.

Said Moore: "One of the girls—I don't remember which—looked at the other and says: 'Well, did you see the way those clumsy sons of bitches sat down? I was so embarrassed, I didn't know what to do.' Now the girls were very graceful. . . . To see them walking down the street, you would have thought, 'Why are those girls walking close together?' because there were no bobbles, there was never anything awkward or like that."

By the time the Hiltons began their engagement in New Orleans' Chez Paree, it had become an ever-greater challenge for Daisy to keep her pregnancy concealed. In the past, the sisters had always created their stage wardrobe from gowns of identical style and size. Because of Daisy's bulging belly, they now had to pack away all their old dresses and have new costumes made.

If, after two months of marriage to Violet, Moore still had not known his wife in the biblical sense, he did learn something about her internal workings. It struck him as interesting that not only did Daisy stop menstruating after she became pregnant, but so did Violet.

Following the two-month engagement in New Orleans, Daisy and Violet were invited to make two appearances in Minneapolis, Minnesota; one of them at the Palace Theater and another at Lindy's Supper Club. But the house managers at both venues were stingey to an extreme and refused to cover the salaries of Jim Moore and his dancing partner, Anita Marie Ciska. By then, Moore had been trouping with Daisy and Violet for nearly three years. He had been the most loyal of their employees, sometimes performing with their shows even when they didn't have money to pay him. More significantly, he

was also the twins' most trusted friend. He recalled how pained Daisy and Violet appeared to be when they sat down with him and Ciska to discuss their dilemma:

"The girls had an offer to go to Minneapolis and [the theater managers] didn't want to transport Anita and I up there. . . . And so we talked it over, and the girls said, 'Well, we almost need this job,' and 'would it be all right?' And we said, 'Well, sure,' and so they went to Minneapolis."[26]

At the time of the separation, Violet and Moore were, at least in the eyes of the law, still husband and wife. While the couple had begun a court action to dissolve their union, the proceedings were suspended when the twins left New Orleans. Seven years would pass before they returned to court and made the annulment official.

*Seventeen*

# ·PEOPLE GET BADLY HURT
# BY LOVE SOMETIMES

Daisy and Violet entered the compartment on the train and immediately drew down the shades, blocking out the bright morning and what they hoped would be their last sight ever of anything or anyone in New Orleans. They took their places on a small divan, positioning themselves back-to-back as the train began to pull away from the terminal. Slowly they began to feel a release of the tension that had been building in them for weeks. Never before had they been so anxious to leave a place.

They had come to feel like pariahs: It seemed to them that everyone in New Orleans reviled them. It all started when the city's newspapers reported that Violet's much-publicized marriage had been a charade, a mere publicity stunt carried out by the twins and their agents in the hope of energizing the Hiltons' flagging box office appeal. In the petitions Violet and Jim Moore filed with a New Orleans court seeking to have their marriage annulled, the couple claimed that they were coerced by their managers into marrying. But neither the public nor the press was quick to forgive and forget. The Hilton sisters lost the quality that had endeared them to much of the nation. Stripped of their innocence, from then on, they were personas non grata wherever they appeared. The doorman and the desk clerks at their hotel stopped greeting them. In the past, they had always been given the choicest tables in restaurants but now they were seated

nearest to the kitchen or washroom. The sisters even had trouble hailing taxis. Most cabbies sped right by them.

Camille Rosengren, their goddaughter, said she was sure that neither Violet nor Daisy ever really understood why, after the news of Violet's sham marriage came out, the sisters were shunned in so many circles. Former librarian and later the operator of one of the nation's most distinguished book stores, Rosengren provided an analysis of the backlash in literary terms.

"From the time the twins had come to America as eight or nine-year-olds, remember, they were in the news all the time," Rosengren said. "There probably were never two souls who endured more wretched childhoods. They were cursed at birth with the most terrible of conditions. They were given up by their mother. As children, they were kept as slaves and cruelly exploited by their warders. Yet they triumphed over all their adversities. They blossomed into bright, talented, beautiful young ladies without a trace of self-pity.

"Because the twins endured so much tragedy, I don't think there was anybody in America who didn't want them to find great happiness. When Violet married the tall and handsome Jim Moore, it was one of those loopy, feel-good stories in which an entire nation could take a little giddy joy. Now maybe some thought it was goofy for them to get married in the Dallas Cotton Bowl, but probably the ceremony was no less loopy than those pageants in England where royals marry before thousands of commoners with great pomp and ceremony. I think almost everyone viewed Vi's marriage as a beautiful ending to a modern Cinderella story. Who, after all, was more deserving of love and bliss? And if she could walk down the aisle and take the hand of a handsome prince, well, then, it could be expected that Daisy, too, would someday soon find love, marry, and like her sister, live happily ever after. Then, hardly a month passed and it was exposed by the newspapers that the wedding had been a masquerade,

that Vi and Jim were never romantically involved, and that they were now seeking to have their marriage annulled. Maybe the poor little Siamese twins weren't so sweet and pure after all. What everybody thought was a real life fairytale turned out to be a sick joke. People felt disappointed by them, if not betrayed."[1]

Like Rosengren, Rose Fernandez, too, was convinced the twins "never really figured out" why they fell so swiftly and sharply from public grace.

"People may be willing to forgive certain extremes of behavior from celebrities," said the nightclub dancer and acrobat. "But they won't put up with being suckered by them. Vi and Daisy put their careers at risk by agreeing to that phony-baloney wedding in the Cotton Bowl. Even the twins' most loyal supporters felt deceived by them. And just like that, a lot of the powers in the entertainment field—the agents, the bookers, the managers of theaters and clubs—saw them as damaged goods."[2]

After Violet and Moore had begun the legal proceedings to have their marriage annulled, Hernandez said, they started experiencing so much ill will just going out to a movie or dinner that they tried disguising their identities. "I never knew them to have worn dark glasses before, but now they had them on whenever they were out in public. I don't know if they saw the foolishness of this. They were joined together physically, for Betsy's sake. Did they really think that dark glasses were going to hide who they were?"

It may be that Daisy and Violet wore the glasses less to mask their identities than to hide their red eyes. Almost daily they experienced slights and tongue-lashings that left them in tears. Probably their ugliest encounters involved the manager of the Chez Paree. The Chez had been waging a publicity campaign urging the public to stop in and see "Violet Hilton, the newly married Siamese twin, along with her sister, Daisy, and the very blushing bridegroom, the handsome and

talented James Moore." The club enjoyed turn-away crowds initially, but when the news came out that the newlyweds were seeking an annulment, business absolutely dried up. In his confrontations with Daisy and Violet, the Chez's manager called them "has-been entertainers" and "cheats." Not only did he refuse to pay them for their appearances, but because he had booked their stage show with the understanding that Moore and Violet had married not for mercenary reasons but purely out of love, he threatened to sue the Hiltons for entering into a contract with an intent to defraud the club.

The train was only a few miles out of New Orleans when there was a rapping at the door of Hiltons' compartment. It was the conductor.

"Tickets, please," he asked when Violet opened the door. Violet handed him a single ticket.

The conductor looked to Daisy. "And your ticket, ma'am?"[3]

There was no second ticket. The twins were probably close to destitution when they left New Orleans. They had received no pay for nearly two months during which they had incurred expenses, including hotel bills, salaries for Jim Moore and dancer Anita Marie Ciska, and attorney fees.

In an effort to save on their travel expenses, Daisy and Violet had boarded the train in New Orleans on a single fare. When the conductor demanded two tickets, they tried to persuade him that because their bodies were joined together as one, they were entitled to travel on a single fare. The trainman refused to accept their argument. Unless they bought a second fare, he would have to put them off the train at the next stop. There was an exchange of sharp words between the conductor and the sisters. Finally, he left to telegraph a passenger agent in St. Louis. Apparently not wanting the matter to escalate into an ugly scene, the agent wired back: "If unable to collect extra fare, make no attempt to put one of them off the train."[4]

The trip didn't become any easier for Daisy and Violet even after

the uneasy truce with the conductor. Their compartment was hot and stuffy. Because of her pregnancy, Daisy suffered from motion sickness. The sisters spent more time in the lavatory than in their seats.

The twins were already in high dudgeon even before they arrived in the Twin Cities, but they became even more infuriated when they stepped off the train. Always in the past when they appeared in a new town, they were received by hordes of fans, theater and nightclub managers, and sometimes even a mayor or city official. This time when they disembarked from the train there was nobody to greet them, not even the local booking agent who had lined up the engagements for them. The twins were even left with the task of finding a hotel.

After exiting the terminal and lugging their bags to a taxi stand, Daisy and Violet were spotted by a reporter and photographer for the *Minneapolis Tribune*. By now, newspapers across the land had revealed that the wedding of Violet Hilton and Jim Moore had been a publicity stunt, but somehow the news had eluded the *Tribune* reporter. He asked Violet where her husband was.

She glowered at her inquisitor and then exploded. "Don't you even read your own newspaper?"[5]

"I wouldn't blame them if they didn't," Daisy piped in.

The reporter was stunned by the sharp responses, but he pressed on. He asked how the marriage had worked out.

"It didn't," Violet shot back.

"And we're going to get an annulment," added Daisy, using the plural.

Trying to be as diplomatic as possible, the reporter finally asked if, during the honeymoon, the twins and the bridegroom had all slept in one bed.

No," snapped Violet.

"And it's nobody's business but our own if we had," Daisy added.

Things didn't improve for the twins in the days ahead. They had

been booked to head a five-act variety show at the Palace on a Saturday and Sunday, before beginning a week-long engagement at Lindy's, a downtown club. The theater and club had booked the Hiltons soon after the Cotton Bowl wedding, expecting to cash in on the national publicity. The Palace and Lindy's both made the claim that audiences would not only be treated to performances by the most famous Siamese twins of the twentieth century, but they would also have a chance to "see the only man in America who has a legal right to go to bed with two women every night." The promotion, of course, misfired badly when weeks before the scheduled engagements, the story of the sham marriage broke.

Daisy and Violet played mostly to empty houses. Worse, they were notified by their booking agent that no stage appearances had been lined up after their Minneapolis dates because the theaters and clubs could no longer advertise that Violet's new husband was part of their show. After their runs at the Palace and Lindy's, Daisy and Violet sequestered themselves in their Minneapolis hotel room, uncertain when or even if they would work again. Finally, after a month, they did receive another assignment, this one as a last-minute replacement for an act that had canceled a week-long engagement at the Alhambra theater downtown.

Their appearance at the Alhambra only provided the twins with more evidence of how fast and far they had tumbled from the favor of the public and press. Except for the ushers, there was almost no one in the theater for their shows, and the Minneapolis papers didn't even bother to send reviewers. It probably was just as well that the press boycotted their appearances. If any professional critics had taken in the sisters' performances, they likely would have cut the pair to ribbons. Daisy, now eight months into her pregnancy, moved awkwardly and without grace, and whenever the sisters danced onstage, Violet seemed to be attached to a ball and chain.

Daisy delivered late in November or early December of 1936, most likely in a hospital somewhere in Minneapolis or St. Paul. The baby was a boy and born healthy and normal physically, according to Florenza Williams of Sacramento, California, whose husband, Clifford, a circus performer, toured with the sisters during their carnival years and became a lifelong friend and confidante.[6] Jim Moore and others said Daisy surrendered the baby for adoption immediately after his birth. It will probably never be possible to determine with certainty the exact date of the boy's birth, nor the hospital where he was delivered, as birth and adoption records are not made public in Minnesota.

Considering the period, Daisy had no other real options to consider but to give up her baby. Society had already decided that for her. She was, after all, a public figure and unmarried. Because the sisters seem never to have talked about the baby, even to those who were closest to them, it is impossible to do anything more than speculate on the searing sense of loss Daisy must have experienced in surrendering her child. No doubt her decision put her in mind of another woman, her own mother, who twenty-eight years earlier, also out of fear and desperation, gave her children away. Upon giving up her son, Daisy may have come closer to loving her own mother on a new level and empathizing with the remorse and inconsolable sorrow Kate must have felt in forsaking her daughters. If it was unthinkable for Daisy, an unmarried Siamese twin, to keep a child, could it have been any more imaginable for Kate Skinner, also unmarried, to keep Siamese twins?

After firing their booking agents Stanford and Ben Zucker who, along with the promoter Terry Turner, concocted the wedding debacle, the twins cast their lot with a woman agent in Minneapolis. A year-and-a-half or so after Moore and the Hilton sisters separated in New Orleans, Moore and Anita Marie Ciska traveled back to the

*Violet and Daisy, December 1937. (Author's collection)*

Twin Cities for a nightclub engagement. While there, Moore looked up the twins' new agent. He said he was sure the agent suspected him of having fathered Daisy's child. "She treated me as though I were the big bad wolf," he said. "And she would give me no information. She would not tell me where the girls were. They may have been in Minneapolis at the time."[7]

There is at least one matter about Daisy's love child that intrigues even today. It seems possible, perhaps even probable, that he is still in our midst—although, as an adoptee—it may be that not even he knows that he issued from a Siamese twin.

From the time five years earlier when a San Antonio court had granted them complete emancipation from Myer Myers, the twins had formulated a series of romantic goals for achieving happiness. Daisy and Violet had often recited the objectives in magazine interviews: Both would fall in love and marry. They would quit show business and settle in some place in the country. They would raise children,

and, to the extent that it was possible, they would vanish from the public eye.

But in late 1936, it seemed unthinkable to the twins that their futures would ever hold a quiet country retreat with devoted husbands and flocks of children. Violet had allowed herself to be used in a national hoax that made a mockery of marriage. Then Daisy had a baby and gave it up.

So the twins seem to have reconciled themselves to going for just one part of their shared dream: They would try to vanish from the public eye. As conjoined twins, they knew, of course, that wherever they tried to live, they would never be able to stroll down a sidewalk or take in a movie without attracting stares and provoking comment. But by keeping away from the entertainment world, maybe they could begin healing — Violet from her disgrace at being turned into a national joke, Daisy from her guilt and suffering at having surrendered her child.

It seems an astonishing feat, but Daisy and Violet *did* almost completely erase themselves from America's consciousness, and they did so virtually overnight. No record exists of where in the Twin Cities they took up residence at the end of 1936. Their near complete seclusion continued well into 1937, and perhaps even longer. And wherever they lived, they seemed to have been largely left alone. The Hilton sisters stories, a regular staple of magazines and Sunday newspaper supplements, just disappeared. After having been bamboozled by Violet's sham wedding, the press apparently had become chary about seeking out the pair.

It's unlikely the twins had much money put aside when they left the public eye. In the nearly three years they been on the road, they lost what would have been a fortune, probably all of the $100,000 they had received in the court settlement and then some.

After entering into their voluntary exile, Daisy and Violet seem to

have entirely broken off contact with other stage and film performers. They did, however, remain in touch with at least a few people with whom they had long and close relationships, among them Emmett Sweeney. "They were always writing or wiring Mom and Dad for money," said Camille Rosengren, daughter of the San Antonio attorney and well-to-do businessman who, along with his wife, had been devoted to Daisy and Violet from the time the sisters were twelve or thirteen. "I don't think Dad ever said no to them."[8] It seems likely the twins also regularly asked for financial help from another wealthy San Antonian, their friend Harry Hertzberg, whose admiration for the sisters verged on veneration.

Certainly the frugality that the twins' straitened circumstances necessitated must have been hard on them. In the past, they had always acted as though the money would never run out. They always stayed in the best hotels and dined in the poshest restaurants. Their trips to department stores always occasioned great excitement among the clerks. They swept through the aisles, loading up the arms of their assistants with the priciest dresses, shoes, hats, and handbags. They also bought expensive gifts for their friends, especially their boyfriends, and thought nothing of taking parties of a dozen or two dozen fans to exclusive restaurants, and picking up the tab.

Rose Fernandez was amazed by the freedom with which the twins spent money, especially when they were touring with their road unit. Besides the expected complement of musicians and backup performers, the troupe included publicists, secretaries, property boys, bookkeepers, porters, and assorted personnel whose only responsibility seemed to be to keep the sisters' bank accounts running near empty.

"Financial security never seemed to be the least bit of concern to Daisy and Violet," Fernandez recalled. "When they came into a new town with their show, you half got the impression that the Ringling Brothers and Barnum & Bailey Circus had arrived. The twins had a

reputation for being very kind to their help. They were always sur-rounded by hangers-on who had their hands out."[9]

Jim Moore remembered that because Daisy and Violet were so extravagant in their spending, there were times when they had to resort to extraordinary measures just to survive. He recalled one occa-sion when they turned a saxophone over to a pawn shop just so they could get enough change for cigarettes and coffee. "They were just so generous with their money," said Jim Moore. "It meant absolutely nothing to them."[10]

As difficult as the regimen of self-imposed austerity must have been, what was probably even harder for Daisy and Violet was their voluntary abstention from parties and other social occasions where they often had found men who were attentive and, sometimes for a night or two, romantically adventurous. To ease some of their pain and loneliness, they turned to alcohol.

"They became quite heavy drinkers," said Rosengren. "I don't know if they were alcoholics, but they seemed to be at least slightly buzzed much of the time. They were such sweet, fragile girls. From the time of their earliest reasoning, all they knew was the loneliness of being so different from everybody else. How could anyone be expected to cope with such baggage? My dad and mother worried about the girls' drinking and the effects it might be having on their health. I think the twins were using alcohol as a palliative, as something to numb the pain they were feeling."[11]

After becoming big stars of the vaudeville stage, Daisy and Violet had vowed they would never again return to the carnival world. But so destitute had they become by the spring of 1937, they were hav-ing trouble meeting even their most basic living expenses. Because no other offers of work were coming in, the twins, in desperation, decided they would once again have to exhibit themselves in one of the circus sideshows that were crossing the country.

Newspaperman E. Burke Maloney remembered seeing the twins at about this time when, as headliners in a circus sideshow, they came to Elmira, New York. Maloney, then a young cub reporter, was assigned to interview the pair and carried out his meeting with them over lunch. He found the sisters to be pleasant enough, although, "They had fielded the same questions so often all over the world that they gave answers almost before the questions were asked."[12] By his description, the twins at this time were "pretty in an anemic way— they had dabs of rouge high on the cheekbones and each mouth was a dash of vermilion." Sadly, they were already showing marked deterioration from their vaudeville years. Maloney summed up the encounter this way: "After all these years one thing stands out in my memory of these Siamese twins: They both had dirty fingernails."

Following their summer travels with the circus sideshow, the twins resumed their lives as shut-ins in Minneapolis, but once every month or two, they emerged long enough to take a paying job somewhere. In February of 1938, for example, they traveled by train to San Francisco to an engagement at the Tivoli Club and after a week returned to their Twin Cities redoubt, not to be heard or seen again in public for a long time. The Tivoli was a swank house that probably paid them well. But most of the twins' occasional appearances in 1937 and 1938 were made either in the halls of flyspeck towns or the tawdrier theaters and clubs of big cities.

Sometime in 1939, the years of self-imposed exile ended when Daisy and Violet received a phone call from Arthur Argus, an important booking agent in Rochester, New York. He presented them with an opportunity for one of the cushiest assignments available to entertainers of the day: He had lined up an engagement to appear as floor show entertainers on the ocean liner, *Berengaria*, a ship of almost sybaritic luxury that ferried nobles, oil magnates, and other wealthy voluptuaries between New York City and Southampton, England.

Daisy and Violet were elated. After practicing self-denial for so long, they relished the idea of the hedonistic living that life aboard the superliner would offer. And after appearing almost exclusively before bumpkins and rustics in sideshows and shabby theaters for the last two or three years, they were thrilled by the chance to once again perform for the rich and privileged. It was, Daisy imagined, going to be "fun to sing with the tuneful orchestra where the guests laughed and drank."[13]

Nearly a fifth of a mile long and the pride of the Cunard Line, the *Berengaria* was the largest luxury liner on the seas. Its interior, hung with Renoirs and Gainsboroughs, was decorated by the same designer who did the Ritz hotels in Paris and London. Its massive indoor swimming pool was styled after a Pompeian bathhouse, complete with marble columns and frescoes, and boasted toga-clad ladies-in-waiting. The dancing started in the *Berengaria's* lounge at nine each night and usually continued until the stewards cheerily announced, "Caviar breakfast being served!"

Buddy Sawyer, who was also represented by Arthur Argus, served as the twins' pianist and emcee. He, along with another young man, also partnered with Daisy and Violet in their four-way dance routines. For Sawyer, just twenty at the time, life aboard the *Berengaria* had aspects of a nonstop bacchanalia.

"Whether we were sailing from New York to England or England to New York, every day and every night seemed like a never-ending Roman carnival," he recalled. "The passengers, most of them filthy with money, seemed to exist only to be fed, entertained, and pampered. And the ship's crew, like indentured slaves, seemed to exist only to see to it that the passengers were glutted with food, filled to the gills with booze, kept amused, and waited on hand and foot every moment. Some of this was a little disgusting to see."[14]

Sawyer remembered his days aboard the *Berengaria* as being among

the most exciting of his life. It also was the time of his earliest profes-
sional relationship with the Hiltons, a relationship that would con-
tinue for several years and ultimately take a surprising turn. "I wasn't
much more than a kid then, and here I was, working with the world-
famous Hilton sisters," Sawyer said. "It was a heady experience."

Sawyer, who was christened Harold Thomas Estep, had been fas-
cinated with the twins long before he joined their act. As a boy, he
had been regarded as something of a stage *wunderkind*. In the mid-
1920s, about the time he was eight, Buddy began appearing with a
beloved aunt, Bobbie Cunningham, in a dance duo that traveled the
Keith-Albee circuit of vaudeville theaters. In the years ahead, there
would be times when he and his aunt found themselves appearing in
vaudeville lineups that included the Hiltons.

"The twins, of course, were always the headliners and all the other
acts on the bill, including mine and my aunt's, were considered
fillers," Sawyer explained. "I still remember how the twins took the
country by storm during their first years in vaudeville. They were
truly phenomenal. It was SRO for them everywhere. They were still
girls then, just sixteen or seventeen, but in the history of vaudeville,
there may not have been more than a half-dozen performers who were
their equals in endearing themselves to the audience. There was so
much love between the people in the seats and Daisy and Violet that
you could slice it with a knife. People flocked to the theaters think-
ing they were merely going to see a couple of sideshow freaks. What
they really saw, though, were two of the most beautiful and talented
girls God ever created.[15]

Because of the high pay and luxury lifestyle they were enjoying as
performers on the *Berengaria*, Buddy and Daisy and Violet would have
loved it if they could have held on to the assignment for years.
However, some of the ship's wealthier passengers considered the ves-
sel their primary residence, and because the *Berengaria*'s entertainment

director knew it was important that these guests never get bored, he felt it necessary to make at least periodic changes in the floor shows. The twins and Sawyer retained their jobs on the ship for two or three months before they were replaced by new acts.

Daisy and Violet separated from Sawyer for a time after the three finished their stint aboard the liner. Because the sisters and Sawyer meshed so well in their performances, and because they also shared the same agent, they kept getting back together.

"Probably the best times I had with Daisy and Violet came when we were playing some dates in Los Angeles," Sawyer said. "The twins were invited to parties almost every night and I tagged along. The parties mostly were thrown by Hollywood people—producers and directors—and there were always famous movies stars around. You wouldn't believe the way people drank and what was going on in the bedrooms. Some of the parties were almost like orgies."[16]

Sawyer, who was extremely shy, tried to blend into the walls, although he was often the subject of no little attention at the show-biz soirées. Revelers who spotted him standing off in a corner by himself would turn to one another and remark how disgraceful it was that somebody had been thoughtless enough to bring a child to the party. Sawyer had attained voting age, although he was just five-foot-two and weighed only a little over 100 pounds. His shoes, Buster Browns, were size 4 ½. He had another characteristic that made him stand out in any crowd: He had yellow hair, not blond or flaxen, but yellow, like butter or sweet corn.

Sawyer remembered the taxicab conversations the twins had while traveling back to their hotel after the Hollywood parties. "Daisy might say, 'I had a nice long visit with Jackie Coogan. He said to give you his regards.' At that point, Violet might chime in, 'Oh, Jackie is always such a dear. By the way, the Barrymores just returned from Rome. We had a nice time looking through their photo album of the

ruins. John said that the whole time they were there, they only had two days of rain."[17]

Sawyer never got over his amazement at the preternatural gift Daisy and Violet had for being able to enter totally different spheres, while at the same time occupying the same physical space. He said the twins were able to co-exist in relative tranquility only because of their ability to now and then escape into entirely separate worlds. But there were instances when their equipoise went out of balance. Sawyer observed, "Sometimes Daisy and Vi could get so angry with one another that they'd stop talking for days. Surprisingly, though, they'd go on stage and there would be all this loving patter and hand-holding between them. Then they'd leave the stage, and again they'd stop talking to each other. They were such pros as entertainers that their audiences never guessed when the sisters were having a spat."[18]

Increasingly, around 1940 or so, according to Sawyer, there was one matter over which the twins quarreled more and more: Violet's drinking. "Daisy liked to have a cocktail now and then, and certainly I did, too. But there were times when Vi just didn't know when to say when. We'd have dinner someplace and Vi would say, 'I want just one more drink before we leave.' Then she'd have three or four more." Sawyer said that Daisy was not entirely unaffected by Violet's excessive drinking, but because the two had separate circulation systems, which only allowed for a very gradual transmission of blood from one sister to the other, "Vi could be completely crocked while Daisy might only have a slight buzz."[19]

Late in the summer of 1941, the Hilton sisters and Buddy Sawyer settled in for an extended booking at a Buffalo, New York, supper club, Brogan's. Famous for its hospitality to acts of a more *outré* variety, among the entertainers who appeared there regularly was Baron Nowak, a popular midget, 23 inches tall and 17 pounds, who played xylophone, rode a unicycle, tap danced, and did voice impersonations

of Edward G. Robinson, Rudy Vallee, and the new singing sensation of the day, Frank Sinatra. Another favorite at Brogan's was Yvette Dare, an exotic dancer who had two or three performing parrots that had been trained, as part of the routine, to pluck off her bra and sarong.

Sawyer had been separated from the twins for some months before the three were reunited for the engagement at Brogan's. Following the trio's opening night, the twins invited him up to their hotel room to catch up over a night cap. Violet, as usual, downed three drinks for each one Sawyer and Daisy had. In time, she nodded off on the sofa they shared.

With her sister softly snoring at her side, Daisy continued to brim over with news. After a time, Sawyer remembered that her effervescent mood changed and her manner became very serious.

"It happened in the wee small hours of the morning, with Vi slumped there on the sofa, off in dreamland someplace," he recalled. "Daisy looked directly into my eyes. Then she started talking in a way that gave me goose bumps. She said, 'Buddy, I just hate it when you're off working one place and Vi and I are off working somewhere else. I think we should always be together. Buddy, do you feel anything for me? Do you feel about me the way I feel about you? Buddy . . . Buddy, do you think we should get married?' She looked over to her sleeping sister for a moment and then returned her gaze to me. 'We, all three of us, get along so well, don't you think? It could work.'"[20]

Sawyer admitted to being momentarily speechless, although he had "always secretly loved" Daisy. There had been times, on and off the stage, when Daisy seemed to show an amorous interest in him, he recalled. But because she flirted with many men, he never thought there was any great depth to her feelings for him.

"Daisy was definitely the aggressor in the marriage proposal," Sawyer said. "It was probably a good thing. As fond as I was of her, I probably would have been too shy ever to get down on my knees and

say, 'Daisy, will you be my wife?'" Sawyer did, however, answer 'yes' to Daisy's proposal.

Violet knew better than anyone how rash her sister could be when it came to romance. But even she admitted to being "startled" when, after Sawyer left for the night, Daisy woke her up to tell her that she and Buddy had decided to marry. "I felt then that her marriage with Buddy would not be right," Violet reflected later. "I thought she had not weighed the idea well."[21] Violet also said she felt sure that Daisy was not so much in love with Buddy as she was in love with love. Violet may also have been troubled by the disparity in age between Sawyer and her sister. At twenty-five, Sawyer was eight years younger than Daisy.

Of all the pacts the Hiltons developed for maintaining sisterly harmony, none was more inviolable than their agreement never to meddle in one another's affairs of the heart. As badly mismatched as she believed Daisy and Buddy were, Violet said, "I did not argue with my sister about her choice." Instead, she tried to give the couple the impression she was happy for them. ". . . Buddy was pleasant to me, and he was most friendly when we sat down to talk about our future together," Violet said.[22]

Daisy and Buddy wasted little time in going ahead with their plan. Just days later, on September 15, 1941, they were at the marriage bureau in the Buffalo City Hall, filling out an application. To comply with the minimum twenty-four-hour waiting period, the wedding was set for the next day.

As long as he was on a stage, Sawyer delighted in jousting with the drunks and hecklers in the audience because he always bested his antagonists. And when he was singing or dancing before an audience, he always appeared insouciantly relaxed. Curiously, acquaintances say Sawyer's confident manner vaporized the instant he left the stage. He then became introverted. It was as if he worried that if the customers

got to know the *real* Buddy Sawyer, they would find him beset with insecurities. He even had trouble responding graciously when a patron approached him and complimented him on a performance. Daisy was sensitive to Buddy's shyness. She was determined not to let their wedding become a spectacle before the press and public. She wanted everything about the marriage to be low-key.

A local newspaper, the *Courier-Express*, reported that Daisy and Buddy had applied for a marriage license, but, mercifully, this news did not seem to catch the attention of many locals. The news item was conveyed in a single paragraph on page 22. And unlike the experience that Violet and bandleader Maurice Lambert had had ten years earlier, Daisy and Buddy did not encounter any impediments to obtaining a permit in Buffalo. Judge Christy J. Buscaglia, probably the most respected jurist in all of Erie County, not only agreed to preside over the ceremony, but assured the couple he would be honored to do so. In campaigning for a place on the bench, Buscaglia once declared, "I have made it my rule that tolerance and patience should govern my every action. . . ."[23] When Daisy and Buddy asked him if he would join them as husband and wife, Buscaglia told them to return the next day.

The twins and Sawyer entered city hall on the morning of September 16th. There was little about their dress that would have caused anyone to guess the trio was a wedding party. Daisy had wrapped her blonde hair in a polka-dotted blue silk scarf. She wore a simple, gray suit with a fluffy white blouse beneath her jacket. Violet, too, was dressed in a gray suit, but it was of a different cut and style than Daisy's. Sawyer wore a dark business suit. Once inside, the three were ushered into the private office of the clerk of city courts. Buddy, his hands sweating and trembling, pinned a simple white corsage on his bride. Daisy attached a boutonniere to Sawyer's lapel. At the couple's request, no photographers or reporters were permitted inside the room.

The marriage ceremony was carried out with dignity in just a few minutes. Sawyer was damp with sweat but relieved that he and Daisy had been able to exchange vows without attracting a mob of busybodies and reporters. He kissed his bride, shook the judge's hand, and hugged Violet. He was feeling so at ease about how quietly the ceremony had gone that he even agreed to pose for a newspaper photographer with the new Mrs. Buddy Sawyer and his sister-in-law. He didn't know yet about the fête that had been planned for the bridal couple that night at Brogan's, nor about the press releases the night club had placed in the Buffalo papers that day:

> **BROGAN'S**
> Seneca At Michigan
> See the
> BRIDE!!
> Daisy Hilton
> One of the Siamese
> Twins, who was
> married today!
> Attend the
> Wedding
> Celebration
> Tonight!
> See the Groom,
> Buddy Sawyer!
> See the Mammoth
> Wedding Cake!
> Never a Minimum
> or Cover Charge

Because winter in Buffalo often slams down on the city like the white lid of a freezer and sometimes keeps the landscape almost hermetically sealed for weeks at a time, residents have a particular need

for hometown fun spots where they can vent steam. In the 1940s, Buffalo had over forty nightclubs, maybe more than just about any other city its size. Except for Brogan's, all the other clubs might as well have switched off their lights the night of the wedding reception for Daisy and Buddy. The crowds at Brogan's were thick as locusts. Out on the sidewalk, there were hundreds more hoping for a chance to enter. Everybody in town, it seemed, wanted to get a look at the freak twins and the man who could be presumed to be some kind of sexual superman.

Sawyer felt like a prey animal that had been thrown to a pack of jackals to be toyed with and then devoured. He was miserable. All night long, strangers approached him and asked whether he had decided on which of the twins he was going to mount first. "It was terrible," Sawyer remembered. "Because I had taken a Siamese twin as a bride, a lot of people thought that our sex life should be an open book. It was nobody's business but ours back then. It's nobody's business today."[24] Sawyer and the twins got no relief from their taunters even when Brogan's closed in the early morning. A splinter group from the club followed the three to their hotel. Massing outside on the walk beneath the window of the honeymoon suite, the tormentors kept crying out, "Buddy, you in bed yet? The girls are waiting." There was no lessening of the crowds at Brogan's the next evening, or the next. Hours before the cabaret opened, people started lining up at the door. They didn't want to miss out on the opportunity to see the three grotesques. It was with considerable horror that Daisy recalled her first evening as a bride and the days that followed: "All that night, and through every night and day for the following ten days, we were pursued."[25]

Given Sawyer's youth and shyness, what was probably the inevitable eventually happened. Daisy described the denouement this way: ". . . One morning when we looked across the twin bed where

Buddy had been when we drowsed from the incessant phone calls from reporters, Buddy had disappeared. I, the bride, who had not yet known a honeymoon, tried to believe that Buddy would come back. For a while I waited for him, although I knew he would not return."[26]

Sometime later, a reporter located Buddy back in his hometown of Elmira, New York. He provided an explanation for deserting his bride. "Daisy is a lovely girl," he said. "But I guess I am not the type of fellow who should be married to a Siamese twin. As a matter of fact, I am not even what you would call gregarious. In the show business, there are times when you get tired of seeing anybody—let alone twin brides."[27]

Two years later, Daisy started a divorce action in the Court of Common Pleas in Pittsburgh, Pennsylvania. Naming Buddy by his christened name of Harold Thomas Estep, rather than his *nom de theater*, she charged that he "committed willful and malicious desertion from the habitation of the libellant, without a reasonable cause, from the 27th day of September, 1941, to the present time." In an affidavit filed in response, Estep rejoined that his wife's account of why they parted had some "errors and imperfections." But when the final hearing on the action was held in February, 1944, he failed to appear in the courtroom. Daisy was granted the divorce unconditionally.

Sawyer never again saw the woman he had married. He still seemed rueful when he was interviewed more than a half century later on the subject of his whirlwind union with a Siamese twin. "Maybe it was my fault, but how many marriages could have stood up to the test ours was given?" he asked. "Some people thought we got married only for the publicity. They were wrong. I loved Daisy very much. She loved me. Even when we parted, I thought that when the hysteria of the press died down, maybe we could get together again and have a life together after all. It just never happened. She went her way, I went mine. People get badly hurt by love sometimes."[28]

*Eighteen*

# BE GRACIOUS UNDER
# ANY CIRCUMSTANCES

D aisy's and Violet's craving for love was so extreme, it often moved them to the brink of lunacy. Daisy's marriage to Buddy Sawyer, after a courtship lasting only days, was only the latest example of their madness. Anyone who really knew the sisters could have predicted that the union was doomed.

If their pursuit of husbands bordered on the pathological, it was certainly impelled by a desperate need to belong somewhere, if only temporarily. For all their ease in relating to others, and the acceptance accorded them in showbiz society, they still felt like aliens. They had one another, but no one else. Their loneliness was profound. Daisy and Violet were thirty-three and had never heard from anyone who acknowledged having a blood relationship to them. If ever they were going to validate their humanity, they believed it could only be through the marital bonds to mates and the production of children. In other words, because they had no family that would claim them, they needed to create their own.

While Sawyer's abandonment and the beating they took in the press were emotionally devastating for the Hiltons, the sisters made some gains in putting their professional lives temporarily back together. Certainly they were no longer the incandescent stars they had been as teenagers when they were the most talked-about and highest paid new act in vaudeville. But thanks to careful steering by

their agent Arthur Argus in the late 1930s, they had made a surpris-
ing comeback from the bleak years that followed Violet's Cotton
Bowl wedding debacle.

As was true of their love lives, their professional lives seemed
never to purr along smoothly for very long. Near the end of 1941,
Daisy and Violet again found their careers seemed all but finished
after December 7th when Japanese warplanes attacked Pearl Harbor,
and the United States entered World War II.

The nightclubs had always been predominantly patronized by free-
spending young men, but young American males began answering the
call to arms. With the nation in shock over the slaughter of 2,400 men
in Hawaii, not many Americans were in the mood for clubbing. In New
York City alone, dozens of night spots went out of business within
weeks of the nation's entry into the war. The clubs that weathered the
sharp drop in patronage were able to do so only by resorting to dras-
tic measures. Most cut back their floor shows to just one or two nights
a week and replaced their expensive celebrity acts with local talent.

The period was especially trying for Daisy and Violet and the war
wasn't the only reason. They had been appearing in theaters and
nightclubs for nearly two decades. As humiliating as it must have been
for them, they had to face a harsh reality: In entertainment circles,
they were starting to be seen as relics. By constantly making over and
updating their show, such veterans as Sophie Tucker, Jimmie Durante,
and George Burns and Gracie Allen had always been able to keep fans
coming back year after year. The Hiltons, too, always tried to keep
their productions *au courant*, and added the requisite gibes at Tojo,
Hitler, and Mussolinito to their stage patter and sang songs like "Over
There" and "You're a Sap, Mr. Jap." They also made appeals to their
audiences to buy Defense Bonds. The truth was, audiences never
viewed Daisy and Violet in the same way they saw such timeless
entertainers as Tucker, Durante, or Burns and Allen. For all their

polish as entertainers, their drawing power had always been centered on their strangeness rather than talent.

Theodore D. Kemp, a sometime booking agent for the twins during the 1930s and 1940s, characterized the relationship the twins had with their audiences: "The girls were so outstanding as musicians, vocalists, dancers, and even comediennes that they could have had careers in entertainment even if they weren't Siamese twins. The problem was, though, that the public never really appreciated the girls for how gifted they really were. They were fascinated by Daisy and Vi first and foremost because they were oddities of nature, freaks. I don't think it really mattered much that the girls were terrific entertainers or that that they always tried hard to give their act the look of being the current year's model. Most people saw them as a novelty and that created a problem for the girls. All but their greatest fans seemed to feel that if they saw the Siamese twins once, that was quite enough."[1]

There was another reason why the twin's marketability kept slipping. By the 1940s, some segments of society had begun taking a different view of what they saw as the exploitation of human misery. They began to feel it was indecorous to go to a theater or a nightclub to look at freaks, however brilliant these souls might have been as performers. There were, to be sure, still carnivals and circuses crisscrossing the country with tents full of quarter-ton ladies, alligator-skinned boys, living skeletons, and armless wonders. Thanks to exceptional social charm, beauty, and stage radiance, Daisy and Violet had been able to escape these sorry caravans. They were, at least for a while, embraced by the same audiences that gave their hearts to such luminaries as Al Jolson, Fanny Bryce, and Edgar Bergen. Popular tastes were changing as the world approached the midpoint of the century. Daisy and Violet represented the last of their kind. They were the sole surviving freak royals.

By 1942, the twins found themselves sometimes going for a month or two without work. Even when Argus managed to book engagements for them, the venues were often so far from one another that when the sisters finished a date in one place, they often had to travel across the country to get to their next one. With their pay-days spaced farther and farther apart, and their road expenses higher than ever, Daisy and Violet once again were at the edge of a financial precipice.

Desperate for some upturn in their fortunes, they quit Argus late in 1942 to join a new booking operation, the Jolly Joyce Agency in Philadelphia.[2] Their new agents did find them steady work. When Daisy and Violet learned what their new act would be, their self-esteem sank to its lowest depth ever. They were informed they were now going to be repackaged as "Daisy and Violet Hilton, The World's Only Strip-Teasing Siamese Twins." The Joyce agency had booked them to travel the I. Hirst Circuit, a chain of about thirty-five burlesque houses in the East and Midwest.

Burlesque was suffering a severe womanpower crisis at the time Isadore Hirst signed the Hiltons. The premier strippers like Ann Corio, Georgia Sothern, and Rose La Rose had already quit the burly houses to work in nightclubs where the pay was much better and the audiences more polite. The burlesque theaters' ranks of professional undressers became even further decimated when America entered World War II. Many soubrettes packed away their G-strings and picked up their welding torches for both the war effort and higher wages. So desperately low had the supply of strippers become that Hirst and his brethren were willing to do just about anything to attract new hirelings. This meant relaxing some of the usual qualifications for dancers. If a woman could move from one end of the stage to the other without falling on her face, she was almost always offered employment. The burlesque barons also raised the age ceiling for

dancers. The lowered standards for strippers didn't go unnoticed by the press. A writer for *The Billboard*, for example, carped:

> [The] only requirement for getting a job . . . was that the girl
> have two legs, and be able to lift one of them part of the time.

Daisy and Violet launched their burlesque careers in January 1943, at Isadore Hirst's flagship theater, the Trocador in Philadelphia. Even in a business where dancers imaginatively employed such diverse props as mannequins, pythons, and whipped cream to add a little novelty to their routines, the Hiltons' act stood out for its bizarreness. They provided their own musical accompaniment, bleating and honking on their saxophones through songs like "St. Louis Blues," while at the same time shedding their costumes. Because the twins were so tiny, not even five feet tall, their instruments provided a degree of modesty.

Daisy and Violet came to dirty dancing with the naturalness of eaglets making their first attempts at flight. During the years they traveled with carnivals, they had watched the hootchie-cootchie dancing girls often enough to know what to do. Through their artful use of stage lighting and the care they took never to turn their backs to the audience, the twins disrobed to G-strings and pasties without ever exposing the thick, fleshy ligature uniting their bodies at the lower spine. Even so, there was no way they could make their audiences forget that they were Siamese twins. Except for the randiest of viewers, their audiences may have been provoked less to sexual excitement than to pity, if not outright revulsion.

The twins also made nondancing stage appearances at the Trocador during which they served as a foil for a goatish old comedian in a dented brown derby and an outsized yellow plaid suit. As part of his stage routine, the comedian made claims of having Olympian sexual

powers and promised the pair delivery to paradise if they would only give him a try.

"Yeah, yeah," Daisy would rejoin. "If you're such a good lover, why do the other dancers call you Peanut behind your back? From everything we've heard, you have neither the equipment nor the stamina to satisfy even one woman, let alone a pair."

As the buffoon continued his boasts of sexual superiority, a change in his appearance would start taking place that would quite astonish the audiences. The nether region of his baggy trousers would begin billowing outward and the bulge would keep growing until it had swelled to impossible size. With the audience hooting, cheering, applauding, and stomping their feet, Daisy and Violet would investigate the source of the comic's supposed elephantine tumescence. They would tug at the waist of his pants, drawing his suspendered trousers a foot away from his body, and then gaze into the abyss. Daisy would turn to the audience, roll her eyes and flash an I'll-show-him expression. Next she would fish into her curls and pull out a five-inch-long pin. With an exaggerated gesture, she would twirl the pin in her fingers and feel its point. With Violet still pulling at the waist of the comic's trousers, Daisy would aim the needle at her target. There would be a loud pop as Daisy punctured the source of the comic's priapism. It was a balloon that had been inflated through a long rubber tube extended through the bottom of a pant leg to a bicycle tire pump a stagehand was operating behind the curtain.

Following their appearances at Philadelphia's Trocador, the sisters went on tour on the "wheel" as it was called in burlesque circles, playing week-long and sometimes two-week-long engagements in cities like Baltimore, St. Louis, Boston, Pittsburgh, and Detroit. Appearing in these cities during their vaudeville years, the twins had performed only in the most sumptuous show temples. Now they were playing in mostly decrepit buildings that had been added to the Hirst chain

only after they had fallen into disuse. The audiences were also different than those to which Daisy and Violet had become accustomed. By the 1940s, burlesque had already descended to such an abased form of entertainment, its patronage was predominantly made up of just two types: bums who used its theaters as flophouses, or lonely men who sat and watched with their fists moving jerkily, hidden under hats, threadbare coats, or overturned popcorn boxes.

There were times when the twins became so discomfited by the loud snoring, belching, and farting in the seats that they could scarcely continue their act. If they felt dishonored at having descended to such stink-holes, some of their dearest friends were equally tortured at seeing the sisters on burlesque house stages. One of the witnesses to a performance by "The World's Only Strip-Teasing Twins" was Bud Robinson, who, with his wife CeCe, formed a dance duo that for years had appeared on some of the same variety bills as the sisters. Robinson, who later became the manager for bandleader Doc Severinsen, caught one of the twins' performances in a Louisville burlyhouse. Even after the passage of many years, his memory of the spectacle hadn't blurred.

"It was Kentucky Derby time, and as was often the case at that time of year, CeCe and I were booked at the Rosemont Hotel," he recalled.

"We saw in the papers that Daisy and Vi were in Louisville, playing at a local burlesque house. We hadn't seen the girls in years, although now and then we would get a letter or Christmas card from them. CeCe and I thought we'd surprise the girls. We went to the burlesque theater with the thought that we'd take in their show and then visit them backstage and invite them out for dinner someplace. When we saw them onstage, it just broke our hearts. As they danced, they peeled off parts of their costumes. They did some bumping and grinding. As strip-tease performances go, their exhibition was pretty

tame. Still, it tore us up watching them. They were lovely, vivacious girls. They had genuine talent as entertainers. Now they were reduced to this. When their performance ended, CeCe and I just left the theater and went back to the hotel. We couldn't bring ourselves to go backstage to say hello. We were embarrassed for them and we knew that they, too, would have been terribly shamed at knowing we had been in the audience. It was one of the saddest things I ever saw in my life."[3]

Daisy and Violet were often jeered by their audiences, and some of the more boisterous spectators yelled at the sisters to leave the stage and make room for the real tassel twirlers. Hirst's Howard Theater in Boston or his National Theater in Detroit delivered sexual displays of the lewdest, most revealing kind. As outré as the twins' act was, some patrons may have viewed it as more sickening than sexual. Because the sisters' very survival now depended on their keeping their jobs, they had no choice but to take the insults and go on with the performances. "We run into drunks and hecklers, but we just ignore them," Violet once said, revealing what it was like to perform before mobs of disparagers. "Our motto is to be gracious under any circumstances."[4]

Sometime during 1943, Daisy and Violet switched to yet another booking agent, Don D'Carlo of D'Carlo Entertainment Services in Pittsburgh. At D'Carlo's encouragement, they also established residency in Pittsburgh, moving into the Kirkwood Hotel. A small but stately brick structure at 5935 Kirkwood Avenue in the city's New Liberty section, it had a reputation as a hotel that never slept. It was a warren for performers, painters, and assorted bohemians. Wafting through its hallways at any time of day or night was an olfactory broth of cooking cabbage, oil paints, turpentine, and burning leaves from plants other than tobacco. Jostling in the same passageways were the sounds of rehearsing Irish tenors, tap dancers, and concert

pianists. Many of the Kirkwood's residents were entertainers who were either trying to launch new careers or put broken careers back together. The hotel's restaurant, advertised as "The Area's Finest Bar, Grill and Lounge," had a small stage on which comics, singers, and magicians could test new material before fellow aspiring performers and, now and then, local talent scouts.

With their switch from the Jolly Joyce Agency in Philadelphia to D'Carlo, Daisy and Violet were able, at least for a while, to quit their lives as strippers. The war was still raging overseas, but by now a certain uneasy calm had befallen the nation and opportunities for entertainers had improved. America's factories were operating around the clock, turning out armaments and other military supplies, and the workers had more money to spend than ever. With no new houses, automobiles, or refrigerators to buy, the plant workers felt free to spend their earnings on good times and escapism. In greater numbers than ever, working people flocked to the theaters, nightclubs, and movie houses. Suddenly there was work for comics, dancers, impersonators, and other entertainers who hadn't been on stage in years.

Daisy and Violet were beneficiaries of this upturn. Once again they were in demand by the nightclubs and variety theaters. They were also flooded with invitations to appear at military training camps and USO clubs. They especially relished these engagements. Like most civilians, they felt an obligation to contribute to the country's war effort in any way possible. And because England was being pummeled nightly by German bombs during the Blitz, they may have felt an even greater sense of patriotism. Sometimes by themselves and sometimes in company with other entertainers, they regularly appeared at rallies organized to sell United States Defense Bonds.

"I don't think there were another two entertainers who worked harder at selling bonds than Daisy and Vi did," Buddy Sawyer once said. "The girls would even cancel paying dates if they were asked to

take part in a rally. Such entertainers as Kate Smith, Bob Hope, and Jack Benny were always credited with selling the most war bonds. But it was said that right after big name stars like those, the twins were next in getting people to buy the bonds."[5]

One gathering place for soldiers, sailors, and marines where the Hiltons regularly appeared, always without taking a fee, was Pittsburgh's USO–Variety Club Canteen. Among the other regular drop-ins there was L. Daniel Schmidt, an attorney and amateur hypnotist. Schmidt had a reputation for being imperious and overbearing. He was a man of normal height, but he had somehow perfected a technique of looking down on people even when they were five or six inches taller than he was.

Always seeking ways in which to extend his renown, Schmidt dreamt up an experiment in behavioral science that he apparently believed would make him a cover boy of the psychology journals if not *Time* magazine's Man of the Year. His plan was to simultaneously place Daisy and Violet into hypnotic trances. By examining the twins while they were in dream states, he said he would provide the scientific community with empirical evidence of how dissimilar in personality two people can be even when both have the same genetic makeup and have shared the exact same experiences and environments all their lives.

Schmidt decided to carry out his experiment in a decidedly non-scientific laboratory: Pittsburgh's USO–Variety Club Canteen. Carl Jung didn't respond to his invitation to see the demonstration, but the event did pull in a standing-room-only crowd of GIs.

Schmidt called Daisy and Violet to the stage and asked them to sign their names on a blackboard. Both had long been separated from their husbands, but, curiously, they chalked "Mrs. Jim Moore" and "Mrs. Buddy Sawyer" onto the slate.[6] Next they seated themselves on a divan. Schmidt started talking to the sisters softly while at the same

time swinging a pendulous pocket watch before their eyes. Before a minute had ticked away, the twins' heads were leaning together, their eyes were closed, and their expressions were placid. Clearly Schmidt was pleased by how well the first phase of the experiment had gone. He tendered a slight bow to the audience, winked, and then returned his attention to his subjects.

"Violet, I want you to think very hard. Can your remember when you and Daisy made your very first appearance on the stage of a theater?"

Violet moved her head up and down languidly. Her words emerged slowly, deliberately. "I think we were three. Yes, yes, I'm sure of it. We were just three years old."

"Now, Daisy and Violet, I want both of you to continue the peace of your sleep and drift back . . . back . . . back in time. I want you travel back through the years to the time when you were three. Perfect. Now please concentrate very hard. Daisy, I want you to tell me where you and your sister performed for the first time."

"It was far, f-a-r a-way.

"How far?"

"A-a-a-cross the o-o-o-cean."

"Violet, you heard your sister say you made your performing debuts in a theater across the sea. Think very hard, Violet. What did the theater look like? What was its name?"

"Oh, it was so beautiful. . . . A great and splendid vaulted ceiling painted with frescoes of the Muses. . . . gold, decorated, horseshoe-shaped seating sections that rose in three, four . . . no, five tiers over the orchestra section. The theater was completely filled, and all the ladies and gentlemen were in their finest evening clothes. The theater was in Italy . . . Milan, Italy. It was called . . . called La La La Scala."

The response set off tittering in the audience and then cackling, especially with its more erudite members. Schmidt's face became a

lantern of red. Of all the highlights that musicologists had docu-
mented in the 200-year history of the opera house, somehow even the
most meticulous of them had overlooked the appearance on its baroque
stage of grown-together toddlers singing "Un bel di."

Able lawyer that he was, Schmidt decided against questioning
the twins any further. Visibly flustered, he abruptly terminated his
experiment. Later he asked Violet if she knew how badly she humil-
iated him before the crowd. Violet confessed she had been faking her
hypnotic trance all along, and that her only experience with La Scala
had been in the pages of a travel book she had checked out from the
library a few days earlier.

The relationship between the attorney and the twins, while
strained for a while, wasn't over. Schmidt later provided counsel for
Daisy in her divorce action against Buddy Sawyer.

After dimming during the late 1930s and early 1940s, and at times
almost guttering out altogether, the twins' stars started flaring with
bright, white light beginning in the fall of 1943. It was then when
the king of all Sunday newspaper supplements, the *American Weekly*,
began running on six successive Sundays, what was purported to be
the first tell-all, no-holds-barred autobiography of the Hilton sisters:
"The Private Life of the Twins."[7] There wasn't a fading entertainer
anywhere who wouldn't have entered into a Faustian bargain for
such publicity. the *American Weekly*—proclaiming itself "The Nation's
Reading Habit"—was owned by the Hearst empire and boasted a cir-
culation of 6.5 million, the widest of any publication in the world.
Once the series began, the twins were instantly restored to America's
consciousness.

"The Private Life of the Twins" was represented by Daisy and
Violet Hilton to be a "true and full double-autobiography," as told to
Ethelda Bedford, apparently a staff writer for the *American Weekly*. In
the series' opening paragraphs, the twins promised readers "the story

we never intended to tell." They promised, too, that there would be nothing in the account that had not been "carefully, factually" set down. In detail upon detail, they described their childhoods as a time of unrelenting horror. Their mother, they said, died in childbirth; their father, whom they described as a Belgian military officer, was killed in the war without ever seeing them. They lived in terror of the woman who was to become their warder, identified not by the name Mary Hilton, but as a "Mrs. Mary Williams." Except for the times when they were on exhibit on the rickety stages of sideshows or in the exhibition pits at country fairs, they were kept sealed away from the rest of the world. They never had any opportunities to interact with other children, and while "Mrs. Mary Williams" and their subsequent keepers became rich, the twins knew only penury, they wrote.

As unrelentingly lugubrious as the published tale of the girls' early life was, parents across America started telling their youngsters of the Hilton twins, recasting the story as a parable, explaining that the sisters finally triumphed over the most evil of forces to become creatures of grace, beauty, and worldwide adulation.

Daisy and Violet were sensitive about having been born out of wedlock. It's understandable why they would change the identity of their parents from an unmarried barmaid and a skirt-chasing, apparently married hairdresser and reinvent them as a loving, married couple who, because of their tragic and untimely deaths, left the twins orphaned. What was more amazing was how circumspectly Daisy and Violet treated their one-time slave masters, Mary Hilton and her son-in-law, Myer Myers. Not only did they change Mary's surname from "Hilton" to "Williams," but they were careful never to identify Myers by name in their memoir. Instead, they referred to him only as "Sir."

If the twins were chary about identifying the people from their past, they showed no reticence in talking about the men with whom

they had been romantically involved. They named all the names: the publicist Bill Oliver whose wife brought a suit against them for alien-ation of affection; the Mexican-born troubadour Don Galvan; the orchestra leaders Blue Steele, Maurice Lambert, and Jack Lewis; the boxer Harry Mason; their one-time husbands, dancers Jim Moore and Buddy Sawyer, and more. Readers of the Sunday serial must have got-ten the idea that the Hilton sisters were so experienced in love that, by comparison, such heartbreakers as Carole Lombard and Mae West didn't even belong in the same league. As well-tried in romance as Daisy and Violet might have been, they apparently didn't want to leave the readers with a final impression that they were through with love. Indeed, they concluded their memoir with what sounded like an open casting call for other beaus:

> We still long to find real romance and love equal to our tolerance and forgive-ness. We dream of having homes and families. (Doctors tell us there is no rea-son why we can't have children.)
>
> Perhaps you have seen through this story that life has given us plenty of problems, and that we have adjusted our lives to most of them. And some-where still, we believe and hope we will find the right mates, to whose understanding and love we can entrust our private lives.[8]

The twins' mailbox did fill up with marriage proposals after the *American Weekly* published the memoir, but apparently none of the candidates seemed quite right to Daisy and Violet. Some of the offers came from prison inmates. There were also proposals from three-legged men, midgets, fat men, and other sideshow attractions. Many of these correspondents claimed that because they inhabited a place beyond the periphery of the broader society, they could empathize with the sisters' pain and loneliness. But most of the love notes they received came from gold diggers who clearly were most interested in receiving a percentage of their earnings.

The vast dissemination of the twins' autobiography may not have improved their romantic fortunes, but it was a boon to their performing opportunities. Offers poured in from all over in the United States and Europe. For Daisy and Violet, the choice of where to travel first was easy. They picked Florida. They were able to coordinate a string of engagements that would have them opening in Miami's Club Bali in the fall of 1943 and then stay in Florida throughout the winter, playing houses up and down its eastern coast.

From the time they stepped off the train in Miami, Daisy and Violet felt that they had arrived in the Promised Land. They loved the look of the new and renewed that was everywhere to be found in the winter playground. Gypsies most of their lives, the place struck them as a spot where they could happily make their home forever.

Like the twins themselves, Miami was well on its way to resurrecting itself. Hotels, nightclubs, and apartments were pushing up everywhere on its coastal land, and magazines like *Life* and *Time* were referring to the city's renewal as an urban miracle. The boom was spurred in part by the war. Unlike during the 1920s, when it was mostly the spectacularly rich who flocked to the beaches, by the 1940s, Miami had attracted hordes of factory workers and their families.

These fugitives from the ice and snow of Detroit, Cleveland, Pittsburgh, and Chicago headed south by train, plane, and bus, but rarely by automobile, since civilian consumption of gasoline was still strictly rationed by the Office of Transportation. Many wage earners seemed eager to splurge a month or two of their pay in a single week. And why not? Where was a worker's reward for spending twelve hours a day slow-stewing in the foundries or tamping explosives into torpedo shells if he could not be a prodigal in Miami for at least one week out of fifty-two?

By the time Daisy and Violet opened their engagement at the Club Bali, their audiences thought they knew more details about the sisters'

*The sisters on Miami Beach, mid-1940s. (Author's collection)*

lives than they did about their own spouses. By then, "The Private Life of the Twins" had been serialized in the Sunday papers for weeks. Club Bali seized the opportunity and ran large ads in the Miami dailies, declaring "You're Reading About Them In The Newspapers! Now See Them In Person!" And people did see them. They went in droves. Looking over the crowd from the big stage, Daisy and Violet saw men in white tuxedos and women in expensive dresses that exposed gleaming shoulders. They also saw, huddled around the bar, raffish men in dark glasses and slouch hats.

The club at 734 Biscayne Boulevard was famous for its shows and its food, but it was also a hangout for racetrack touts and bookies. Even though the Bali was always awash with vacationers, the establishment likely raked in its greatest profits from a tiny, second-floor space that operated days as the Arena Barber Shop. Nights, after the barbers had swept up the day's cuttings and turned out the lights, the shop became a gambling boiler room where bookies throughout Miami called in bets to a half-dozen men manning phones. Police made regular raids, but because the Bali's ownership seemed to change almost every month, the district attorney found it difficult to prosecute anyone.

Because the population of Miami Beach changed almost completely from week to week, with tens of thousands of tourists entering the city at the same time that tens of thousands were leaving, Daisy and Violet probably could have attracted full houses at Club Bali all winter long. Don D'Carlo had booked the sisters to make appearances at numerous other clubs in Florida, however, and after two weeks, Daisy and Violet traveled on to Key West, then to Palm Beach, then to other resorts.

The money rolled in throughout the winter of 1943–44, and there was no interruption when spring came. The Boyle Woolfolk Agency in Chicago signed the sisters to head an eight-act grandstand unit, billing them as "The Sensation of An Era . . . The Most Talked Of Couple In The History of Theatricals." The Woolfolk productions, part rodeo and part circus, included such fare as the Glades, trick horseback riders; Ray Thornton, a lariat twirler and Will Rogers impersonator; and Krick and Bodo, a comedy trampoline duo.

The shows were primarily intended for fair audiences and were decidedly more low-brow. According to trampolinist Howard Krick, the sisters seemed to enjoy appearing before the rustics. "I never got the impression that they felt it was beneath them to be playing before

the country folks in the grandstands," said Krick, who toured with the twins in the summer of 1944. "It didn't matter to them if they were playing to an audience in a ritzy nightclub or to some farmers sitting in bleachers downwind from a fairground pig barn. They just seemed to genuinely enjoy putting on their show."[9]

No records have been found that show what the twins received for their fair appearances, but Krick said he and his partner, George Bodo, earned $375 a week. "Because the Hilton sisters were the top-billed act in the unit, it's likely they were earning at least three times as much as George and me," Krick estimated.[10]

Not since their earliest years of touring with carnivals three decades earlier had the twins faced such hard traveling. Because the country fair sites were often in remote regions not served by railroads, they traveled everywhere by automobile. As the twin on the left, it was Daisy who had always been at the wheel in the past, but the sisters now found a way to share the driving. They bought a car with a steering wheel and controls on the right side as well as the left side. The car, a second-hand Buick, had seen earlier service in a high school drivers' education program.

Because it was still a time before motels sprouted every ten or twenty miles along America's highways, Daisy and Violet often slept in the car at night while en route to their fair engagements. "They were real troupers," according to Krick. "They never complained about the rigors of traveling to the fairs and, as far as I know, they never asked for any special treatment anywhere. They were also generous with their concerns for other performers in the road unit, even those way down the ladder."[11]

"We were in Knoxville, Illinois, for the Knox County Fair. Just a couple hours before the first show, while George and I were rehearsing, I cut my knee quite badly on one of the trampoline springs. Some fair officials rushed me into town to see a doctor. The doctor found it

necessary to stitch up the wound. He then wrapped the knee in bandages and advised me to stay off the leg for six weeks. Upon my return to the fairground, the girls invited me into their dressing tent. Daisy said she had something to make my knee feel better. She got out a bottle of gin and gave the doctor's bandage a good soaking with the stuff. I don't know if her first-aid really helped, but some of the pain did go away. With a little adjustment of our usual routine, George and I were able to go on with our act that very afternoon. Today, fifty years later, a scar from that gash to my knee is still visible. I treasure it. It often puts me in mind of Daisy and Violet. It reminds me of their kindness."[12]

Daisy and Violet toured continuously through the end of the decade, playing the resorts and big cities in winter, and traveling the fair circuit in summer. If they were still having romantic liaisons during this period, they were likely of the one-night-stand variety. While they had never been shy before about discussing their latest heart-throbs, they no longer made declarations to the press about boyfriends. After going through two disastrous marriages, bringing an illegitimate child into the world, and making business decisions that had wiped out their fortune, what seemed to matter most to them at this point was holding on to their careers. And they worked as hard as ever.

Thanks to the constancy of their engagements, they were probably earning $75,000 or more a year from the mid-1940s on. While that was considerably short of what their act had generated during their vaudeville years in the 1920s, the twins collected all their earnings, minus the 10 percent skimmed by their booking agents. Financially, at least, they may have been better off than at any time in their lives.

But while their fortune was rebuilding, they were imperiled by an occupational hazard that almost all entertainers seem to face whenever

they start accumulating wealth conspicuously and rapidly. Sooner or later they were going to be approached by an opportunist operating in the belief that other peoples' money was there for the taking by anyone smart enough to get it.

# THEIR PHONE WAS NOT GOING
# TO STOP RINGING

The gray-white cumulus cloud hanging over the desk of Ross Frisco's office kept massing thicker and thicker, bloated from the smoke of Frisco's cigar and the Old Golds that Daisy and Violet kept firing up. Frisco appeared immensely pleased with himself. He peered across his desk at the twins with a you're-going-to-love-me expression, and posed a series of questions that were purely rhetorical:

Were they prepared to become so fabulously rich they would be able to turn away invitations to appear at all but the poshest theaters and nightclubs? How would they feel about seeing their names emblazoned on the marquees of half the movie houses in the country? Was there a fireplace mantel in their apartment where they would be able to show off a couple of Oscar statuettes?

Even in his elevator shoes, Frisco stood only a few inches more than five feet tall. His black hair was slicked back with Vitalis. He wore tortoise-shell framed glasses that were so over-sized he appeared to be looking at the world through the windshield of a Packard. His booking agency, Ross Frisco Attractions, Inc., operated out of a scruffy fifth-floor suite in an office building on Boston's Tremont Street next door to the one of the world's largest and most glittering movie palaces, the 4,400-seat Metropolitan Theater.

Frisco tried to style himself as the most egalitarian of the talent

bookers in the East. He engaged opera divas and string quartets and nine-year-old violin prodigies for the garden and yachting parties of Boston's Brahmins, but he also represented spoon players and big-top aspirants with names like Cuddles and Blinky who twisted balloons into animals.

Daisy and Violet were forty-two. Certainly their stars had lost a lot of the candlepower with which they had once blazed. Still, Ross Frisco regarded them as the hottest property to have entered his stable since the early 1930s when, for a brief time, he was the booker for the Will Mastin Trio, the dance troupe in which a peewee-sized kid named Sammy Davis, Jr. made his professional debut. Frisco bagged the twins by dint of being in the right place at the right time. Daisy and Violet had always found Boston appealing. Financially flush from nearly a decade of regular engagements, they left Pittsburgh in 1950 and settled into a big and gracious apartment in Boston's toney Back Bay. They had scarcely gotten their names on the mailbox at 22 Dartmouth Street when Frisco started ringing their doorbell. They politely turned him away at first. Don D'Carlo, their agent in Pittsburgh, had kept them working and their relationship with him had always been good. But Frisco persisted. He assured the sisters that because they were now in his backyard, he could serve them better than any out-of-state booker. He promised he'd make the girls bigger stars than they had ever been and, ultimately, wooed them to his agency.

Frisco didn't get off to the smoothest of starts with Daisy and Violet, according to Abe Ford, another talent booker in Boston.[1] Frisco consistently found work for the twins, but the engagements were hardly what they had been expecting.

"Ross's specialty had always been novelty acts—magicians, jugglers, acrobats, tap dancing midgets, and the like," Ford noted.

"He had handled acts like that since the 'twenties when he booked

for a lot of the smaller houses. By the time Ross started handling the twins, though, there were no longer many opportunities for placing variety acts in the theaters. Mostly what he did was use the girls as headliners in unit shows that also included such dime-a-dozen attractions as tumblers, plate spinners, ventriloquists, and magicians. He sent these unit shows to entertainment-starved small towns where the programs were often presented in school auditoriums and gymnasiums. The pay the entertainers got in these unit shows was lousy, and a lot of nights they were put up in flea-bag hotels. Because the Hiltons were known the world over, I don't suppose this sat too well with them. I had the sense that they were unhappy with Ross almost from the beginning of their relationship with Ross."[2]

Ford was correct in surmising that Daisy and Violet had quickly become disenchanted with Frisco. They were on the phone with him every day, asking how he expected them to meet their living expenses when he found them so few engagements. Frisco was aware that the twins were losing faith in him. He was sure he was going to lose them unless he could quickly stop their careers from moving in reverse. He phoned the twins one day late in 1950 and asked if they could meet at his office as soon as possible. He had an exciting new plan, he said.

Daisy and Violet were prepared to issue an ultimatum to Frisco: Either start finding them work in the better theaters and clubs or they were walking. They were cool and standoffish when they appeared at his office. Their agent, on the other hand, was more chirpy than the twins had ever seen him. He asked them to settle into a chair across his desk and then he unfolded his plan.

Frisco asked the sisters to forget about nightclub and theater engagements for a while. He had something much bigger in mind. His plan was going to transform them into movie stars . . . no, not mere movie stars, but big-screen heroines who would become so adored by

the public they would stand out like Venus and Athena at a convention of cleaning ladies.

Frisco said he already had a rough draft of the screenplay. It was a vehicle he had created just for them and one only they would be able to play. It was so unlike any other movie ever made, Frisco promised, it was a foregone conclusion it would win an Academy Award. Daisy and Violet shifted forward to the edge of their chair. Frisco continued to effuse, describing in detail Daisy and Violet's ascension into Hollywood's firmament.

Eventually, the sisters interrupted his growing list of superlatives and asked which studio would be producing the picture. Frisco cleared his throat and said they would have to take on full responsibility for bankrolling his film project. Daisy and Violet flashed looks of disgust at one another, stubbed out their cigarettes, and rose from the chair.

"We'll be sure to see the picture when it comes to town, Mr. Frisco," Violet declared. "You'll have to find another pair of Siamese twins for the project, though. Come on, Daisy, let's not waste another minute here. We've got work to do. We need to find another agent."[3]

The sisters knew that a movie production could wipe out every dollar they had in the bank. This had happened before when they were persuaded to produce their own road show. Ultimately, the venture gobbled up every cent of the fortune they had been awarded in their lawsuit against Myer Myers.

Frisco begged Daisy and Violet not to leave before hearing more about his project. He tried to allay their concerns about the risks involved in investing in the film. He would not, he averred, have any trouble at all getting Metro-Goldwyn-Mayer or Paramount to produce it. But if he were to turn the project over to one of the big studios, he went on, the three of them would not only have to surrender all artistic control over the production, but they would also miss out

on the hundreds of thousands, if not millions, of dollars the movie was sure to earn.

"Listen," Frisco said, "Here's how strongly I believe in this picture. I'm going to go to Hollywood with you. I'm going to close down this booking agency of more than thirty years. I'm going to lock the door, throw away the key, and walk away from the place. Would I even think of doing that if I weren't absolutely sure the three of us would be wading in money?"

Frisco leaned well back into his leather chair, clasped his hands behind his head, and turned his gaze to the ceiling. He seemed enraptured, as though he were having a vision of what things were going to be like after the premiere.

"The movie is going to be titled *Chained for Life*, and, of course, it's going to say right up there on the screen, 'Starring Daisy and Violet Hilton.'"

Frisco went on to describe the story in detail. The movie he outlined may not have been DeMillean in scope, but it did seem cinematic. It had tension, drama, quirkiness, and a corker of an ending.

The story, he said, would play out against the backdrop of a road company called the Dorothy and Vivian Hamilton Revue, starring singing and dancing Siamese twins, and, of course, these roles would be assumed by Daisy and Violet. The cast also included a magician, a comedian, a juggler, and a sharpshooter.

Early in the story, Dorothy and Vivian, along with the company's manager, are seen fretting over patronage so paltry there is barely enough money to fuel the bus to get them to the next town. Dorothy and Vivian are agonizing over the realization they may soon have to hand pink slips to their troupers and leave them stranded somewhere without funds to return home. The show's manager, Ted Hinckley, hatches an idea he believes might save them: If he can engineer an onstage marriage with one of the twins, the event might trigger the

kind of media buzz that could draw people to the revue just to see the new bride and groom. Hinckley determines that the best possible pairing would have Dorothy, portrayed by Daisy, marrying André Pariseau, the sharpshooter. At first, Hinckley encounters resistance from Dorothy and André when he tells them he wants them to wed before a paying crowd in a grand ceremony. Through his gifts of persuasion, he finally convinces the pair that a public marriage might be the last hope for keeping the Dorothy and Vivian Hamilton Revue alive.

Frisco brought out three glasses, filled them with scotch and water, and lit another cigar. Up to this point, the narrative Frisco was unreeling seemed to closely mimic those in the twins' actual lives. But as Frisco resumed his recounting, the story took some new twists and turns. Although Dorothy is at first romantically indifferent to André, she finds herself falling in love with him once the two begin to plan their arranged marriage. The sharpshooter seems equally smitten with Dorothy, even strumming a guitar and serenading her over the telephone with love songs.

Just as Hinckley had hoped, the press falls all over the announcement that Dorothy Hamilton, a pretty Siamese twin, is going to marry the strikingly handsome André Pariseau. Pictures of the two run on the front pages of newspapers everywhere, and crowds of people now appear at the box offices for every performance of the Dorothy and Vivian Hamilton Revue.

The penultimate scene in *Chained for Life* occurs on the eve of Dorothy and André's scheduled wedding. It is revealed then that André has resumed a relationship with Renée, a beautiful stage assistant who balances apples and oranges atop her head as André, from twenty-five paces away, blasts away at them with his pistols. When Dorothy Hamilton learns of André's perfidy, she feels desolate and, because of all the attention her engagement has received in the press, publicly humiliated. Her sister Vivian has a different set of emotions.

Her realization that André has been cheating on Dorothy fills her with murderous contempt for him. While André is on stage with Renée before a capacity audience, Vivian drags Dorothy into the wings, picks up one of André's revolvers, takes aim, and with a single squeeze of the trigger, leaves him mortally wounded.

Frisco's screenplay finishes with an ending he is sure is going to leave its audiences gasping for air. Vivian is brought to trial for the first degree murder of her sister's intended, and is ultimately found guilty as charged. But the sitting judge is left in a quandary that no amount of legal arguing can resolve. Because Dorothy and Vivian are physically bound to one another, "chained for life," as it were, how can he sentence Vivian to death, or, for that matter, even life imprisonment? To do so would exact the same punishment on the innocent sister.

While Frisco claimed full credit for the concept of his story, it was, in fact, heavily borrowed from *Those Extraordinary Twins*, Mark Twain's short story of fictional Siamese twins, Luigi and Angelo Capello. As with Frisco's Vivian, Twain's Luigi is placed on trial for murder. The judge finds him guilty, but because Luigi is physically connected to an innocent sibling, he falters over how to mete out justice. In the Twain story, the judge's dilemma is resolved by a mob of angry townspeople. They take the law into their own hands and hang Luigi, simultaneously also snuffing out the life of his innocent brother.

Even though Daisy and Violet had vowed they would never again allow themselves to be taken in by someone else's schemes, they were absorbed by Ross Frisco's film project. The screenplay he outlined sounded like it had all the components of a blockbuster. And certainly it struck them as a movie that was absolutely tailor-made for them, a vehicle whose starring roles only they could carry. Said Daisy: "Maybe we were crazy—how many times before had we been taken in by the

wild dreams of others?—but if ever Violet and I were presented with a proposition that seemed to be absolutely a sure-fire winner, Ross' movie sounded like it might be such a thing. Vi and I talked over the proposition for only a little. Then we gave Ross the answer he wanted to hear: we would go to Hollywood and if it meant that we would we could retain full artistic and financial control over the picture, then we would put up the money for its production."[4]

Once he received the twins' assurances they would underwrite the costs of bringing his story to the screen, just as he had promised, Frisco shut down his talent agency, and, accompanied by Daisy and Violet, entrained for Hollywood.

It was January or February of 1951 when the three arrived in Hollywood. At this point, Frisco's movie project had no existence anywhere outside his mind. His first job was to find a producer, someone who could commission a script, hire a director, choose a cast and put together a film crew. It isn't known how many doors might have been slammed on him, but, ultimately, he was able to sell the idea to George Moskov. A movie man of long, rich, and varied experience, Moskov had apprenticed with the highly regarded producer, Lewis Milestone. In the late 1930s, Moskov launched his own career as a producer, shepherding the development of such solid hits as *Angel Island* (1937), *Joe Palooka, Champ* (1946), *Isle of the Missing Men* (1947), *Heading for Heaven* (1947), and *Search for Danger* (1949). Only months before he was approached by Frisco, Moskov had completed *Champagne for Caesar*, a sparkling, critically well-received comedy about radio quiz shows. The film featured such A-list stars of the day as Ronald Colman, Celeste Holm, and Barbara Britton, and boasted a score by Dimitri Tiomkin. It was perhaps surprising that a producer of Moskov's credentials would agree to participate in a film project as amorphously defined as Frisco's *Chained for Life*. He may have been impressed that the sisters themselves were entirely underwriting the

project and that he would be spared the responsibility for raising any of the production costs.

Moskov's first step in developing the film was to bring in writer Nat Tanchuck. A graduate of the University of Southern California, Tanchuck worked as a newspaper reporter, a short story writer, a movie reviewer for trade publications, a public relations flak, and a developer of scripts for radio and television. But at the time he was tabbed by Moskov, Tanchuck could only claim credits as an assistant writer on three pictures, all of them forgettable: *Federal Man, I Killed Geronimo,* and *Timber Fury.* Moskov probably was not in a position to attract a more seasoned writer for the project. No records exist of how much money was budgeted for *Chained for Life,* but it seems doubtful Moskov could have had much more than $100,000 with which to work, if that.

As a hired pen, Tanchuck knew from the beginning he would have to take direction from Frisco and Moskov. But from the moment the project began, Daisy and Violet became increasingly proprietary about their investment and kept trying to influence the film's shape. With so many authors, the screenplay soon became a multiheaded monster.

It was an era when the golden age of big Technicolor musicals was just dawning. While Frisco had conceived *Chained for Life* as a taut murder and courtroom drama with a heartbreaking ending, Daisy and Violet were more interested in having the film showcase their stage talents. They prevailed on Tanchuck to develop a script that would give them opportunities to sing and dance between the stretches of love-making and gunfire. Tanchuck met with Moskov, Frisco, and the twins almost daily. At each session, he was bombarded by conflicting ideas about what should be added, subtracted, modified, or restored. He would return to his typewriter to incorporate the changes, report back to the group the next day with his rewrites, and face yet more new ideas.

Tanchuck's difficulties in producing a script that satisfied all his bosses may have been compounded by a personal quirk. Just as Dr. Jekyll metamorphosed into a werewolf only when the moon was bobbing in the sky, Tanchuck transformed into a writer only late at night when all of Los Angeles was asleep. "Dad was the consummate night person," said his daughter Heather Tanchuck. "He always had some trouble getting his schedule to gibe with that of most other people in the workaday world. He did his writing only at night, late at night. My mother and I would find him pushing away from the typewriter at about the same time in the morning when we were rising for a new day."[5]

It isn't known how many rewrites Tanchuck made on his script, but ultimately "the committee" never felt he got things just right. Moskov complained the dialogue didn't have an authentic ring, so he brought in a script doctor, Albert DePina, a writer with whom he had worked on *Joe Palooka, Champ.*

As difficult a time as Moskov was having in getting what he considered to be a creditable script, he had an even greater struggle finding the right director. Three or four different directors were hired, but because each balked at taking orders from Frisco and the twins, all of them either walked off the job or were fired. The director's job ultimately went to Harry L. Fraser. He was known throughout Hollywood as the "King of the B-Movies," a sobriquet in which he took great pride.

A seasoned professional, the sixty-two-year-old Fraser had directed more than sixty films, many of them westerns in which he had worked with such celluloid cowboys as Gene Autry, Harry Carey Sr., Ken Maynard, and John Wayne. Few critics ever described his directorial talents in terms any more glowing than "workman-like," but Fraser had a reputation for making the best of mediocre scripts and casts. He was also known for turning out his films on time and on budget.

*Autographed publicity still taken during a break in filming* Chained for Life,
1952. *(Courtesy of the Motion Picture Academy of Arts and Sciences)*

Fraser had begun his film career in the mid-teens as an actor, appear-
ing in western serials. He started directing in 1930, working for
Monogram Studios. Besides directing, he often wrote and re-wrote
scripts, sometimes operated the cameras, and even lit the sets. If he
had trouble getting an actor to follow his direction, he would fire the
player on the spot, go to the make-up tent, and assume the role him-
self. Even more important to Daisy and Violet, something that gave
him cachet in their eyes, Fraser had been a vaudeville comedian dur-
ing the 1920s and played in many of the same theaters where the
twins performed. Said Fraser: "Daisy and Violet had fired several
directors before I took over for one basic reason—none of them knew

anything about vaudeville. Well, I had headlined on the Keith and Orpheum circuit two different times and had been on and off Broadway for a good many years before becoming first an actor and a later a director in the motion picture medium. So the Hilton sisters welcomed me with open arms—all four of them."[6]

The twins were attracted to something else about Fraser: unlike the other directors who had been brought in on the project earlier, he was a director who could be directed. It may have rankled his predecessors that they were expected to take orders from women whose experience in film was limited to the five minutes they were on camera in Tod Browning's *Freaks*. But Fraser was free of any artistic pretensions. He took the position that so long as the Hiltons were providing him with regular paychecks, it was fine with him if they wanted to have a say in the picture's production.

In the history of motion pictures, there couldn't have been many casts that were more motley than the ragtag gang that Moskov, Frisco, and the twins eventually drew together. It was almost uniformly comprised of actors and actresses who could be placed in the categories of has-beens, never-beens, and never-would-bes.

Of the fifteen players that were hired to join Daisy and Violet, only one, Jack Mulhall, had a name that could have resonated with the film-going public, and then, only those with long memories. Mulhall was the cinema world's first star ever to earn $1,000 and then $2,000, $3,000, and $4,000 a week[7]. A dapper, wavy-haired, handsome man with an urbane manner, in his much younger years he been paired as leading man with such stars as Mary Pickford, Billie Dove, Dorothy Gish, Lillian Gish, Norma Talmadge, and Constance Talmadge. Mulhall was able to purchase much of the land that is known today as Sherman Oaks, California. There, he built a mansion that would later be bought by Spencer Tracy. But Mulhall's glory years had been during the era of silent films. Born in Wappinger

Falls, New York, and raised in New Jersey, he had a flat, nasal voice that no amount of vocal coaching seemed able to modify. The liability rendered him all but extinct as a film star when the talkies came in. Thereafter, all he could get were small parts and small wages. Mulhall was sixty when he was hired for *Chained for Life*. He was cast for the part of Judge MacAdoo, the jurist who presides over the Vivian Hamilton murder trial. Because it had been decades since he had worked in film, he was thrilled to land the job. The one-time star was working as a greeter at a Sunset Boulevard restaurant when the twins approved his hiring. Having experienced falls from grace themselves, Daisy and Violet may have given Mulhall a job as much out of sympathy as out of a need to only hire players who commanded modest salaries.

The role of Ted Hinkley, the conniving manager of the Hamilton Sisters Revue, was handed to longtime character actor Alan Jenkins. This may have been the film's best casting. Jenkins, too, had also begun his acting career during the era of silent films. Unlike Mulhall, he remained in demand after sound came in. On and off camera, Jenkins had a raffish air. He had the face of a ferret, a pronounced New York accent, and a mouth whose right corner was permanently drooped from the cigars that were always plugged there. Jenkins almost always played one or the other of two stock types: the itchy-fingered triggerman or the confidence man of constantly misfiring schemes.

The role of André Pariseau, the leading male part, was given to somebody named Mario Laval. Just where Laval was found remains unknown. At a certain angle, in a particular light, at sufficient distance, Laval may have borne some resemblance to Tyrone Power. But his acting bore no resemblance to that of a working professional. As one of the other actors remarked, "This Laval guy was so clumsy with his lines that the rest of us thought they'd have to flash English subtitles on the screen whenever he was speaking."

The talk among the other cast members was that Daisy had hand-picked Laval because she secretly hoped an off-screen romance might blossom between them. At least some credence might be given to the claim. Laval bore some resemblance to Don Galvan, the Mexican-born troubadour and Daisy's first love. Laval had a trim figure, a mouth full of teeth that glowed in the dark, and swarthy Latin good looks. Amazingly, like Galvan, Laval also strummed a guitar and sang romantic ballads.

Besides Mulhall, Jenkins, Laval, and the twins—all of whom were designated for the principal roles—an even dozen additional actors were hired. While a cast of seventeen was a small number even for a B film, Fraser and Moskov found ways to multiply the cast list, according to Whitey Roberts. "Except for the actors who were the principals, everybody handled several parts," Roberts said. "I was hired to play a doctor who examines the twins to see if they can be cut apart. I was also given the part of the minister that the girls visit to see about one of them getting married. Since much of the film's footage was about a struggling road show, I also assumed the roles of three or four stage entertainers. I appeared as a juggler, a rope twirler, a unicycle rider, and, I think, also a magician. They got more than their money's worth out of me, and from the other cast members, too. Most of us handled five or six roles."[8]

Roberts seemed well-suited to handle the multiple roles. In the 1920s, he had performed in vaudeville as both a comic and juggler.

At the sisters' insistence, and probably much against his will, Moskov went shopping for some tunesmiths to turn out original songs the two could introduce in the movie. He hired Henry Vars, a melodist, and George R. Brown, a lyricist. Neither Vars nor Brown seem to have had any prior film credits as professional songwriters.

After subjecting Tanchuck and DePina to four or five months of rewrite after rewrite, Frisco, Moskov, and the twins finally gave

their approval to a script in mid-July of 1951. The finished screenplay was next submitted to the Production Code Administration. The four didn't have to wait long for a response. In a letter to Moskov dated July 26, 1951, Joseph I. Breen had this reaction:

> We have read the shooting script received here July 23, 1951, of your con-templated motion picture production . . . , CHAINED FOR LIFE, and regret to inform you that the Production Code Administration could not approve a screenplay photographed from the material on hand.
>
> As we see it, this is a story of a pair of Siamese twins (females), one of whom gets married, causing the other to murder the other's husband for which murder she is tried and convicted by a jury, and which conviction the judge negates.
>
> The unacceptability of this material lies in the fact that it is considered to be a repellent subject for general . . . audiences, and could not be produced without offending good taste or injuring the sensibilities of an audience.
>
> We regret having to report unfavorably on this script, but, under the cir-cumstances, it is the only judgment we can give.

Moskov, and especially Frisco and Daisy and Violet, were plunged into deep depression upon learning the Production Code's ruling. They had already hired the entire cast. They were under contract with a studio to begin shooting in just two weeks. If Moskov, Frisco, and the twins had chosen to do so, they could have proceeded with the filming without the watchdog agency's seal of approval. The Production Code Administration recommendations were purely advi-sory and didn't have the force of law. But the agency did have the backing of the Motion Picture Theater Owners Association, an organ-ization with powerful influence over which films were shown in the country's major movie house chains. It was a foregone conclusion that if *Chained* could not win the imprimatur of the movie policing agency, it was going to be blackballed by all of the bigger and better movie houses across the country.

What Breen seems to have found most "repellent" about the story-line was that it allowed one twin to get away with murder because, at the conclusion of her trial, the judge could not resolve the execution of one sister without simultaneously sending her innocent sibling to the electric chair. Someone—maybe Moskov, maybe Fraser, maybe Tanchuck—came up with a possible solution to Breen's objection. A decision was made to rewrite the script in a way that would leave the moviegoer in suspense as to whether or not Vivian Hamilton, and by necessity her conjoined sister, were going to incinerate in the electric chair or go free. An appeal would be made to the audience to put themselves in the judge's position and try to decide in their own minds how justice could be served.

Two weeks after rejection, Breen's shooting on *Chained* began at the Eagle-Lion Studios at 7324 Santa Monica Boulevard in Los Angeles. The decision by Moskov to use the Eagle-Lion facilities may have been one of his smarter moves. The production company, just three years old, had six sound studios and was equipped with state-of-the-art equipment. More important, Eagle-Lion had developed a series of cost-cutting measures that enabled it to turn out professional-looking films at about half the usual cost. Eagle-Lion Studios had been the creation of Arthur B. Krim, a young lawyer with no film experience, but a genius for developing economies in movie-making. While other studios were foundering, Krim's company was being approached by so many movie and television producers, it had to turn away business.

Because Daisy and Violet were putting all their savings at risk, Harry Fraser had been warned the twins might try to second guess his directorial decisions. In fact, Fraser said the sisters allowed him to work with carte blanche. He explained it this way: "Once we got together for the film, I took the girls under my wing, and escorted them to a supper club for a night on the town. As a result, when we

started shooting, the scenes rolled along smoothly, like water off a duck's back."[9]

Whitey Roberts also remembered the filming went easily, if more than a little rushed. "Right from the start, Moskov and Fraser told everyone that we were to handle our roles right the first time so they could avoid wasting time and money on a lot of retakes," he said. "The shooting went so fast that as soon as we'd finish one scene, we'd all be herded into makeup to change our characters. In ten or fifteen minutes, we were back on the set, appearing before the cameras for the next scene."[10]

The script for *Chained for Life*, as it was finally snipped, clipped, and pasted together, told the story of the Hamilton sisters through a series of flashbacks. The film opens inside a courtroom, with Vivian Hamilton on trial in the shooting death of André Pariseau. Various witnesses are called to the stand. As each is examined and cross-examined, the movie flashes back to the events leading up to Pariseau's death.

For Harry Fraser, the most challenging scene was a dream sequence: Soon after she and André decide to marry, Dorothy is shown completely detached from her twin during the reverie. Wearing a gossamer nightgown, she is in an Elysian garden, seemingly unfettered by her sister. She and André gambol, dance, and kiss. "The sequence posed some special problems for the camera department when the action called for scenes in which the twins appeared to be separated," Fraser remembered. "We solved it with carefully angled close-up shots which gave the illusion of one of the twins being alone. . . ."[11]

Like all seasoned film crews, the cameramen, lighting technicians and production assistants at Eagle-Lion Studios were usually blasé about being around movie actors. But none had ever before been on a set with real Siamese twins, Fraser noted, and not even they could hide their fascination with Daisy and Violet Hilton. Said Fraser: "I

remember that the script girl asked Daisy and Violet in her brash, forthright way about their love life. 'I know you both have been married,' she said. 'How'd that work out?' Daisy and Violet looked at each other rather ruefully. 'It had its embarrassing moments.' And that was all that was said. The subject was not pursued any further."[12]

During the many months they were in Hollywood before and during filming, Daisy and Violet made several guest appearances on the Spade Cooley Show radio broadcast from Los Angeles. Because of a close friendship they had formed with him, they invited the singing cowboy to the set. Cooley was the only outsider permitted to watch the filming. The closed set extended even to Hedda Hopper, the powerful Hollywood columnist. A genius for smoking out stories, Hopper was able to piece together enough details to provide her readers with at least a hint of what the production was about. "I'm fascinated by *Chained for Life*, a picture Moskov is producing," she wrote.

> The title fits the story, for it stars the Hilton Sisters, famous Siamese twins. The set is chained, too. No visitors allowed. Story's about a Siamese twin who falls in love, and seeks a medical separation so she can marry her lover, played by Mario de Laval. . . . The other sister murders Laval. A court convicts her of premeditated murder, and the judge is confronted with the problem of a twin execution, one of whom is innocent.[13]

Because the backdrop for the screenplay is the world of vaudeville, a lot of its action takes place inside a theater with the cameras panning back and forth between the entertainers onstage and the audiences. Most important for the twins, the theater setting allowed them to show off their singing talents and, at least in Daisy's case, no small amount of décolletage. Ever the hopeful coquette, she appears in a satiny strapless gown apparently designed to allow her growing

zaftigness to follow a line of least resistance and pour out of its plunging neck line.

In the way they braided their voices in harmonies, and also in their bouncy choreography, the twins delivered their songs in a jaunty, upbeat manner that suggested the Andrews Sisters. The movie gave Daisy and Violet an opportunity to introduce three new songs that Henry Vars and George Brown penned just for them. As trite as the tunes were in their sentiments, they carried images of simple, homey domesticity that, for all their yearning, the twins still had never experienced. One of the ditties, titled "Never Say You'll Never Fall In Love," had this refrain:

> Never say you'll never fall in love
> Never say you don't like dreamin' of
> A cozy cottage. A garden too
> And tiny feet
> To run to welcome you.

Whitey Roberts remembered how high the twins' expectations were for their movie. "They were having the time of their lives all the time the shooting was going on," he said. "They were just so excited at the idea of making a picture in which they were going to be the stars. They were friendly to everybody on the set. Their hopes for how the movie was going to turn out were higher than the moon."[14]

As delicious as Daisy and Violet found the experience, they didn't have a lot of time to savor their experience as working actors. "We were in and out of the studios in two weeks," Roberts noted. "The actors, the lighting people, the cameramen, everybody worked hard to get everything right the first time. Moskov and Fraser may have seen things in the rushes that weren't quite right, but apparently they didn't think they were so bad that they couldn't live with them.

As near as I can remember, there were few if any second takes for any of the scenes."[15]

Daisy and Violet were left exhausted by the punishing shooting schedule. But just one day after the filming was finished, they boarded a train for Vancouver, British Columbia, where they were scheduled to appear as headliners at the Hastings Theater. It was critical they immediately resume their stage appearances to get some cash rolling in. Not only had they used up all their savings on filming *Chained for Life*, but now they were also faced with editing and other post-production work that had to be done before the movie was finished. There was also the matter of getting the Production Code Administration's blessing so the picture would be deemed suitable for the widest possible distribution. Ross Frisco told Daisy and Violet not to worry about these matters when he saw them off at the train station. He assured them that he and Moskov and Fraser could take care of all the movie's unfinished business. He also told them it was absolutely critical to raise additional cash quickly. Finally, Frisco told Daisy and Violet to enjoy the days ahead before the public release of *Chained for Life*. The movie was going to change their lives, he assured them. Once it appeared on the big screen, their phone was not going to stop ringing, he promised.

*Twenty*

# SCARED, SHAKING, HUNGRY LITTLE PUPPIES

As cursedly restricting as that odd ribbon of flesh and cartilage at their lower spines could be on their love lives and their individual freedom, it was another handicap that more consistently brought Daisy and Violet sorrow. They seemed utterly incapable of seeing through the come-ons of dream weavers who viewed the twins as their tickets to fortune and fame.

It had happened again. For all the assurances Ross Frisco made that *Chained for Life* was a fail-safe proposition that would prove to be the greatest move in their careers, the Hiltons once again had been left completely disassembled by someone else's scheme. Gone entirely was the nice nest egg they had managed to build during the past six or eight years through steady nightclub and theater work. To make matters worse, they still owed thousands of dollars to the Eagle-Lion Studios for production work on the movie, and the company was refusing to release the picture until all the bills were paid in full.

The film project had gone awry at every stage of its production. With its cast of has-been and no-name actors and its impossibly erratic script, the picture, as it was finally realized, had nothing to do with the just-can't-lose, career-rejuvenating, money-minting blockbuster that Frisco promised the twins it would be. Even he was dispirited when the shooting was finished.

How could such a perfect idea have turned out so badly? *Chained*

was an artistic disaster. Frisco hoped he could now salvage some-
thing from the celluloid mess so it could recover at least some of its
costs.

He placed a small, two-column advertisement in *Variety*. The ad did-
n't characterize the movie as the murder and courtroom melodrama it,
in fact, was. Rather, it billed the production as a "Full Length Feature
Musical," starring "The Hilton Sisters — World Famous Siamese
Twins." Clearly, Frisco was hoping he could delude some exhibitors
into believing the film was another light and frothy piece in the vein
of such recent musical releases as *Singin' In the Rain* and *Stars and Stripes
Forever*.

If the twins regarded the *Variety* ad as deceptive in its characteriza-
tion of the movie, they may have been even more troubled by something
else: The notice advertised the picture as a "road show release." Movies
designated as such were widely understood in the industry to mean
low-budget, slammed-together, exploitation pictures. Such films were
largely ignored by the critics. They were also spurned by the owners
of the better movie houses and typically were screened at drive-in the-
aters and impromptu venues created by tacking up a bed sheet screen
inside a vacant store front. By advertising *Chained for Life* as such, Frisco
was publicly acknowledging it was of a lower order than the films
screened in respectable theaters.

The ad made no references as to when the movie might be available
for bookings. Everyone who had been involved with the movie knew
that liens had been slapped against it by Eagle-Lion and other credi-
tors and that *Chained* would not be screened before all the unpaid bills
were cleaned up. Said Harry Fraser: "The film became tied up in lit-
igation shortly after its completion."[1]

As formulaic as his films were, Fraser never took the slightest
umbrage at being referred to as the "King of the B-Movies." Still, he
seemed to admit that this movie, as it finally turned out, didn't even

manage to rise to the level of mediocrity that characterized his other works. He summed up his involvement with what sounded like resignation. "It was not a production in which I took much pride, but it had an interesting premise and two unforgettable performers who overcame a tremendous handicap."[2]

In truth, the picture was so conspicuously bad it may have struck the *coup de grace* in Fraser's thirty-plus-year film career. He had been the producer on more than sixty movies, and the assistant director on at least sixty others, but after completing *Chained*, he never again got a Hollywood assignment of any significance.

The only even passably creditable performances in the movie were turned in by the long-time pros Alan Jenkins and Jack Mulhall, and by Alan Keys, a svelte and handsome young actor who portrays the defense attorney in the Vivian Hamilton murder trial. While Daisy and Violet comported themselves satisfactorily in the film's three musical numbers, neither showed even the slightest talent for dramatic acting. Each delivered her lines as though reading them for the first time. The performance by Mario Laval, the leading man, was even worse. He spoke English with the diction of a Slovenian in the third week of a Berlitz course.

Fraser, Moskov, and Frisco had all been involved in the film's editing. Because of their eagerness to win Production Code certification, they chopped out any language and every scene they thought Joseph Breen might find even slightly objectionable. They then delivered a copy of the newly cut movie directly to the film czar. Breen announced his ruling in February of 1952. Even though he had rejected the project a year earlier on the basis of reading the screenplay, he said he had had a change of heart after seeing the finished product. He finally deigned to give *Chained for Life* the Production Code's seal of approval.

At about the same time that Frisco, Fraser, and Moskov received Breen's tidings, they received the additional good news that *Chained*,

*Autographed publicity still of a scene from* Chained for Life, 1952.
*(Courtesy of the Motion Picture Academy of Arts and Sciences)*

as edited, had passed muster with the state film censorship boards in Massachusetts, Pennsylvania, Maryland, and New York. Only one state body—the Ohio censorship board—suggested further pruning and declared that unless its recommended cuts were made, it would ban screenings of the film throughout the state. The Ohio film censors, in their letter to Moskov, said they were especially troubled by a wedding night scene in which André Pariseau, wearing a robe and pajamas, enters the twins' bedroom and kisses his bride who is covered only by a negligee. The Ohioans wanted the kissing scene cut. They apparently believed it constituted a form of foreplay that all moviegoers could imagine would lead to a *menage à trois*. Frisco, Moskov, and Fraser chose to ignore the Ohio board's objection. They

apparently believed that banning the film in a single state wouldn't seriously affect anything.

If the principals were at all cheered upon hearing that *Chained for Life* had at last won Code approval, as well as the imprimaturs of four out of five state censorship boards, they also knew the time for popping champagne corks could still be a long way off. The picture was still heavily encumbered by liens. By court order, the film couldn't be released until all the claims were lifted

Because Ross Frisco was more eager than ever to clean up the last of the film's debts and get it out of hock, he started arranging bookings for the twins without regard to where they were playing or how much pay they were promised. The relationship between the agent and the sisters grew increasingly strained as the months passed. Daisy and Violet believed Frisco regarded them as his personal drudges. They were also resentful that he continued to pocket 10 percent of the proceeds from their stage appearances when he expected them to apply all their earnings to the film's remaining bills.

Daisy and Violet had had enough. They began refusing some of the engagements Frisco lined up. They also started arranging bookings on their own, cutting off his commissions. Frisco claimed betrayal. But finally, late in 1952, Daisy and Violet quit him altogether, casting their lot with a new booking agent, Edward Salzberg of Essar Productions, Cincinnati, Ohio.

By then, the twins had paid off the last of the outstanding debts on *Chained*. At long last, more than a year after the shooting was finished, the movie was free to be released to commercial audiences. Daisy and Violet alone now had full possession and control of the picture, and they promptly told Frisco they were cutting him out of any future interests in the property. Frisco, of course, was furious. He reminded Daisy and Violet that the idea for the picture had originated entirely with him. He also reminded them he had given up his Boston talent

agency of thirty years just so he could shepherd development of the film. Vowing he wasn't going to disappear, he filed for breach of contract in the superior court of Boston, the city where the Hiltons still maintained an apartment. In his lawsuit, Frisco contended he held a binding contract with the twins that extended to September 14, 1953. He further claimed the contract not only guaranteed him a percentage of the earnings from all the Hilton sisters' professional appearances, but also a portion of the proceeds from any filmed and published property by or about the two. He asked the court to direct the Hiltons to fulfill each and every term of their contract with him. He also petitioned the court to order an accounting of the sisters' earnings during the time they were under contract with him and that they be directed to immediately make full restitution of any fees and commissions that were owed him. The court did issue a temporary restraining order which, for a time, prevented the twins from circumventing Frisco regarding professional personal appearances or commercial showings of their film. After about six weeks had passed however, the court lifted the order and directed both sides to prepare for a trial. Frisco must have concluded that if he pressed on with the case, he likely wouldn't gain anything but a big legal bill. He gave up any additional legal maneuvers and left the lawsuit to languish. Finally, the superior court of Boston threw the case out.

Now free to make all the decisions concerning their film, Daisy and Violet started shopping for a distributor to handle its marketing and placement. They didn't have an easy time of it. Movie patronage had been declining sharply in recent years as television sets entered more and more households. There didn't seem to be a major film distributor anywhere interested in handling a low-budget, small-studio, black-and-white production whose leads were largely unknown. Even the lavishly produced wide-screen Technicolor releases by the major studios were having trouble attracting big audiences.

After descending lower and lower on the ladder of their expectations, Daisy and Violet finally did find a distributor for their film, Classic Pictures, Inc., a small New York operation that mostly placed its offerings with movie houses in declining neighborhoods and drive-ins. Max J. Rosenberg headed Classic Pictures, and while he could be brilliant at dreaming up promotional schemes for even the trashiest pictures, he had a quirk that was an irritant to many of his clients: He had what seemed to be an insatiable appetite for cinematic midden. As a result, he could almost never be reached at his office.

"What I remember about Max," said a friend, "was that from about 10 o'clock in the morning until about 10 or 11 o'clock at night almost every day, he was in one or another of the Time Square movie houses, watching B-grade horror and sci-fi flicks. He had the complexion of Bela Lagosi because he was never in the sun longer than the time it took him to walk from one movie house to another. And I don't think Max ever sat down to a home-cooked meal. He had his own interpretation of the doctors' recommendation that people eat three square meals a day. Max observed the recommendation by only eating foods that came in boxes—buttered popcorn, Black Crows, Milk Duds."

Even though Rosenberg was running a film distributorship, his real ambition was to be a producer. He viewed Times Square as his university, spending endless hours carrying on his studies. Ultimately, Rosenberg did achieve his ambition to become a producer. He gained distinction as grand mogul of the fright flick, presenting horror movie fans with such chiller classics as *The Curse of Frankenstein* (1957), *They Came from Beyond Space* (1967), *The House That Dripped Blood* (1970), and dozens more.

The twins had hoped *Chained for Life* would premiere at Grauman's Chinese Theater in Hollywood. After the opening, they would step out into the theater's forecourt and, with flashbulbs exploding everywhere, press their hands and feet into wet concrete, imprinting them

alongside those of Marilyn Monroe and Jane Russell. Rosenberg swiftly disabused them of their fantasy. He was still uncertain where the film might have its first public screening, but he suggested the event was more likely to take place at a venue where the audience was about evenly divided between people and cows. While he didn't rule out showings in real theaters, he believed the "ozoners," the outdoor open-air theaters were more realistic. Rosenberg told the twins to get their Buick tuned up and make sure it had a new set of tires. He said his company could handle the marketing and distribution of the picture, but he expected them to go out on the road to help promote it.

Clearly, Rosenberg seemed to be the right man for ballyhooing and distributing *Chained*. His first move was to develop suitable advertising for the picture, which made only the most glancing contact with the storyline of the film. One of his posters, for example, showed Daisy smooching a lover while an insouciant looking Violet seemed to be twiddling her thumbs. In about 100-point type, Rosenberg referred to the twins as "The Seventh Wonder of the World," and without the slightest regard for teratological accuracy, further overdrew them as "The Only Female Siamese Twins Ever Born." Another creation, a broadside, titillated its viewers with a lot of lurid questions, none of which is answered in the film: "What Happens In Their Intimate Moments?" . . . "Can a Siamese Twin Have a Shy Husband?" . . . "Joined Together, How Can They Make Love to Separate Husbands?" Still another poster referred to the Hiltons as "Playthings of Desire" and aggrandized the screenplay as "The Strangest Love Story Every Told."

Within about a week, Rosenberg delivered his mockups to a printer where, with some refinements by the house artists, they were transformed into billboard-sized come-ons.

The earliest showings of *Chained for Life* began in the spring of 1953, although the exact location of the premiere showing is

unknown. Wherever it took place—a drive-in somewhere in the Utah scrublands; a theater in a crumbling Cleveland neighborhood; a county fair livestock barn in North Dakota—the event apparently occurred without fireworks, a visit by Louella Parsons, or searchlights raking the sky.

Daisy and Violet didn't make personal appearances at every venue, but there were times when they motored great distances to a drive-in theater or small-town movie house only to discover that fewer than 100 people had turned out. During the early 1950s, adult admission to a movie was typically 50 cents or less. The owners of road show pictures commonly agreed to make their films available to the exhibitors for 15 or 20 percent of the box office receipts. Because the twins had to share this with the theater owners, their take for an appearance could be less than $100. Their proceeds would be further decimated by travel expenses and the percentage they had to turn over to Rosenberg's film distribution company.

To augment their earnings, Daisy and Violet tried selling autographed, black-and-white photos, as well as a cheaply-produced booklet titled *The Intimate Lives and Loves of the Hilton Sisters, World Famous Siamese Twins*. The booklet was simply a compilation of the six-part series that the *American Weekly* syndicate had made available to newspapers ten years earlier. To help justify the $2 cover price for the forty-eight page potboiler, they threw in a second publication, a recreation in novella form of *Chained for Life*. Usually the twins piled their booklets on a card table set up inside a theater lobby or beside a drive-in concession stand. They always displayed a hand-lettered placard on their table that declaimed, "More Than 100,000 Already Sold." They seldom did brisk business as booksellers, however. Sitting through *Chained for Life* was so torturous an experience for most viewers that, when the movie was over, they exited the theaters as quickly as they could.

Jim Moore took in the film when it appeared at San Antonio's Rigsby's Drive-In. By then, Violet's one-time husband had retired from show business and was a restaurateur of some success. He operated the El Matador, a popular Mexican restaurant in downtown San Antonio. During the intermission, Moore made a trip to the food concessions, eager to renew his acquaintance with Daisy and Violet. Upon seeing the twins from afar, Moore said he was so startled by how the sisters had changed in appearance over the dozen years or so, he turned around and left before they recognized him. "I never felt more sorry for anyone in my life," he said. "They were wearing cheap evening dresses and had dyed their hair."[3]

By the early 1950s, more than 4,000 drive-in theaters were already in operation and more were appearing every day in cornfields, swamplands, and abandoned air strips. One reason the ozoners became so popular, especially with families, was they often presented live entertainment, like western stars, Punch and Judy shows, trained dog acts, and even such circus features as the Great Wilno, a human cannonball, and the Nervous Nocks, daredevils who did headstands atop 100-foot sway poles. The live acts appeared during the twilight hours, before darkness fell and the screen became aglow with what was usually a Bugs Bunny or Elmer Fudd cartoon.

The twins, too, often put on mini-shows at the outdoor theaters. They sang duets, usually accompanied by a scratchy phonograph record. They danced and played their saxophones. But there were nights when mosquitoes and June bugs were their only spectators.

Philip Morris, a professional magician and host of a late-night horror movies show televised in Charlotte, North Carolina, had this recollection: "Daisy and Violet were the attraction at an outdoor theater in Concord, North Carolina, a town about thirty miles outside Charlotte. They barely stood five feet tall and because they were so tiny, the only way they could be seen by a crowd was to be on some

kind of elevated stage. Like most drive-ins of the day, this theater
didn't have a real stage. It presented its live attractions on the rooftop
of its concession stand. A couple of step ladders were brought out for
Daisy and Violet, and they were asked to climb to the top of the
building. The spectacle that followed might have been funny in a
Laurel and Hardy routine, but because it involved the twins, it was
heartbreaking to witness. As hard as they tried to coordinate their
ascents up the two ladders, and as hard as the drive-in people were
trying to help them, there was just no getting them up on the rooftop.
It was just physically impossible. Of course a lot of the drive-in
patrons gathered around to watch this operation. There was snicker-
ing and crude remarks from some of the people. The twins must have
suffered great humiliation. Finally they gave up the effort to get atop
the roof. They put on their little show in an area that was roped off
inside the concessions building."[4]

Wherever *Chained* was screened, it was most often presented as
part of a double and triple feature with *Reefer Madness, Test Tube Babies,*
or the twenty-year-old *Freaks.* Now and then, usually at very small
theaters in the remotest of regions, Max Rosenberg arranged screen-
ings where the sisters were not required to show up. But without the
added attraction of personal appearances by Daisy and Violet, these
showings rarely produced much of a return. It was one thing for a
farmer to load his wife and kids into the car on a weekend night and
drive to a weedy field for the rare opportunity to see actual Siamese
twins. It was another matter to pull a working man away from his tel-
evision set on a Friday or Saturday night and then expect him to
shell out $2 or $3 for a black-and-white movie without a single legit-
imate star.

Throughout most of the 1940s, Daisy and Violet had been getting
consistent bookings, many of them well-paying nightclub engagements,
and, as a result, had been enjoying a comfortable, if not conspicuously

extravagant, lifestyle. But by the early 1950s, they were living the life of gypsies, spending most nights in cheap motels and sometimes even in the Buick. Besides the drive-in appearances, there were even rarer invitations to appear at small-town theaters and fairs. So the twins, once again, were sending telegrams to businessman Emmett Sweeney, their dear friend in San Antonio, and presumably to others, pleading for funds to tide them over until their situation improved.

As hard a time as Daisy and Violet were having trying to survive on their drive-in appearances, things grew even worse for them early in the summer of 1953, when Max J. Rosenberg went to the federal courthouse in New York and filed voluntary petitions for bankruptcy. He reported that the film distributing company he created, Classics Pictures, Inc., had debts totaling $336,795 and assets amounting to a mere $2,000. He also claimed he had personal liabilities totaling $248,699 and no cash or property of value whatsoever.[5]

Before entering into the agreement with Classic Pictures to circulate their movie, the Hiltons had already shopped the property to dozens of other film distributors and were turned away by all of them. The twins knew there was little likelihood they would find another distributor to take over, especially since the film had done so poorly during its first months in release. They decided to have Edward Salzberg, their agent in Cincinnati, arrange all future screenings of the film.

Over the next two years, the twins rarely saw any manmade structures taller than silos. Even though their advertisements still referred to the sisters as "World Famous," Daisy and Violet seem to have been almost completely forgotten. Sometimes months would pass between appearances, and even when Salzberg did find them work, the twins usually appeared as last-minute replacements for acts that had canceled.

Late in 1955, Daisy and Violet received some cheering news. Ed

Salzberg had arranged for them to return to Florida, where he had lined up a series of club bookings in Palm Beach, Miami Beach, Key West, and other resort towns.

But the twins' comeback was anything but triumphant. The club owners who had booked Daisy and Violet ten years earlier were startled by how much the sisters had aged. They were forty-seven years old and long past their dewy comeliness and girlish brio. Sadly, the twins didn't even look like a matched set anymore. Violet was now dyeing her hair red and looked bony and thin. Daisy, on the other hand, was a bleached blonde, and she had packed on at least twenty more pounds than her sister, most of them, it appeared, at her midriff. About the only physical attributes Daisy and Violet seemed to have in common anymore were the wrinkles crazing their faces.

At the famed Five O'Clock Club in Miami Beach, the twins were featured with what was advertised as an "All-Star Girlie Revue." The club goers may not have altogether lost their fascination in human curiosities, but their interest now seemed to have shifted to wonders of a different type. The physical marvels that were now pulling in the big crowds at the cabarets were attractions like Evelyn West and Her Million Dollar Chest.

When the twins performed, they often did so amidst the sounds of patrons sliding back their chairs to leave. No Florida club owners told the sisters they hoped the two might return again the next year. The last of their Florida bookings was at a Key West cabaret. The house manager was jubilant when, after the sisters' contracted weeklong run, he was able to remove their names from the marquee. If the Hiltons' stay had been any longer, he half feared his cash registers were going to rust shut from lack of use.

Word of the twins' steadily declining drawing power had spread. Ultimately, even their agent Salzberg abandoned them.

Late in the spring of 1956, after their last disastrous appearance in

Key West, Daisy and Violet resigned themselves to a grim reality: The time had arrived when, once and for all, they should pack away their costumes. Alone and terrified, dislocated from the only business they had ever known, they must at least have taken some solace at being in Florida. It was the place they had always planned to live when they retired as entertainers.

Traveling north to Miami, they settled into a tiny apartment at 215 NE 5th Street. Now they faced the question of what they were going to do to survive. They were aware that as conjoined, middle-aged twins with no skills that were easily transferable off the stage, they weren't likely to find many employment opportunities.

☙    ☙    ☙    ☙

The Hilton Sisters Snack Bar was swarming four and five deep with customers on the day of its grand opening in May of 1956.[6] Wearing sexy, bare-shouldered sarongs, Daisy and Violet were dressed in a manner that suggested they were the hostesses, not for the opening of a new hot-dog stand, but for the Fountainbleu cocktail lounge.

A Miami reporter asked the sisters if, as women who had experienced the thrill of entertaining the beautiful people, they might now find their lives as food stand operators somewhat humdrum. "Because we have so enjoyed our lives as entertainers, it may be a little hard at first to live outside the limelight," Daisy answered. "But Violet and I have been on the move all of our lives. We feel it's time to put our roots down in one place. We're anxious to try another way of life that's a little quieter."

"This is just a start for us in the restaurant business," Violet chimed in. "Next we want to get our own club on the beach. We'll have the best dining in Miami, and also the finest in entertainment—Jackie Gleason, Milton Berle, Sophie Tucker, Edgar Bergen, Eddie Cantor. All of them are our dearest of friends from our performing years.

They'll all appear in our club. And if Daisy and I get bored with our lives as club owners, maybe there will be nights when we get back up on the stage."[7]

Their Hilton Sisters' Snack Bar was tableless and chairless. It was also roofless. It was situated in a downtown open-air arcade a short amble from their apartment. The most exotic items listed on its menu were cheeseburgers and chili dogs. Daisy and Violet operated the stand from mid-morning to early evening seven days a week. It was neither easy nor pleasant to be working over a grill in the blazing Miami heat. Still, they seemed to enjoy the secure routine the little business brought to their lives. Because of the generous publicity that attended the opening of their stand, at first, business was brisk. After the store clerks, shoppers, and tourists got used to the novelty of being served hot dogs by Siamese twins, business soon started to slacken. The twins were forced to close their Hilton Sisters' Snack Bar before a year had passed.

Some said the twins' business was doomed from its start because of a prejudice some downtown merchants had against people with conspicuous physical anomalies. A bookkeeper and tax preparer who maintained an office nearby remembered the sisters' attempt at entrepreneurship this way: "I hate to say it, but from the first day those ladies opened, there were store owners and restaurant operators who said those ladies were bad for the image of downtown Miami and that everything must be done to shut them down. Some business owners forbade their employees from patronizing the twins' stand and they also talked down the Hilton sisters with their customers. One of my clients, a shoe-store operator, told me that if those Siamese twins were able to make a go of their little business, then soon every street corner would be taken over by double amputees in wheelchairs and blind people with cups selling pencils. He said the shoppers and tourists would be so repelled by the sight of these people that they

would start taking their business elsewhere. It was a shame for those ladies. They were as pleasant and friendly as could be."

After the food stand failed, Daisy and Violet tried selling beauty products door-to-door. Out of pity for the sisters, if for no other reason, some women looked through the Hiltons' sample case and bought lipsticks and nail polish and facial creams. But more often, Miami housewives kept their doors shut to the sisters, irritated that these two strange creatures would invade their neighborhoods and frighten their children.

Because it was the only way they could continue surviving, in 1958 Daisy and Violet again entered into a contract to appear as "The World's Only Strip-Teasing Siamese Twins." Most of the clubs were ratty beerhouses where patrons jeered at them. There had never been another time in their lives—not even when they were being exhibited in carnival pit shows as freaks—when they felt so thoroughly degraded. They were fifty and struggling simply to survive.

The Cat and Fiddle, a seedy nightspot in downtown Cincinnati, Ohio, seemed to go out of its way to import strippers who diverged wildly from the profession's norm. Among its bump-and-grinders, besides the conjoined and aging Hilton sisters, were midgets, obese women, and Ricki Covette, a towering six-foot-nine-inch amazon from Canada.

A newspaperman familiar with the twins' past as one-time vaudeville sweethearts sat down with them during one of their engagements at the Cat and Fiddle. He asked them if, as middle-aged women, they didn't feel they were debasing themselves by playing in lowly dives where they had to peel off their clothes. Daisy replied that of course, she and Violet would prefer to appear in legitimate theaters and entertain their audiences with music, song, and dance, but because their talents no longer seemed salable, they had turned themselves into exotic dancers "to adapt to the times."[8]

Violet added: "We made the big switch to this sort of dancing for two reasons—money and fun. Mostly fun."

The reporter pressed them further as to whether they felt there was something morbidly sick about club owners who ignored their gifts as versatile entertainers to present them as mere freak strippers. Daisy and Violet apparently believed that if they spoke harshly of their employers, they could lose one of their last sources of income. "We can't say anything bad about it," Violet replied. "Who wants to bite the hand that feeds you?"[9]

The twins developed hardened exteriors and seemed to enjoy talking in Mickey Spillane-speak. "We shun things we don't like and heavily indulge in things we love," Daisy once said in characterizing the sisters' constitution. "In other words, we stay away from fat women, rock-and-roll, and filter cigarettes, and surround ourselves with mature men and Dixieland music."[10]

Unable to afford the luxuries they had once known, Daisy and Violet concentrated their energies on just keeping food on the table and paying the rent on their tiny Miami apartment. They spent much of their time on the phone, prospecting for engagements. They also continued peddling cosmetics, going house-to-house in Miami with their cases of rouge, lipsticks, and toilet water. And when they had to, which was often, they called old friends, asking for loans to tide them over until the next engagement came along.

In September of 1959, Daisy and Violet were hired for what should have been one of their choicest assignments in years—grandstand headliners at the Michigan State Fair in Detroit. But even this ten-day engagement went badly for them. Daisy had been bothered by a hernia that developed soon after she gave birth to her baby in 1936. Because of the twins' fear of doctors, the condition was never corrected. After finishing only one performance at the fair, Daisy began experiencing a pain so great she collapsed. The sisters were rushed to

Mount Carmel Mercy Hospital. In the operating room, with Violet chatting amiably with the nurses while her sister was anesthetized, three surgeons worked for two hours on Daisy. By the time Daisy had sufficiently recuperated from the operation and the twins were able to leave the hospital, the fair had ended for another year.

In late 1961, desperate for employment as ever, the twins placed a phone call to Kemp-Morris and Associates, a talent booking agency in Charlotte, North Carolina.

"They said they were looking for work, any kind of work," recalled Philip Morris, who, with Theodore D. Kemp, ran the agency. "I had heard of the Hilton Sisters, but didn't know them personally. T D., on the other hand, knew the girls quite well. In his long career, he had found bookings for the girls before, probably in the 1930s or early 1940s. We decided to do what we could for the girls."[11]

One of the major booking agencies in the mid-South, Kemp-Morris sometimes arranged arena shows for major stars, such as Elvis Presley, Amos 'n Andy, and Vaughn Monroe. Its specialty, however, was packaging shows whose lineups featured mostly aging film and television actors or recording artists who were well beyond their prime years as entertainers.

Morris talked of the frustration he and Kemp experienced when they tried to sell the Hilton sisters as a stage act. "Over and over, we kept ringing up the heads of the motion picture theater chains in the South, and we just couldn't get anyone interested in taking the twins," he noted. "The theater people would respond, 'Oh, yeah, the Hilton Sisters. I remember them. Weren't they a big draw about thirty years ago? Nope, sorry, they just wouldn't go over today. It's a different era, you know. Not even the younger people get excited by the chance to see Siamese twins, bearded ladies or alligator-skinned boys. They're only interested in rock 'n roll.'"[12]

After spending a couple of days trying to find work for Daisy and

Violet and being turned down by everyone they contacted, Morris and Kemp concluded that they were engaging in a futile exercise. "Because it's so hard to tell once well-known entertainers that there's no longer interest in them, I delayed a little bit in getting back to the sisters," Morris said. "I should have attached more urgency to the call. The next thing I knew, only a few days after the Hilton twins phoned our agency for the first time, they were getting out of cab right outside our door."

One of the sisters was cradling a pet Pekinese, apparently Boy III or Boy IV. Back at the Charlotte train station, still in the baggage room, were a couple of trunks and several large cardboard boxes. The containers held all the twins' worldly possessions, their costumes, their instruments, the four reels that made up *Chained for Life*, and a few thousand copies of their booklet, *The Intimate Lives and Loves of the Hilton Sisters, World Famous Siamese Twins*.

After ushering the twins into their office, Morris and Kemp reported to the sisters that although they had made dozens of calls, they had struck out everywhere. "We learned then just how desperate things were for the girls," Morris recalled. "They were absolutely at the end of their rope. They had spent the last of their money on their train fare from Florida to Charlotte. T. D. and I would have happily dug into our pockets to pay for the girls' return trip home. The problem was they no longer had a home—not in Florida nor anywhere else. They were like a couple of scared, shaking and hungry little puppies who just happened to show up at our doorstep one day."[13]

Morris led Daisy and Violet out to his station wagon and delivered them to the Clayton Hotel where he told the desk clerk to bill the agency for the twins' accommodations. He told the sisters he would do some more phoning. Daisy and Violet returned to the booking agency a day or two later.

"The girls seemed to be in one of those weird time warps that the

characters in Rod Serling's *Twilight Zone* sometimes entered," Morris recalled:

"The subject got around to transportation. By the time the twins came to Charlotte, at least, they had no car and were no longer driving. We explained that if there was any chance at all of their getting stage work, the theaters would likely be in small, small towns. How did they think they were going to get around? 'Oh, that would be no problem,' they answered. 'We could just take the train.' They were absolutely out of touch with the times. They lacked any comprehension that passenger train service to the small towns, even by the early sixties, was all but nonexistent."[14]

Morris and Kemp went back to the phones. After going through their A- and B-lists of presenters, they started working the names on their C- and D-lists. They finally found a taker.

Charley Reid was the operator of the Park-N-Shop supermarkets in Charlotte. He was also a major employer of magicians, clowns, ventriloquists, and singing cowboys. Early in his career as a grocer, Reid reasoned that if he offered free and wholesome entertainment at the spacious and modern supermarket he had just erected on Wilkinson Boulevard, his store would draw lots of families, and at least some of those families would keep coming back. The plan worked. On weekends, the cars were backed up on Wilkinson as parents brought their kids to see aging cowboy stars like Lash LaRue and take free rides on the carousel and bumper cars in the supermarket's parking lot. Reid prospered and eventually opened a small chain of supermarkets.

Daisy and Violet had been hired for a weekend by Park-N-Shop to do an in-store promotion on a new grocery product, twin-packed potato chips. Rosemary Land, now a librarian at Mecklenburg/Charlotte Public Library, was in ninth grade when, accompanied by her mother, she went to the supermarket to see the Hilton sisters. "They left a vivid impression on me," she said. "I was both attracted by them and at the

same time a little frightened. How could this be, two people in one? The twins were sitting at a table. People lined up to talk with them and, in some instances, have them sign their boxes of twin-packed potato chips."[15]

In addition to the promotional appearance at the Park-N-Shop, Daisy and Violet also found a few engagements at drive-in theaters, one of them at the Fox on Old Statesville Road. The Fox regularly featured such fare as *The Bikini Busters, Our Scarlet Daughters*, and *Some Like It Cool*, filmed "in naturalistic blushing color." On Friday and Saturday evenings, the Fox offered "All Night, All Girlie Shows," during which it screened films shot inside nudist colonies. These programs, which continued until dawn, were patronized disproportionately by single men arriving alone in their cars.

Morris arranged bookings for Daisy and Violet at three or four other drive-in theaters in small towns outlying Charlotte. "These appearances were all absolute disasters," he remembered. "Wherever the twins' movie was shown, the sisters put on mini-versions of the same song and dance performances they had once given in grand theaters. They just didn't have any drawing power anymore, though. I remember phoning the operator of one of the drive-ins where the twins appeared and asking how the night had gone. 'Oh,' he answered, 'I guess we took in $20 at the box office and the girls sold maybe $6 worth of their books.' Here were two sisters who had once captivated the show world and made millions. As entertainers, they were now all but abandoned."[16]

Morris said he and his partner met with the twins one last time and tried to be diplomatic in pointing out that the public sometimes was fickle, and that for reasons that were not always explainable, even great acts like theirs could lose their appeal. "We tried to suggest that they start exploring ways to survive outside the entertainment world," Morris said. "The sisters just didn't want to leave show

business, though. They were stuck someplace in the past. I remember one of them asking, 'Did you contact the James Theatre in Newport News, Virginia? The people were lined up around the block when we last played there. I think it was 1928 . . . no, maybe it was 1929.' Then we had to break the news that there was no James Theatre anymore, that it hadn't existed for decades."[17]

Morris said the meeting ended with Daisy and Violet thanking him and Kemp for all they had tried to do. "The thought of their making a final exit from the show world was just too much for them to bear, though," Morris said. "They still imagined themselves to be stars. I think they thought that somewhere out there, they still had a big adoring public, but that somehow this audience just happened to have gotten misplaced. We said our goodbyes and I never saw them again."[18]

Daisy and Violet returned to the Clayton Hotel where Kemp and Morris had offered to cover their bill for as long as they needed a place to stay. The sisters had tried to remain gracious when Morris and Kemp suggested that, in an age of rock-and-roll and Sandra Dee movies, acts like the Hilton's had become passé. But their hearts had been lacerated, and certainly not for the first time. They had heard the same thing from other agents, especially in recent years. But Daisy and Violet took the position that all these ten-percenters were wrong, just plain wrong. There was no reason why an act that had drawn standing-room-only houses back in the 1920s and 1930s couldn't still attract turn-away crowds in 1961.

Daisy and Violet knew that Morris and Kemp were only trying to be helpful but the advice was hurtful, nevertheless. The sisters were fifty-four-years-old. What were they supposed to do if not continue as performers?

Daisy and Violet concluded that if they could no longer find an agent on whom they could count, they would do what they had sometimes done before: They would line up their own engagements.

They opened the Charlotte Yellow Pages and began dialing. They phoned supper clubs, theaters, and drive-ins. The owners listened to their story and expressed sympathy for their situation but rejected the twins' pleas for work.

What were they to do? Beg? Daisy and Violet were homeless. But for Morris and Kemp, they would have been on the street. Daisy and Violet grew ever more desperate. What would they do if the last of their funds ran out before they found work?

Finally, they did find work in the small town of Monroe, twenty-five miles south of Charlotte. Clifford and Wade Faw, operators of the New Monroe Drive-In, agreed to present a weekend screening of *Chained for Life*.

Unknown to the twins, the Faws' drive-in regularly screened X-rated films and, after local church groups mounted a protest against it, was shut down for a time. Not long after the theater resumed operations, a local judge ordered the Faw brothers to present him with copies of two films they had been showing, *Garage Girls* and *Hot Pursuit*. The Faws complied with the order but only after they had snipped large chunks of footage from the features. They were found to be in contempt of court and each was jailed for ten days.[19]

"It seemed like the theater's operators were always getting in hot water with people in the community, especially the local politicians and church leaders," said Curtis McCauley, who was a teenager during the years the New Monroe was operating. "It was located right off a busy boulevard, and its screen faced the road so that anybody driving by could see what was playing. On nights when it was showing risqué movies, a large percentage of Monroe's twelve- and thirteen-year-old boys could be found lying in the grass just outside the theater grounds, getting what was probably their earliest education in sex. Because of all the protests from local parents, the Faws finally did something about it. They installed some big lights at the edge of the

theater grounds. Because of the glare from the big, bright lights, you could no longer see from the highway what was playing on the screen.[20]

Before leaving Charlotte to travel to Monroe early in December 1961, Daisy and Violet hired someone in Charlotte to serve as their new road manager. No one who remembered the twins' arrival in Monroe knew the identity of or anything about their manager, other than that he drove a newer, bigger black car, maybe an Oldsmobile, Buick, or Cadillac. The trio's first stop was the Mary-Lynn Motel where Daisy and Violet booked a room for a few nights. Next they traveled to the New Monroe Drive-In to meet with the Faw brothers and look over the area where they would peddle their autographed photographs and their booklet. They were heartened when they saw a large sign outside New Monroe:

SEE THEM ON SCREEN
AND SEE THEM LIVE!!!
THIS FRI, SAT, SUN ONLY!!!!
DAISY AND VIOLET HILTON!!!!!
WORLD FAMOUS SIAMESE TWINS!!!!!!

Because of the New Monroe Drive-In's unsavory reputation with many in Monroe, it drew its greatest patronage from the rural areas and from Charlotte.

It was winter, 1961, and just a few weeks before Christmas, traditionally a slow time for drive-in theaters. The nightly turnouts for Daisy and Violet and their motion picture were by no means large, but business was good enough to keep the Faw brothers content. Daisy and Violet, too, were happy to be working again. They enjoyed mingling with patrons. At closing time each night, the twins' manager and the Faw brothers divvied up the gate receipts and earnings from the booklet and photo sales. The manager then returned Daisy and

Violet to the Mary-Lynn Motel, only to come back late the follow-ing day to again deliver the twins to the theater.

Following the twins' final appearance at the New Monroe, their manager presented them with what they received as great news. He said he had lined up three or four additional drive-in appearances for them. He told them to pack their bags and he would be back early the next day to ferry them to their next engagement. The twins never saw him again. He drove off in his big, black sedan that night, making off with all of the sisters' earnings from the weekend.

Daisy and Violet were absolutely stranded. Not only did they lack the means to get out of Monroe, they didn't even have the money to settle their motel bill or pay for their next meal. Like much else in Monroe, the Mary-Lynn Motel was owned by Clegg Keziah. The twins tearfully related their plight to him. They said that while they had no immediate prospects for work, they were sure that opportu-nities would present themselves soon after the Christmas season. They promised they would pay him with their first paychecks.

"Dad told the twins not to worry," said Lynn Keziah, a son of Clegg. "He told them they could remain at the motel as long as they needed to, and to forget about how they might settle the bill."[21]

Clegg Keziah told the twins something else. He owned the Orange Bowl, a restaurant on Roosevelt Boulevard just a short walk from the motel. He informed the sisters he was extending free dining privileges to them. Thus it became a thrice-daily ritual for Daisy and Violet to leave the Mary-Lynn, walk to the Orange Bowl, then return to their room with table scraps for their Pekingese.

Each day Daisy and Violet posted letters to the managers of clubs and theaters where they once worked: Did they have, or did they know anyone who had, any open spots the twins could fill? Christmas 1961 passed. The new year arrived. Their letters went unanswered.

Among the Monroe residents who saw the twins almost daily was

Marlene McCauley. At the time, she was the sixteen-year-old proprietor of Marlene's Beauty Parlor. The twins passed her window everyday on their way to and from the Orange Bowl Restaurant.

"I felt so sorry for them," McCauley said. "Imagine how hard it must have been for them to be cooped up in a little motel room day after day, stuck in a strange little town where they didn't know a soul. They looked so sad and lonely and bedraggled. To this day, it bothers me that I didn't do more to extend myself to those ladies. I could have at least invited them into my shop for some hair styling. I don't know why I didn't. My only excuse is that I was so young then, and probably a little bit afraid of them."[22]

The twins created quite a stir with the customers inside, McCauley said. "Somebody would say, 'Here comes the Siamese.' Then all the ladies would get out from under the hair dryers and run to the window. The twins hated being gawked at. Sometimes they would shake their fists. The twins wore the same outfit every day — two very plain dresses that were cut and sewn in a way that covered the way their bodies were attached together. As time went on, their outfit started looking more like a rag. Probably it was the only outfit they had that wasn't a show costume."[23]

In addition to operating the motel and restaurant in Monroe, Clegg Keziah developed several shopping malls. He also owned a road grading company and several rental properties. Keziah was not popular with everyone. Some were resentful that while still in his early forties, he owned so much of the town. It apparently didn't occur to his detractors that Keziah amassed his wealth by working about five times harder than the average person. He also may have been the only person in Monroe who took anything deeper than a voyeuristic interest in Daisy and Violet. Along with his wife Helen, he regularly looked in on the twins. The Keziahs tried to keep the sisters' hopes up. But their efforts to elevate the twins' spirits grew tougher with

each visit. As the weeks and then months passed, Daisy and Violet sank ever deeper into despair. It struck Clegg and Helen that the twins seemed to be aging perceptibly. Each had lost weight and Violet, especially, looked almost skeletal. Daisy had quit peroxiding her hair and Violet no longer colored her hair with henna. The sisters told Keziah they worried they would die in the little motel room. It bothered them to imagine how the gawkers at Marlene's Beauty Parlor would watch as the coroner's attendants struggled to roll a gurney out through the narrow motel door with the twins' bodies, side-by-side, spilling over the edges.

It was May, 1962. Daisy and Violet had been marooned for six months in Monroe, still holed up in the tiny motel room with their Pekinese. One day Clegg and Helen came to take the sisters away to their very own place. They loaded the car with all of Daisy and Violet's worldly possessions.

Daisy and Violet dressed in their finest outfits: floor-length gowns, now a little frayed at the hems and faded, in which they had often appeared on stage.

Less than an hour later, the sisters got their first glimpse of their new home, a twelve- by thirty-eight-foot trailer in Patsy's Park, a mobile home court on the west side of Charlotte. They wept when they saw, stacked on the floor, all the provisions they would need to establish their own household: pots and pans, dishes and utensils, towels, blankets, bed sheets, and groceries. It was more than they had ever had, even in the best of their times.

When the time came for the Keziahs to say goodbye, all four were crying. "We'd have been dead long ago if it hadn't been for you," Daisy sobbed. She embraced Clegg first and then Helen. "You took us in when no one else in the world offered any help. We'll never forget what you did for us."

Violet told the Keziahs their new home and new city represented a

fresh beginning for the sisters. She was sure they would be able to put their lives back together, they would find work, and when they did, they would start sending weekly payments for all the bills they had left behind at the Mary-Lynn Motel and the Orange Bowl Restaurant.

Clegg put a finger to his lips and tried to shush Violet. He said he and Helen were thankful just to have had the opportunity to extend helping hands and that they expected nothing in return. He drew out a pen and wrote something on a slip of paper. He handed the note to the sisters. "Here's our phone number," he said. "If you should need anything, you call me or Helen, you hear."[24]

Accounts vary as to where the funds to resettle Daisy and Violet in the trailer park came from. Some said Clegg Keziah called on all the ministers in Monroe, including the pastor of the First Presbyterian Church, and got them to take up special collections for the sisters. Others said the funds came from Clegg and Helen Keziah themselves. Still others contended that Charley Reid and his wife, La Rue, the owners of the Park-N-Shop supermarkets, put up the money to move the twins. The truth may never be known. Real angels don't leave business cards behind.

## Twenty-One

# THOSE DAYS ARE NOW OVER, OVER FOREVER

D aisy and Violet had been settled into the trailer for a week or two when they received a phone call from La Rue Reid. Within an hour or so, she would be sending somebody over in a car to pick them up, La Rue announced. She and her husband wanted to see if there was something else they could do for Daisy and Violet.

The call left the twins excited but also fitful. They had made casual contact with La Rue and Charley Reid the previous year when, desperate for paying work of any kind, they appeared at one of the couple's Park-N-Shop supermarkets to promote the sale of twin-pack potato chips. Daisy and Violet hoped the couple could again give them employment.

Knowing the Reids' driver might already be on the way, they raced to a mirror to try to make themselves more presentable. Neither could remember when they had last visited a beauty salon. Their hair badly needed cutting. They tried bringing some style to it with brushing and pinning. Then they cracked open the large case of theater makeup. With the abandon of De Kooning attacking a fresh canvas, they covered their faces with hastily applied color.

Charley and La Rue had asked John Dunnagan if he wouldn't mind driving to Patsy's Park to pick up the twins. Dunnagan, a close friend of the Reids, operated a Charlotte advertising agency that developed

and placed the Park-N-Shop's radio, television, and newspaper ads. He retained vivid recollections of his assignment.

"What I didn't know was that before Charley and Rue called me to pick up the sisters, they called several other friends and relatives," Dunnagan said. "All these people turned them down. There was nothing in the world I wouldn't have done for Charley and Rue. I would have shoveled do-do for them. But this was a mission for which I wish I had been better prepared. I drove into the trailer court and pulled up in front of the twins' place. As I watched these two ladies stepping out of their trailer and then walking to my car, I couldn't believe my eyes. My first thought was that Charley and Rue had sprung a joke on me. They never told me that I would be picking up Siamese twins. What a sight those ladies were—and not just because they were joined together. They were wearing clothes that seemed to come from a different era—outfits of faded and worn cloth that they had somehow sewn together. The dresses had long pleated skirts that brushed the ground. They were caked with makeup—rouge, mascara, eye shadow, tomato red lipstick. One was blonde and the other had hair that was dyed a shade of orange. Their hair was shaggy and stringy. They needed shampoos. Both were doused with toilet water."[1]

Dunnagan remembered how excited the twins seemed after they settled in his car. "We were only traveling the mile or so to the Park-N-Shop, but you would have thought they were starting one of the great adventures of their lives," he said. "They were so chipper. I guess it meant a lot to them that there were still a couple of people who cared enough about them to want to help."[2]

Upon the delivery of his passengers to the Park-N-Shop, Dunnagan was asked by the Reids to sit in on the meeting. "The visit began with La Rue and Charley asking the twins what they now wanted to do with their lives, and whether they thought there might be some way they could help them," he recalled.

Certainly the sisters must have viewed their little trailer house in Patsy's Park as a comedown from the days when they were perched high in a light-filled apartment overlooking New York's Central Park or Boston's leafy Back Bay. But Dunnagan remembers them telling the Reids that the tin box suited them fine, and that they were grateful to have it. Daisy and Violet also said they had already gotten to know some of their neighbors in Patsy's Park and found them to be most welcoming. "The twins said they really felt at home in Charlotte," he recalled. "I got the impression they were willing to do anything to stay put where they were. They were still up against a hard reality, though. They were destitute, really strapped, and had no means for surviving very long."

So sorely pressed were Daisy and Violet for money, Dunnagan said, they told Charley and La Rue they were willing to do any kind of work, even scrubbing floors, and would take a single salary. Dunnagan said the Reids appeared deeply sympathetic. "Charley and Rue promised to do everything in their power to find work for them," he said. "I, too, offered to phone some of the my ad clients to see if there was one that could fit the twins in somewhere."

As solicitous toward Daisy and Violet as the Reids were, Dunnagan noted, there came a point during the meeting when La Rue's manner turned somewhat reproving. He said La Rue's usually benign expression changed to revulsion as she focused on the twins' appearance, appraising the heaviness of their makeup, their tattered, soiled, out-of-date clothes, and the grayness of their sandaled feet. "Rue looked them squarely in the eyes and, with no mincing of words, told them they were going to have to clean themselves up," Dunnagan said. "She said no employer would think about putting them on a payroll as long as they looked the way they did."[3]

A woman whose own hair burned auburn without enhancement from drugstore products, La Rue told the twins to ease up on the per-

oxides and henna. She advised them that the heaviness with which they applied their mascara, eye-liner, and lipstick, while perhaps appropriate for the stage, made them look like hussies. She also told them that if they expected to become part of the workaday world, they would have to dress like ordinary women and pack away their costumes. "You have to get over any ideas that you're still stars and that you're going to be able to return to the stage," La Rue said. "Those days are now over. Over forever."

As another condition of their offer to help Daisy and Violet, the Reids may also have suggested that the sisters publicly declare their faith in God. Although the twins had been christened soon after birth, there is no evidence that they had ever been religious. On June 2, 1962, just days after their meeting with the Reids, the twins were visited by the Reverend Ernest Fitzgerald, pastor of the Purcell United Methodist Church where Charley and La Rue were members. Fitzgerald, in an interview years later, said he was elated after his visit with the Hiltons who agreed to become congregants at his church. "I can't tell you how much joy I felt when they came to the church for services the first time," he said. Fitzgerald's sense of triumph was not to be lasting, though. Daisy and Violet attended services perhaps three or four times, he recalled. They then stopped coming to church altogether.[4]

The Reverend John Sills, who succeeded Fitzgerald as Purcell's pastor a few years later, said it was likely that Daisy and Violet joined the church at Charley Reid's bidding. "Mr. Reid worked as hard as anybody to recruit new members for our church," Sills said. "He was a very active member of the congregation and was also very generous with gifts to the church."[5]

From the time of her meeting with the twins, La Rue took the sisters "completely under her wing," said John Dunnagan. "She took them shopping for new clothes. She got them to the beauty parlor.

La Rue could present a gruff exterior when the occasion warranted, but her heart was as soft as a cream puff. She was always looking out after the twins' interests."[6]

Because the twins were so lonely and hungry for companionship when they arrived in Charlotte, they also stirred the sympathy of a Mrs. S. C. Hannah, a neighbor in Patsy's Park.[7] Mrs. Hannah, a widow and longtime resident of the mobile home court, made it a practice to invite the sisters to her trailer at mealtimes. Because Daisy and Violet didn't own a television set, they also spent many of their evenings with Mrs. Hannah watching TV.

"I think I enjoyed these nights more than they did," Mrs. Hannah said. "We'd be watching George Burns and Gracie Allen or Bob Hope or Phil Silvers or somebody like that, and then the twins would say, 'Oh, we know George and Gracie or we know Phil.' Then they would launch into stories about appearing in the same theaters where these stars once appeared. They'd tell me about going out to dinner with these big name entertainers."

Mrs. Hannah also recalled how thrilled Daisy and Violet were after their meeting with the Reids during which Charley and La Rue promised they were going to do everything in their powers to find employment for the sisters.

Because of the high regard with which they were held in Charlotte's business community, Charley and La Rue may not have expected much difficulty in finding employment for the twins. But they soon learned that some of their business contacts had an almost pathological fear of people with extreme physical abnormalities. Paula Payne, Inc., a manufacturer of hair care products, was reportedly contacted on the twins' behalf either by the Reids or Dunnagan. The company had a reputation for hiring workers with disabilities. Violet and Daisy were asked to report to the company in person to fill out job applications. According to Dunnagan, when word spread

through the plant that Siamese twins had applied for jobs, some workers began to talk about an insurrection. "A female employee who was pregnant was terrified that if she had to work under the same roof as the twins, the child she was carrying could turn out to be a freak," he recalled. "The worker said that if the twins were hired and her baby later turned out to have some problem, she'd hold the company responsible and sue it for all it was worth. The threat may have killed any chances of the twins getting a job there. As far as I know, the company never offered them jobs."

After making futile call after to futile call to prospective employ-ers, the Reids decided they would hire Daisy and Violet themselves. The sisters could work as produce weighers at the Wilkinson Boulevard Park-N-Shop.

But not all the supermarket workers were welcoming when the twins first reported for work, according to Guy Rodgers, manager of the store's produce department and the twins' immediate supervisor. "There were at least a few employees who thought it was a terrible mistake to put freaks on the payroll of the Park-N-Shop," he said. "They thought it would be bad for business, and that we were going to lose a lot of longtime customers because of it."[8]

From their first day on the job, Daisy and Violet endeared them-selves to their Park-N-Shop co-workers as well as the shoppers, Rodgers said. "They were as friendly and pleasant as could be. Much of the time they worked the produce scales, but I also gave them jobs like shucking corn and bagging potatoes and apples. It was fun to watch them. They'd be a-fussin' and a-gabbin' every minute. I don't know if they had ever done any manual labor before, but they turned out to be excellent employees."

Linda Beatty, a daughter of Charley and La Rue, also remembered Daisy and Violet as being exceptional workers. "Guy rigged up a cou-ple of produce scales side by side for the twins. It turned out to be a

good system, especially when the store was busy. The customers queued up in two lines that stretched out from the scales. They waited their turns to have one twin or the other weigh and bag and price their bananas, grapes, cucumbers, or whatever. Daisy and Vi enjoyed exchanging pleasantries with the customers. They may have been big show business celebrities at one time, but they took to their new humbler posts with the naturalness of ducks taking to water."[9]

Surprisingly, the twins seemed to draw little attention when they were on the job, according to Linda Beatty. "Now and then, when Daisy and Vi were walking through the store's aisles, there would be people, especially children, who would gawk at them," she said. "But when the twins were at their scales, they simply looked like a couple of women who happened to be working fanny-to-fanny because they were operating in a rather confined work space. I suspect a lot of shoppers had their produce weighed and bagged by the girls and never realized they were being served by Siamese twins."[10]

If the twins were able to carry out their work at the Park-N-Shop without attracting attention, it was not so easy for them in the wider world. Daisy and Violet usually walked to their job during morning rush hour, when the boulevard was clogged with slow-moving school buses, delivery trucks, and automobiles heading downtown. While the twins walked at normal speed, their gait was never quite natural. They moved forward in a slight bobbing and weaving lockstep that gave some observers the impression the sisters must have been counting one-two-three, one-two-three to keep their movements unified. The conspicuousness of the tiny women tripping along Wilkinson Boulevard was only heightened by their clothing. Each was outfitted in the uniform of all the female employees at the Park-N-Shop, red and white checked blouses with ankle-length, blue denim skirts.

The cruelest of the gawkers were teenagers. There were mornings when jalopies packed with young people pulled up and crept along-

*The sisters at work in the Park-N-Shop, Charlotte, North Carolina, 1968.*
*(Courtesy of Linda Beatty)*

side the twins, laughing and whistling at them. The boldest teens jumped from the slow-moving cars in pairs or trios and shadowed the sisters, mimicking the odd, herky-jerky manner of their progress.

Pauline Harton, a cashier at the Park-N-Shop, remembers when the twins first reported to work at the supermarket, they looked to be of retirement age. "I don't think Daisy and Vi ever told us their age, but I thought they were already old, old ladies when they first took jobs with us," she said. "I guess that's the price they paid for being on the road almost all their lives."[11]

Linda Beatty observed, "I think they were grateful to have steady jobs where they could mix with the shoppers and their fellow workers. Certainly they weren't making anything close to the money they once earned. But now, at least, they didn't have to worry about any

agents or managers taking them for all they were worth. And now they had their own little home in Patsy's Park and some friendly neighbors. I remember them telling me once that in some ways they were happier than at any time in their lives."[12]

Once Daisy and Violet had settled in Charlotte, they seemed reluctant to travel outside a sphere that was roughly circumscribed by the mile between their home and the Park-N-Shop. Gene Keeney, a magician from Indianapolis, Indiana, had long been a fan of the twins, and had assembled a small collection of Hilton Sisters memorabilia, including booklets, posters, photographs, and newspaper clippings. Upon arriving in Charlotte, he found them in the supermarket's produce department and had both twins autograph a Hilton Sisters poster.

"Because I had all these magic props to carry from one engagement to another, I traveled around in a small truck in those days," Keeney said. "After I had been in Charlotte for a day or two, I happened to spot Daisy and Violet at a bus stop. I stopped the truck and offered them a ride. They remembered me from my short visit with them in the supermarket. They climbed in beside me. I had seen them perform onstage when they were much younger and, from then on, had always been fascinated with them. I really wanted to learn all I could about their performing days and to become friends with them. They were pleasant enough, but I quickly learned that they weren't interested in reminiscing about their lives in show business. They seemed to want to put all that behind them. I was staying in Charlotte for a few days and I asked if I could do something for them. I thought I could take them to a nice restaurant or that maybe they would even enjoy a sightseeing ride in and around Charlotte. They thanked me for the offer, but said no, they had absolutely no interest in going anywhere or seeing anything new. They didn't go out to restaurants anymore, they said. They didn't even go to movies either. Except for the time they were at the supermarket, they said, they spent all their time at home."[13]

There was unusual closeness among the employees at the Park-N-Shop. Many of the workers were related the Reids, among them La Rue's brother Guy Rodgers. Park-N-Shop employees often socialized at weddings, christenings, bridal showers, barbecues, and picnics. Pauline Harton said the twins were always asked to take part in the events. "Whenever an invitation was extended to the twins, Daisy would say, 'Oh, I'd like nothing better than to be there.' But then Violet would say, 'Daisy, don't you remember? We have something else to do that day.' Violet was always throwing a wet blanket on things. The twins never appeared for any of the parties."[14]

"The sisters were as different as day and night," Harton said. "Daisy was warm and friendly and soft and feminine. Violet, on the other hand, was hard and could be gruff. I really think she hated all men and children. I had become a new mother of twins, and, when the babies were just weeks old, I wrapped them up in blankets, and took them to the store to show them off. Daisy cooed over the babies. Violet never gave them a second look. I often heard her say that she couldn't stand children. She said they all became meanies by the time they were eight or nine years old. Probably it was understandable for her to have such a strong dislike kids of that age. As Siamese twins, the sisters probably took a lot of taunting from children."

Guy Rodgers remembered one occasion when Violet's antipathy towards children had disastrous consequences for the sisters. The event occurred after Daisy and Violet had begun to regard the store's produce section as their little fiefdom. "A father came in with a small boy, and while the man went up and down the aisle, picking out produce, he let his son run around unsupervised," Rodgers said. "The boy started swinging like a monkey on the produce scales. The twins warned the child that he could fall and hurt himself and asked him to get down. The boy ignored them and his father did nothing about it. Violet grew more and more irritated, but she never raised her voice.

Finally the father got his things weighed, and then moved with his son to another aisle. Violet stopped biting her tongue. She started complaining to other customers about how bad it was that some parents exercised no control over their children. Unknown to Violet, the father of the mischievous boy was only one aisle away and he overheard everything she said about irresponsible parents. He stormed into the store's office and told someone there that he was not going to take insults from a lowly store clerk. He left his cart filled with groceries right there and walked out, announcing that he would never set foot in our store again."[15]

According to Rodgers, there was an unwritten policy at the store that all children, even bratty, poorly behaved kids, were to be treated like royalty. Children were the reason why the stores featured magicians, puppet shows, clowns, and free pony rides. They were also the reason why the Park-N-Shop stores advertised heavily on the locally produced televised children's shows. Said Rodgers: "Charley wanted the kids to see our stores almost as free amusement parks, because if they begged their moms and dads to bring them to the Park-N-Shops for the free magic shows or the rides on the merry-go-round and the ponies, then we could count on getting the families' business for groceries."

Rodgers said Violet didn't always find it easy to abide by the store policy that all children were privileged guests. More than once she had scolded those who sent her displays of neatly pyramided apples and oranges tumbling to the floor. And more than once La Rue had taken Violet aside to warn her about being too reproving with poorly disciplined children. One incident involving the offended father was the last straw, Rodgers said.

"Charley called me into his office and said we can't have that woman continuing to insult our customers even if the customers are wrong, " Rodgers recalled. "Because I was the twins' supervisor, the

job of firing them fell to me. I had to tell them to turn in their aprons and uniforms, that they were through."

Although he felt awful after he discharged Daisy and Violet, the sisters never showed any resentment toward Rodgers. "They continued to do their shopping at the store," he said. "They came in at least once a week, and when they did, they always visited with me and asked how things were going. They told me not to feel bad for firing them. They said they understood that I was acting on orders."

After the twins had been gone a month or two, it became evident to everyone at the store that the Hiltons were struggling. "They started to look almost as bedraggled as they were before they came to work for us," Rodgers said. "They didn't have money to go to the beauty parlor anymore. Their hair was a mess, half-gray, half-dyed, and stringy. I really felt very sorry for them. One day I took them aside and asked them if they wanted me to try to get them their jobs back. Both of them started crying. They told me how grateful they would be if they were given a chance to be working again. I told La Rue how bad things seemed to have gotten for the twins. She said let's give them another chance. Daisy and Vi were so happy when they returned to work. I don't know how much longer they could have survived."

Rodgers said he couldn't remember another time when either of the twins had to be reprimanded again. "They were model employees— two of the hardest workers I ever had," he said.

While the twins' attendance at Purcell Methodist stopped within a month after they joined the congregation, their membership was not without its rewards. The church owned a two-bedroom cottage at 2204 Weyland Avenue, kitty-corner from its parking lot. After Daisy and Violet had been living in Charlotte for a year or so, the church's elders, apparently at the Reids' request, offered to make the dwelling available to the twins. The frame house was small, but it was on a quiet street and well maintained. Because it was owned by the

church, the rent was even lower than what they were paying for the trailer in Patsy's Park.

The move to the Weyland Avenue cottage put Daisy and Violet within a couple hundred feet of the Purcell church's portal, but their relocation didn't bring about a resumption of their church attendance.

After the Reverend Fitzgerald, the pastor of Purcell, was elevated to bishop of a presbytery, the Reverend John Sills was assigned as the church's new leader. Sills remembered paying a visit on Daisy and Violet soon after becoming head of the church. "I think it was in the early afternoon when I rang the twins' doorbell," he said. "They welcomed me inside. I don't want to suggest that any kind of questionable activity was going on, but they had a man in the house with them. He was very friendly, very nice, and so were the twins." Sills said he would learn later that Daisy and Violet's male guest was Zeke Pierce, a sometime actor and the "Uncle Zeke" of a locally-produced children's television program.[16]

Sills said he took a seat with the twins and Pierce in the living-room, and the four of them made small talk. "I felt a little uncomfortable in this situation," Sills remembered. "Each of them had a highball in hand, and even though it was still quite early in the day, it was pretty obvious from the way they were talking that all of them had already been drinking for some time. I was there strictly to pay a social call. The subject of why the sisters were no longer coming to church never came up. I don't know if it was true, but others told me the twins didn't come to church because they didn't like people gaping at them."

Zeke Pierce seemed to be a frequent caller, showing up on their doorstep day and night. The twins might have felt that this was acceptable because he was at least nominally connected with show business and, thus, had something in common with them. According to Sills and others neighbors, Pierce may have been the single

Charlottan to have anything like a close friendship with the Hiltons. "The women were the most private people I ever saw in my life," said one Weyland Street resident. "They'd say good morning and wave at you when they left for work each day. But then they'd come back from their jobs and go directly into their house. You wouldn't see them again until the next morning when they left again for their jobs."

Other callers at Daisy and Violet's house were reporters and local television crews who wanted to develop features on the once prominent entertainers. Daisy and Violet always refused to cooperate. "Our show days are over. We only want our privacy now. We would be grateful if you would respect our wishes."

Some of the twins' Weyland Street neighbors regarded them as antisocial, a surprising trait for women who had been in show business most of their lives. But it wasn't really surprising at this stage in their lives that Daisy, and especially Violet, had developed a need for privacy. More than once, they had been ruined by con artists who had left them broke and paranoid. After six decades of losing incalculable sums of money, they had finally come to the conclusion that the best way to protect themselves was to be distrustful of just about everyone.

A few days before Christmas, 1968, a taxi stopped at the Park-N-Shop's front door. The cab's rear seat was piled high with holiday-wrapped gifts the twins had selected for their fellow workers and a few of their favorite customers, but the sisters themselves were not in the vehicle. The driver made several trips carrying in the presents and leaving them in an office.

It had been more than a week since the sisters had been to the store. Like several other workers, Daisy had been suffering from the Hong Kong flu. A couple of weeks earlier, Violet, too, had been laid low by the illness. After a few days of bed rest, Violet was again feeling fine and the twins were able to return to work. The sisters had only been back on the job for a week when Daisy fell ill.

One in five Americans contracted Hong Kong flu over the winter of 1968–69. Most started feeling normal again after a three or four days. But even after being bedridden for more than a week, Daisy only seemed to be growing sicker. When it became clear to the twins they would not be returning to work before Christmas, they arranged to have the gifts delivered to the supermarket.

The sisters spent Christmas in bed. Daisy was swathed in heavy quilts but still burning with fever and shaking from the chills. She had no appetite, and when Violet insisted she eat or drink something, she wasn't able to keep it down. Because Violet had rebounded so quickly, she was growing increasingly concerned that Daisy wasn't getting better.

The twins had never gotten over their childhood terror of physicians, and indeed, Daisy and Violet retained such a strong aversion to doctors that even when their vision started failing, they had to be forced to visit an ophthalmologist to get fitted for glasses.[17]

Violet recognized that Daisy's condition was growing graver day by day. She finally persuaded her sister they needed to seek help. Apparently traveling by taxi, the twins visited the office of Dr. Thomas Leath three days after Christmas, 1968.[18] After examining Daisy, the physician concluded that because she had become so malnourished and dehydrated, it would be best if the twins were hospitalized. Daisy was adamant in refusing it. The best Leath could do was prescribe medication for Daisy. The sisters returned to the cottage.

❧　❧　❧　❧

What could it have been like for Violet?

After never knowing a time in sixty-one years when she could not feel another life pulsing with her own, what was it like when, in an instant, that other life stopped? Did she panic? What did the sisters

talk about in the last moments before Daisy lost consciousness? Was Violet asleep when Daisy took her last breath? Or did she wake up to discover that, for the first time in her life, she was alone? And how acute was Violet's terror, knowing that with each passing hour, more of her own life was draining from her? Did she consider having herself rushed to a hospital to be cut away from her sister's corpse, and perhaps, if the virus in Daisy's body hadn't already infected her own, go on living?

No physician, no friend, no neighbor was with Violet in the cottage at the time Daisy died, so these questions will never be answered. It is impossible today to determine the exact time and date of Daisy's death, although pathological evidence would suggest that the end came for her sometime between the very last day of 1968 and the first or second day of the new year.

Immediately after Daisy died, according to John Dunnagan, Violet phoned La Rue Reid.

"I know this because right after Rue got off the phone with her— it was probably close to midnight—Rue called me at my house," Dunnagan said. "Rue was feeling very sad. She said she had just talked with the surviving sister. The sister told Rue that the other one had just died. She told Rue that now she knew that she would soon be dying, too. She said she was just calling to thank Rue and Charley for all they had done and to say goodbye for the last time."[19]

Dunnagan conceded that his version of how Violet responded after Daisy's death was secondhand because it was based on an account relayed to him by La Rue. But if it can be accepted that Violet rang up La Rue soon after Daisy died, then some other facts can also be inferred. The only phone in the cottage was in the living room. Daisy died in the twins' bedroom. This suggests that before getting to the phone, Violet had to remove Daisy from the bed, probably wrapping her sister's arms around her neck. Half-lifting and half-dragging Daisy's

body, she then would have struggled the twenty feet or so to the phone in the living room.

It can also be surmised that during her call to La Rue, Violet would have pleaded with her employers not to report Daisy's death to the police or coroner's office. La Rue may have felt conflicted about acceding to the request. If so, she must have concluded that the most loving, generous, and humane final act she could carry out for the twins was to honor Violet's wish and resist the temptation to report the death. Throughout their lives, the sisters had lived in fear that when death came to one of them, doctors might seek to save the survivor by surgically separating them. The sisters had entered the world as an inseparable pair and, from the time they were young children, they had determined they wanted to remain a pair in death. Neither could imagine life without the other.

But could there have their been another reason why Violet phoned La Rue, one whose intention she never stated? Could Violet have secretly hoped that La Rue would ignore her pleas not to report Daisy's death to the authorities? Did she covertly long for an ambulance to be dispatched to rush the pair to a hospital operating room where waiting surgeons would separate the two and perhaps keep Violet alive. Violet might have felt that if such a series of events were to play out, she would not have to suffer guilt at having broken the sisters' life-long pact never to leave one another. After all, the events described above would have been set into motion by others. Their unfolding would have been beyond her control.

Two or three days into the new year of 1969, the Charlotte police started getting reports from neighbors that Daisy and Violet hadn't been seen outside their house in days, and they weren't answering their phone, although the sisters' failure to answer their phone wasn't necessarily cause for alarm among those who knew them well.

When Daisy and Violet didn't want to be bothered at home, they ignored their phone or even took the receiver off its hook.[20]

After calling the Hilton cottage repeatedly for a day or two, Charley and La Rue Reid drove to the house in the early evening of January 4th.[21] They pounded on the locked door. They called out the sisters' names. They could hear the dogs barking inside. But when no one came to the door, they called the police. An officer pulled up in front of the house in a squad car at about 7:30. After a brief discussion with the Reids, the officer jimmied open the door.

The bodies of Daisy and Violet were found sprawled over a hallway heating grate. It could be that Violet was suffering from chills in her final hours, and, with Daisy's corpse at her side, positioned herself on the grate because it was the cottage's best source of constant warmth. Or, because the twins' bodies were discovered close to the front door, it might be conjectured that as her penultimate act, Violet let their dogs outside to relieve themselves. In what may have been her last moment of consciousness, Violet then called dogs back inside and collapsed on the grate.

How much time did Violet spend attached to her sister's dead body before she succumbed herself? The Mecklenberg County medical examiner's report recorded that someone checked on the twins at their home on December 31, 1968, and that both sisters were alive. Who was that visitor? Dr. Leath? La Rue? Their close friend Zeke Pierce? The report doesn't identify the caller, nor does it record the time of the day. It also fails to provide any information as to the caller's impression of Daisy's condition at the time of the visit. Since both twins were seen alive by somebody sometime on December 31st, it can be concluded that Daisy either died later the same day after the caller left, or that she died on the first or second day of January, 1969. When the policeman forced his way into the cottage on the

**SIAMESE** twins Violet and Daisy Hilton born in England 60 years ago, were found dead yesterday in their home in Charlotte, North Carolina.

They are believed to have died from flu. They were joined at the base of the spine yet had a successful vaudeville career. Both married; both marriages were dissolved.

*Siamese twins Violet and Daisy Hilton born in England 60 years ago, were found dead yesterday in their home in Charlotte, North Carolina. They are believed to have died from flu. They were joined at the base of the spine yet had a success-ful vaudeville career. Both married; both marriages were dissolved.*

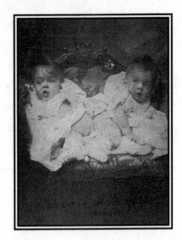

*The Brighton United Twins. This photo, circa 1908, ran with the obituary at left, one of many that ran in newspapers around the country. (Author's collection)*

night of January 4th, the decomposition of Daisy's body was already quite advanced, indicating that she could have been dead for between two and four days. Violet's body, on the other hand, showed little deterioration. All evidence suggests she must have struggled with Daisy's stiffening and decomposing body for somewhere between forty-eight and ninety-six hours before her own death.

No autopsies were performed on the bodies, but Dr. Hobart R. Wood, the Mecklenberg County medical examiner, recorded that the sisters had been ill with the flu. He attributed both deaths to influenza pneumonia.

About sixty people attended the services, held in the Hankins and Whittington Funeral Home and presided over by the Reverend John Sills. Most of the mourners, including the six pallbearers, were worked at Park-N-Shop. Also paying their last respects were a few of

the twins' neighbors and some of the regular shoppers with whom they had become close, among them Dot Thompson Correll.

La Rue and Charley Reid, along with the Reverend Sills, planned the service. They wanted everything to be simple. They were sure that Daisy and Violet wouldn't have wanted their last event to become a sideshow exhibition. Inevitably, the service did attract a sprinkling of curiosity-seekers. As few in number as the funeral crashers were, Sills seemed intent on making them feel out of place amidst the twins' co-workers and friends. He stood before the small gathering and looked directly into the eyes of the people whom he suspected had turned out only because of morbid curiosity. "How many of you," he asked, "are here to grieve?"[22]

The interlopers may have been too insensitive to feel any chagrin even after having been recognized by the minister as intruders. But almost certainly these infiltrators were disappointed. The funeral was not a freak show. There was no opportunity for anyone to get a last look at Daisy and Violet Hilton. The lid on the single, over-sized casket remained closed.

The floral offerings in the funeral chapel — a reporter from the *Charlotte Observer* counted twenty-three of them — came from colleagues and customers. Although accounts of the twins' deaths had appeared in newspapers across the country, not one person from the stage or cinema worlds attended their funeral or sent flowers. Sills couldn't get over how sad it was that the world had exploited the sisters all their lives and then, when every last bit of their stage appeal was used up, rejected and forgot them.

"Daisy and Violet Hilton were in show business all but the last half-dozen of their sixty-one years, and who could even count the number of people who profited on the misfortune with which they went through life?" he asked. "In the end, though, they were cast aside by the glittery and glamorous world that they had been a part of for so

long. In the end, it was only ordinary people who showed they cared about them—the stockboys and cashiers at the Park-N-Shop, the shoppers whose apples and potatoes Daisy and Violet weighed and bagged, the neighbors around their little house on Weyland Avenue."[23]

At the time of their deaths, the combined assets of Daisy and Violet totaled $4,644.57.[24] All but about $1,000 of the amount was retirement money accumulated through a profit-sharing plan at the store. By the time all their bills were paid, their savings had shrunk to $1,611.23. These were skimpy leavings for two women who once had earned $4,000 a week.

Charley and La Rue Reid remained silent on the subject, but some say they helped with the funeral expenses. Help also came from Dot Thompson Correll. She had come to know the twins through her weekly trips to the Park-N-Shop. She adored the sisters, and because Daisy and Violet had once been great stars, she felt it would be disgraceful if the two were lowered into a pauper's grave. Dot Thompson Correll and her second husband, James, owned four burial plots at Forest Lawn Cemetery. One of them was already occupied by a Private First Class Troy Miller Thompson Jr., Dot Correll's son from her first marriage.

Brenda McCallum, a niece, explained what happened. "Aunt Dot felt terrible when the twins died," she said. "She had been so fond of them. She knew that their lives had been filled with a lot of suffering and loneliness. She wanted them to at least have a nice final resting place. Aunt Dot went to Mr. Reid and said, 'I've got a plot of four grave sites in Forest Lawn. My son is already in one of them. I'll only need two more, one for myself, one for my husband. Why not let Daisy and Vi have the one that's left over?"[25]

And so it happened. Daisy and Violet Hilton were lowered into the ground just feet away from Pfc. Troy Miller Thompson Jr. All three now share the same address, Lot 313, Section M, Forest Lawn

Cemetery, Charlotte, North Carolina. They lie beneath a large, gray granite slab. The stone, at its center, is incised in large letters with the name THOMPSON. Near the monument's base, in smaller letters on the far left and far right sides, respectively, are the names: TROY M, June 21, 1944–Sept. 26, 1965, and DAISY & VIOLET HILTON 1908–1969.

Today, Daisy and Violet rest in peace beside Pfc. Thompson, a young man thirty-six years their junior, the third of eighty men and women from Mecklenburg County who lost their lives in the Vietnam War. Daisy and Violet, of course, had never laid eyes on him in life. If they had had any say in the matter, perhaps they would have made different arrangements. But probably they wouldn't have objected too strenuously.

# NOTES AND SOURCES

## Chapter One ∾ *Pages 1–19*

The author is much in debt to Joseph Haestier, Kent, England, and P. D. Rooth, Esq., Sussex, England, for help in reconstructing the events of February 5th, 1908. Haestier's mother, Maggie, was present in the household and recounted the events of that day and night to him. Rooth is the son of James Augustus Rooth, the physician who was present shortly after the birth. "My father often spoke of this extraordinary birth, and one might classify this as one of the high-lights of a long and interesting medical career," the younger Rooth said in a letter to the author.

1. Military records provided to author by P. D. Rooth.
2. Birth records for Charles Laker Skinner and his daughter, Kate Skinner, show both to have been twins. Charles, born July 26, 1855, in Steyning, England, had a brother, Harry Beggat Skinner. Kate, born August 23, 1886, in Brighton, England, had a sister, Maggie.
3. Rooth, J. "The Brighton United Twins," *British Medical Journal*, 1911. 653–654.
4. *The Intimate Lives and Loves of the Hilton Sisters, World Famous Siamese Twins*, undated and unpaginated, was purported by Daisy and Violet to be their autobiography. The self-published booklet was printed in the mid-1950s by Wonder Book, Hollywood, California. Subsequent citations will refer to the work as *Lives and Loves*.
5. According to city census records: documentation obtained from Office of Population, Censuses and Surveys, St. Catherine's House, London.
6. He was publisher of a weekly paper: correspondence with John B. McKee, County Archives of East Sussex, England, May 1, 1966.

7. "Their mother (Kate) was a serving girl": Jim Moore interview conducted by Esther MacMillan for Bexar County Oral History Program, June 30, 1978.

8. "My mum had always been devoted to her sister Kate": Joseph Haestier, Sussex, England, phone interview with author, April 8, 1996.

9. Kate was never to marry: ibid.

10. "The sisters were joined so tightly at the buttocks": J. Rooth, op. cit.

11. "Take my babies"; Kate Skinner cited by Edith Myers, "Decision In Siamese Twins Receivership Case Due Today," *San Antonio Express*, January 21, 1931.

12. Minutes before the hour: *Brighton Herald*, March 28, 1908.

13. "A volley of smack, smack, smack": ibid.

14. "Were they older": ibid.

15. "Brighton's United Twins are thriving": *Brighton Herald*, April 22, 1908.

### Chapter Two ❧ *Pages 20–26*

1. "Our earliest and only recollection": Daisy and Violet Hilton, "Life and Loves of the Siamese Twins," *World News*, September 27, 1937.

2. "I fell in love directly": Mary Hilton, *Brighton Herald*, March 28, 1908.

3. Business so boomed: correspondence with Roger Davey, County Archives of East Sussex, England, June 27, 1995.

4. "Daisy's lower right leg was twisted slightly": Edith Myer, "Decision In Siamese Twins Receivership Case Due Today," *San Antonio Express*, January 21, 1931.

5. "When we were turned loose": Daisy and Violet, *Lives and Loves*, op. cit.

6. "She never petted or kissed us or even smiled:" ibid.

7. "I am not your mother:" Mary Hilton quoted by Daisy and Violet, *Lives and Loves. Op. cit.*

8. "About her waist was a wide leather belt": ibid.

9. "We were pinched and prodded and probed": ibid.

10. After examining X-rays of the twins: J. Rooth, op. cit.

### Chapter Three ❧ *Pages 27–43*

1. Correspondence with D. Patrick, Mitchell Library, Glasgow, Scotland, April 24, 1996.

2. "Ike Rose's First Fifty Years in Show Business," 121, *Billboard*, December 8, 1928, Subsequent citations will refer to "Ike Rose's First Fifty Years."

3. The American escapologist had been appearing in the Glasgow Coliseum: Frank Koval, *Illustrated Houdini Diary*. Oldham, England, 1992.

4. "He himself always felt like an outsider": Dr. Morris Young, New York, phone interview with author, October 23, 1995.

5. Houdini's excitement at his discovery: "Ike Rose's First Fifty Years," op. cit.

6. The Glaswegians, most of them boys and men: ibid.

7. The grotesque clump: untitled, *Duluth News Tribune*, undated.

8. "The future groom will have": Signor Saltarino in Frederick Drimmer, *Very Special People*. New York: Atheneum, 1988, 67.

9. He signed them for a reported $10,000 yearly: "Ike Rose's First Fifty Years," op. cit.

10. Two of the prettiest children he ever saw: ibid.

11. Ike Rose, "The Story of Saharet," 35–36. *Theatre Magazine*, May 1, 1914.

12. Over and over, Rose repeated his knack: *Billboard*, December 3, 1921.

13. "Teach the girls the hard way": Mary Hilton cited in *Lives and Loves*. Op. cit.

14. The year 1911 was the last: correspondence with Roger Davey, County Archives of East Sussex, England, June 27, 1995.

15. "He thought we should go to religious services": Daisy and Violet, *Lives and Loves*, op. cit.

16. "The theater thundered with applause": ibid.

17. "It will be a worthwhile and interesting experiment": Dr. Bochheimer, ibid.

18. "The girls belong to me": Mary Hilton, ibid.

19. "We lived in dingy . . . boarding houses": Daisy and Violet, *World News*, op. cit.

20. He found he could not: "Ike Rose's First Fifty Years," op. cit.

21. Rose's road expenses may have decreased: death certificate for Henry Hilton, Leipzig, Germany, May 5, 1912.

22. "We appeared before the public": Daisy and Violet, *World News*, op. cit.

23. At the same time things were unraveling: 37, *Theatre Magazine*, May 1, 1914.

24. "The upcoming fair prepares itself for a visit by Ike Rose": *National Zeitung*, April 1, 1912.

25. Rose may have regarded the wire: "Ike Rose's First Fifty Years," op. cit.

## Chapter Four ❧ Pages 44–56

1. "Their peculiar malformation": "Freak of Nature," 19, *Argus*, Melbourne, Australia, February 8, 1913.

2. Ibid.

3. The descriptions of Luna Park St. Kilda are largely drawn from *Luna Park Just for Fun*, Luna Park Reserve Trust, Sydney, Australia, 1995—a scholarly but thoroughly entertaining book by Sam Marshall, an invaluable friend who generously provided copies of much of the original source material for his book and introduced the author to other scholars who have been helpful.

4. Around 1904, he saw his first motion picture, *New York Times*, October 19, 1924, 9, section VIII.

5. Despite the bad portents: *Luna Park Just for Fun*, op. cit.

6. There was no stinting of hyperbole: *Table Talk Magazine*, Melbourne, Australia, February, 1913, and *Argus*, Melbourne, Australia, February 10–15, 1913.

7. While Daisy and Violet had been given headline billing: *Melbourne Herald*, February 17, 1913.

8. A principled businessman: "Ike Rose's First Fifty Years," op. cit.

9. According to *Billboard*: ibid.

10. The show, a British company called Tiny Town: ibid.

11. Birth certificate, Registry of Births, Deaths and Marriages, Victoria, Australia, obtained through professional genealogist, Wendy Baker, Victoria, Australia.

12. "We need a man to travel with us": Mary Hilton cited in *Lives and Loves*. Op. cit.

13. "We took this to mean": Daisy and Violet, ibid.

14. And, as if to impress the twins: ibid.

15. Having a troupe of midgets on his hands: "Ike Rose's First Fifty Years," op cit.

16. By his account: ibid.

17. Marriage certificate, Registry of Births, Deaths and Marriages, Melbourne, Australia, obtained through professional genealogist, Wendy Baker, Victoria, Australia.

18. The ship on which the family was traveling: passengers list, USS *Sonoma*, June 21, 1916.

19. "Maritime News," *San Francisco Chronicle*, July 11, 1916.

20. John Tomarces of Greece died: ibid.

## *Chapter Five ❧ Pages 57–68*

The author is grateful to a dear friend, Carol Ness of San Francisco, California, for calling attention to the difficulties Mary Hilton and Myer Myers had with U.S. Immigration Service in 1916.

1. As Daisy and Violet cried hysterically: Myer Myers in letter dated March 14, 1936, to Clifford J. Williams, Sacramento, California, who appeared with the Woolworth Circus. Addressing Williams by the professional name of "J. Hass," Myer discussed in detail the efforts by Immigration Service officials to block the twins' entry into the United States. A copy of the letter was sent to the Reverend John Sills, Charlotte, North Carolina, January 7, 1969, by Williams' wife, Florenza.

2. United States Immigration Service manifest of alien passengers arriving at Angel Island, California, from Sydney, Australia, dated July 10, 1916.

3. "Can you read, sir": Myers, op. cit.

4. "My advice, sir": Immigration Service officer cited by Myers: ibid.

5. The Myers, Mary, and the twins had been at sea: *San Francisco Chronicle*, July 11, 1916.

6. "Them little girls": Myers, op. cit.

7. "Physically and biologically inferior": ibid.

8. "No, no, no": Edith cited by Myers, ibid.

9. "We have to be strong": ibid.

10. Mary was surprised when she entered the *Chronicle's* news department: Myers letter, ibid.

11. In part, the *Chronicle* account read: "Tie That Binds Them Seems No Bar to Earning a Living": *San Francisco Chronicle*, July 14, 1916.

12. He ordered the twins' immediate release: *San Francisco Chronicle* and *San Francisco Examiner*, July 17, 1916.

13. "The Modern Siamese Twins": July 22, 1916.

14. Myers didn't have to wait long for a response: *Billboard*, July 29, 1916.

## *Chapter Six ❧ Pages 69–80*

1. "Like Toulouse-Lautrec, Napoleon and some of the other runts of history": Joe McKennon, Sarasota, Florida, interview with author, Ringling Museum of Art, February 8, 1996.

2. Long lines were queued: *Billboard*, December 23, 1916.

3. "If he had his designs": McKennon, op. cit.

4. The crowd was still roaring: *Billboard*, October 7,1916, 16.

5. "Men and boys always outnumbered the female patrons": McKennon, op. cit.

6. Examination of copies, *Anaconda Standard* August, 1916, Hearst Free Library, Anaconda, Montana.

7. After finishing the stand in Anaconda: *Billboard*, August 19, 1916, 28.

8. "Making a hit all along the way": *Billboard*, October 17, 1916, 35.

9. "The Myers kept them isolated": Moore, op. cit.

10. "When you went into their tent": ibid.

11. "I want you to be the smartest Siamese twins": Mary Hilton cited in *Lives and Loves*, op. cit.

12. City of Phoenix, Arizona, residential directory, 1916.

### *Chapter Seven* ❧ *Pages 81–103*

1. "That little baby": Jim Moore interview with Robert Warren, circa mid-1980s, San Antonio, Texas. The author is indebted to Karen Connors (Mr. Warren's sister) of Houston, Texas, who provided transcriptions of two interviews conducted with Moore. Mr. Warren had hoped to write the Hilton sisters biography but was unable to realize the project. The author is also grateful to Ms. Connors for providing photographs and other materials collected by her brother.

2. "In effect, Daisy and Violet had their own tutor": ibid.

3. "It was easy for do-gooders to condemn the carnival": Percilla Bejano, Gibsonton, Florida, interview with author. June 21, 1998.

4. "Would Daisy and Violet have been better off?": Jeanie Tomaini, Gibsonton, Florida, interview with author, November 7, 1996.

5. For the 1917 tour: *Billboard*, February 17, 1917.

6. Their theater was sited: *Billboard*, March or April, 1917.

7. The production advertised such attractions: ibid.

8. "All is as spick and span as in any theater": 21, Rubin Gruberg, *Billboard*, Dec. 10, 1921, 12.

9. "The twins were in beautiful, ruffled white dresses": Moore in Warren interview, op. cit.

10. "It was almost impossible to have contact with the girls": Moore, ibid.

11. They smiled and simultaneously blew him kisses: ibid.

12. "One of his publicity maneuvers": McKennon, op. cit.

13. And maybe more than any other carnival man: ibid.

14. Scouts for Barnum & Bailey's *Greatest Show On Earth*: Moore in MacMillan interview, op. cit.

15. There, Myer made such great displays of profligacy: "This is the Birthday House San Antonio's Siamese Twins Gave to Aunt Who Mothered Them," *San Antonio Express*, October 2, 1927.

16. "No neighborhood children were allowed": Camille Rosengren, San Antonio, Texas, interview with author, May 28, 1996.

17. "Except for the people who entered their tent": ibid.

18. "The Johnny J. Jones show was one of the biggest carnivals": Bejano, op. cit.

19. "Percilla learned to dance early": Ward Hall, Gibsonton, Florida, phone interview with author, June 15, 1998.

20. "Mostly we entertained ourselves": Bejano, op. cit.

21. Bejano said she thought it was unfair: ibid.

22. ". . . The kaiser has abdicated": Johnny J. Jones quoted in *Billboard*, undated.

23. "We had become strangely wise": Daisy and Violet, *Lives and Loves*, op. cit.

24. "As we looked at her, our first corpse": ibid.

25. "Why cry?": ibid.

26. "You girls belong to us now": Myer Myers cited in *Lives and Loves*. Ibid.

27. He even insisted: Daisy and Violet, ibid.

28. We all considered ourselves members of the same family": Tomaini, op. cit.

## *Chapter Eight* ❧ *Pages 104–123*

1. "Believe it or not": Joe Fanton, in John E. DeMeglio, *Vaudeville, U.S.A.*, Bowling Green, Ohio: Bowling Green University Press, 1973, 31.

2. Sitting in on the audition: unidentified, undated clipping, collection of New York Public Library for the Performing Arts.

3. "Well," said Turner, "God made the Siamese Twins": Theodore Strauss quoting Terry Turner, "Tricks Without Mirrors," *New York Times*, November 24, 1940.

4. A couple weeks before: Lew Dufour with Irwin Kirby, *Fabulous Years: A Showman's Tales of Carnivals, World's Fairs and Broadway*, New York: Vantage, 1977, 48.

5. The Newark Police Department had to rush in reserve forces: *Newark Evening News*, February 17, 1925, and *Billboard*, February 28, 1925.

6. "Both," he instructed, "like movies, flowers and bon-bons": Ray Traynor, *Variety*, February 25, 1925.

7. He revealed, too: ibid.

8. Fearful that another vaudeville chain might try to pirate the act: *Billboard*, March 14, 1925.

9. The reviews of the twins' theater debut: *Variety*, February 25, 1925.

10. So great was the demand for tickets: *New York Morning Telegraph*, February 20, 1925, and *Billboard*, February 28, 1925.

11. New box office records were established: *Billboard*, March 28, 1925.

12. "If we could have had our choice of fathers": Daisy Hilton, *San Francisco Call & Post*, July 22, 1936.

13. "These dolls are almost as interesting as the Twins themselves": *New York Mirror*, March 16, 1925.

14. "In the lines assigned to them by Traynor": Sam M'Kee, *New York Morning Telegraph*, March 24, 1925.

15. "You laughed at their girlish patter": Rose Fernandez, Honolulu, Hawaii, phone interview with author, February 2, 1997.

16. "If one of the girls should fall in love": Edith Myers unidentified, undated clipping, collection of the New York Public Library for the Performing Arts.

17. After receiving "hundreds of requests": *New York Evening Bulletin*, March 27, 1925.

18. "Well," said Rosetta, "let's enter into agreement": *New York World*, April 9, 1925.

## *Chapter Nine* ❦ *Pages 124–135*

1. "See, Daisy, I told you he'd still remember us": Violet Hilton quoted in Milt Josefberg, *The Jack Benny Show*. New Rochelle, New York: Arlington House, 1987, 34.

2. Because the Miller could seat 1500: "Wisconsin Theater Breaks Record In Milwaukee," *Billboard*, October 17, 1925.

3. Under the new contract: "Siamese Twins for Orpheum," *Billboard*, December 12, 1925.

4. "At first it was a funny sensation to dance with a Siamese twin": Bob Hope as told to Pete Martin, *Have Tux Will Travel*. New York: Simon and Schuster, 1954, 54.

5. Violet once revealed: *Lives and Loves*. Op. cit.

6. "We wore the high hats and spats": Hope, 55, op. cit.

7. Their scouting ended: "This is the Birthday House . . . ," *San Antonio Express*, October 2, 1927.

8. While there already were examples of the new architectural style: ibid.

9. The *Express* account: ibid.

### Chapter Ten ☙ *pages 136–150*

1. Not only did Myer gain custody of the twins: ruling filed April 1, 1927, 45th District Court, Bexar County, Texas.

2. He kicked the vase: *Lives and Loves*. Op. cit.

3. "You still keep us caged up like wild animals at a circus": ibid.

4. He said he would immediately see to it: *San Antonio Express*, January 13, 1931.

5. "They both loved him": Mabel Oliver, *Kansas City Times*, March 26, 1931.

6. Inside his bag, she found a sheaf of perfume-scented letters: *San Antonio Express*, circa April 1, 1931.

7. "Mary and Margaret were no more trainable than jellyfish": Ray Traynor, unidentified, undated clipping.

8. "Their (piano) playing and dancing pass as well as anyone could want": *Variety*, April 14, 1927.

9. "The one that was walking (was) bent over a little bit": Moore in MacMillan interview, op. cit.

10. "The reviewer for the *The Billboard* fairly fumed at the breaches of taste": *Billboard*, February 15, 1930.

11. "Last Saturday's *Newark Star* was hogged by Turner for his Gibb Girls": *Variety*, April 13, 1927, 26.

12. The report from the contracting agent wasn't good: *Lives and Loves*. Op. cit.

13. The lawsuit naming the twins: Lawsuit naming Daisy and Violet filed with circuit court, Kansas City, Missouri.

## Chapter Eleven &#x2604; *Pages 151–165*

1. "We don't want anything cheap": Daisy, *Lives and Loves*, op. cit.

2. It would later be reported: *San Antonio Express*, January 31, 1931.

3. "He would welcome the train at the railway yards:" Peyton Green, *San Antonio: City in the Sun*, New York: McGraw-Hill, Inc., 1946, 235.

4. During the teens and twenties: Peyton Green, op. cit.

5. "You have to fight this": Myer Myers cited in *Lives and Loves*. Op. cit.

6. Myers referred to Mildred Oliver's lawsuit: *Kansas City Times*, March 26, 1931.

7. "They're twenty-one, aren't they?": Martin Arnold cited in *Lives and Loves*. Op. cit.

8. "You're two frightened girls": Arnold, ibid.

9. "You can come out now, Miss Stozer": Arnold, ibid.

10. "It was a strange experience to see someone crying": Daisy, ibid.

11. "What became of all the money your earned?": Arnold, ibid.

12. "I'll help you," he promised": Arnold, ibid.

13. "Girls," Lucille told them, "you're Mr. Arnold's guests": Lucille Stotzer, ibid.

14. "It was like a dream": Daisy, ibid.

15. "I had always thought that Don told me with his songs": ibid.

16. "I always hoped you'd break away from Sir": Don Galvan, ibid.

17. "He was even better looking than I remembered": Daisy, ibid.

18. "It was disappointing": ibid.

19. "Gee, Daisy, I'm getting tired of waiting for Don to kiss you": Violet, ibid.

20. "They don't seem to be making any allowances": Edith Myers, "Manager Says Twins Out for Life of 'Whoopee," *San Antonio Light*, January 13, 1931.

21. "The girls must have the idea they can make 'whoopee' ": Myer Myers, ibid.

## Chapter Twelve &#x2604; *Pages 166–189*

1. "The arrogance of this man": Martin Arnold, "Hilton Case Delayed for Three Days," *San Antonio Light*, January 16, 1931.

2. "I intend to use Myers as my first witness": Martin Arnold, *San Antonio Express*, January 17, 1931.

3. "Do you mean to say the defendants are trying to dodge the proceedings?": ibid.

4. "Since Mr. Thomas J. Saunders claims there is no need": ibid.

5. "I do not know": Thomas J. Saunders, *San Antonio Express*, op. cit.

6. "We will furnish counsel": ibid.

7. "It's different from the stage": Daisy, *San Antonio Light*, January 16, 1931.

8. Rose said he would travel to San Antonio to "tell the true story of the girls": Ike Rose, "Hilton Sisters Hearing Set for Monday," *San Antonio Light*, January 16, 1931, 1.

9. "My clients say that Ike Rose": Saunders, ibid.

10. "This is not a show": W. W. McCrory, *San Antonio Express*, January 21, 1931.

11. "I don't know": Myer Myers, "Myers Says He Spent $213,000 of Cash Made By Hilton Twins," *San Antonio Express*, January 20, 1931.

12. "In a way": ibid.

13. "If this man makes another remark like that": Arnold, ibid.

14. "I do not wish to turn this into a personal matter": ibid.

15. "It was bought with *my* money": Myers, ibid.

16. "We did not need him in the act": ibid.

17. "Well there were other reasons": ibid.

18. "I considered it my money": ibid.

19. "That was just a big publicity splash": ibid.

20. "Never in my life!": ibid.

21. "Spectators must respect the decorum of the court": W. W. McCrory, "Decision In Siamese Twins Receivership Case Due Today," *San Antonio Express*, January 21, 1931.

22. "When we hesitated": Violet, ibid.

23. "No sir": ibid.

24. "He told us we were born in England and had no rights in this country": ibid.

25. "I never swore at him": ibid.

26. "In about 1929 when we found out that we were not being treated right": ibid.

27. "The doctors told us they could not possibly live": Edith Myers, *San Antonio Express*, January 21, 1931.

28. "We gave them the best teachers we could find": Edith Myers, ibid.

29. "The girls came to me in 1929 and demanded to know who their mother and father was": ibid.

30. She screamed, "How much do you expect to take?": ibid.

31. "Which one of your press agents gave you that?": Saunders, *San Antonio Light*, January 21, 1931.

32. "I knew my client was at a disadvantage": ibid.

33. As another part of his ruling: *San Antonio Light*, 1, January 21, 1931.

34. "Jack Dempsey was nothing but a ham-and-egger": W. W. McCrory, *Variety*, January 31, 1931.

35. "Our freedom was the most important part": Violet, *Lives and Loves*, op. cit.

36. A few nights after McCrory handed down his decision: Pat Hammond, San Antonio, Texas, interview with author, May 19, 1996.

37. Daisy and Violet remembered the night of their liberation this way: *Lives and Loves*. Op. cit.

### *Chapter Thirteen* ✷ *pages 190–213*

1. "You were not conscious of it after you were with them": Lucille Stotzer in Bill Hendrick, "We Just Want to Be Normal," *San Antonio Express*, September 29, 1985.

2. "Daisy would have a date": Stotzer, *San Antonio Express*, 1969.

3. "We would just be sitting there chatting": Moore in MacMillan interview, op. cit.

4. "It gave us grave moments and much wonderment": Daisy, *Lives and Loves*, op. cit.

5. "I have thought it out": Don Galvan, ibid.

6. "Violet still carried a torch for Blue Steele": Daisy, ibid.

7. "I know that I should not like a separation from the man I married": ibid.

8. "Every day they sweep, scrub and dust their little flat": "Why the Siamese Twins Left Home," *San Antonio Express*, March 1, 1931.

9. "We would like to adopt a child": Daisy, *San Antonio Express*, January 13, 1931.

10. "They all started wearing sunglasses and acting funny": Johnny Eck in Joe Colluras, "Johnny Eck—Beyond Measure," *Classic Images*, 139, July 1991, 51.

11. "She was grand and ritzy": Leila Hyams in Grace Macks, "Venus and the Freaks," *Screenplay*, April, 1932.

12. "First I met the midget": Olga Baclanova in John Kobal, *People Will Talk*. New York: Alfred A. Knopf, 1985, 52.

13. "He was so handsome": Baclanova, ibid.

14. Willard Sheldon . . . remembered Daisy and Violet as "bright, intelligent girls": Willard Sheldon, Los Angeles, California, interview with author, October 25, 1995.

15. "They were lovely girls": ibid.

16. Joined by other M-G-M employees from floor sweepers to executives: Harry Rapf quoted by Samuel Marx interview Elias Savada, Los Angeles, California, April 4, 1972, cited in David J. Skal and Elias Savada, *Dark Carnival: The Secret World of Tod Browning*. New York: Anchor Books, 1995, 168.

17. "I'd not only make [people] laugh. I'd make them love me": Marie Dressler, *The Life Story of An Ugly Duckling*. New York: R. M. McBride, 1924, 24.

18. "Scott and I had no sooner seated ourselves": Dwight Taylor, *Joy Ride*. New York: G. P. Putnam's Sons, 1969, 247, 248.

19. "Just about every day you picked up the paper": Sheldon, op. cit.

20. "Daisy and Violet are more than pretty": Faith Service, "The Amazing Life Stories of the Freaks!", *Motion Picture*, April, 1932, 100.

21. They had a "big sedan": ibid.

22. "We're happier now than we've ever been": Daisy, ibid.

23. "Halfway through the preview": Merrill Pye in Skal and Savada, *Dark Carnival: The Secret World of Tod Browning*, 174. Op. cit.

24. "Everyone who worked on the film wanted to go into hiding": Sheldon, op. cit.

## *Chapter Fourteen* ✿ *Pages 214–233*

1. He had seen Daisy for only seconds: "One of the Hilton Sisters to Marry," *American Weekly*, circa 1934.

2. "Probably the most delicate of all Jack's courtship's problems": *New York American*, April 23, 1933.

3. "Both of the girls are swell": Jack Lewis, ibid.

4. "Here's a nickel": ibid.

5. [Blue] then mounted the stand: Don Dearness, "Blue Steele Emerges Second Best from Fray," *Billboard*, April 18, 1931, 23.

6. "The Hilton sisters created a sensation": *Variety,* February 14, 1933, 52.

7. "I love to defeat an opponent, it's true": Harry Mason, "Harry Mason Admits, 'Yes, I'm a Pensioner,' " *London Daily Express,* December 22, 1938.

8. "It's not exactly Keats": ibid.

9. ". . . To my great relief": Violet, *Lives and Loves,* op. cit.

10. "I used to go on dates with Violet and Harry": Daisy, *Lives and Loves,* op. cit.

11. "They were a grand pair": Albert Dunk, "They Were the Greatest Double Act In the Business," *Brighton and Hove Gazette,* January 10, 1969.

12. The twins, according to Albert Dunk: ibid.

13. "The poor girls must have been heartbroken": Haestier interview, op. cit.

14. "Brighton is taking its own Siamese twins very much to its heart": *Brighton Herald,* 1933.

15. "I remember them at two grand pianos": Dunk, op. cit.

16. ". . . They are performers of real merit": Frederick H. U. Bowman, "The Hilton Sisters," *World's Fair,* Oldham, England, May 27, 1933.

17. In Wolverhampton: caption on photograph from *Wolverhampton Express & Star,* undated.

18. "Harry Mason . . . has made a great comeback": *The Ring Magazine,* August, 1933.

19. "I'm quite sure we will be the happiest foursome in the world": Violet, *New York American,* October 15, 1933.

20. "We're tired of vaudeville and tired of exhibiting ourselves": Violet, ibid.

21. "Jack has been writing to me almost every day": Daisy, ibid.

## *Chapter Fifteen* ☞ *Pages 234–255*

1. "I danced with one twin": Moore in MacMillan interview, op. cit.

2. "The formula we had was an especially good one": ibid.

3. "Violet and Daisy are, with the exception of the joining of their bodies": *New York Herald,* undated.

4. "Too bad only one of them cared for boys": 174, Dufour, op. cit.

5. "Both girls were the sweetest things:" Fernandez, op. cit.

6. "Moore said that Violet and Daisy were nymphomaniacs": John Bramhall, San Antonio, Texas, in interview with author, January 6, 1996.

7. "One thing we agree on": Daisy, *Lives and Loves,* op. cit.

8. "Ah . . ." was the only sound he was able to emit: Julius Brossen, *New York Sun*, July 5, 1934.

9. "We want to get married as soon as we can": Maurice Lambert, ibid.

10. "Then, after a time, Violet and I realized we were in love": ibid.

11. "The very idea is quite immoral and indecent": William C. Chanler, "Pygopagus Marriage," *Time*, July 16, 1934, 20.

12. "I can't give you a license": Harry Reichenstein, *New York American*, July 6, 1934.

13. "How do they expect a girl to be moral?": Violet, ibid.

14. "Why shouldn't I marry?": Violet, "Twin Still Plans Early Marriage," interview with Lady Terrington, *New York Mirror*, July 7, 1934.

15. "I want children," Violet replied. "A boy and a girl": ibid.

16. Many of the wires came from jerkwater towns": City Wedding of Siamese Twin," *New York Times*, July 6, 1934, 19.

17. "*I am Violet Hilton*": Fox Movietone, July 1934. The author is grateful to James Taylor, publisher of *Shocked and Amazed!* for providing the author with a copy of this newsreel.

18. Levy went on to argue: "A Ridge of Bone Upsets Violet's Romance," *American Weekly*, September 23, 1934.

19. "In my opinion, Siamese twins are two persons": Dr. D. H. L. Shapiro, "Siamese Twins One or Two Persons?" *Brooklyn Eagle*, July 10, 1934.

20. ". . . Because of an accident of birth": Levy, "Siamese Twin Wedding Held Publicity Stunt," *San Francisco Examiner*, July 16, 1934.

21. "I deny that": Levy, ibid.

22. "This cannot offend public decency": *American Weekly*, September 23, 1934.

23. "Any pair of male and female half wits": *American Weekly*, 1934.

24. Ibid.

### *Chapter Sixteen ☞ Pages 256–277*

1. "Harry is too conceited": Daisy, *New York Daily Mirror*, July 7, 1936.

2. "A semi-name band": Moore in MacMillan interview, op. cit.

3. "Both of the girls had boyfriends": ibid.

4. "Maybe there is someone in our band I like": Daisy, *New York Daily Mirror*, op cit.

5. "It may seem funny": Daisy, *New York Daily American*, July 18, 1936.
6. "They wanted," Moore explained, "to have it done right": Moore in MacMillan interview, op cit.
7. "So the doctor says": ibid.
8. "It was the only time"; ibid.
9. "Maurice . . .tried to get a marriage license": Violet, *Lives and Loves*, op. cit.
10. "That's right," he concurred": Terry Turner, ibid.
11. "I'll be your goat": Violet, ibid.
12. "I look up on the billboard": Moore, op. cit.
13. "It was too late": ibid.
14. "My daddy disowned me": ibid.
15. "I can't go through with it": Joe Rodgers, *Lives and Loves*, op. cit.
16. "Rent a dress suit": Turner, ibid.
17. "Unhappy as a dog being washed": *New York American*, August 23, 1936.
18. "I looked into the crowd": Violet, ibid.
19. She was, she said, "convulsed with mirth": Daisy, ibid.
20. "When Jimmy kisses me goodnight": Daisy, *New York American*, August 23, 1936.
21. "That's the real truth": Daisy, ibid.
22. "Jim Moore was as gay as a rag": Rosengren, op cit.
23. "I never slept with them": Bramhall quoting Moore, interview with author, op. cit.
24. "Your petitioners had no desire to be married": petition for annulment filed in New Orleans District Court.
25. "One of the girls—I don't remember which": Moore in MacMillan interview.
26. "The girls had an offer to go to Minneapolis": ibid.

### *Chapter Seventeen* ❧ *Pages 278–299*

1. "From the time the twins had come to America": Rosengren, op. cit.
2. "People may be willing to forgive": Fernandez, op. cit.
3. The conductor: "Marriage Was Just a Gag, 'Siamese' Twins Say Here," *Minneapolis Tribune*, October 2, 1936.
4. "If unable to collect": ibid.

5. "Don't you read your own paper?": Violet, ibid.

6. The baby was a boy: Florenza Williams in letter dated January 7, 1969, to the Reverend John Stills, Charlotte, North Carolina.

7. "She treated me as though I were the big bad wolf": Moore in MacMillan interview, op. cit.

8. "They were always writing or wiring Mom and Dad for money": Rosengren, op. cit.

9. "Financial security never seemed to be the least bit of concern": Fernandez, op. cit.

10. "They were just so generous with their money": Moore in MacMillan interview, op. cit.

11. "They became quite heavy drinkers": Rosengren, op. cit.

12. "They had fielded the same questions so often": E. Burke Maloney, *Ashbury Press*, June 11, 1978.

13. It was, Daisy imagined, going to be "fun": Daisy, *Lives and Loves*, op. cit.

14. "Whether we were sailing from New York": Buddy Sawyer interview with author, November 20, 1997.

15. "The twins, of course, were always the headliners": ibid.

16. "Probably the best times I had with Daisy and Violet": ibid.

17. Sawyer remembered: ibid.

18. "Sometimes Daisy and Violet could get so angry with one another": ibid.

19. "Daisy liked to have a cocktail now and then": ibid.

20. "It happened in the wee small hours": ibid.

21. "I felt that her marriage": Violet, *Lives and Loves*, op. cit.

22. "I did not argue with my sister about her choice": ibid.

23. "I have made it my rule": "Judge Buscaglia Dies In Midst of Campaign for Surrogate's Court," *Buffalo Evening News*, October 3, 1953.

24. Because I had take a Siamese twin as a bride": Sawyer, op. cit.

25. "All that night and through every night and day": Daisy, *Lives and Loves*, op. cit.

26. ". . . One morning when we looked across the twin bed": ibid.

27. "Daisy is a lovely girl": Sawyer, "Left His Bride Because Three's a Crowd," *American Weekly*, February 6, 1944.

28. "Maybe it was my fault": Sawyer interview with author, op. cit.

## Chapter Eighteen ☙ Pages 300–319

1. "The girls were so outstanding": Theodore D. Kemp, Charlotte, North Carolina, interview with author, July 10, 1995.
2. Desperate for some upturn in their fortunes: "Hilton Sisters Set By Jolly Joyce Agency," *Billboard*, November 7, 1942.
3. "It was Kentucky Derby time"; Bud Robinson, Los Angeles, California, interview with author, October 20, 1996.
4. "We run into drunks and hecklers": Violet, *Cincinnati Post*, June 13, 1958.
5. "I don't think there were another two entertainers": Sawyer interview with author, op cit.
6. Both had been long separated from their husbands: *Pittsburgh Press*, undated.
7. It was then when the king of all Sunday newspaper supplements: Emile C. Schumacher, *Nothing's Sacred On Sunday*. New York: Thomas Y. Crowell, 1951.
8. ". . . We still long to find romance": *Lives and Loves*. Op cit.
9. "I never got the impression": Howard Krick, Salem, Oregon, interview with author, September 22, 1996.
10. "Because the Hilton Sisters were the top billed act": ibid.
11. "They were real troupers": ibid.
12. Krick told this story: ibid.

## Chapter Nineteen ☙ Pages 320–339

1. "Frisco didn't get off to the smoothest of starts:" Abe Ford, Boston, Massachusetts, interview with author, March 13, 1998.
2. "Ross' specialty had always been novelty acts": ibid.
3. "We'll be sure to see the picture": Violet, quoted by Ford, ibid.
4. "Maybe we were crazy:" Daisy, quoted by Ford, ibid.
5. "Dad was the consummate night person": Heather Tanchuck, Los Angeles, California, interview with author, July 11, 1998.
6. "Daisy and Violet had fired several directors": Harry L. Fraser in *I Went That-a-Way*, edited by Wheeler W. Dixon and Audrey Brown Fraser, Metuchen, New Jersey and London, Scarecrow Press, 1990, 131.
7. Mulhall was the first cinema star to earn $1000 a week: *Screenland*, 28–29, 95–96, in collection of New York Public Library for the Performing Arts, date unknown.

8. "Except for the actors who were the principals": Whitey Roberts, Los Angeles, California, interview with author, October 7, 1997.

9. "Once we got together for the film": Fraser, op. cit.

10. "The shooting went fast": Roberts, op. cit.

11. "It posed some special problems": Fraser, op. cit.

12. "I remember the script girl"; ibid., 132.

13. "I'm fascinated by *Chained for Life*": Hedda Hopper, date unknown, presumably written for *Chicago Tribune Syndicate*.

14. "They were having the time of their lives": Roberts, op. cit.

15. "We were in and out of the studios": ibid.

### *Chapter Twenty ☺ Pages 340–367*

1. "The film became tied up in litigation": Fraser, op. cit., 131.

2. "It was not a production in which I took much pride:" ibid.

3. "I never felt more sorry for anyone in my life": Jim Moore in Bill Hendricks "Ex-Spouse: Siamese twins' life normal," *The Sunday Express-News*, after 1969.

4. "Daisy and Violet were the attraction at an outdoor theater": Philip Morris, Charlotte, North Carolina, interview with author, September 27, 1995.

5. Classic Picture, Inc. had debts totaling $336,795 and assets of a mere $2000: *Variety*, June 10, 1953.

6. The Hilton Sisters' Snack Bar was swarming: *Miami News*, June 6, 1966.

7. "Because we have so enjoyed our lives as entertainers": ibid.

8. A newspaperman who had been familiar with the twins' past: Daisy, *Cincinnati Post*, June 13, 1958.

9. "We can't say anything bad about it": Violet, ibid.

10. "We shun the things we don't like": Daisy, ibid.

11. "They said they were looking for work": Morris, op. cit.

12. Morris talked of the frustration: ibid.

13. "We learned how desperate things were for the girls": ibid.

14. "The girls seemed to be in one of those time warps": ibid.

15. "They left a vivid impression on me": Rosemary Land, Charlotte, North Carolina, interview with author July 7, 1995.

16. "Wherever the twins' movies was shown": Morris, op. cit.

17. "We tried to suggest": Morris, ibid.

18. "The thought of their making a final exit": ibid.

19. They were found in contempt: Kerry Segrave, *Drive-In Theaters: A History from Their Inception in 1933*. Jefferson, North Carolina and London: McFarland & Company, Inc. Publishers, 1992.

20. "It seemed like the theater's operators were always getting in hot water"; Curtis McCauley, Monroe, North Carolina, interview with author, January 8, 2005.

21. "Dad told the twins not to worry": Keziah, op. cit.

22. "I felt so sorry for them": Marlene McCauley, Monroe, North Carolina, interview with author, July 11, 1995.

23. "Somebody would say, 'Here comes the Siamese' ": ibid.

24. "Clegg put a finger to his lips": Keziah, op. cit.

*Chapter Twenty-One ✑ Pages 368–389*

1. "What I didn't know": John Dunnagan, Mooresville, North Carolina, interview with author, October 11, 1995.

2. "We were only traveling the mile or so": ibid.

3. "Rue looked them squarely in the eyes": ibid.

4. "I can't tell you how much joy I felt": Bishop Ernest A. Fitzgerald, Winston-Salem, North Carolina, interview with author, September 4, 1995.

5. "Mr. Reid worked as hard anybody": Reverend John Sills, Charlotte, North Carolina, July 7, 1995.

6. "She took them shopping": Dunnagan, op. cit.

7. Because the twins were lonely and hungering for companionship: Dot Jackson "The Only Bargain We Get Is Our Weight For A Penny," *Charlotte Observer*, January 6, 1969.

8. Not all the supermarket's workers: Guy Rodgers, Rock Hill, South Carolina, interview with author October 25, 1995.

9. "Guy rigged up a couple of produce scales": Linda Beatty, Denver, North Carolina, interview with author October, 25, 1995.

10. "Now and then, when Daisy and Violet were walking": ibid.

11. I don't think Daisy and Vi ever told us their age": Pauline Harton, Charlotte, North Carolina interview with author, November 20, 1995.

12. "I think they were grateful to have steady jobs": Beatty, op. cit.

13. "Because I had all these magic props": Gene Keeney, Indianapolis, Indiana, interview with author, June 20, 1995.

14. "Whenever an invitation was extended to the twins": Harton, op. cit.

15. "A father came in with a small boy": Rodgers, op. cit.

16. "I think it was in the early afternoon": Sills, op. cit.

17. Indeed, Daisy and Violet retained such a strong aversion to doctors: Rodgers, op. cit.

18. Apparently traveling by taxi: Mecklenberg County medical examiner's report, January 6, 1969.

19. "I know this": Dunnagan, op. cit.

20. When Daisy and Violet didn't want to be bothered: Charley Reid in Tommy Tomlinson: "A Story of Two Sisters, Together, Always," *Charlotte Observer*, December 7, 1997.

21. After calling the twins' cottage repeatedly: Reid, op. cit.

22. "How many of you," he asked, "are here to grieve?": Henry Woodhead "City's Siamese Twins Buried Simply," *Charlotte News*, January 9, 1969.

23. "Daisy and Violet were in show business": Sills, op. cit.

24. At the time of their death, their combined assets: filed January 16, 1970, Superior Court, Mecklenburg County, Charlotte, North Carolina.

25. "Aunt Dot felt terrible": Brenda McCallum, Charlotte, North Carolina, interview with author, May 14, 1999.

# INDEX